Lesley Loksi Chan, 2011 (Lisa Narduzzi)

STEPHEN BROOMER and MICHAEL ZRYD

Moments of Perception

Experimental Film in Canada

Edited by
JIM SHEDDEN and
BARBARA STERNBERG

Goose Lane Editions

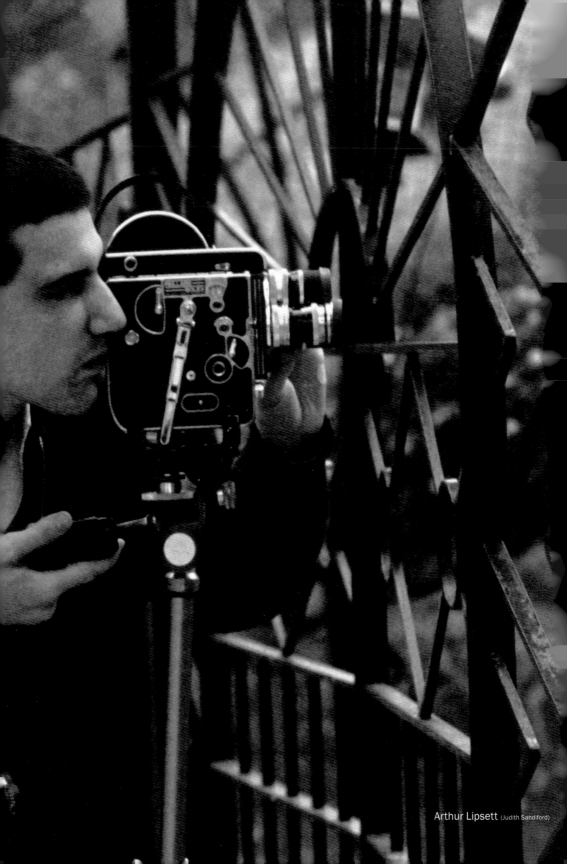

Arthur Lipsett (Judith Sandiford)

Josephine Massarella
(photographer unknown)

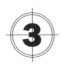

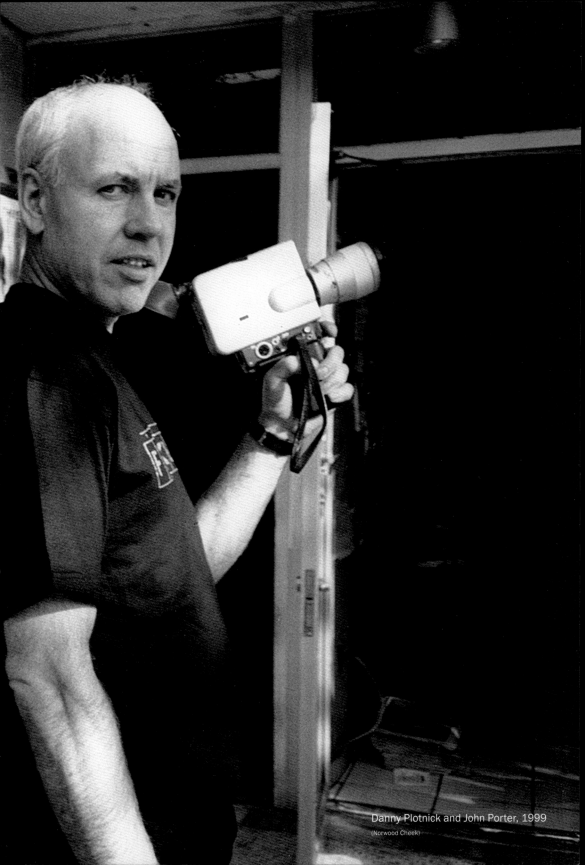

Danny Plotnick and John Porter, 1999
(Norwood Cheek)

Wendy Michener (left) and Joyce Wieland (right), 1969 (YUL)

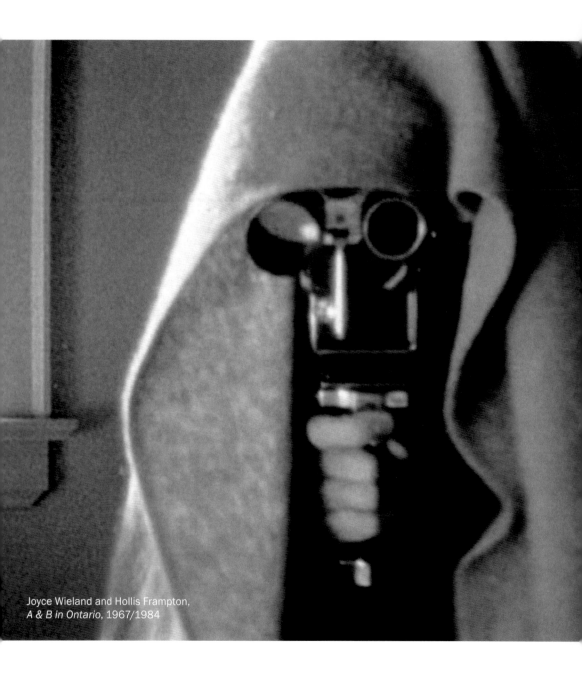

Joyce Wieland and Hollis Frampton,
A & B in Ontario, 1967/1984

Introduction
Why this book? And why now?

When I'm asked what I do, and I say, I make experimental films, the response is invariably, "What's that?" This book is an answer to that question. —Barbara Sternberg

Experimental film has existed since the beginnings of film. Though critics have identified movements and styles over the years (formal/structural film, materialist, lyrical, autobiographical), it is a richly varied genre, as each film artist explores and defines their own style, technique, themes, subject matter. Experimental film is a hands-on, personal practice. Each film creates its own reality.

The potential of the film medium is unlimited, and experimental filmmakers have been making work in this vast territory ever since the invention of the camera and projector—magical, sensual, intellectual, emotive moving image works that have engaged with political, personal, medium-reflexive, and philosophical themes. Throughout the history of film, experimental film (also known as avant-garde, underground, subversive) has been present and active as the definer of film as an art form, as agent provocateur, as personal expression, as innovator.

Experimental film challenges the dominant language of cinema itself and honestly reveals its artifice. In the stylized use of silent movie techniques in Guy Maddin's films, and Al Razutis's re-presentation of *Lumière's Train (Arriving at the Station)*; in the use of text as image in Kelly

Egan's work; in the use of special camera mounts and mechanized camera movements in the works of Chris Gallagher, Richard Kerr, and Alexandre Larose, which serve to confound what is filmed and what we see on the screen; in the near abstraction of the image through hand-processing and optical printing in Carl Brown's and Louise Bourque's films, revealing the material basis of film's emulsion—in these and many more ways, experimental film points to the illusion and illusory nature inherent in film.

Although this artisanal form of filmmaking is as old as film itself, it has not had the visibility and popular exposure that mainstream industry filmmaking has had; it continues to reach small committed audiences in small "underground" venues. Its impact, however, is visible in the work of visual artists and the commercial media world.

From surrealism through abstraction, to minimalist and feminist movements, and beyond, the visual and film arts have had parallel developments. Often the practitioners of one were also working in the other: Dalí, Léger, Richter, Serra, Snow, Wieland, Chambers. In contemporary practice, the line between visual and media arts is constantly being traversed, with gallery installations involving film by visual artists (Stan Douglas, for example), and performative screenings by filmmakers. John Porter and Alex MacKenzie use altered projectors in live performances of film; Christina Battle's work is shown almost exclusively in galleries.

Experimental film is international; practices cut across national boundaries. Canadian filmmakers are known and their work is shown to acclaim in Britain, France, Germany, Indonesia, Spain, Turkey, and the USA, among other countries. Canadian experimental film now has a long and well-reputed history. Its story needs to be told, but no book has done so—until now.

Moments of Perception: Experimental Film in Canada is a multi-authored book mapping the history of artist (avant-garde/experimental) filmmaking in Canada from the mid-1950s to the present. *Moments of Perception* is designed to provide an overview of artists' film as an expression of Canadian culture—including all the contradictions and complexities of that term—by understanding how artists have taken up the moving image as a form of artistic expression over the last seven decades.

The book is divided into three sections. Section 1 gives a broad overview of the terrain—the institutional and individual players whose presence and support (or lack thereof) helped shape the field, the main directions and many side paths and loops taken. Written by Michael Zryd, who teaches cinema and media arts, it considers how institutions like the National Film Board (NFB), film schools, the Canada Council, and independent groups like the Funnel, Canadian Filmmakers Distribution Centre (CFMDC), and the Winnipeg Film Group (WFG) shaped how artists worked and

audiences accessed this work. Who have been some of the key movers and shakers creating the scene? For whatever the specific mandate of an institution, and whether from within an institution or without, it is individuals with their particular interests and passions who make things happen. How have artists—and distributors and exhibitors—navigated periods of economic excess (e.g., the 1960s) or scarcity (e.g., the 1980s)? How have artists been part of social movements like feminism, multiculturalism, LGBTQ2+, and Indigenous protest, and how have audiences changed as Canada has grown and matured over the last half-century? Changes in technology have given artists new tools (e.g., the digital revolution) and restrictions (e.g., the so-called "death" of film) that have shaped how artists have explored the landscapes (urban and natural), cultures, and themes of their work. The backbone of *Moments of Perception* is a history of these broad cultural changes from the early moments of experimental film in Canada in the 1950s through the explosion of moving image art in the early twenty-first century. Section 1 lays out the social and institutional context for the individual artists profiled in section 2.

An important function of the book is to provide serious critical/analytical writing on key films and filmmakers. To this end, we've commissioned Stephen Broomer (scholar, author, film preservationist, and film artist) to write critical studies of key filmmakers. The filmmakers selected for section 2 represent those well-known figures (e.g., Snow, Wieland, Chambers, Rimmer), as well as other individuals whose works extend the "canon" in manifold ways through the exploration of film's formal properties, creative techniques, hybrid approaches, politics, and identity: Snow's formal films setting out how the camera sees; Wieland's playfulness within the formal; Hoffman's and Torossian's differing approaches to reconstructions of personal history; Chambers's and Epp's considerations of light and spirit; Sternberg's of time's mysteries; Brown's and Bourque's materialist exploitation of emulsion and colour to express emotion; Hoolboom's questions of authorial identity. The works are labelled to distinguish between an artist's complete portfolio constituting twenty-five films or fewer (Filmography); otherwise, the author has made a selection of works from a more extensive portfolio (Selected Works). The filmmakers in section 2 exemplify both those whose work early in the history and substantial and recognized *œuvres* forged paths and laid foundations, and also the younger and more recent practitioners as the genre continues, vibrant and vigorous, into the twenty-first century.

The filmmakers examined in section 2 do not represent nearly all the moments of perception of Canadian experimental film, however. This book aims to be as inclusive as possible in the interest of representing the diversity and richness of the Canadian experimental film community, and so section 3 includes entries on the many filmmakers who have contributed over the years and across Canada to this large, diverse, and

interesting field: Ross McLaren's Super 8 work, Rick Raxlen's wry humour and unique animations, Madi Piller's and Francisca Duran's recall of their South American roots, Linda Feesey's raw take on sexuality, Marnie Parrell's Métis play on language and myth, and many more.

Experimental film is political in its very existence, critical of the status quo by definition as an "alternative" to the mainstream. But it also has explicitly political themes in many filmmakers' work: Mike Hoolboom's exposure of the horror of AIDS, Josephine Massarella's and Daniel McIntyre's concern for the environment, Joyce Wieland's satiric look at US patriotism. The politics of identity seen in Helen Lee's view of herself through the lens of *The World of Suzie Wong*, Midi Onodera's examination of her identity as Asian and as lesbian, Wrik Mead's reveal of the gay male body, Izabella Pruska-Oldenhof's and Gariné Torossian's lyrical connections with their elsewhere pasts, all address in personal ways the problem of representation, otherness, not seeing oneself reflected in mainstream media. They present, in Adrienne Rich's words, a way of resisting amnesia to affirm one's identity and roots. These films are often short and always personal. As 1960s feminists knew: the personal is political.

Like all art, experimental films sometimes provoke, sometimes celebrate beauty, sometimes reflect on their own material nature, and sometimes question the human condition. But whether situated within a movement or style, or not, each film artist contributes their individual approach, personal vision, world view. Experimental film is not market-driven work—it is outside the market. There is no fortune to be made, no fame to be had; other values necessitate the making.

Why this book now? We are at a strange intersection: the death of film has been written about for several years, fuelled by media hype and promotion of digital technology. Yet, at the same time, we are witnessing a resurgence of production in Super 8, 16mm, and 35mm by film artists—*young* film artists. There is a return to materiality and to artisanal, hands-on filmmaking. A profusion of worldwide screening venues and festivals and small publications; expansion of festivals to include performative film events and installations; the use of film in gallery installations; and the involvement with film art by the major public galleries (Pompidou, Barbican, Tate Modern, for example) all put the lie to the "death of film" proclamations.

Canadian experimental film has a distinguished place within the arts and media worlds. Six Governor General's Awards have gone to experimental filmmakers; there have been retrospective screenings at the Art Gallery of Ontario and the Power Plant; individual filmmakers—as well as Canada itself—have been spotlighted at international film festivals from Paris to Bologna to Seoul. It is time to record the history of this contemporary art form in Canada and its acknowledged excellence worldwide.

We are both lifelong devotees of this art form in different ways: Sternberg as a filmmaker, advocate, film lecturer, and programmer, and Shedden as curator,

publisher, writer, and filmmaker. Our aim is to give readers from the general public and educational institutions inspiring insights into Canadian artists' films, encouraging readers to watch, study, and perhaps make, moving image art. We hope *Moments of Perception* will create a lasting presence for this ephemeral art.

The title *Moments of Perception* reminds us that perception is the essential aspect of film art, offering, at its best, momentary flashes of transcendent vision. Film is *the* art of our times—it has formed the background of our lives, has influenced visual arts practices, and has given shape to our culture's stories, its memory.

—JIM SHEDDEN and BARBARA STERNBERG, Toronto, 2021

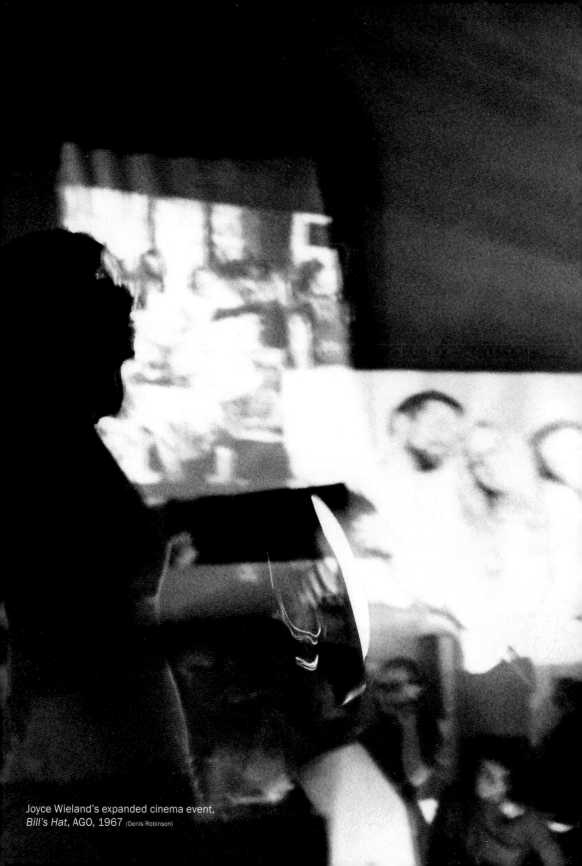

Joyce Wieland's expanded cinema event, *Bill's Hat*, AGO, 1967 (Denis Robinson)

A Short Institutional History of Canadian Experimental Film

MICHAEL ZRYD

Commonly used acronyms

AGO	Art Gallery of Ontario
AFCOOP	Atlantic Filmmakers Cooperative
AMAAS	Alberta Media Arts Alliance Society
ARC	Artist-run centre
BIPOC	Black, Indigenous, people of colour
CBC	Canadian Broadcasting Corporation
CCA	Canadian Council for the Arts
CFDC	Canadian Film Development Corporation (later Telefilm Canada)
CFDW	Canadian Filmmakers' Distribution West
CFMDC	Canadian Filmmakers' Distribution Centre
CQ	Cinémathèque québécoise
CSIF	Calgary Society of Independent Filmmakers
GIV	Groupe Intervention Video
IMAA	Independent Media Arts Alliance (AAMI: Alliance des arts médiatiques indépendants)
LAC	Library and Archives Canada
LGBTQ2+	Lesbian, gay, bisexual, trans, queer, two-spirit, and others who identify outside normative categories of sexuality or gender
LIFT	Liaison of Independent Filmmakers in Toronto
NFB	National Film Board of Canada
NGC	National Gallery of Canada
SFU	Simon Fraser University
TFS	Toronto Film Society
TIFF	Toronto International Film Festival
TRC	Truth and Reconciliation Commission
UBC	University of British Columbia
UK	United Kingdom
US	United States of America
VAG	Vancouver Art Gallery
WFG	Winnipeg Film Group

A Short Institutional History of Canadian Experimental Film

PART 1: Contested Terms

A survey of the rich tradition of Canadian experimental film is at first glance both inviting and daunting: the films are beautiful and profound, difficult and delicate and urgent, and they cover a range of artistic expression as rich as that of feature film narrative ("the movies") and even documentary, Canada's most famous cinematic form. Yet, when looking back from 2021 at the history of Canadian experimental film, we have an immediate problem: How do we even start to define it, since the ways that we understand each of these three terms—*Canadian, experimental,* and *film* itself—have changed so much over the years?

This survey attempts to capture a history of what has been recognized as "Canadian experimental film" and also to broaden this history to suit the expansive state of our current moment, when *moving image arts, artists' film,* and *experimental film and media* are just some of the new terms used to describe how people are experimenting with moving image and sound to create new visions, and new moments of perception. But to start with, let us define those three key words.

A. Define Canadian. I Dare You.

Indigenous moving image experiments in the context of Truth & Reconciliation

Appropriately, this volume begins with a Land Acknowledgement: the nation known as Canada sits on lands that have been inhabited by Indigenous people for millennia and has legacies of settlement and genocide that persist to this day. The imperatives of the 2015 Truth and Reconciliation Commission (TRC) require that we restore forgotten Indigenous activities to Canadian histories and also consider reframing conventional ways of knowing art—here, the art of moving image and sound—in light of Indigenous epistemologies: ways of knowing the world that are rooted in Indigenous frameworks.

The title of this book is *Moments of Perception*, and to acknowledge Indigenous ways of knowing the world is fully in the spirit of a long tradition of experimental film practice that has been dedicated to opening up perception and critical understanding of the world. Indigenous epistemologies help us further open up the history of moving image art made by and for this people on this land. The TRC documents social histories, most centrally the legacy of residential schools, whose violence and cultural dislocation blocked the involvement of Indigenous people in many endeavours, including experimental film. There is currently an eruption of Indigenous moving image artists who have taken leading positions in artists' use of direct process cinema (Lindsay McIntyre, Rhayne Vermette); virtual reality (Lisa Jackson, Danis Goulet); experimental animation (Tasha Hubbard); media art (Skawennati); performance and video (Rebecca Belmore, Thirza Cuthand); and experimental documentary (Geronimo Inutiq, Caroline Monnet), not to mention the boundary-blurring work of the Isuma collective. These artists remind us of the shadow generations of missing Indigenous artists who can never be written into this history due to the legacy of residential school violence and exclusion.

On the National Film Board of Canada (NFB) website, a blog post quotes Indigenous artist Jeremy Dutcher, who asked the rest of Canada a critical question when he accepted the 2018 Polaris Prize for *Wolastoqiyik Lintuwakonawa* (an avant-garde album that adapted traditional Wolastoq songs captured on wax cylinder recordings):

> Canada, you are in the midst of an Indigenous renaissance. Are you ready to hear the truths that need to be told? Are you ready to see the things that need to be seen?[1]

One challenge that this survey of the history of Canadian experimental film accepts is to attempt to see and recognize the existence of moving image art by Indigenous artists. For instance, we can include early examples of Indigenous production like *The Ballad of Crowfoot* (1968), made by Willie Dunn, who was part of the Indigenous Film Crew in the Challenge for Change program at the NFB, and *Animation from Cape Dorset* (1973), a collection produced by the NFB with Inuit artists Timmun Alariaq, Mathew Joanasie, Solomonie Pootoogook, and Itee Pootoogook Pilaloosie of the Cape Dorset (Baffin Island) Film Animation Workshop.[2]

A useful litmus test for developing a more capacious sense of the history of Canadian experimental film is the remarkable decades-long practice of the Isuma collective. Indeed, to include Isuma productions in this history challenges us to examine our understanding of experimental film itself. On the one hand, Isuma's work seems neither always experimental nor always film. Isuma worked in video and, later, digital technologies. Isuma productions were made to preserve Inuit stories and traditions and share qualities with community media, documentary, and fiction (but are unique

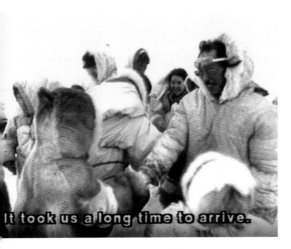

It took us a long time to arrive.

Zacharias Kunuk, Pauloosie Qulitalik, Norman Cohn, Isuma Collective, *Qaggiq*, 1988

variants of these forms). The narrative feature film *Atanarjuat* (2001) was the breakout work that won awards at Cannes and Toronto International Film Festival (TIFF), and through the 2000s, director Zacharias Kunuk's features seemed to position Isuma closer to the world of art cinema.[3] On the other hand, early Isuma pieces like *Qaggiq* (1988) and *Saputi* (1993) use techniques familiar to experimental film and especially video art (Isuma works are distributed by Vtape, the largest and most prominent video art distributor in Canada).[4] Isuma's use of the long-take aesthetic, alongside its attention to the textures of everyday life and to how the camera captures and transforms the light of the North, were both of and ahead of its time. We can position Isuma's work as part of a larger realm of Canadian experimental *moving image media art*, which, looking back from 2021, includes video and digital work in addition to film.

The fact that Isuma's works are the products of a collective dedicated to community history and education differentiates them from the dominant configuration of Canadian experimental film, which emphasizes the expressions of individual artists removed from industrial, mainstream cinema production, distribution, and exhibition contexts (although co-operative artist-run centres, ARCs, have been important to the Canadian experimental film and media ecosystem). Isuma, a relatively non-alienated production collective (important members have included Paul Apak Angilirq, Norman Cohn, Marie-Hélène Cousineau, Mary Kunuk, Pauloosie Qulitalik), forms part of a community that is certainly removed from urban centres, which mostly host experimental film culture. Isuma's current prominence in both the film and art worlds (e.g., chosen by the National Gallery of Art for the Canada pavilion at the 2019 Venice Biennale) points not only to the recent integration of film and media art into art gallery and museum contexts but also to the ways that Indigenous epistemologies help redefine how we understand experimental film and media, and indeed, Canada itself.

Wanda Nanibush, who has served as the Aboriginal arts officer at the Ontario Arts Council, executive director of the Association for Native Development in the Performing and Visual Arts (ANDPVA), and curator of Indigenous art at the Art Gallery of Ontario (AGO), argues that Indigenous film and media art—by accessing "millennia-old artistic traditions"—challenges the historical "progressivism" and colonialism that might adhere

to visual art and experimental film's celebration of the "avant-garde."[5] She cautions that "cultural progress in the arts seems biased toward avant-garde and non-realist forms," which may have the effect of devaluing seemingly realist forms in Indigenous media. For example, she notes the historical association of Indigenous media with documentary, holding up the work of Kunuk (whose early documentary work morphed into hybrid narratives) as "exemplary" of how Indigenous film and media challenge these very categories—allowing Kunuk to be rightly celebrated in narrative, documentary, experimental, and visual arts worlds.[6]

Canadian multiculturalism

Canada is a settler nation, but one with a complex history of immigration and multicultural coexistence and conflict—along with explicit and systemic racism that further complicates the term *Canadian* in Canadian experimental film. Like most Canadian art forms, such as theatre, visual art, and music, Canadian experimental film was dominated by White artists through most of the twentieth century, albeit with many important exceptions. The most recognized Canadian experimental film artists (Jack Chambers, Arthur Lipsett, Norman McLaren, Michael Snow, and Joyce Wieland) made films starting in the 1940s to 1960s, and all have White Anglo-European ethnicity (with a variety of class backgrounds). Today, moving image artists come from a much wider range of international cultural backgrounds, especially in the major cities in which Canadian moving image art culture is most prevalent. It's no accident that the vitality of media arts in our period has coincided with increased cultural diversity in Canada, as well as increased attention to the eclecticism of art production, especially from the 1990s to the present.

Multiculturalism was announced as an official government policy in Canada by Pierre Trudeau in 1971 and ensconced as a principle of the Charter of Rights and Freedoms of 1982. In 1986, the federal Employment Equity Act outlined measures to respond to the historical discrimination against women, Indigenous peoples, people with disabilities, and "visible minorities" (a term that has been superseded in the 2020s by *racialized* or *BIPOC*—Black, Indigenous, people of colour). The Canadian Multiculturalism Act of 1988 made it a priority for the government to foster more equitable participation of people from the full array of immigrant groups in Canadian society; its legislation was meant to protect ethnic, racial, linguistic, and religious diversity within Canadian society. Though the policy has had many positive effects, it has also been heavily contested by many of the same cultural groups the term ostensibly covers. Part of the problem is that multiculturalism structures Canadian culture around a base of White European settlers—especially the English and French—to which have been "added" cultures to fill out the Canadian "mosaic" (a popular metaphor that attempts to distinguish Canadian culture from the American "melting pot," a more explicitly assimilationist metaphor).[7]

The rhetoric of Canadian peacemaking and multiculturalism often disavows the history and continued existence of racism and discrimination on the basis of skin colour, ethnic identity, religion, language, or any number of other identity categories.[8]

Increasingly from the 1980s onward, the influx of new Canadians, the rise of Indigenous media artists, and multi-faceted expressions of gender, sexuality, and disability began to diversify experimental film artists and institutions. Yet this increase in diversity is missing from our published histories of experimental film and media. Deanna Bowen comments on what she rightly calls the "appalling deficiency" of "histories of First Peoples, racialized, differently abled, or LGBTQ2+ organizations, collectives, artists, and their works."[9] What she politely calls "(often) less than ideal creative climates" are rooted in "broader structural inequities" in a Canadian arts scene and society that have frequently disavowed systemic racism and other forms of discrimination, partly by pointing smugly to the more cartoonish versions of racism in the US. But a full understanding of the richness of the Canadian experimental media arts, its "political concerns and thematic complexities," will not be possible unless we address how these moving image practices "incorporate a broad spectrum of intersectional identity-based issues": the ways that artists have implicitly and explicitly expressed how social categories like race, language, gender, and sexuality shape and intersect to further inform artists' "thematic complexities."[10] I shall do my best to take up Bowen's challenge, which she delivered on in the substantial compilation she edited, *Other Places: Reflections on Media Arts in Canada* (2019), to amend "the woefully myopic 'histories' that fail to acknowledge or appreciate the boundary-pushing individual, collective, and organizational practices of media arts makers who rightfully critique or reject the norms and omissions of white mainstream media arts cultural circles."[11]

Within the larger field of Canadian film- and media-making, the experimental and independent media arts sector was the first to foster the expression of identities apart from White mainstream media. While that expression has been hampered by forms of systemic discrimination, on the whole it remains ahead of mainstream fiction film and television industries. The full understanding of the Canadian media arts landscape—and the full range of persons within it—requires attention to both forms of expression and histories of repression. One effect of this shift in historical focus is that it provokes an examination of how definitional boundaries around narrative, documentary, and experimental forms of film, video, and media art are inflected by considerations of categories of identity. This survey text is by definition incomplete—but it will attempt to be inclusively incomplete.

Canadian internationalism

One consequence of Canada's relative openness in welcoming cultural diversity has been the benefit of cross-border movement. For if Canadian experimental film has not always been culturally diverse, it has always been international, especially in relation to the United States and Europe through the 1980s, and more recently in relation to parts of South America and Asia. To name a few exemplary cases, Scottish artist Norman McLaren made Canada his home after joining the NFB in 1941; one of the foundational Canadian experimental films, *Wavelength* (1967), was filmed by Michael Snow in New York City; and some important festivals featuring Canadian experimental film have been curated and mounted outside Canada. *The Visual Aspect: Recent Canadian Experimental Film*, co-curated and coordinated by French filmmaker Rose Lowder in Avignon, France, in 1991, is typical of many formations of a national cinema: curators outside Canada have innovative notions of how to identify Canadian cinema.

In fact, while many festivals, galleries, and museums in Canada have been resistant to nurturing Canadian experimental film, Canadian experimental film has sometimes been more legible to film and arts communities outside Canada. This visibility was created and sustained through the initiative of independent international curators like Lowder and festivals like Senza titolo in Italy (which programmed R. Bruce Elder's *Book of All the Dead* in 1996), as well as by Canadian cultural consulates and affiliated offices like Canada House in London or Berlin that programmed Canadian films as part of their official mandate to promote Canadian culture (e.g., UK/Canadian Video Exchange, organized by Stuart Marshall in 1984, and revived in 1999-2000, focusing on video). Almost all local experimental film scenes in Canada have been open to international artists and curators, which has led to connections that are often as or more robust outside Canadian borders than between regional scenes in Canada. Artistic connections between Toronto and New York or between Vancouver and San Francisco have sometimes been stronger than links between Toronto and Winnipeg, or between Calgary and Montréal.

Two examples of Canadian artists whose careers cross borders are Vincent Grenier and Oliver Husain. Grenier is a prominent Canadian experimental filmmaker originally from Quebec, who has been based in the US since the 1970s, and has been teaching at Binghamton University (NY) since 1986. Grenier could sometimes access Canada Council for the Arts (CCA) funding, and his films and digital works are linked thematically to concerns with landscape and technology important to many Canadian experimental films of the 1980s and 1990s. Grenier's work is included in accounts of Canadian experimental film, but the question of "home" has complicated his visibility inside Canada. Oliver Husain is a prolific multimedia artist working in film, video, performance, and installation art; he is originally from Germany but now based in Toronto, and his funding for screenings, installations, and grants is largely from Canada and Germany. Like many important moving image media artists, Husain has an international

profile, screening work in emerging experimental media sites like Jakarta and Bangalore, as well as traditional centres like New York and Berlin.

The permeability of Canada's borders for experimental moving image artists has ensured that artists working in Canada have been exposed to films and artistic traditions outside Canada. CCA and other artist travel resources have created opportunities to travel and thus enabled Canadian artists to screen films outside Canada and to learn from international contexts. For example, Jack Chambers's training in Spain, while focused on painting, influenced his approach to light and composition, counterintuitively grounding his strongly regionalist approach to art upon his return to London, Ontario. Michael Snow and Joyce Wieland, while they began filmmaking in Toronto, were immeasurably enriched through the 1960s by their exposure to the generation of New York–based filmmakers like Hollis Frampton, Ernie Gehr, Ken Jacobs, and Jonas Mekas during their stay in New York, the centre of the international art world during this period. Snow's canonical *Wavelength* achieved prominence by winning the Grand Prize at the 1967 International Festival of International Cinema (EXPRMNTL) at Knokke-le-Zoute, Belgium. The rise of film festivals—in Toronto alone, the number of festivals rose from 3 before 1990 to over 130 in 2018—further increased the number of international films and filmmakers in Canada, while CCA-funded festivals were required to include a certain percentage of work by Canadian artists.[12] Cultural nationalism has been, at various times, an important topic within the Canadian arts scene, especially from the 1970s through the 1990s, when the politics of resistance to US "cultural imperialism" was widely felt in Canadian experimental film and video art. But throughout the history of Canadian experimental film, although there have been vocal bouts of petty nationalism and regionalism that have demanded Canadian festivals, distributors, and other cultural powers-that-be privilege "Canadian" artists, the overwhelming international sweep of artists across the Canadian border—in both directions—has largely prevented Canadian experimental film from becoming fatally parochial.

An illuminating case study is the Images Festival of Independent Film & Video (now simply the Images Festival, as in addition to film and video it includes installation, performance, and all manner of moving image media). It emerged in 1988 out of a collective called Northern Visions, and initially had the somewhat nationalist agenda to "promote the excellent work being created by filmmakers and video artists across Canada."[13] But by its second year, it had already begun to show works from India and the US, and its catalogue announced that the festival celebrated not just the work of independent producers in Canada but also those from "abroad."[14] Many of the works by Canadian artists in that 1989 festival took as subject matter immigrant and diasporic experience or international topics intersecting with China, El Salvador, France, Germany, Haiti, Honduras, India, Japan, Mozambique, the Netherlands, Palestine, the Philippines, Poland, Switzerland, and the US (four works related to Indigenous

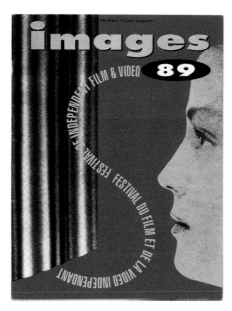

Images Festival, 1989

topics were screened, two by Indigenous artists). In short, even a festival with a nationalist mandate could not help but become international in its ambit. Over its more than three decades of existence, the Images Festival has become one of the largest international experimental film and media festivals, sometimes featuring Canadian artists on opening night or Toronto artists on a particular screening, but more often mixing Canadian with international artists. In more recent years, Images Festival has organized touring packages of Canadian and other films to screen at international experimental film and media festivals like EXiS in Seoul, Korea, and Experimenta in Bangalore, India.

Canadian distributors like the Canadian Filmmakers Distribution Centre (CFMDC) and Vtape regularly screen programs at festivals like the Oberhausen International Short Film Festival (Germany) and International Film Festival Rotterdam (the Netherlands), and Canadian filmmakers distribute their films through all the major experimental film distributors around the world: US (Film-Makers' Cooperative or FMC; Canyon Cinema; Museum of Modern Art, New York or MoMA; UK (London Film-Makers' Co-operative/LUX); France (Centre George Pompidou, Light Cone/Experimental Film Archive of Avignon or AFEA); Germany (Arsenal); among others. Canadian filmmakers have screened work at all major international experimental festivals and those large festivals that increasingly incorporate experimental work (e.g., Ann Arbor Film Festival, Berlinale, Views from the Avant-Garde/Projections as part of the New York Film Festival). In this regard, Canadian experimental filmmakers and media artists continue to participate in what has always been a highly international field of production, distribution, and exhibition.

While cross-border mobility has been a constant, there have been moments of interaction that have led to "scenes" arising. For example, as mentioned above, Michael Snow and Joyce Wieland were central to the New York scene in the 1960s. They had followed other Canadian artists to New York—for example, Robert (Bob) Cowan, a filmmaker and actor who moved to New York in 1955, worked as a projectionist for the Film-Maker's Cinematheque (including for Andy Warhol's two-screen *The Chelsea Girls*, 1966), and wrote a column on experimental film in New York for Canadian-based *Take One* magazine from 1967 to 1974. There was also an active exchange between Berlin and

Toronto in the late 1980s grounded in Super 8 and punk film and figures like German curator Alf Bold and Canadian filmmakers like Penelope Buitenhuis.[15] In recent years, in concert with the worldwide growth of hand-processed cinema and the proliferation of micro labs that have revived the artisanal ethos of analog film, there has been important influence from Philip Hoffman's Independent Imaging Retreat, or Film Farm (est. 1994 with Marian McMahon) in Mount Forest near Toronto. Hoffman has taught "process cinema" principles and practices in Cuba, Finland, England, and elsewhere, tapping into the international network of experimental filmmakers, students, festivals, and other institutions worldwide.[16]

Boundaries within Canada: regional aesthetics

If Canadian experimental film has been in dialogue with film culture outside Canada, divisions within Canada between provinces, regions, and cities have sometimes been more prominent, especially long-standing debates between Quebec and other parts of Canada around language, culture, and "national" autonomy.[17] In many ways, film generally in Quebec has a more robust history than English Canadian film, especially in feature narrative, in television, in documentary film, and in relation to synergies between the performing arts like theatre and dance and a range of moving image media. Quebec's unique cinematic legacy has allowed more experimentation in narrative and documentary independent cinema, whether through the intense influence of the French New Wave on independent fiction and documentary film in the post–Quiet Revolution in the 1960s or the remarkable multimedia work of artists like Robert Lepage starting in 1980s.

Another division in experimental film history lies between cities and regions. Internationally, experimental filmmaking has tended to arise in major cities. Influential experimental film scenes have emerged in Berlin, London, New York, Paris, San Francisco, and Tokyo, where the concentration of artists and favourable economic and social conditions created the critical mass necessary for the development of production co-operatives (co-ops), distributors, dedicated (or ephemeral) exhibition spaces, and magazines and writers to publicize and create viewing communities for critical discussion about the work. Cities also have art schools, colleges, and universities, which have quietly nurtured these scenes. Yet, regional scenes have been equally important. Sometimes they are populated by artists forced out of urban centres as cities have cyclically become unaffordable or inhospitable to artists, but sometimes these scenes have been driven by regional pride, exceptionalism, or the sheer energies of individual figures who have mobilized local resources and communities. In Canada, while major metropolitan cities like Montréal, Toronto, and Vancouver have housed national distributors like CFMDC, Vtape, Groupe Intervention Vidéo (GIV), Vidéographe, and VIVO, important regional scenes have developed elsewhere, sometimes temporarily, as in London, Ontario, in the late 1960s, or in more sustained ways in places like Halifax, Winnipeg, and Regina,

where the particular nature of each scene's development has given each a unique style: outsiders in an outsider culture.

Many iconic Canadian experimental filmmakers are associated with one city (e.g., Chambers in London, Ontario; McLaren and Lipsett in Montréal; Rimmer in Vancouver; Snow and Wieland in Toronto), although all of them travelled to expand their horizons. But there are many counter-examples to regional specificity, artists who have worked in multiple sites across Canada, contributing in different ways to different scenes. Christina Battle is an Edmonton-based artist who was born and raised there but has resided in Toronto, San Francisco, Colorado, and London, Ontario (where she completed a PhD in Art and Visual Culture at Western University), while curating and exhibiting widely, often with collaborators like The League (with Sara McLean and Michèle Stanley) and Shattered Moon Alliance (with Serena Lee). Amanda Dawn Christie is another example of an artist who has worked in ARCs across Canada; she has roots in New Brunswick (Galerie Sans Nom, Moncton, and Struts Gallery & Faucet Media Arts Centre, Sackville), moved to Vancouver to complete an MFA at Simon Fraser University or SFU (during which time she was involved in Cineworks), and ended up in Montréal to take up an academic post at Concordia University, with stops in Halifax and Amsterdam. Moving to schools for graduate training is a major factor in determining where a filmmaker might dwell (e.g., Clint Enns moved from Winnipeg to Toronto to Montréal or Mike Rollo from Regina to Montréal back to Regina), or for faculty positions (e.g., Patricia Gruben from Texas to Toronto to Vancouver, Rick Hancox from Charlottetown to Toronto to Montréal, or Richard Kerr from Toronto to Regina to Montréal).

B. Define Experimental. I Double Dare You.

A blizzard of terms

The term *experimental film* has been highly contested throughout film history. It is almost impossible to define, but we can outline parameters for understanding what has been a highly varied mode of filmmaking since the 1910s. Erika Balsom points to an article by US filmmaker Larry Jordan whose title suggests the plethora of terms available in 1979: "Survival in the Independent–Non-Commercial–Avant-Garde–Experimental–Personal–Expressionistic Film Market of 1979"; writing in 2017, Balsom updates the list to "artistic–independent–experimental–non-industrial–non-commercial–artisanal–expanded–oppositional–avant-garde."[18] Some resist the term *experimental*, as the very range of expression of the films—their lyrical beauty, sharp outrage, critical sophistication—does not seem to be captured in a term that one critic called "pejorative."[19] Nonetheless, historically, *experimental film* has been the term with the most usage. Moreover, it is important to recognize that what was called an experimental film

in the 1950s might be quite different from what would be called experimental film in the 1970s or 2000s: the category itself has varied historically.

Experimental film is sometimes used as a catch-all category in which to dump any film that doesn't quite fit into the more familiar categories of narrative fiction and documentary film. This approach, while flawed, at least captures the open, dynamic, and critical qualities of the tradition. On the one hand, there are some clear distinctions between narrative fiction and documentary: narrative films tell fictional stories using actors, while documentary films make assertions about reality. On the other hand, there are some overlaps between these film types: narrative fiction films can be based on real events, and many documentaries tell stories and may use actors for re-enactments. To further complicate matters, experimental films can incorporate narrative and fiction and may also have the documentary quality of making assertions about reality. But experimental films tend to subvert conventional narrative or documentary forms, or simply set up their own frames of reference. At certain points in film history, experimentation in narrative fiction and documentary has led to innovation such that the terms *experimental narrative* and *experimental documentary* are used widely.

Over time, some experimental film practice developed its own stylistic conventions (e.g., abstraction, rapid montage, looping, non-synchronous sound) and experimental film "genres" like the city symphony, found footage film, or the psychodrama have developed with recognizable stylistic and thematic patterns. Notwithstanding this, I would assert that the unique quality of experimental films is that *each film invites a new approach by the viewer.* With each experimental film, we need to learn how to watch it. This means that the openness of form—and thus new perspectives on the content or theme—is the key quality. As Canadian video artist Gary Kibbins puts it, "Whatever its other defects, the term 'experimental film' has, at least in the last few decades, been usefully vague," an indefinability that has positively served artists' open range of exploration.[20]

Objections to the term *experimental* take many forms. Some artists object to its scientific connotations, as if artists were "just" experimenting, like scientists in lab coats, or they don't really know what they are doing. Some artists have embraced the sense of exploration in the term; Kibbins notes modernism's emphasis on innovation and "the new," and cites American artist and composer John Cage's description of an "experimental situation": "one in which nothing is selected in advance, in which there are no obligations or prohibitions, in which nothing is even predictable."[21] Some experimental filmmakers are inspired by early film (those made in the decades after the Lumière brothers' first public screening of film in 1895): although film inherited nineteenth-century aesthetic and cultural norms from photography and theatre, almost every early film was a new experiment until conventions of narrative and actuality films were established.[22]

In the twentieth century, the term most commonly used as an alternative to experimental film was *avant-garde film*, which has its own problematic connotations. Avant-garde is a military term that has been widely appropriated in the arts, especially in the early and mid-twentieth century, to describe provocative art movements that had the explicit intention to subvert establishment forces. Avant-gardes tend to be invested in the political desire to change the world, usually by changing minds; for self-described avant-gardists the term *experimental* is tainted as apolitical or quietist. There are many activist traditions of experimental film (e.g., *oppositional film*) united, if not in their politics, then in their desire to transform the consciousness of viewers. They seek the key in an artistic form that, whether through shock, Brechtian distancing, or modernist defamiliarization, will unlock a liberated consciousness.[23]

Yet, that which is avant-garde one year has a tendency to become next year's fashion; capitalist markets, whether in art or advertising, have hastily appropriated even the most apparently subversive avant-garde work. For example, until recently, Air Canada had an "Avant-Garde" category of in-flight entertainment, composed not of experimental films but of quirky "indie" feature narratives. In international experimental film history, we now refer to *historical avant-gardes* like the Surrealist or French Impressionist avant-gardes of the 1920s-1930s, a usage which has the benefit of acknowledging that history will catch up to even the most advanced guard. Many experimental film and media artists have radical political and social aims, but those aims have been more varied than the programmatic avant-garde movements of the 1920s, 1960s, or even 1980s sanctioned.

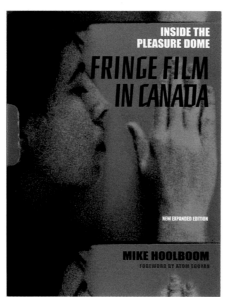

Inside the Pleasure Dome: Fringe Film in Canada by Mike Hoolboom, 2001

Recognizing the contradictions of the term, contemporary film and media artists rarely use the term *avant-garde*, as it does not serve the diversity and complexity of their political and cultural purposes. Indeed, filmmaker Mike Hoolboom, in his writing from 1990 onward, made a point of insisting that the word have an *X* superimposed over it as a gesture to underscore the erasure of its historical political legacy under postmodern capitalism.[24] For his 1997 anthology of interviews with artists, Hoolboom coined the term *fringe film* to capture how experimental and independent filmmakers occupied spaces away from the cultural centre; his 2008 follow-up anthology used the term *Movie Artists*.[25] Experimental film writing has accumulated a host of other such terms

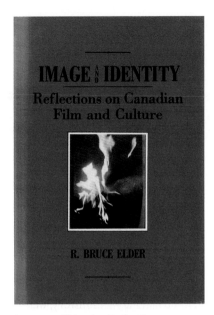

IMAGE AND IDENTITY
Reflections on Canadian
Film and Culture

R. BRUCE ELDER

Image and Identity: Reflections on Canadian Film and Culture by R. Bruce Elder, 1989

seeking to describe the indescribable, although there is little consistency in usage.

In critical writing on Canadian experimental film, *experimental* and *avant-garde* are often used interchangeably. In the 1950s and 1960s, experimental film was the dominant term until the 1970s and 1980s, when critics and some filmmakers began using avant-garde film, influenced by the rise of the term in academic and art world writing. Bruce Elder's book *Image and Identity* (1989), an important treatment of "Canadian film against the background of Canadian thought and Canadian art," discusses a "Canadian avant-garde" but uses the term interchangeably with "experimental filmmaking."[26] This interchangeability was a common pattern in most late twentieth-century critical writing on experimental film; it reflects both the looseness of terminology and the fact that the ostensibly radical thrust of an avant-garde, for better or worse, is not necessarily central to the wide practice of experimental filmmaking. Meanwhile, if *experimental* and *avant-garde* have been the dominant terms, there have been many others, often describing a more specific mode of filmmaking practice.

A short history of experimental film terminology

Experimental film has always been an evolving art form trying to redefine what moving image and sound art can be, and so its terminology has also changed over time. The first films recognized as experimental films were *abstract animations* made starting in the late 1910s and 1920s by artists like Oskar Fischinger, Lotte Reiniger, and Hans Richter. *Experimental animation* was and remains an important form of experimental film in Canada, from the early work of Norman McLaren and Evelyn Lambart through Ed Ackerman, Ann Marie Fleming, Frances Leeming, Rick Raxlen, Richard Reeves, and Steven Woloshen. Many of these artists worked in *direct animation*, painting or scratching the film strip. As part of the vibrant scene in Paris in the 1920s, Cubist and Surrealist visual artists like Marcel Duchamp, Germaine Dulac, Jean Epstein, Fernand Léger, and Salvador Dalí began experimenting with film, creating types of *Cubist, Surrealist, and Impressionist film*.[27] Soviet *montage cinema* of the 1920s and early 1930s was highly influential on subsequent *activist film and media*, developing the power of editing and composition to communicate a political message. In the same period, the *city symphony*

was an *experimental documentary* form in Europe that migrated to Canada and the US; Dziga Vertov's *Man with a Movie Camera* (1929) is an influential example of city symphony using montage. From its earliest days, experimental film had close ties to animation and documentary, and is sometimes grouped with them in the umbrella category *non-fiction film*.

After the Second World War, Maya Deren was part of a cadre of US-based film-makers like Kenneth Anger, Stan Brakhage, and Jonas Mekas, who led the American experimental film scene that exploded as *underground cinema* in the 1960s. Deren's films are seen as important examples of *psychodrama* (depicting the inner subjectivity of the filmmaker, an aesthetic that stretches back to German *expressionist cinema* of the 1910s and 1920s) and *dance films* or *screendance* (a subset of films that integrate dance and film movement). *Subversive film* was a tag used to connote the taboo-breaking effect of some work, especially in challenging sexual mores. Anger's films exemplified how experimental films could engage with and critique popular culture (influential upon the *music video* of the 1980s), and his ironic expressions of sexuality (along with films by Jack Smith and George Kuchar) opened a path for *queer film*. In Canada, a myriad of film- and video-makers engage with queer aesthetics (e.g., John Greyson, Wrik Mead); Margaret Moores's *Labyris Rising* (1980) was an explicit homage to Anger's *Scorpio Rising* (1963), showing elements of lesbian life in Toronto.

Brakhage worked in many forms (psychodrama, direct animation), and was, like many experimental filmmakers, influenced by poetry and music, working in modes like *poetic film* or *visual music*. *Personal film* (sometimes called *autobiographical film*) includes a range of small-scale filmmaking from Jonas Mekas's *diary films* to the work of Canadian filmmakers like Rick Hancox, Hoffman, and Kelly O'Brien, taking ordinary life and internal reflection as artistic material. Personal film captures the individual scale of how many experimental filmmakers work, but it often presumes a Romantic model of individual expression that does not capture how experimental filmmaking can also be collective, institutional, abstract, or indeed, impersonal.

Emerging in the late 1960s alongside and in reaction to the Romantic expressive impulse of psychodrama and underground films was a new generation of filmmakers like Hollis Frampton, Ernie Gehr, Paul Sharits, Michael Snow, and Joyce Wieland who made so-called *structural film* in the 1970s and early 1980s.[28] Whereas many films called experimental in the 1950s or 1960s might include elements of story or characters, structural films more explicitly rejected narrative in favour of abstraction, isolation of formal elements, and—especially in Canada—landscape. Variations of structural film, influenced by art world minimalism, pop art, and conceptual art, were sometimes called *formal cinema* or *pure film* for their investigations of the materiality of film, often following pre-determined formal systems. The formal tendency was powerful in Canadian

experimental film of the 1970s and 1980s, including work by David Rimmer and Ellie Epp, but extends to more recent work by Kelly Egan, Chris Kennedy, and Daïchi Saïto. Snow's long and illustrious career has exhaustively investigated formal properties of a myriad of film, video, and media art forms, from *Wavelength* (1967) to his recent *Cityscape* (2019), made using IMAX technology.

In different ways, *expanded cinema* explored similar territory, often engaging with a wider array of technologies (including electronic media) and a wider variety of exhibition formats.[29] Meanwhile, *video art* had developed as a largely separate medium from the late 1960s through the 1990s, with a stronger tie to the art world due to exhibition in art galleries and museums. In addition to a parallel stream of video art that, like structural film, investigated their arguably medium-specific qualities, early video art often foregrounded performance, personal expression, and activist documentation.

The late 1970s and the 1980s saw a surge of women filmmakers creating a *feminist avant-garde*. Feminist film theory, especially Laura Mulvey's writing on the male gaze, led to work that critiqued the conventions of narrative cinema for their ideological power.[30] Filmmakers like Mulvey and Lis Rhodes in the UK; Su Friedrich, Barbara Hammer, and Yvonne Rainer in the US; and Kay Armatage, Patricia Gruben, Brenda Longfellow, and Midi Onodera in Canada made films that integrated earlier modes of experimental film (e.g., psychodrama, structural film, screendance, expanded cinema) with feminist themes, part of a larger integration of elements of personal identity into film. In the 1980s, *feminist New Narrative*—part of a larger trend across the experimental sector in which some filmmakers attempted experimental feature-length narrative production—were attempts to find new forms for narrative just as feminist writers were finding a new language.[31] While filmmakers who were invested in formal film protested against the presence of narrative, earlier periods of experimental film had often featured characters and elements of narrative, as in Surrealist film and psychodrama. Just as feminism began to engage more intersectionally with race, ethnicity, and other categories of social identity in recent decades, so experimental film and media took up these issues, using experiments with image and sound form as a way to explore new approaches to identity, and its social, political, and cultural effects.

Another important experimental mode in the 1980s was *found footage* or *collage film*, in which appropriated images would be newly contextualized via editing to allow for political and cultural critique of the originals (although this practice extends as far back as Esfir Shub in the 1920s, Joseph Cornell in the 1930s and 1940s, Bruce Conner in the 1950s, and Santiago Álvarez in the 1960s).[32] Found footage film is a central experimental mode in Canadian experimental practice (e.g., Stephen Broomer, Betty Ferguson, Charles Gagnon, Arthur Lipsett, Al Razutis, and Gariné Torossian).[33] Some contemporary found footage filmmakers working at the frame-by-frame level intersect

L to R: Barbara Sternberg, Maria Raponi, Madi Piller, and Rob Butterworth at a workshop by Alex MacKenzie on creating handmade black and white emulsion, LIFT, 2009 (Alex MacKenzie)

with *artisanal film*. Although the term has long been used in relation to small-scale filmmaking, it has enjoyed a resurgence with the embrace of handmade film processes (e.g., developing films at home, experimenting with new chemistry, tinting and toning footage), prompted both by the closure of film labs and a desire for tactile, analog experience in the digital age.[34] Carl Brown was a forerunner of Canadian artisanal processes from the 1980s, with many subsequent artists (e.g., Stephen Broomer, Amanda Dawn Christie, Helen Hill, Hoffman, Terra Jean Long, and Solomon Nagler) making *hand-processed film*. Some artists (Alex MacKenzie, Lindsay McIntyre), have even attempted to make their own film emulsions, exploring the unique textural, colour, and motion possibilities.[35]

Toward an ecosystem of experimental film and media art

The very brief history I have sketched above is largely a history of films and artists, following a traditional art history model that seeks to understand the evolution of an art according to a succession of forms—a morphology of style—and a roster of influential artists. It is a valuable standard way of teaching experimental film, providing a canon

of important films, filmmakers, and readings that interpret the works in the confines of an undergraduate semester. In this historical mode, the terms used to describe certain *film movements* (e.g., structural film) are sometimes coined by film critics, programmers and curators, and art historians characterizing, often retrospectively, a group of films or filmmakers.

But the terms the artists themselves use to describe their work vary widely. Michael Snow famously embraced the multiple forms in which he worked, saying, "My paintings are done by a filmmaker, sculpture by a musician, films by a painter, music by a film-maker, paintings by a sculptor." While not all film artists have Snow's range, they may self-identify in numerous ways (many self-identify simply as *filmmaker* or *artist*). Terms from film movements can be limiting because they classify films in a way that may restrict a work's full range of meanings and may even be resisted by artists who a critic has included in a movement. Critical terms are invaluable as ways to access meaning in opaque artworks, but new critical frameworks continually arise to further explore a film's meanings for historical and new audiences.

Another limitation of this kind of history is that it can be less attentive to the social, economic, and political histories of the cultures in which these artists made their films. The force of will, genius, and imagination at the heart of great art cannot be ignored; however, it is also important to understand the larger context in which these films were produced: the institutions that nurtured and hampered artists, the social and political conditions that affected them, the economic and technological factors at play, and the systemic forces—capitalism, racism, sexism, homophobia—that repressed and shaped the artistic ecosystem and in part determined what films were made, screened, recognized, and written into history.

Attention to experimental film ecosystems also acknowledges the contributions of institutions and individuals who played a part in shaping the development of experimental film through their films and through their behind-the-scenes activities. Just as Dulac and Epstein in 1920s France were not only filmmakers but also organizers of cine-clubs and writers of essays promoting the art, so many Canadian experimental film- and media-makers wear many hats. For example, John Price and Kirk Tougas are professional cinematographers, and many other experimental artists work also in the narrative and documentary film industries. The seemingly stark split between mainstream and avant-garde film worlds has often been bridged by figures who use resources from the industry to make their personal films (and bring new ideas and techniques to the industry). While Deren wrote articles celebrating experimental film in mainstream publications, Barbara Sternberg wrote a column (1985-1989) in Canada's main film trade magazine, *Cinema Canada*, prompted in part by her employment as experimental film officer at CFMDC. Many artists work as administrators in ARCs and festivals, as grant officers, as teachers and writers, and more recently in digital industry

gigs. In Canada, figures like Cecilia Araneda, Bruce Elder, Mike Hoolboom, Alex MacKenzie, Norman McLaren, Lisa Steele, and Kim Tomczak are just a few examples of film and media artists who have also had important roles as administrators, advocates, curators, teachers, and/or writers.

Considering the ecosystem of experimental film can also broaden our understanding of its parameters by looking at its modes of production, distribution, and exhibition, and also its networks of discourse: the associations, festivals, newsletters, and other ways by which people in the community speak and have spoken to each other. In Canada, there are two main film ecosystems: narrative and documentary. Most contemporary Canadian narrative fictions — *the movies* — are made with multi-person film crews and production teams with relatively large budgets (though dwarfed by Hollywood expenditures), distributed by major national or international companies, and exhibited either in film theatre chains like Cineplex or streamed through platforms like Netflix or CBC Gem, often with a film festival premiere to maximize publicity. The movies are reviewed in national newspapers; other networks of discourse range from entertainment magazines/websites to trade magazines like *Cinema Canada* (1962-1989) and *Playback* (est. 1986). Meanwhile, most Canadian documentaries today are made with small crews and production companies with modest budgets, distributed by specialized companies or national institutions like the NFB, and exhibited in documentary festivals like Hot Docs, on television, or specialized streaming services. The same forums that review narrative features will also review high-profile documentaries; *Point of View* magazine (*POV*, est. 1990) is an example of a publication that concentrates on the documentary industry in Canada. There are many exceptions: an independent narrative fiction can be made by a small group distributed through friend networks on YouTube, and there are blockbuster documentary series with massive budgets that show on major television networks. But these are exceptions that tend to prove the rule.

A defining feature of most experimental films is that they are made in an *artisanal* mode, usually by a single person, but often collaborating with fellow artists or engaging specialists in sound design or neg cutting. The budgets are low to non-existent, although arts council funding may cover technical costs. Distribution is handled by specialized artist-run independent distribution co-operatives like CFMDC (est. 1967) or Vtape (est. 1980), and now increasingly by the filmmakers themselves through the internet. Public exhibition is mostly through film societies, and since the 1990s, through festivals, either some that specialize in experimental work or general festivals with an experimental component. Some cities have *microcinemas* that are often low-rent spaces modified for flexible projection (of multiple formats) and performance. A major exhibition site for experimental films is colleges and universities: classrooms and campus film societies. There are now some online streaming channels devoted to experimental film, including a massive catalogue of experimental film and media on YouTube or specialized sites

Opsis: The Canadian Journal of Avant-Garde and Political Cinema, 1984;
Incite Journal of Experimental Media, 2013

like UbuWeb (est. 1996), often of dubious quality and provenance, but sometimes freely shared by filmmakers who favour an open-access approach to copyright. It is exceedingly rare for experimental films to be distributed or exhibited by mainstream companies, reflecting their low level of funding and public reach. Finally, the networks of discourse for experimental film and media are massively varied, with some international magazines and journals, some reviews in Canadian art cinema magazines like *Cinema Scope* (est. 1999), experimental film- and media-focused magazines like *Opsis* (1984-1985) or *Incite* (est. 2008), film co-operative newsletters, handmade zines, and internet listservs like Frameworks.[36]

This list is already more eclectic than conventional narrative fiction and documentary institutions, showing the vast energy of the experimental ecosystem. But the heterogeneity of artisanal modes of experimental production, distribution, and exhibition is also an index of their often-ephemeral nature. For the historian of experimental film and media, even as some institutions have served as points of continuity, there is much that flies under the radar, which further challenges how we understand this history in Canada.

This heterogeneity is reflected in two other terms often used in relation to experimental film: *alternative* and *independent* film. *Alternative* captures how this cinema works outside conventional narrative and documentary, but like the term *avant-garde*, it modifies a moving target of style: one decade's alterative cinema may be the next's mainstream. Sometimes, the experimentation that occurs in alternative narrative and documentary filmmaking appropriates techniques developed by experimental filmmakers.

Independent is a useful term that, in Canada, is used to cover small-scale filmmaking across experimental, documentary, and narrative modes made independently of the industry. As Gerald Saul writes, "In the USA, 'independent' filmmakers are independent of the big studios in Hollywood. In Canada 'independent' means a filmmaker who is not on staff with the established film organizations, namely the NFB, the CBC and other television networks. Virtually all experimental filmmakers in Canada are 'independent' filmmakers."[37] In the 1990s in the US, "indie" films at the Sundance Film Festival made the term connote more commercially aspirant levels of production. But in Canada, *independent* describes the wider mandate of many production and distribution co-ops, which, while important to nurturing experimental film, also included many new filmmakers seeking a route into the narrative and/or documentary film industries. Some independent filmmakers might make one experimental film (e.g., Sturla Gunnarsson's first film, *A Day Much Like the Others*, 1979, launched his career when it won best film at the Canadian Student Film Festival). Others might shift gradually to commercial production (e.g., Penelope Buitenhuis, Dawn Wilkinson) or combine experimental, documentary, and narrative production at different scales at different times in their career (e.g., Guy Maddin).

Animation is another separate but allied cinematic type with its own modes of production, distribution, exhibition, and networks of discourse that have a strong tradition of overlap with experimental film and media. As a production technique, animation is used in narrative (e.g., Disney or Pixar) and documentary (e.g., visualizations like NFB's *Universe*, 1960), and often intersects with experimental film, where the artisanal mode means that many experimental filmmakers work, like animators, at a frame-by-frame level of detail. As mentioned, the Canadian tradition of experimental animation is particularly established, given the importance of the work of Norman McLaren and the animation studio he led at the NFB starting in the 1940s, the wide network of regional NFB offices, and regional film co-ops, many of which had animation equipment. Animation is sometimes culturally devalued, associated too often either with "mere" children's film or with commercial Disney blockbusters. This perceived difference in audience and cultural value has sometimes separated animation from the rest of film history, including histories of experimental film.

Yet, the connection between visual arts and animation is historically robust, especially since many animation styles share traditions of modernist abstraction that involve drawing and painting. The

Ishu Patel, *The Bead Game*, NFB, 1977

bias against craft that one finds in art history can have the effect of relegating animation (whose production process can be painstaking) to a non- or low-art category. This bias is easily refuted by examples like the remarkable sand-on-glass work of Caroline Leaf, Evelyn Lambart's brilliantly colourful cut-out animations like *Fine Feathers* (1968), or Ishu Patel's work with beads and pinhole techniques. Independent animation in Canada has developed its own network of production co-ops (e.g., Quickdraw Animation Society in Alberta), festivals (e.g., Ottawa International Animation Festival), and networks of discourse; nonetheless, many independent animators identify themselves across animation and experimental film traditions, in addition to documentary and narrative (e.g., Ann Marie Fleming).

Moving beyond the darkened theatre: experimental film and its electronic siblings

Through the 1990s, the increasing integration of filmmaking with digital media led to growing overlap of experimental film and video art. One of the most far-reaching impacts of digital technology is its role in literally mediating between film and video in the realms of production, distribution, and exhibition. The film strip and magnetic tape, and the various sound technologies associated with them, can be transferred to digital media and processes that, by the twenty-first century, provided sharp image resolution, sound density, and image processing that could replicate some processes like film optical printing or video feedback at the flick of a switch. In the words of Peggy Gale, Canada's foremost curator and historian of video art, "By 1995, the precision and specificity of the term 'video' itself had mostly disappeared, to the point where it has been replaced in many cases by the more generic and ambiguous terms 'media,' or 'the moving image.'"[38]

Meanwhile, a new generation of "born digital" artists has emerged, many educated in art schools, who engage with the full range of formal possibilities opened up by experimental practice—what Kibbins identifies, with some ambivalence, as a pluralist phase in the experimentalist tradition.[39] This pluralism and increased awareness through the internet of the full historical range of film, video, and other forms of moving image art (including holography, projector performance, and other forms of expanded cinema), has led to new forms of experimental narrative and experimental documentary that increasingly blur the lines with the experimental film tradition. These include the "slow cinema" movement (as digital technology allows for 90-plus-minute continuous takes) and infiltration of experimental film and media into art gallery and museum installations, including forays into augmented and virtual reality.

One important challenge posed by the diminishment of medium specificity, and the entry of the moving image into the gallery and museum world, is a loss of specific historical knowledge. There are some aesthetic qualities of film that emerge from, for example, its basis in chemical emulsion, lens optics, and gauge, and the quality of light

projected through the physical filmstrip. Similarly, there are aesthetic specificities of various formats of magnetic video tape (e.g., scan lines, lens flare) and digital media (e.g., pixel, glitch, lossy compression). The subtleties of each medium require training for both artists and viewers. An unfortunate tendency, not only in Canada but also the rest of the world, has been for some contemporary artists to make experimental media in ignorance of aesthetics and traditions of experimental film and video art. In 2008, John Hanhardt warned art historians and curators of the dangers of ignorance of film history, which "isolates contemporary artists and relegates curators to championing new art without being sufficiently aware of its potential historical links. To do their jobs well, arts professionals need to understand this history to make the critical judgments that will shape the future."[40] As any experimental filmmaker working in the twentieth century can report, film was largely excluded from gallery exhibitions, museum collections, and the art market. The practical issue is that the best space to see most painting and sculpture is a bright gallery, while film is usually best experienced in a dark theatre.

Until recent decades, the screening of experimental films by museums has usually happened in a space less valued by the museum's curatorial divisions: the educational theatre. Hierarchies in the museum and art world between curatorial and educational departments have sometimes been transposed to art and film, whereby film has been tainted by its location, often literally in the museum basement (sometimes sharing space with dusty historical documents and that most belittled category, craft).[41] All of this has meant that experimental film has largely been excluded from art history, and thus from generations of students educated in art schools, which has led to lack of historical consciousness—and some reinvention of the wheel.

For many in the experimental film world, exclusion from the art world is no big deal: better to see a film in a dark theatre than in a bright gallery. Experimental film has its own ecosystem, and autonomy from art world markets and cultural hierarchies gives filmmakers and film lovers freedom to explore less institutionally circumscribed paths. Although blue chip artists might command high prices in the art market, many artworks acquired by museums and collectors lie unseen in storage, whereas the democratic ethos of experimental film means that almost any film distributed by a co-op can be rented for an affordable price. Today, however, film has found a way into the gallery through new forms of installation; creative adaptations by both filmmakers and institutions are part of experimental film's consistent legacy of adaptation and reinvention. In the current moment, art history and film history are each playing catch up, both revisiting the extant history and seeking conceptual parameters to understand the eruption of contemporary media art, and the ubiquity of moving images, sounds, and screens in contemporary galleries and museums. One motive for producing *Moments of Perception* is to increase historical consciousness of what has preceded this eruption.

Two useful contemporary terms that have emerged to extend the tradition of experimental film in this context are *artists' film* (or *artists' moving image*) and *media art*.[42] *Artist's film* was used as early as the 1980s by Canadian writers like Mike Hoolboom and John Porter, and it has the benefit of pointing to the main contemporary field of this work, moving image (and usually sound) media made by self-declared artists—work that is distributed and exhibited most forcefully by ARCs, a particularly Canadian tradition of small-scale arts infrastructure. The term *artists' film* should not suggest that people who make films outside this field are not artists. For instance, feature narrative filmmaker Deepa Mehta or documentary filmmaker Pierre Perrault are unmistakably artists but work in a different mode of production.

Media art (sometimes called *new media* or *moving image media art*) is a prevalent general term that incorporates the convergence of film and video art in digital media and, unlike *artists' film*, de-emphasizes the centrality of the individual artist, referring more widely to the general field of media production and its dissemination. CCA set up Media Art as a category in 1983 to encompass the range of moving image work being made on film, video (magnetic arts), digital media, installations, and hybrid forms. Media Art is defined by Independent Media Arts Alliance/Alliance des arts médiatiques indépendants (IMAA/AAMI), Canada's main media arts advocacy organization: "All forms of time-related or interactive art works that are created by the recording of sounds, visual images, or use new technologies. These art works are creative expressions and encompass the fields of film, audio, video and computer, digital, and electronic art."[43]

With all this in mind, I use the term *experimental film and media* to describe the expansive state of how experimental film aesthetics and traditions have moved beyond film into the wider range of digital moving image media, taking a capacious view of what can be included in the term *Canadian experimental film*, erring on the side of inclusion.

C. Define Film. I Triple-Dog Dare You.

The final term whose meanings have shifted over the course of the history of Canadian experimental film is *film* itself, a (literally) moving target. As a medium, film is usually understood as the physical, photo-sensitive strip of material that is exposed through a camera, developed in a laboratory, and then passed through a film projector to display a rapid series of still images that can give the illusion of movement. One remarkable legacy of experimental film has been the ways that artists have played with every element of that conventional set-up. Artists have deformed photographic processes (e.g., omitting the lens as in Chris Gehman's *Refraction Series*, 2009), misused or redesigned cameras and camera mounts (e.g., Phillip Barker, Richard Kerr, John Kneller), or scratched, cut up, hole punched, drawn, and painted on the film strip (a long tradition

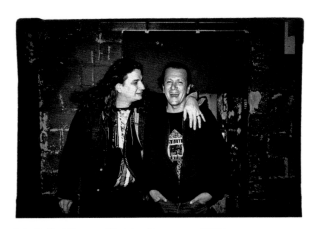

L to R: Carl Brown with John Kamevaar, 1993 (John Porter)

from McLaren and Lambart through Pierre Hébert to Vermette). Developing film outside of commercial film labs — especially when the rise of digital media led to most film labs closing in the first decade of the twenty-first century — has led to remarkable experiments with the chemistry of film emulsion (from important forerunner Carl Brown in the 1980s to more recent artists like Louise Bourque), including Hoffman's recent experiments in ecologically minded film processing at the Film Farm. Artists have exploded or ignored the frame, making the illusion of movement just one effect among many. The projector itself has been mobilized as a performer, its industrial exactitude intruded upon by artists eager to play with the many machines that became surplus as video and digital projection became the norm in schools and non-theatrical spaces, from John Porter's *Scanning* series (1981-1999) to Alex MacKenzie's experiments with defunct and hand-cranked projectors to Daniel Barrow and Shary Boyle's installations and performances.[44]

But a deeper historical understanding of the medium of film reveals that even its industrial norms have changed over its century-plus of existence. Its base has shifted from nitrate to celluloid to acetate, and its variations in brand (e.g., Kodak, Agfa), gauge, and especially photographic stocks show that film itself has always been a protean medium. These changes have presented challenges for film archivists who have attempted to preserve and create new 16mm film prints. For example, the section of haunting grey-and-white superimposed news footage that forms an early part of Jack Chambers's *The Hart of London* (1970) is almost impossible to replicate in new 16mm film prints since that stock is no longer made. A worn older print of that film from the 1970s would be more accurate than clean new prints, in which a sepia tone replaces the translucent grey original. Yet, these are typical trade-offs involved in experimental film and media archiving, and are even more pronounced in video art, where digital migration is preferable to maintaining original magnetic tapes and tape players for the multitude of 1", ¾", ½", Beta, and other tape formats. Meanwhile, many so-called "born digital" media arts (e.g., CD-ROM) are difficult to archive or emulate and present new challenges in terms of archiving and presentation with rapid changes in computer software, hardware, and operating systems. Compared to magnetic and digital media, film is relatively stable,

as mechanical cameras, splicers, and projectors—and the physical film strip—can last decades, even centuries.

The 16mm film gauge has dominated Canadian experimental film, matching the US tradition, in which artists adopted the gauge used since 1923 by amateur, educational, and industrial filmmaking, and then in the 1950s and 1960s in television production (European experimental filmmakers more often used 35mm). For most of the late twentieth century, film artists would generally shoot, edit, and finish films in 16mm for distribution and exhibition. Among filmmakers, technical debates revolved around the relative merits of gauges like Super 8 (mobile and grainy but lacking fine visual resolution), versus 16mm (the most popular gauge, balancing resolution, ease of shooting, and affordability), versus 35mm (too expensive, heavy, and tainted by its commercial use). It is notable that artists like Stan Douglas, Rodney Graham, and Mark Lewis, working in the gallery and museum world, embraced 35mm for its high production values and, in the case of gallery installations of 35mm loopers, sheer scale (though all three have used 16mm, e.g., Douglas's important early installations *Overture*, 1986, and *Der Sandmann*, 1995).[45] At various times in Canadian experimental film history, artists might use several gauges, for example shooting on Super 8 and then optically printing onto 16mm, or optically printing original 35mm film or video or digital work onto 16mm. There is even a tradition of standard (a.k.a. regular) 8mm production, which preceded the introduction of Super 8 film in 1965.[46] Video artist Lisa Steele began working in regular 8mm, and Joyce Wieland and Keith Lock made films in this format. Later, filmmakers like Linda Feesey and John Kneller continued to use the format, while Larissa Fan and Marnie Parrell would shoot on an 8mm camera but process the 16mm film unsplit, yielding four-images-to-a-frame (half upside down) to rhythmic and striking effect that relied on chance.[47]

As noted above, the relationship of film to electronic and magnetic arts like video art, digital media arts, computer animation, holography, new media, augmented and virtual reality, and internet art is complex and evolving. In some cases, like video art, the differences in media technology and the institutions needed to support them led to an evolution separate from experimental film. Cameras, recording media, and, most importantly, the exhibition technology of the televisual monitor ensured that separate production and distribution co-ops emerged, and video art entered art galleries before film, which gravitated to theatre spaces. In other cases, like digital moving image media, the interactions with film are deeper. For example, the icons used in digital media editing software (e.g., razor blades for "cut") suggest how digital media uses analogies from filmmaking technology.

Alongside the digital revolution, there has also been a simultaneous revival of analog film in experimental media production, partly because the use of film as a physical medium has become the almost exclusive domain of experimental media artists working

at an artisanal scale. In production, film is mainly used for shooting or optical printing, while editing has moved to the digital realm, with equipment to transfer between analog and digital formats. The increased exposure of film in galleries and museums has led to the use of installation loopers in exhibition. We still use the term *film* to describe many works that have nothing to do with the physical substance of film, while works projected on film projectors may have had digital media intermediaries in the shooting or editing process. In short, film is not dead, but it has entered an expanded ecology of production, distribution, and exhibition that has embraced multiple media forms, including video and digital media.

Seeing film on film is complicated. Theatrical screenings involve a projection booth, a reflective screen, and a sound system, with different projectors involved for 35mm, 16mm, and Super 8. Portable projectors, speakers, and screens allowed many non-theatrical spaces like community halls and bars to be adapted for experimental film screenings.[48] Video presented other challenges; prior to high-quality video projection (or streaming), seeing a video required a player, monitor, sound system, and wires connecting all components. Limits on monitor size meant that video exhibition tended to be more intimate; Peggy Gale describes Art Metropole's "living room environment for screening work in its early days" on "comfortable chairs or couches."[49] Prior to the 1980s, in the absence of video or digital copies, seeing experimental film and media was often a once-in-a-lifetime occasion, limited mostly to city- or university-based folks who could attend public screenings.

The migration of film to home video formats in one way increased public access to more diverse viewers. From the mid-1980s onward, new formats from VHS to DVD to Blu-ray to online streaming allowed more people to access film history, even if, along the way, there were trade-offs in image and sound quality (as there had been in the migration of 35mm film to 16mm and 8mm reductions). But in the commercial realm, each new format involved a reduction in the available catalogue of film history. Only a fraction of 35mm or 16mm films were transferred to video. Films formerly available on VHS were not released on DVD, and fewer still on Blu-ray; the full range of film history is not available on current commercial streaming platforms. Nonetheless, there is a rich range of film history available today through all of these formats combined, including experimental film and media art, and available to wider audiences: twenty-first century viewing is every which way, especially on the internet, where open access creates viewing options outside copyright restrictions.

Prior to the availability of high-quality transfers to video or digital formats, programmers and curators needed to preview film and video to arrange screenings, and students needed to see them for study purposes. Outside theatrical screenings, machines like Moviolas, Steenbeck editing beds, and analytic projectors could be used for individual viewing (in theory these machines cause less wear and tear on a film,

which can be broken, smudged, or burned during projection). A programmer or student seeking access to 16mm prints would go in person to film distributor offices, public and university libraries, or cultural agencies like Goethe-Institut. Film and video distribution offices usually had spaces set aside for preview purposes. Notably, these institutions provided a degree of access markedly more open than that of art galleries or museums. Museums tend to guard any films they have in their collection in the same way they would guard access to paintings or sculptures; they prioritize preservation over access, meaning that a film might sit in storage rather than be unwound for a researcher.[50] Today, some commercial galleries that represent artists' films (that are not also distributed by co-op distributors) make access very difficult, whether they are protecting the aura, brand, or market value of film (perhaps fearing illicit dubbing of video or digital copies).

The "quality" of a screening has many variables. If the priority is seeing and hearing the aesthetic textures of a film, then these conditions are preferable: bright projection (that starts on time!) of a clean print in a well-designed cinema theatre with a clean, reflective screen (preferably matted) with excellent multi-speaker directional sound—or complete silence, if applicable. For video, playback on the historically correct technology, or for installation, replication of the architecture and textures of the artists' design is best. Some conditions are just bad. An incompetent projectionist who damages a print or can't keep focus will ruin a film screening. For video, as Gale puts it, the "terrible quality" of early video projectors made theatrical screenings of video "highly problematic."[51]

These differences in projection quality exacerbated divisions between film and video audiences in the 1990s, but in the early decades of the twenty-first century, pluralism rather than purity reigns. In the 1990s, the cultivation of connoisseurship in viewing led some people (including myself in this period) to extoll the virtues of film-only projection or one video format over another (NTSC vs. PAL vs. Beta, etc.). Especially as the centenary of the Lumière brothers' film's 1895 debut approached, laments for the "Death of Cinema" could be heard, leading some cinephile film purists to insist on defending the specificity, even sanctity, of the film image. But the digital revolution led to increased access to affordable digital cameras, editing software, and digital projection in narrative and documentary production, distribution, and exhibition. The "tyranny of small differences" between film and video was exposed when digital resolution increased and projectors became sufficiently bright, sharp, and reliable. Today, an ideal sophisticated exhibition space will have high-quality digital projectors installed beside functioning 16mm and 35mm projectors. But the expense of new film prints has reduced demand for film projectors in festivals; in the educational classrooms that were once a crucial film exhibition space, the enhanced quality and ease of use of digital projectors have made film projectors increasingly rare.

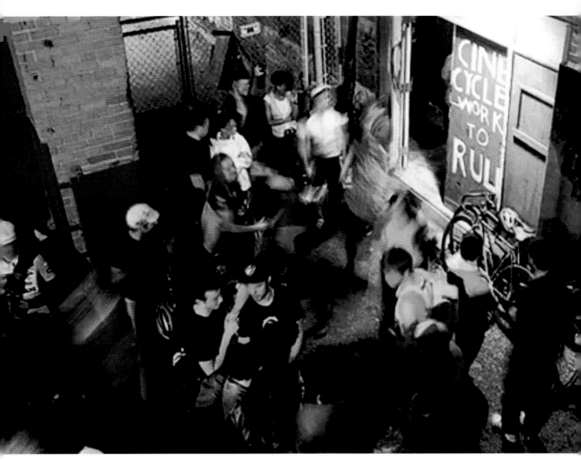

Martin Heath's CineCycle, 2010 (Sean Connors)

The recent rise of gallery and museum installations presents particular challenges.[52] Here is an all too familiar scene: a gallery projects a digital image against a wall. Ambient light obscures the image, and voices and random noise garble the sound. The textures and paint on the wall further muddy the image.[53] A label or program note might tell you the title, artist, running time, and format, but you usually have to hunt that down after you have already had a distracted glance at the work. You wonder if you have entered the room in the middle of the piece, or if it's near the end or start. Or if that matters. With some exceptions, galleries have hours of operation rather than a screening's series of start times. The time-based nature of film and video means that most gallery ambulatory set-ups undermine film and media that have an aesthetic logic of sequence (unless the gallery installation is structured as a loop). Michael Snow's *That/Cela/Dat* (1999) is a video installation version of his 16mm film *So Is This* (1982) that acknowledges the difference between viewing situations; where the film taunts seated film viewers about

being trapped for the film's duration, *That/Cela/Dat* beckons to the walking gallery spectator to stay and watch longer than the fifteen seconds most museum viewers take to look at an artwork.

Yet, in many cases, a good experimental film and media screening or gallery installation is less about image and sound quality than about the occasion, audience, or cultural scene. A raucous screening in a dingy bar of underground films that start late so you can have a beer; an informal viewing of activist media in a community centre that allows for post-screening discussion; chatting about what you are seeing with friends at a gallery opening as you walk by video monitor loops: all may be preferable to a "pristine" screening situation, depending on the nature of work being screened, the desires of the audience, or the goals of the programmers. In each experimental film and media scene in Canada, a range of screening spaces and occasions arose to suit each ecosystem and community.

Another tradition is the mobile itinerant cinema, with touring screenings hitting smaller towns across parts of Canada. A key early figure is Martin Heath, a master projectionist who was involved in mobile cinemas in the UK in the 1950s, worked at Expo 67, and was involved with Rochdale College and Deanne Taylor's VideoCabaret performances in the 1960s. Heath produced inflatable Mobile Cinemas that could be placed in the water, as Heath toured small towns in Canada.[54] In the 1980s, Martin Rumsby toured versions of his itinerant experimental film programs as Invisible Cinema and Hidden Cinema, adding to his collection films he bought along the way.[55] In 1989, Isabelle Rousset, armed with a minibus and a projector, toured the country for a summer, setting up her Film Trek screenings in small towns.[56]

Preservation: archives and counter-archives

The preservation of film and video is medium-specific and intersects increasingly with digital media. Film preservation is notoriously expensive and labour intensive.[57] Experimental film in Canada is only fitfully preserved, partly because the use of CCA and other arts council funding for archival purposes is forbidden. Library and Archives Canada (LAC), Cinémathèque québécoise (CQ), and TIFF's Film Reference Library are the three major film archives in Canada, each under-resourced and understaffed, and with massive national mandates that often leave experimental film and media low on the

list.[58] Experimental film and video distribution co-ops have become de facto archives, often using project grant funds to sneak preservation into a distribution venture. Vtape has become an international leader in video preservation, with a collection of old video technology, including playback decks for obsolete formats, that are used to remediate and copy electronic signals to archive-grade tapes (LTO), now the best preservation medium for electronic data and media art. Nonetheless, the ease of availability of media on the internet, where so much is newly accessible, creates what Hollis Frampton called, in another context, "the fiction of copious and the readily available," the illusion that all media history is available.[59] But this is not the case: more films and media disappear each day.

What is at stake in the preservation and archiving of experimental film and media is the question of what gets included in history. The long-standing problem with official archives is that, for the most part, only culturally mainstream objects are seen as valuable and thus preserved. This brings us back full circle to the problem that Deanna Bowen posed of the "appalling deficiency" of "histories of First Peoples, racialized, differently abled, or LGBTQ2+ organizations, collectives, artists, and their works."[60] One hopeful sign is that the experimental and independent media ecosystem is increasingly attuned to the need to archive and make accessible film and media by women, BIPOC makers, and other socially marginalized persons so that it is not even more lost to history. We sometimes hear about archival "discoveries," when lost films suddenly come to light. In fact, the reels were always there: the discovery is often more a matter of the artifact becoming legible as culturally valuable, a matter of historical consciousness allowing for discovery.

A hopeful example of a contemporary archival initiative connected to experimental film and media is the Archive/Counter-Archive project (A/CA, est. 2018 at York University), a partnership among scholars and community partners to bring attention to "vulnerable media," including audiovisual material "created by Indigenous Peoples, (First Nations, Métis, Inuit), the Black community and People of Colour, womxn, LGBT2Q+ and immigrant communities," communities whose audio-visual heritage is often not collected by major archives.[61] The project connects these small film and media organizations to memory institutions, a broader category than archives that recognizes the de facto historical work done by community arts and historical organizations to maintain film and media history. A key A/CA strategy is archival activation and remediation, inviting artists to collaborate with the A/CA network to "activate" material from the archive through "remediation," often using digital forms to create new articulations of media and community history.

PART 2: Histories & Moments

Any history has its limits, and this one is no exception: it attempts to synthesize major historical trends while also attending to specific moments. My hope is that readers involved in experimental film and media art will challenge it, supplement it, correct it, and write their own histories of moving image arts in Canada.

In addition, any history looks different depending on when it was written. In histories written before 2000, the separation of experimental film and video art meant that a historian of experimental film might exclude video art (and vice versa), while the few visual artists using film were written about within an art history perspective, which often ignored their film work.[62] But from the perspective of 2021, the aesthetics and thematic commonalities are clearer among experimental film, video art, and films made by visual artists, especially in light of the ways that contemporary moving image artists, many emerging from art schools, draw from multiple aesthetic traditions. While not ignoring the differences among these traditions, this brief history makes a point to combine experimental film, video art, and artists' film, in addition to some independent narrative, documentary, and community film and media-making, as part of a larger category of experimental film and media.[63]

Contemporary activism around #MeToo, Black Lives Matter, and the Truth and Reconciliation Commission has precursors in the long tradition of struggles for equity that have often been part of the experimental film and media ecosystems. For many historians today, a key imperative is to restore previously ignored women and BIPOC figures whose histories have been repressed (e.g., archivists, artists, academics, and students organize Wikipedia edit-a-thons to restore people and events written out of history). There are now extraordinary historical resources publicly available through the internet, whether film co-op newsletters on the Internet Archive or exhibition catalogues on *The State of Blackness*.[64] I likewise aim here to give proper recognition to the contributions of women and BIPOC figures to experimental film and media art. If history is seen as a mosaic, this work fills in gaps, providing a better picture of what was. But sexism, homophobia, racism, and other forms of discrimination have their most profound effects in repressing the full participation of people in the first place. Demographically, experimental film and media art has simply not been representative of Canada's gender, racial, and ethnic diversity. There may be a host of reasons for this, and experimental film and media art is not the only art with this disparity, but it is a legacy that must be acknowledged and, looking forward, ameliorated. We may never know how many potential artists or cultural workers have been repelled by forms of overt or systemic discrimination and unconscious bias in the organizations surveyed. Here, the historian has the duty, in Bowen's words, of "honouring absence."[65]

Most histories of Canadian experimental film and media have concentrated on artists and their films. By dint of being an institutional history, this brief overview concentrates on organizations like co-ops and festivals and schools. Organizations are composed of people who, on a basic level, get together to make things happen. Any event—from making a film, to programming a screening, to organizing a workshop or festival—involves, first, the energies of people (artists, arts workers, grant officers, projectionists, curators, technicians, writers, and many others), and second, a matrix of institutions collaborating at different levels to provide time, budget, space, materials, and equipment. For any event in this history, there is a story of how it was planned, took place, and had an afterlife: each of these events deserves its own history, and readers are invited to tell these stories, going beyond the necessarily sketchy terms of this history to fill in the web of the extraordinary history of experimental film and media in Canada.[66]

Early Years to 1939

Even taking a broad-minded view of experimental film, there are very few examples in early Canadian cinema history before the 1940s that could be called experimental. The few that appeared were connected to the three main sites of filmmaking that existed outside the small commercial feature narrative industry: documentary shorts, amateur filmmaking, and campus film societies. Generally speaking, in the early decades of the twentieth century, the Canadian film industry was overshadowed by Hollywood, but a number of private companies and government film divisions made newsreels, short subjects, and industrial and educational films. Gordon Sparling's *Rhapsody in Two Languages* (1934) was part of the Canadian Cameo series produced by Associated Screen News and is recognizable as a city symphony film in imitation of the European tradition of modernist evocations of urban energy (e.g., Walter Ruttmann's *Berlin: Symphony of a Metropolis*, 1927). The film is in fact a defiantly unilingual city symphony of Montréal that uses optical effects like superimposition and negative images. *Another Day* (Leslie Thatcher, 1934) is a good example of amateur filmmaking, which was undertaken by a small number of enthusiasts across North America. Also a city symphony, but about Toronto, the film was recognized as one of the ten best amateur films of 1934 by *Movie Makers* magazine (published by the Amateur Cinema League in New York).[67] Thatcher helped found the Toronto Amateur Movie Club in 1934, which grew to at least ninety members in 1937 and had a workshop, social space, and *Shots and Angles* newsletter.[68] *And...* (c. 1939-1940), made by Douglas S. Wilson and produced by Dorothy Fowler and Margaret Roberts, is from the campus film society tradition: "Perhaps the first experimental film made in British Columbia, this short uses found footage, painted and scratched emulsion, negative and reversed images, chaotic camera movements,

and holes punched in the frame and filled with other images. Some portions are hand coloured."[69] With these few exceptions, Canada had little infrastructure for artisanal film production, lacking even the small networks of cine-clubs in France or Little Cinemas in the US.[70] In the words of Stanley Fox, "Filmmaking in Canada was a very exotic activity in the 1940s. Outside of the National Film Board there was almost no support for aspiring filmmakers."[71]

1939 to 1967: The NFB, Film Societies, and International Exchange

The National Film Board (NFB)

The key institution in Canadian film history is the NFB, established in 1939 under the leadership of John Grierson, a Scot with experience setting up the national documentary film unit in Great Britain. Driven by the imperatives of public communication during wartime, the NFB grew rapidly, attracting a host of talented people who continued to develop documentary after the Second World War and beyond. Grierson didn't just value film's capacity to teach and communicate, he also understood the importance of film form for effective communication. His famous definition of documentary, "the creative treatment of actuality," emphasized the importance of poetic and rhythmic qualities of cinema, albeit always in service of the public message of the films. As a large institution with a public mandate, "To interpret Canada to Canadians and to those abroad," the NFB, on the one hand, controlled the message of the films according to what David Clandfield calls "the 'general sanction,' that is, the limits of tolerable social change across the range of dominant partisan interests."[72] Under the "general sanction," films from the NFB could be progressive but not radical, which muted the boundary-pushing energies of much experimental film. On the other hand, within a large bureaucratic institution it was sometimes possible for individuals to fly under the radar, use institutional resources, and fight to push "the limits of tolerable social change." The NFB regional offices and production centres in the 1960s and 1970s made filmmaking viable outside major urban centres, often allowing experimental filmmakers to use editing and other facilities after hours, and they helped support some independent organizations like film co-ops, some of which formed in reaction against the NFB itself.

Some remarkable experimental films have emerged from the NFB; Canadian film scholar Seth Feldman calls these films "the institutionalized experimental film," a term that captures their location and limits but should not undermine their artistic quality and interest.[73] Many famous experimental filmmakers, especially those associated with an avant-garde, rejected institutions, whether the Surrealists in 1920s Paris, mid-century mavericks like Maya Deren or Marie Menken, or 1960s underground artists like Jack Smith. Subsequently, artists who managed to fit their work into the structures and limits

of the institution were sometimes tainted by association. But in the words of innovative animator Caroline Leaf, who worked at the NFB from the 1970s to 1990s, institutions sometimes nurture artistic freedom: "I had security, peace of mind, the freedom to make the films I wanted to make." Nonetheless, Leaf acknowledges the limits of the institutional mandate: "Because of the public funding, there was a conservative style and often a moral or didactic message in the films that were made at the Film Board.... Maybe you had to watch what you said and how you said it, but there was a lot of leeway to specialize."[74] The lack of a commercial market for experimental film in Canada has meant that almost every filmmaker has had to have a "day job" to make a living, or more likely juggle multiple jobs, commissions, and grant applications. Many experimental filmmakers have worked at institutions like colleges, grant agencies, and ARCs. In short, institutions are an important part of experimental film history.

The first great Canadian experimental filmmaker was Norman McLaren. Grierson hired him in 1941 to make animations like *V for Victory* (1941) in support of the war effort. He went on to become the most important figure in the history of Canadian experimental film prior to the 1960s. He innovated in several animation styles, including direct animation (painting or scratching directly onto film strips, e.g., *Lines Horizontal* (with Evelyn Lambart, 1962), direct sound (using the optical soundtrack, e.g., *Pen Point Percussion*, 1951), pixilation (*Neighbours*, 1952), and dance (e.g., *Pas de deux*, 1968, and *Narcissus*, 1983). McLaren and René Jodoin's majestic *Spheres* (1969) is a stunning example of abstract film: a mathematically precise play of shapes in 2-D and 3-D space set to Glenn Gould's Bach performance.

Almost all McLaren films have the quality of being delightful, in line with the classic definition of art that "delights and instructs." His films are not overtly confrontational or subversive in the tradition of 1920s or 1960s avant-gardes, although *Neighbours*, an anti-war film made at the height of the US-USSR Cold War, is appropriately disturbing (and won the Academy Award for Best Documentary [Short Subject] in 1953). The aesthetic of the films is direct and accessible, not without irony, but eschewing what Stephen Broomer has discussed as an "aesthetics of difficulty" in the dominant tradition of Canadian experimental film, and academic criticism.[75] *Begone Dull Care* (1949), a hand-painted and scratched film McLaren made with Lambart, is an exhilarating visualization of a performance by the Oscar Peterson Trio. The illustration of musical rhythms, tones, and sonic colours is inventive and expressive, but it is more syncopated than dissonant, like an abstract version of an excellent Hollywood musical number. *Begone Dull Care*'s seeming effortlessness invites viewers simply to delight in what they are seeing and hearing. American experimental animator Robert Breer captures the common critical hesitation about McLaren's work: while he appreciates his work, he says "his films sometimes carry too much 'message' or are knee deep in charm."[76] Breer says

out loud the critical biases held by some in the experimental film world: that some films are devalued for communicating a message or for being enjoyable.

Recent approaches to McLaren that recognize him as a queer artist (in a long-term relationship with NFB executive Guy Glover) invite interpretations of his films as dramatizing quietly resistant forces: *A Chairy Tale* (1957), in which a chair revolts and cheekily negotiates equity with a human actor, or McLaren himself dealing with a recalcitrant microphone in *Opening Speech* (1960), desisting only when McLaren throws himself into the screen. Robert Lepage's ballet about McLaren's life, *Frame by Frame* (National Ballet of Canada, 2018), brings to light the poignancy of McLaren's relationship with Glover.

McLaren was situated throughout his career in Canada at the NFB, which rewarded his service by acknowledging him in a 1980 tribute catalogue as "the civil servant as artist."[77] At the NFB, McLaren was important not just as an artist but as an administrator who nurtured other artists. From the early 1940s, he led the NFB's animation unit and assembled an atelier of animators, often from Canadian art schools, who made films (sometimes collaboratively with McLaren) and often went on to animation careers afterwards. Early on, McLaren recruited Lambart (already at the NFB) into his animation unit, and later added George Dunning, Jim MacKay, and Grant Munro from the Ontario College of Art in Toronto. McLaren hired Jodoin and Jean-Paul Ladouceur from the Montréal School of Fine Art; Jodoin went on to lead the French animation unit at the NFB in 1966.[78] In the spirit of the NFB's public mission, McLaren also actively taught and shared his formal methods, made films that showed his technique in action (e.g., *Pen Point Percussion*, 1951), and published an illustrated essay, "How to Make Animated Movies without a Camera," in a 1949 UNESCO bulletin that was subsequently distributed by the NFB as a teaching pamphlet in 1958.[79]

Film societies: seed beds for experimental film culture

A larger and even more far-reaching contribution of the NFB was to aid the formation of non-theatrical film culture in Canada, a massive task in such a vast country.[80] In addition to artists making films, there must be audiences to watch them, argue over them, write about them, and share them with others. Experimental film is part of an ecosystem of film distributors and libraries, film circuits, and community halls and other spaces equipped with film projectors (and, since the late 1980s, video and digital projectors). This is the infrastructure needed for the development of film culture, and the NFB was a major contributor in Canada, feeding and complementing the activities of film enthusiasts who created a second key institution: film societies. People in film societies would fundraise, research, find and rent film prints, and then program and screen films, often accompanied by program notes written by film society members. They would host guests who gave introductory remarks and/or engaged in question-and-answer sessions

after the screenings. After seeing and discussing these films, some audience members then wanted to make them; as Joyce Wieland said, "I was inspired to make films by what I saw at the Toronto Film Society."[81]

In Canada, film societies gained critical mass with the establishment of the National Film Society of Canada in 1935: chapters were soon established in Ottawa, Vancouver, Toronto, and Montréal. In 1947, the Yorkton International Documentary Film Festival was founded out of the Yorkton Film Council, an example of the post–Second World War regional diffusion of film culture from the NFB. In 1954, the Canadian Federation of Film Societies broadened the movement and worked in the 1960s to ensure that 16mm film prints were available for society screenings. These film societies were by no means solely devoted to experimental film programming, but they would include experimental films in the larger field of film art that was emerging as part of early and mid-twentieth century culture: European art cinema, Hollywood classic silent film, animation, documentaries, and the historical avant-gardes of the 1920s and 1930s.

A staple of the NFB film circuit and film society screenings was NFB animations, especially the films of McLaren. While the NFB distributed its films nationally to multiple regions, it also promoted its films internationally, entering films in the many film festivals that emerged around the world in the 1950s and 1960s. It would not be an exaggeration to say that Canada's international film presence from the 1940s through the mid-1960s came almost exclusively from the NFB (similar to other nations

with centralized governmental film production and national film schools). In 1965, the NFB had over 18,000 film bookings, ranging from community halls to US and international television screenings.[82] Within local film societies in Canada, experimental animation complemented occasional forays into historical experimental films. For example, Gerald Pratley notes in his history of the Toronto Film Society (TFS) that in addition to films by McLaren ("much praised and appreciated"), experimental films were often screened as short subjects before features; in one program, "Three silent 'experimental' films, Fernand Léger's *Ballet Mécanique* [1924], Joris

Fernand Léger and Dudley Murphy, *Ballet mécanique*, 1924

Ivens's *Rain* [1929] and Douglas Crockwell's *Long Bodies* [1947] will be accompanied by musical scores from phonograph records."[83] TFS, founded by Dorothy Burritt (who had earlier founded the Vancouver Film Society), hosted figures like Adolfas and Jonas Mekas, Hans Richter, and Marshall McLuhan; as Pratley puts it, the film society "was sort of Film Central" for independent film culture in the city. Within the growing film

Maya Deren, *Ensemble for Somnambulists*, 1951

cultures in post–Second World War Canadian film societies, European and American experimental film was part of a large mosaic of film art.

Maya Deren visits Canada

A major event in Canadian experimental film history was the visit to Toronto and Montréal by groundbreaking filmmaker Maya Deren, a visit significant for dramatizing the difference between institutional experimental film and the more free and eclectic film culture that was developing in the US.[84] In 1950, TFS and the University of Toronto Film Society screened her films followed by a screening at the University of Montréal Ciné-Club. Dorothy Burritt of TFS was likely familiar with her work; after all, as part of the Vancouver Film Society, she participated in the making of *Glub* (1947), an affectionate parody of Deren's films.[85] A year later, Deren conducted a three-week production workshop in Toronto, from which emerged a 6-minute dance film, *Ensemble for Somnambulists*, which was screened at the University of Toronto. Deren scholar Sarah Keller notes that the film "seems as complete as any of the other works in Deren's oeuvre," although she says the film was never distributed but rather served as a study for *The Very Eye of Night*, which Deren worked on from 1952 to 1958.[86] In 1951, Deren published a short text in *Canadian Film News*, "The Poetic Film," one of a series of writings she published throughout her career in film and popular magazines as a spokesperson arguing for the importance of film as an artistic medium: "I was struck by the soundness and 'poise' (for want of a better word) of the Canadian attitude towards the poetic film. I do not mean that the 'avant-garde' is necessarily more accepted, or prevalent in Canada; nor that it is more casually taken for granted. The lively enthusiasm with which my films were complimented was in evidence in reference to the films of Norman McLaren, Claude Jutra, but neither acceptance nor enthusiasm carry the edge of defensiveness which is characteristic in the U.S."[87]

Deren's legacy for experimental film includes her work not only as a filmmaker but also as a writer, programmer, exhibitor, and itinerant cultural maven—roles that future figures in Canadian experimental film history would play. Her oft-noted charisma and even celebrity acted as a gravitational pull, and her visit to Canada was witnessed by emerging filmmakers like Cowan, Graeme Ferguson, Jutra, and artist/broadcaster William Ronald. What is clear is that her presence and attitude were as important as the impact of her films. When two of her films were screened in 1949 at TFS, Pratley

commented, "I don't think our audience was ready for this."[88] And it is clear that her visit in 1950 was unsettling for strait-laced Toronto:

> [I]n these early years Maya Deren caused a sensation....Most of us didn't understand it [*Meshes of the Afternoon*]—or her, although several of our group professed to do so! She hitchhiked her way to Toronto and stayed with friends of a similar taste in clothes, smokes and make-up. We provided meals and drinks—more of the latter than the former! She excited almost everybody with her lively behaviour and outspoken manner. At Dorothy [Burritt]'s reception for her she sang, danced, played some kind of tambourine, drank and smoked copiously and ate very little! This was certainly the first '*wild party*' in the history of TFS; whether there were many others I'm not sure.[89]

Deren represented independent cinema with an *edge*. While the expansive parameters of what was called experimental film in the 1940s and 1950s could include independent, personal, and institutional films made in documentary, narrative, and animation modes, it is the challenging, "wild" cinema that is more sharply characteristic of its artisanal strain. For a foundational figure like Cowan, who would have a sustained relationship to experimental film through the 1960s and 1970s, Deren was the model. He attended her 1950 event: "I didn't understand what I was looking at and nobody else did. Everyone seemed to dislike what she was showing except me....She was hypnotizing, but positive."[90] Cowan went on to make regular 8mm and 16mm films in the 1960s, including *Go Out with Anyone Because They May Have Interesting Friends* (1964), and was an important liaison between Toronto and New York filmmakers.

Early experimental activity

The 1940s and 1950s were a famously bleak period for Canadian arts, and it took time before the recommendations of the 1951 Massey Report (Royal Commission on National Development in the Arts, Letters and Sciences) resulted in the establishment of key institutions like CCA (1957) and the National Library of Canada (1953, now LAC), and changing roles for extant institutions like the NFB (moved from Ottawa to Montréal in 1956), Canadian Broadcasting Corporation (CBC), and National Art Gallery (now National Gallery of Canada or NGC).[91] In addition to activity at the NFB, some artists engaged with film as part of local art scenes (mostly far removed from these institutions), which in the late 1950s were influenced by American arts like jazz, beat culture, action painting, and experimental poetry.

In Toronto, several visual artists began engaging with film but largely through commercial arts. In 1950, NFB-trained animators George Dunning and Jim MacKay

formed their own private animation company in Toronto, Graphic Associates, which had a central role in introducing artists in Toronto to independent filmmaking. Graphics hired visual artists Dennis Burton, Graham Coughtry, and Richard Williams, along with Cowan, Snow, and Wieland, many of whom had their first experience working in film with fellow employee Warren Collins, proud owner of a 16mm camera, often making films during their lunch hours.[92] Williams and Dunning eventually left for commercial animation careers in the UK, with Dunning contributing an animated multi-screen film for Expo 67, *Canada Is My Piano*. An example of the overlap of commercial and experimental worlds in this period was the International Design Conference in Aspen in 1959, at which a McLaren retrospective took place and Coughtry (with McKay) screened a 30-second "promo," *The Unforeseen*, which was reviewed in the *Star*. Gordon Rayner attempted filmmaking projects but became discouraged when he lost a project due to fire. Porter says Rayner received the first Canada Council grant for film in 1960, "after he lobbied against their neglect of film art."[93] Rayner along with fellow artist and Artists' Jazz Band member Robert Markle (of Mohawk ancestry), who also worked in and taught film, are featured in a fascinating experimental documentary, *Cowboy and Indian* (1972), directed by Don Owen, which evokes the bohemian quality of the scene in the later 1960s and early 1970s.

Of this group, Snow and Wieland would have the most enduring impact on Canadian experimental film. In the Dulac and Deren tradition of women-led experimental film organizing, Wieland organized what Porter says may have been "Toronto's first public screening of personal films by local artists" in 1960 during her solo exhibition at Dorothy Cameron's Here and Now Gallery (most of the films were by artists associated with Graphics).[94] Snow made his first film, *A to Z* (1956), using cut-out animation. Other early films incorporated his evolving *Walking Woman* series, especially *New York Eye and Ear Control* (1964). Wieland made a series of witty 8mm films, *Larry's Recent Behaviour* (1963), *Peggy's Blue Skylight* (1964), *Patriotism 1 and 2* (1964-1965), and her masterpiece of what she called "tabletop cinema," *Water Sark* (1965). But it was only during and after their decade of immersion in New York in the 1960s that their major film work was completed.

The rise of the experimental film in the 1960s

The active but intermittent history of experimental filmmaking in Canada prior to the 1960s was like that of other countries: in the US, a cadre of experimental filmmakers like Anger, Brakhage, Breer, Conner, Deren, and Menken showed their films in film societies; a small avant-garde in France (Lettrist filmmakers like Guy Debord, Isidore Isou, and Maurice Lemaître) was active in the 1950s. But in the 1960s, experimental filmmaking exploded.

We can take the pulse of experimental film in Canada at the start of the 1960s with a little-known oddity, *The Experimental Film* (1962), a half-hour arts documentary made by

Arthur Lipsett at the NFB for broadcast on the CBC. *The Experimental Film* appears just after the first films of the French New Wave had made it to North American theatres, but it was ahead of the wave of underground film that was about to erupt in the US and beyond. Experimentation in film—indeed, the very idea that film could be art—was just becoming intelligible to a mass audience. *The Experimental Film* ultimately reflects the conflicted status of this new and amorphous category, experimental film, at the start of the decade when film slowly became taken seriously as an art form for a larger public.

Lipsett, after McLaren, is the most notable experimental filmmaker who worked at the NFB. As an art school graduate who had frequently visited New York and had been introduced to the work of major avant-garde filmmakers like Anger, Conner, and Deren (in Montréal through the film collection of Guy L. Coté), Lipsett was invested in avant-garde art as provocation.[95] Lipsett made *The Experimental Film* between *Very Nice, Very Nice* (1961), the Academy Award–nominated film for which he is most famous, and *21-87* (1963), which had some US festival screenings and awards, and was notoriously beloved by, and influential upon, George Lucas, the director of *Star Wars* (1977) who made experimental films as a student at University of Southern California.[96] *Very Nice, Very Nice* and *21-87* are more characteristic of Lipsett's style of rapidly edited collage filmmaking, with dense and often contrapuntal sound-image montage. In contrast, *The Experimental Film* is a more conventional half-hour television show in which Lipsett wants to make a case for experimental film—including his own filmmaking, as he embeds the entire seven minutes of *Very Nice, Very Nice* in the documentary, taking up almost a quarter of the running time! It must be said that for experimental film, usually completely off the mainstream cultural radar, to be on television is remarkable in itself, though it is testament to the profile generated by McLaren (whose film *Blinkety Blank*, 1955, ends the program), and to the fact that both the NFB and CBC were public institutions with mandates to show contemporary developments in arts and culture.

The Experimental Film expresses both personal and institutional viewpoints, staging an important debate about experimental film as a tension between art as communication and art as provocation, one particular to Feldman's concept of the Canadian strain of institutionalized experimental film.[97] Lipsett's own individual and institutional position as an emerging artist and filmmaker at the NFB shows the benefits and stresses of the institutional home. As Lipsett himself stated in 1968, "Working at the Film Board, you are made to become aware that you are making films for an audience and they just won't let you make films that are too excessive and too private and I have always had quite a fight with getting each film done."[98] Lipsett certainly had conflicts with the NFB's bureaucratic structures and culture. As time went on, despite the interventions of sympathetic figures like Donald Brittain, Tom Daly, Glover, and Colin Low, Lipsett increasingly became an outlier, and he left the NFB in 1970. Yet, for all this conflict, it is remarkable that he was able to work at the NFB for a decade; there is no comparable

example in the US of an experimental filmmaker working consistently in the 1960s at any institution outside of a college or university. Nonetheless, while it is important to give the NFB its due as an important home for experimentation in film in Canada, it is equally important to remember its history of bureaucratic impediments and internal censorship, and its status as a "closed shop" that has at different times sucked the air out of the room, consuming resources that would likely have been used more efficiently in the independent film sector.

During the 1960s and beyond, film experimentation in Canada was recognized in a number of ways, but often hovering around and intersecting with other categories of art and film at the time when New Wave movements in Eastern Europe, France, Japan, US, and UK were revolutionizing cinema. In addition to McLaren's animation unit and the singular work of Lipsett, the NFB continued to nurture experimentation in film in the 1960s, although from the late 1950s through to the early 1970s generally, this overlapped with animation and documentary film. Derek May's *Angel* (1966) uses high-contrast optical printing over a Leonard Cohen song while Ryan Larkin's *Syrinx* (1965) and *Walking* (1968) were both acclaimed animated films.[99] It is notable that both *Angel* and *Syrinx* won Canadian Film Awards for best "arts and experimental film."

The Canadian Film Awards (now the Canadian Screen Awards) might be thought of as Canada's equivalent of the Oscars; they are administered by the Academy of Canadian Cinema & Television, while Hollywood's Academy of Motion Picture Arts and Sciences runs the Oscars. The Canadian Film Awards began in 1949 and had an Arts and Experimental category from 1958 to 1976, which points to the relative visibility of experimental film in this period. Yet, what fell under the category of Arts and Experimental points also to the continuing fluidity of the term, and the tension between communication (or mainstream legibility) and experimental provocation. In many years, no award was given in this category, and winners ranged from experimental filmmakers Norman McLaren (several times), Rick Raxlen (1970), and Bruce Elder (1976), through makers of documentaries about the arts. In 1969, the Canadian Film Awards disqualified David Cronenberg's *Stereo* from the feature film competition as they deemed it an "experimental film" (to retaliate, Cronenberg cross-programmed a "grudge" screening the night before the awards).[100] In the 1980s, some self-identified experimental filmmakers like Martha Davis and Hoffman were nominated in the Genies' Short Documentary category, which reflects the ways that experimental and documentary film—often allied aesthetically as forms of non-fiction cinema—dovetail in Canada as small-scale personal film production.

1967: Four Visions of Film in Canada

Canada's centennial year, 1967, was a pivotal year in the history of film in the country, and it had particular impacts for experimental film due to four seemingly disparate events. First and best known is Expo 67, a world's fair with innovations in film and media technology at its core. The second event was the founding of Intermedia, a short-lived ARC (1967-1972) in Vancouver that was ahead of its time in bringing together filmmakers and video artists with poets, performers, architects, technologists, and engineers for a vision of integrated media arts that is closer to the cross-media possibilities digital media allows in our current time.[101] Third, the Canadian Film Development Corporation (CFDC), now Telefilm Canada, was established as the central funding body supporting narrative filmmaking in Canada. Fourth, the CFMDC was founded as a film distribution co-operative for experimental and independent cinema; it was kick-started by Cinethon, a three-day international underground cinema marathon. These four events in 1967 laid out alternative visions for film and media art in Canada that continue to this day. The tensions between national institutions, arts funding, artist and filmmaker culture, and changing political and cultural conditions dramatized and set in motion by these four events in 1967 would be played out in the film, video, and media arts infrastructures that developed through the 1970s and 1980s, until the digital revolution transformed the sector in the 1990s and into the twenty-first century.

CFDC and CFMDC are institutions that support two very different conceptions of cinema.[102] CFDC supports "the movies" produced by the film (and later television) industry, while CFMDC distributes films made in an artisanal production mode for all manner of personal, political, or cultural motives, for small to no audiences. Of course, this binary oversimplifies what is often a complex spectrum of filmmaking and film viewing conventions between the two extremes. Many filmmakers working in the industry got their start in independent film co-ops and made experimental films; to cite just one contemporary example, Jeremy Podeswa, who has directed episodes of *Game of Thrones* (2011-2019), has three short films in the CFMDC collection. Many films at CFMDC have had decades of influence on educational and community audiences—and while some other experimental films have had little impact, the same is true of many CFDC-funded films. CFDC supported a narrow type of narrative filmmaking; in addition to experimental film, the CFMDC distributes narratives, documentaries, animation, and has special collections of LGBTQ2+ cinema not supported by conventional distribution. The openness to varieties of cinema at the CFMDC and other co-ops has been part of what has fed the current strength of the narrative feature and television industries in twenty-first-century Canada, but it has taken several generations of often precarious development to get there.

If CFDC and CFMDC present a contrasting pair for single-screen film, Expo 67 and Intermedia present a contrasting pair—on contrasting sides of the country—for the "expanded cinema" that American Gene Youngblood would discuss in his influential 1970 book of the same name.[103] Expo 67 continued the legacy of the Canadian institutionalized experimental film that intersects with animation and documentary at the NFB. But the eclectic range of media technologies and experiences at Expo 67 were also being explored, on a much smaller scale, by filmmakers and electronic media artists at Intermedia. Some of Intermedia's early exhibits presaged the NFB's subsequent (if intermittent) support for media experimentation; for example, the NFB funded computer graphics (e.g., Daniel Langlois), interactive documentary (e.g., Katerina Cizek's *Highrise*, 2011), augmented and virtual reality (e.g., Lisa Jackson's *Biidaaban*, 2018), and other forms of 360-degree audio-visualizations.[104]

Many nations have the equivalent of a CFDC/Telefilm that supports national fiction filmmaking (usually meant to fight off the influence of Hollywood and other export film industries). Many nations have a central film institute, school, or other body supporting non-fiction cinema—though few as robust as the NFB. The Canadian ARC/film co-op has precedents in 1920s cine-clubs in France, and parallels in the media arts centre movement in the US (e.g., NAMAC or National Association of Alliance Media Arts and Culture).[105] Despite parallels in other countries, there is a particularly Canadian mix of institutional, industrial, and artist film, video, and media institutions that is worth understanding in more detail.

Expo 67

Probably the most popular examples of experimentation in Canadian film in the 1960s were the many film and media presentations housed in pavilions at Expo 67 in Montréal, reflecting how experimental film was more connected to mainstream culture in the 1960s than it would be in subsequent decades.[106] These institutional experimental films, subsidized by government or industry, are films or audio-visual spectacles designed to be experienced by large audiences, taking experimental forms of film, visual art, music, design, and other arts and presenting them in massive scale. The Expo 67 experiments brought together many filmmakers influenced by the heady swirl of visual art and intellectual ferment in this time; some continued their careers in industrial cinema (for example, Expo 67 presaged the development of IMAX by Graeme Ferguson and Roman Kroitor at the Osaka World's Fair in 1970); some continued in smaller scale cinema; and some pursued both.[107]

The most famous expanded cinema experience was *Labyrinth*, a multi-screen pavilion through which fairgoers would walk. One part was projected in 70mm in a chamber with two massive screens, one on the floor, and the other arranged vertically; the last part was a multi-storey five-screen installation in the shape of a cross. *Labyrinth* brought together

many talented filmmakers from the NFB, including Brittain, Daly, Jutra, Kroitor, and Low. Many of these artists were the same ones who had protected Lipsett's experiments, and in the NFB tradition, they were interested in both the experimental aesthetic possibilities of cinema and the need to communicate a public message. *Labyrinth* used myth to attempt to tell a universal "Man and his World" story that now seems less universal and more a reflection of 1960s Western culture's alarming presumptions about gender, race, and indigeneity. At the other pavilions, *Kaleidoscope* was a colour projection designed by Morley Markson and Associates that was influenced by László Moholy-Nagy and figures like McLuhan and Buckminster Fuller. It featured the music of Canadian experimental composer R. Murray Schafer.[108] Markson would go on to join the independent film scene in Toronto, making documentaries on countercultural figures. At the centre of a multimedia installation at the Christian Pavilion (with music by John Cage and Charles Ives) was *The Eighth Day*, a 16mm collage film by artist and filmmaker Charles Gagnon.[109] Expo 67 was exceptional in demonstrating how receptive public audiences were to audio-visual experimentation.[110]

A notable lesson from Expo 67 is that, after having such a huge impact on the millions of people who experienced them, the films almost completely disappeared from Canadian film history. This is a common fate of moving image art tied to custom-built technologies that render the films impossible to see after the exposition concluded. This remains a burning issue for multimedia installation art, and a pressing one for archives in the twenty-first century, since film and digital media installation by visual artists is so prevalent in museums and galleries. Installation art's solidity, its physical, architectural dimensions, ironically make it more ephemeral: a challenge for archivists to preserve and for curators to remount. For example, while there is a single-screen rendering of the cruciform part of *Labyrinth* currently available on the NFB website, the two-screen portion is inaccessible and exists only in some photo documentation and in the memories of its spectators.[111]

Polar Life (directed by Graeme Ferguson with assistance from Toni Myers and Shirley Clarke) was an ambitious eleven-screen pavilion in which the audience, seated on a carousel, moved around the film projection, seeing roughly three screens at a time. The film was thought lost until Monika Gagnon and Janine Marchessault's scholarly project recovered mislabelled reels and partially reconstituted them in a digital widescreen version. The telling counterexample is *A Place to Stand*, Chris Chapman's single-screen 70mm film that used complex optical printing to embed up to fifteen images on the screen at once. Not tied to a specific pavilion architecture, the film was screened widely after Expo 67 in 70mm-equipped theatres, winning an Oscar for best Live Action Short Subject, and seen by an estimated 100 million people.[112] The fate of the Expo 67 films reflects the dominance in this period of single-screen projection as the main way films were seen.

Intermedia

Vancouver in the 1960s had an active arts scene that shared interests in many of the themes of Expo 67 but in a more countercultural and less monumental approach. Zoë Druick describes the scene: "In Vancouver, a kind of West Coast utopianism merged modernist technological experimentation with mystic dabbling and cultural exoticism. In Gene Youngblood's influential concept of 'expanded cinema,' visual technologies became, along with psychotropic drugs and transcendental meditation, techniques of mind expansion. Film experiments of all kinds merged with other types of social and personal experimentation on the Canadian frontier."[113]

Intermedia was a collective that brought together artists of all media along with scientists and speculative thinkers to experiment with media arts. It provided equipment and facilities for workshops and performances—provided by a considerable (for the time) CCA grant of $40,000 (the first CCA grant given to an ARC)—and mounted three influential exhibits at the Vancouver Art Gallery (VAG). The large grant allowed the organization to have a major public profile, attracting art world attention from *Art in America* and *Artforum*. Its ethos was openness: its first building was four floors of open studio space, and it also purchased film and video equipment (an early Sony Portapak) that the public could use.

Like Expo 67, but for different reasons, Intermedia was short-lived, its utopian energy impossible to sustain. People involved in Intermedia created a number of subsequent media-related organizations in Vancouver, including The Cinematheque (originally Pacific Cinémathèque Pacifique), Western Front, and Satellite Video Exchange Society/Video Inn. But Intermedia's legacy—especially being a site for artists who wanted to work across film and video—was to become "one of the energizing factors for Vancouver's growing art scene," and stands in as a precursor for other independent co-ops that nourished independent film and media in cities and towns across Canada.[114]

CFDC/Telefilm Canada

The generation of documentary filmmakers coming through the NFB in the 1960s wanting to make feature narrative films, especially in Quebec (e.g., Jutra, Gilles Carle, and Gilles Groulx), and the increasing public interest in film, all energized by the wave of nationalism that crested in the Canadian centennial celebrations, led to the federal government's establishment of the CFDC in 1967. The history of CFDC, and of government support for feature filmmaking in Canada, is baroque in its complexity, waxing and waning according to economic conditions, political parties, trade and industry conditions (especially in the US), and new technologies. The CFDC became Telefilm in 1984 to incorporate broadcast television, and subsequent reorganizations of the agency have adapted to cable and satellite and to variations on digital media like "multimedia" and "new media." With some exceptions, the history of experimental

film in Canada rarely intersects with CFDC/Telefilm, with the important caveat that the pull of the commercial industry has been a powerful force shaping film co-ops.[115] Conflicts often arose between, on the one hand, people wanting to hone their craft and make "calling card" films to enter the industry and, on the other hand, self-identified artists seeking to use film and other moving image media for self-expression and social commentary. This sharp division has eased somewhat in the twenty-first century as internet streaming platforms have opened up avenues for people seeking to tell stories outside the two-hour feature film format, although careers in the industry still require hewing to feature film or episodic television story or documentary formats.

CFMDC & Cinethon

A much lesser known event in 1967 was Cinethon, an underground film screening event in Toronto, a forty-five-hour movie marathon on June 15–17 organized by Rob Fothergill and Lorne Lipowitz.[116] The event was relatively high profile, reviewed in the press, and featured many now-classic experimental films from the US (by Brakhage, Conner, George and Mike Kuchar, Gregory Markopoulos, Gunvor Nelson and Dorothy Wiley, Barbara Rubin, and Warhol, among others). Underground film was making a splash in the US and the goal of Cinethon was to bring that buzz to Canada. The prevalent insecurity of the Toronto art scene meant that the event would be seen as legit if artists from New York and San Francisco attended, and figures like Anger, Clarke, Ed Emshwiller, Jonas Mekas, and Robert Nelson arrived in person, in Fothergill's words, "stoned to the eyeballs."[117] Alongside these US films and artists, Cinethon also featured films by Canadian artists like Jacques Chenail, Cronenberg, John Hofsess, Sam Perry, Gerald Robinson, Burton Rubenstein, Snow, John Straiton, and Wieland.[118]

The event took place at Cinecity, an independent cinema that continued to show some experimental films until 1975 and was funded by an investment banker named David Fry and by Willem Poolman, who also had Film Canada, a distribution company that focused on European art film and Quebec cinema. Poolman wanted to distribute underground films at a moment in the late 1960s when underground film culture in the US received mainstream attention, connected to the emerging youth counterculture with its liberatory rhetoric of sex, drugs, rock and roll—and Andy Warhol. The glamour of Warhol's Factory and sold-out screenings of *The Chelsea Girls* (1966) in New York suggested that money could be made. Cinethon was a lure to get Jonas Mekas, who distrusted Film Canada as too mainstream, to allow underground films to be distributed in Canada at a "Film-Makers' Cooperative of Canada," similar to the Film-Makers' Co-operative that Mekas had founded in New York in 1962.

It mostly worked. But the co-op that was founded was instead called the CFMDC, or Canadian Filmmakers Distribution Centre, with Cronenberg, Fothergill, Lipowitz, and Jim Plaxton attending the first meeting a month before Cinethon. Fothergill and Iain

CFMDC film vault, Toronto Media Arts Centre, 2018 (Jesse Brossoit)

Ewing became the first directors of CFMDC, still one of the key sustaining institutions for Canadian experimental film. The future paths of the founding members (Fothergill to an academic career, Plaxton and Cronenberg to the Canadian film industry, and Lipowitz/Michaels heading to New York) reflects the particular convergence of mainstream and experimental film cultures in 1967 but also the academic and film industry institutions that would continue to intersect with experimental film in later years. The CFMDC is the oldest film artist–run organization in Canada, and part of its longevity may be a result of its quietly unsexy primary function as a distributor, shipping prints to exhibitors and distributing a portion of rentals back to artists. When Peter Rowe, an underground filmmaker central to the McMaster Film Board, dismisses CFDMC ("It was just a distribution centre. I never took it too seriously myself. I gravitate towards where there's some action in terms of production"), he articulates how many filmmakers tend to ignore the mundane but crucial function of film distribution.[119] Thankfully, many filmmakers have contributed to its all-filmmaker Board of Directors and supported other CFMDC initiatives, as with other Canadian independent film and video distributors.

In Fothergill's memoir of the founding of CFMDC, he acknowledges the vital contributions of the early co-op office managers Patricia Murphy, Clara Meyer, and Sharon Venné (a.k.a. Granada Gazelle). It's important to note the gender divide between male "founders" and female staff, which is part of a larger pattern in Canadian independent and experimental film culture of women working "behind the scenes" and doing much of the unglamorous administrative workings necessary to sustain the field. Sexism in the mainstream film industry is well known, but it is also found in independent and experimental film. On the one hand, more women have historically been able to work in documentary, animation, and experimental film at small-scale, artisanal modes of production, where money and resources are limited. On the other hand, despite this increased access, the careers and energies of women and non-binary persons have

still been impeded by sexism and transphobia, whether encountered on occasions of discrimination in grants and fundraising, toxic film co-op culture, bias in screening and exhibition programming, or the systemic gaps in wages, childcare, and other gendered social factors in society at large.

Important feminist initiatives in the 1970s included the Women and Film International Festival in 1973, which toured eighteen cities in Canada and inspired the creation of what became TIFF, and the establishment of Studio D at the NFB (1974), "the first publicly funded feminist film-production unit in the world."[120] But as we have seen so far, Meyer, Murphy, and Venné are in the tradition of Deren, along with figures like Burritt, Lambart, and Wieland—among many other women—who had already worked to make, program, and distribute films, and helped lay the foundation for the expansion of film culture in the 1970s and beyond.

Contrasts and correspondences

The contrasts and parallels among these four major events in 1967 foretell a number of important trends in Canadian experimental film. The late 1960s were a turning point in Canadian experimental film history that saw, with some notable exceptions, a turn away from large national institutions like the NFB/Expo 67 being the only game in town, to a number of paths for independent production. Arthur Lipsett's trajectory reflects the shift in Canadian experimental film out of institutions like the NFB to a much more independent mode of production that was also much more precarious. In Lipsett's case, after making several more collage films at the NFB, he completed only *Strange Codes* (1974) before his suicide in 1986. But the precarity of independent production was nonetheless provocative and energizing, gathering the energies of a post–Second World War baby boom youth generation that was experiencing, albeit somewhat second-hand, the tribulations of US counterculture and social debates about war, racism, sexuality (and censorship), and new states of consciousness.

At Cinethon, Wieland presented the expanded cinema event, *Bill's Hat*, an illuminating contrast with the films at Expo 67. It too was a multimedia extravaganza, but instead of a display of technology at a monumental scale, it expressed the down-to-earth humour and energy of the underground. Whereas the Expo 67 pavilions were designed and mechanized to accommodate the flow of more than a million people through the world's fair, *Bill's Hat* was ephemeral, presented as part of a midnight performance with hippie staging (flowers, candles), slide projection, a hand-held film projector showing ads, cartoons, and educational films, strobe lights, and live jazz performance led by Stuart Broomer.[121] Fulford notes the contrast between the two events: "The atomic bomb is one of two favourite symbols in the underground cinema. The other is the female nipple. At Expo the two main symbols in the films are the umbilical cord and the rocket ship. This defines the difference between the free and the subsidized cinema."[122]

It's true that the underground was pro-sex and anti-war and ambivalent to technology, while Expo 67 fetishized technology and seemingly universal themes. To some extent, Fulford's "free" vs. "subsidized" binary captures the spirit of how, on the one hand, Cinethon would foretell the rise of artist-run co-operatives as spaces to nurture freedom for experimental filmmaking going forward, while on the other hand, larger institutions like the NFB and CFDC concentrated on documentary and feature narratives. Nonetheless, after the initial burst of energy that led to the first co-ops being established, it was arts council grants and screenings at educational institutions that subsidized independent co-ops into the 1970s and beyond. Wieland described her early films as "tabletop films," which captures their home-made feel. But she too would avail herself of CFDC funding to make a feature narrative, *The Far Shore*, in 1976. Neat binaries like free vs. subsidized don't capture the full complexity of Canadian experimental film history, which teems with contradictions that defy tidy categories.

Co-operative distribution

A defining legacy of 1967 arose when the CFMDC adopted the model of experimental film distribution set up in 1962 by Mekas's FMC, a model that was also adopted across the US and UK. FMC was an open co-op that would accept any film for distribution and would treat every filmmaker equally. Filmmakers paid membership dues and set film rental prices, and the co-op would (in theory) dispense a percentage of rental income back to the filmmaker. This radical concept of egalitarian distribution set the terms for the subsequent economic and cultural organization of Canadian experimental film, with ripple effects for its history, especially relative to its evolution into twenty-first-century moving image arts.[123]

The importance of the Canadian experimental film community adopting the film rental distribution model from the US cannot be overstated, for it dictated how Canadian experimental film would relate economically and culturally to the art world. Overall, film and art developed different levels of cultural organization, urgencies, and prestige in the twentieth century. Although filmmakers have been using the medium of film in an artisanal fashion since the 1910s, film has tended not to be seen as a viable art medium in a way that is comparable to established visual art forms like painting and sculpture. Co-op distribution that would accept any film on principle was anathema to the codes of selection and connoisseurship at the heart of the art world. The experimental film world that gave rise to the co-op distributors in the 1960s was resolutely democratic and anti-industry in ethos. Experimental filmmakers, like most artists, are motivated mainly by their commitment as artists, with a need to make films and have them screened for viewers. In the 1960s, the countercultural (and generally anti-capitalist) energies of experimental filmmaking were facilitated by the relative cheapness of 16mm equipment

and film processing and print charges. In this period of film ubiquity, the emphasis was on getting the films to the public, not on maximizing profit.

It may have been inevitable that Canadian experimental film would adopt the dominant economic model of film distribution and exhibition as the US and UK. Yet, the fact that most Canadian experimental filmmakers in the 1960s were successful visual artists with art gallery representation means they were at least aware of other options. Michael Snow made his first film in 1956 before making films consistently starting in 1964; Joyce Wieland and Jack Chambers began making films in 1963 and 1964, respectively, and worked in 16mm film through the 1970s. Early screenings of experimental film in Toronto took place in the Isaacs Gallery (which represented Snow and Wieland) and Cameron's Here and Now Gallery; later, independent galleries like A Space and YYZ had joint film and video screenings in the 1970s. But larger factors conditioned the ultimately broken relationship between film culture and the art world, especially with museum galleries like the AGO, NGC, or VAG, which—with some exceptions—largely ignored experimental film and rarely acquired it for their collections: first, art as object vs. film as time-based performance; second, art sales market vs. film rental market; and third, gallery exhibition vs. theatrical exhibition.

There are multiple ways for filmmakers to sell their work. The most obvious one is to sell a film like one would sell a painting or sculpture, as an object. This method has the benefit of being harmonized with the art world's commercial system. One problem for film is that most film prints are copies made from an original negative; in theory, unlimited copies could be made, which decreases the uniqueness, rarity, and thus value of the film as object. But this division between precious object and infinite copy is not as simple as it seems. As critics like Balsom have noted, the copy is not foreign to the art world: art studios would paint multiple copies of paintings, and mechanical reproductions of lithographs or cast sculptures have a long history.[124] Moreover, not all films are copies. Films shot on reversal stock create a print original, not a negative. Until very recently, art collectors and museums have rarely purchased films as objects. When they have, it was usually films made by visual artists (like Chambers, Snow, and Wieland) whose work in other media they already collect. More recently, film prints have suffered actual scarcity as libraries have junked film collections, and as many film stocks have been discontinued—or because a film artist has intentionally printed a "limited edition" of film prints, to create the rarity value that the art market requires.[125]

Instead, the market for experimental film is overwhelmingly a rental rather than a sales market. Film prints are rented from distributors, and what are sold are legal performance rights for screenings, often with different rates for commercial screenings (where tickets are sold) compared to educational screenings at schools, colleges, and universities.[126] Indeed, so dominant is the rental option that the 1972 CFMDC catalogue

includes a single line about sales: "WE SELL PRINTS TOO JUST INQUIRE."[127] In rare cases of sales, there remained restrictions on screening rights like locations and audiences; it was less the object that was sold than the right to project it. The filmmaker/artist retained "an author's right to attribution, integrity and association of a work" under Canadian copyright law (e.g., someone who buys a print cannot re-cut it and still attribute it to the artist).[128] Co-op distributors generally had non-exclusive arrangements with filmmakers, meaning that filmmakers were welcome to distribute their films with other distribution companies, or make film prints, electronic transmission, or reproduction sales with buyers, television stations, or VHS or DVD release companies. This freedom, in theory, helped the artists maximize profits, though it disadvantaged the co-ops. Moreover, it contrasts sharply with how galleries and the art market control supply and value rarity over access.[129] The 1984 CFMDC catalogue promised artists 70 per cent of rental amounts and 80 per cent of sales amounts; when the CFMDC was temporarily in a financial squeeze, the proportion was shifted to 60 per cent. Because of these details of rental and rights, film's commercial status is not object but performance. Film's ambiguous status as an object has effectively removed it, until very recently, from the art market.

The final problem is that film's optimal venue for high aesthetic quality of performance, the theatre, has often removed it from the gallery/museum (or even an art collector's wall). On the one hand, it's usually better to see films in dark theatres than well-lit galleries, in the black box rather than the white cube, where a well-lit gallery obscures the essential medium of projected film, light. On the other hand, this separation is also about cultural priorities and hierarchies in the museum world. For example, gallery space is usually controlled by a curatorial division, whereas museum theatres were, for a long time, more often programed by an education division as a form of community outreach or "add on" to the curated exhibitions in the gallery. The art world favours the term *curator*, whereas in experimental film, *programmers* select and arrange film screenings, adopting a term used in film societies earlier in the twentieth century; since the mid-1990s, however, when experimental film and media began to enter galleries and museums, the term curator has become more common in the experimental film and media ecosystem.

Film's location in the theatre also made it less visible to arts press. In 1968, during the heyday of underground film and a year after Cinethon, the AGO hosted a national exhibition and competition, *Canadian Artists '68*, which included three categories, painting, sculpture, and film, juried by Richard Hamilton, William Turnbull, and Jonas Mekas, respectively. There were 126 films entered in the competition; Mekas choose 20 for screening, with 4 winning $1,500 prizes: Chambers's *R34* (1967), Keewatin Dewdney's *Maltese Cross Movement* (1968), Larry Kardish's *Slow Run* (1968), and Snow's *Wavelength*

(1967).[130] But in the reviews of the show, only painting and sculpture are mentioned, even though it is clear from the short exhibition catalogue that film is also included (Snow's and Wieland's films are illustrated in the catalogue with frame enlargements).[131]

CFMDC and other film and media art distributors require arts council and other grants to survive. No experimental filmmakers, living or dead, have been able to support themselves on the income from film rentals alone. Of course, few artists can support themselves on art sales either—in the highly unequal all-or-nothing art market, there are only a few blue-chip artists who can make a living from art sales. The problem with the film rental financial model is that the primary market is not-for-profit institutions. From the late 1960s into the 1990s, the majority of experimental film rentals and sales were from colleges and universities, which in Canada are overwhelmingly public institutions; the remainder of rentals go to museums, individuals, and from the 1990s on, to the many festivals that now show experimental film and media. But rental amounts cannot exceed the capacity of the already publicly subsidized market. The benefit of making the film rental market highly democratized is that renting prints is easy and highly affordable—in 1993, someone could rent a Michael Snow film for twenty dollars. The downside is that no filmmaker could make a living on those rates, and experimental film and video art distributors must run as not-for-profit organizations.

The 1970s and 1980s

Establishing Canadian experimental film infrastructure

Experimental film in Canada was undergirded from the 1970s onward by an increasingly diverse range of small institutions, some national, some provincial or regional, that nurtured experimental film, including production co-ops, distributors, publications, and exhibition sites. Most were created and sustained by artists themselves in the form of ARCs. Experimental filmmakers and media artists, though independent, are still tied to an institutional network, whether they are using industry and ARC equipment and services or accessing government grants, either directly through a project grant or indirectly through co-ops (that are also receiving government grants). Some experimental filmmakers have managed to work largely independently of co-ops and other institutions, but it is impossible never to be affected by them.

The growth of this institutional network was part of a general growth in the arts in Canada from the late 1960s, which was nurtured and structured by five sets of institutions: (a) arts councils and other forms of government funding for the arts, (b) co-ops and ARCs, (c) art-world galleries and museums, (d) colleges and universities, and (e) in a much more antagonistic way, censorship boards.

Arts councils: follow the money

Government arts funding bodies continue to be a crucial set of institutions in Canadian experimental cinema. Arts councils are the major funders of artists and institutions like film co-ops, exhibitors, festivals, and publications. Since 1993, the federal government's Department of Canadian Heritage has administered most national arts agencies, including CCA, CBC, NFB, Telefilm, and other major museums and arts institutions. Prior to 1993, arts came under the purview of a series of government departments with varying levels of support. After CCA, provincial arts councils are the next level of government support (e.g., Saskatchewan Arts Board, Société de développement des entreprises culturelles in Quebec, Ontario Arts Council), sometimes exceeding federal levels of expenditure. Certain large centres like Toronto, Montréal, and Vancouver have municipal arts councils. As well, at various times in some cities and regions, local agreements with NFB regional offices or CBC stations have occasionally provided resources for local filmmakers, including access to film development labs, equipment, and expertise.[132] A foundational principle of Canadian arts council funding is that it is arm's length, peer reviewed, with artists serving on juries. Peer review has its own problems, including those of generational inertia (established senior artists tend to sit in judgment of emerging artists) and implicit bias, but peer review is a vast improvement over either governmental approval or a patronage system relying on rich art collectors. The peer review principle democratized the art world, allowing arts funding, at least in principle, to serve artistic over commercial imperatives.

Experimental filmmakers and institutions have relied heavily on arts council funding, although a few experimental filmmakers engaging in larger projects might get grants from Telefilm and/or provincial film industry bodies (e.g., Alberta Motion Picture Development Corporation, Ontario Film Development Corporation). While arts councils' overall funding levels have fluctuated based on the economy, government deficits, and the variable enthusiasm of political parties interested in supporting the arts, support for experimental and independent film has often depended on the skills of devoted arts council officers who strategized and liaised with the filmmaking community to ensure funding for artists and co-ops working in film and media (e.g., Rita Davies was instrumental in helping increase funding for artists at the Toronto Arts Council). At CAA in the 1970s, Penni Jaques and Françoyse Picard enabled independent filmmaking to be funded by the arts council in the face of pressures early in the decade to shift film funding out of CCA to CFDC. Darrell Varga notes that it "required extensive lobbying inside the Council as well as recognition of film as a legitimate art form and not simply a commercial product."[133] Jaques made the case for filmmakers as artists, which required that only individuals could apply for funding (rather than production companies, as with the CFDC), and ensured artists would have editorial control or "final cut" over their project.[134]

When Picard succeeded Jaques in 1975, she continued to lobby internally at CCA to make sure that administrators saw filmmakers as artists, but she also buttressed CCA support for film co-ops.[135] In Peter Sandmark's history of Canadian film and media co-ops, he interviews Picard, who recalls, "When I arrived at the Council in 1975, there were three co-ops getting funding [Winnipeg Film Group, Atlantic Filmmakers Co-operative, and ACPAV in Montreal], some centres were folding, and the CFDC wanted to get film funding back from the Council. We wanted to fund auteurs, film directors, and not necessarily the centres of production in Toronto and Montreal that the CFDC was identifying. We feared that the government would say no for funding film at the Canada Council, and wondered what could we do to be distinct?"[136]

The answer was to expand the number of regional co-ops, and in the next five years, the Newfoundland Independent Filmmakers Co-op (NIFCO), followed by the New Brunswick Film Co-op, the Calgary Society of Independent Filmmakers (CSIF), and Saskatchewan Filmpool Cooperative were established. Grants were given to a wide array of film activities. For example, in 1976-1977, established narrative and documentary directors like Don Shebib and Robin Spry received grants, as did animators and experimental filmmakers, while organizations like the Canadian Film Institute (CFI), CQ, and The Cinematheque in Vancouver received the largest grants, and many smaller grants went to co-ops and other small institutions. This support for institutions rankled some experimental filmmakers, who preferred direct funding to artists. But even though co-ops also supported filmmakers interested in moving onto film industry employment, the co-op infrastructure nonetheless had a positive effect in nurturing experimental and independent film production and culture, and funded spaces for screenings, workshops, and dialogue.

Conflicts arose in this period around overlaps and differences between film and allied art forms like video art and emerging forms like computer imagery and holography, all of which were funded through CCA's Visual Arts Section until 1983. Varga notes, "A considerable amount of Canada Council energy was consumed by internal territorial debates over whether film should be supported as a distinct art practice or as a component of the then-emergent media arts."[137] David Rimmer tells an anecdote about applying for an arts bursary in the 1960s, and handwriting "Filmmaker" on the application form since that category was missing.[138] Much was at stake, especially in periods when funding cuts threatened to force an already small funding pie to be divided among more and more competing media forms, and applications might be considered under different categories and streams. In 1974, video art began to be adjudicated by separate juries at CCA, and Peggy Gale was hired as assistant film and video officer. In 1975, the inaugural video officer, Michael Goldberg (from Satellite Video Exchange Society), formally marked the separation of film and video.[139] In 1983, the umbrella Media Arts Section was created, led by Tom Sherman, a central figure

in electronic arts; while this was a far-sighted move, it had the short-term effect of increasing funds for electronic media artists.[140]

The separation between film and video in the 1970s and 1980s was first a matter of technology. Each medium uses very different cameras (film vs. magnetic tape), editing processes (flatbed Steenbecks vs. online/offline processes), and exhibition technology (film projectors vs. monitors), all of which separated film and video co-ops into stand-alone operations. On an aesthetic level, the residue of modernist medium specificity debates also led some film and video artists to differentiate themselves into the 1980s. Sometimes, the separation depended on local cultures: film was more separate from video in Toronto than in Vancouver in the 1970s and 1980s.[141] Nonetheless, overlaps and convergences began in the 1980s, as Sandmark describes: "[T]he video centres had graduated from the Sony reel-to-reel portable decks, and by then were working with higher quality 3/4" decks, and special effects generators. By the mid-80's the integration of video and film in the film co-ops across the country stepped up, as filmmakers explored video technology for special effects, often filming video monitors for a final product on film. Video was still seen by many in the film community as a second priority to film; however, its uses were growing."[142]

On the film side, although 16mm was the main gauge used by experimental and independent filmmakers, Super 8 film was also increasing in popularity. At half the cost and with increased portability, and with its different, grainier look, Super 8 had adherents, some fiercely passionate, and others using it as one gauge among many.

The following exchange between Mike Hoolboom and Patricia Gruben captures some of the complexity of the relationship between arts councils and experimental film and media artists:

> **Gruben**: I don't want to say anything derogatory towards the Canada Council or Telefilm because I grew up in a country [US] that doesn't have anything like it, and that's much worse. . . .
>
> **Hoolboom:** Isn't there an artificial quality to the whole of the Canadian independent film sector? Filmmakers receive production monies from Canada Council, who also support production co-ops to provide equipment access. The completed work goes into Council supported distribution co-ops and show in Council supported screening venues. The only people who don't get paid are the audiences.
>
> **Gruben:** But if you call government subsidy artificial, are you saying that the marketplace isn't? That Ellie Epp's films should go out there and compete with *Batman*, and may the best win? Without an exhibition circuit and the

advertising dollars that underpin American films, the notion of a level playing field is ridiculous. I can't blame the government for giving us money. We, as filmmakers, have to take responsibility for our relationship to our money, not to assume that it's our right to get it, or that there's no other way to make work.[143]

Gruben, like other US-born artists who made films in Canada, is aware of the inevitable power relationships that arise from relying on government support for the arts, but she is also aware that within the larger capitalist economic structure of "the marketplace," such support allows experimental filmmakers like her and Epp to make and exhibit work.

Film co-ops and experimental film

ARCs, or artist-run centres, take many forms in Canada, but in the world of experimental film, they are usually in the form of film co-operatives, or co-ops.[144] Film, video, and media co-ops provided the most continuity during the 1970s and 1980s, even as their histories dramatized the stresses and fault lines that developed over these decades. Co-ops took on many roles, covering most of the major activities in experimental film culture, but with some exceptions, the primary mission of most co-ops is production.[145] The cost of filmmaking is high, especially to pay for equipment like cameras and editing suites, but expenses are highest in narrative film, which may require studio space, lighting, costumes, and props. Experimental filmmaking can be relatively inexpensive—minimally, a hand-wound camera like a Bolex and a pair of editing rewinds and a splicer can suffice—but the major expense remains film stock and lab costs, which increased substantially through the 1970s and 1980s. Until the 1990s, film production tasks like lab development of negatives, generation of work prints, negative cutting, and duplicating final film prints would still be covered by commercial film labs or specialized personnel; as labs began to close, the slack was taken up by artisanal hand-developing or independent labs like Niagara Custom Lab (founded by Sebastjan Henrikson in the early 1990s in Toronto).[146]

The wide range of film supported by most co-ops, from animation through documentaries to low-budget narrative features, meant that shared ownership of equipment was a major impetus to co-op formation. But common space and community were just as important to provide critical mass for shared artistic energies, what Penny McCann calls the "willing hands" that community provides, whether it is writing or brainstorming, crewing, and post-production editing.[147] Production co-ops could get project funding for commissioning individual work or operational funding that could be distributed to members. They also provided a social space for the development of film and media culture more generally. Membership requirements often stipulated that people perform

Niagara Custom Lab screening, 2002. L to R sitting: Sebastjan Henrickson, Juliana Saragosa, Nathan Moles, Christina Battle, Christina Zeidler, Elmer Birkbeck, Alexi Manis, and Izabella Pruska-Oldenhof; L to R standing: Riccardo Iacono, John Price, and Michèle Stanley (John Porter)

a certain number of volunteer hours, a condition that was sometimes tied to arts council funding regulations. Many co-ops had an education and outreach mission, providing technical and creative workshops for people in the community, and in some cases outreach to children, seniors, or other overlooked groups in the community. Workshops might function like feeder programs, leading people excited by film into the other co-op activities.

Co-ops might also partner with other ARCs, community arts groups, libraries, and high schools, colleges, and universities in developing programs. For example, the CFMDC produced media literacy study guides for high schools, with staff promoting films at teacher conferences. In 1992, *Through a Filmmaker's Eyes: A Guide to Teaching Film in Media Literacy* was produced with Ellen Besen writing about animation, Keith Lock about documentary and narrative, and Barbara Sternberg about experimental film.[148] Other distributors, co-ops, and festivals prepared educational materials and programs directed to all levels of children's education.

Production co-ops, especially those in regional centres, might also arrange screenings of member work.[149] The politics of programming—whose films get chosen and why—made co-ops sometimes favour the *open screening*, a highly ecumenical approach to exhibition akin to open mike music, spoken word, or comedy performances. Open screenings ensured that anyone with a film print theoretically had a chance to get

their film screened, largely removing the pressure to select (and thereby exclude) films and filmmakers from a screening. But open screenings are notoriously unpredictable, allowing for the possibility of audiences either discovering gems or sitting through mediocre films by sincere but inexperienced beginners. There is nothing like the excitement of a great open screening, and nothing like the tedium of a bad one.

Another important function that both production co-ops and distributors served was publishing, part of the network of discourse crucial to an artistic ecosystem. While a few co-ops have published books, the vast majority of co-op publishing output is ephemeral: a rich trove of newsletters, magazines, program notes, memos, and catalogues, all of which form a vital if only sporadically archived history of independent film culture in Canada.[150] A typical co-op newsletter might include filmmaker statements and interviews, co-op meeting minutes (showing points of conflict and co-operation), notices of workshops, screenings, grants, and organizational developments, and photos. Even the most prosaic of newsletter material provides clues as to the texture and culture of experimental film groups. A few examples of co-op publications (some continuing, most sporadic) include *Splice* (est. 1977, Saskatchewan Filmpool Cooperative), the longest running co-op newsletter in Canada; *Independent Eye* (1979-1991, CFMDC); the *Moose* (1981, 2007, Winnipeg Film Group or WFG); and *FilmPrint* (2005-2007, Liaison of Independent Filmmakers of Toronto or LIFT). Low-budget zines included several produced by Alex MacKenzie's Blinding Light!! Cinema and the Innis Film Society's (IFS) *Spleen* (1989-1990), a multiformat magazine (including a sealed envelope and a cassette tape in a Ziploc bag) that complemented IFS's baroquely layered program guides, notable for their wilful obscurantism.

It is important to remember that experimental film was rarely the central focus of most Canadian film co-ops; rather, their activities are devoted broadly to independent cinema, and only in some cases (or just for some periods of time) dedicated to experimental film. As McCann puts it, "For some, the centres provided an entry into the film and television industry; for others, they facilitated and continue to facilitate the freedom to work independently and/or in opposition to the industry."[151] Indeed, it was often battling over what truly constituted experimental (or avant-garde) film that created conflict in the histories of these institutions. For example, the Toronto Film Co-op, established in 1971 out of the enthusiasm for experimental film that peaked in Cinethon in 1967, had disbanded by 1978, torn between those members devoted to experimental film and those "people wanting a stepping stone to the mainstream of the industry," in the words of Tom Urquhart (a Toronto Film Co-op member who became vice-president of experimentally oriented the Funnel in 1977).[152]

Gruben points to the same tension, influenced by the dependence of co-ops on government grants: "The government wants an equitable and democratic access to the means of production, so that everyone can make work, so that people who have nothing

in common can all enter, and that's the tension within the co-ops. Everyone gets to belong, but some use it only for equipment on their way to making industrial films, while others want to work in a more artisanal fashion. These different factions are forced to work out their differences in order to gain access to equipment and funding."[153]

Although the history of each co-op is singular, and they have varied widely in lifespan and vitality over the last fifty years, it is safe to say the institutions that have survived have been those most open to all types of film- and media-making, and have been organizationally stable enough to continue to earn support from CCA and other government funders. For example, although the CFMDC is the bedrock co-op and largest distributor for Canadian experimental film, it has always distributed drama, documentaries, and animation; over the decades it has adapted to many changes in the sector (including now distributing non-film digital formats).[154] Organizations with prescriptive mission statements were less likely to adapt to changes in the cultural (and funding) landscape. One of the basic elements of production co-ops is that, as part of the ARC ethos, artists' organizations should fundamentally serve the interest of artist members. What this bottom-up form of organization means is that if we want to understand the changing definitions of independent and experimental film, the co-ops are a reliable barometer of the changes in cultural pressure. For example, under CFMDC leaders Deirdre Logue and Lauren Howes, the promotion of LGBTQ2+ films expanded, and numerous curatorial/preservation projects allowed for the creation of CFMDC Special Editions for artists like Christina Battle, Jack Chambers, Wrik Mead, Michelle Mohabeer, and Joyce Wieland.

One struggle in these organizations arises in the dynamic between sometimes polarizing leaders and the ethos of shared co-operative and even collective energies. True collectives often don't endure; some co-ops can be sustained by the energies of one individual and brought to ruin by the same person. Cecilia Araneda describes another issue specifically in regional organizations where the co-op is (almost) the only game in town:

> As I've travelled across the country over the years visiting different film production centres, I've come to understand that internal arguing—for better or worse—is an extremely common trait among them. This struggle is created because the central impetus that precipitates the need for these centres is largely logistical: a proportionally significant number of filmmakers in need of resources live in a similar geographic area. While this creates a viable need, there are very real differences that exist among these filmmakers, which include the more obvious things, such as the genres and forms they work in; and the less visible things, such as the ways in which some personalities just don't mix well.[155]

Another tension lies between the local and the national. Co-ops have the burden of attending to local and/or regional needs while being simultaneously aware of the changing conditions set by national and international contexts that affect provincial and federal arts council funding, technology, and legal frameworks like censorship and copyright. These shared experiences during the 1970s led to the formation of a national organization in 1980, the Independent Film Alliance du Cinéma Indépendant, now the Independent Media Arts Alliance/Alliance des arts médiatiques indépendants (IMAA/AAMI). Film co-ops emerged as part of the wider development of ARC culture in Canada. When CCA was established in 1957, its mandate was "to foster and promote the study and enjoyment of, and the production of works in, the arts" as a government organization with "public accountability."[156] The ARCs that formed in the 1960s and 1970s were centred on artists' needs, fighting for freedom of expression and the rights of artists to ownership and recompense, while also serving as organizations that brought artists together as communities (if sometimes fractious ones) and advocated in legal and funding matters at the local, provincial, and national level.

The first major national artists organization was CARFAC, founded in 1968 by Jack Chambers, its first president. Chambers, along with Greg Curnoe, Ron Martin, Kim Ondaatje, and Tony Urquhart, were part of the first Canadian Artists' Representation (CAR) executive. The organization took on a bilingual acronym CARFAC (Canadian Artists' Representation/le Front des artistes canadiens) in 1971 in order to advocate at the federal level. Its innovation of establishing minimum fee schedules delineating recommended rates to compensate artists continues to be the standard in Canada. In 1975, "Canada became the first country in the world to pay exhibition fees to artists," guided by the CARFAC fee schedule. In 1988, the Copyright Act was amended to give artists "legal entitlement to exhibition and other fees" (in 1992, the federal Status of the Artists Act bolstered these rights).[157] The work of CARFAC and the wider context of ARC advocacy for artists' rights is an important background for experimental film in Canada, in which the status of film as an art form was and is still in flux, due to the popular association of film with mainstream movies, and its federal funding through Telefilm. Another national body that represented ARCs was ANNPAC/RACA (Association of National Non-Profit Artists Centres/Regroupement d'artistes des centres alternatifs), founded in 1976. Though the heart of its activity was visual art through galleries, it also encompassed film and video, and published a magazine six times a year, *Parallelogramme* (1976-1995), an invaluable resource charting artistic activity (edited by filmmaker Lynne Fernie for several years), and *MIX: the magazine of artist-run culture* (1995-2007).[158]

The history of IMAA reflects many of the issues and conflicts facing film co-ops that arose from the 1980s through to today. Originally an umbrella organization of film groups formed to advocate in a unified voice to government funders, the Independent Film Alliance quickly incorporated video, becoming Independent Film & Video Alliance

(IFVA) in 1984; in 2002, it adopted its current name, Independent Media Arts Alliance, since it also included audio art and new media groups.[159] At its founding in 1980, regional clashes were paramount: "Quebec felt a national association could not represent their interests, the Prairies were for it, the Pacific didn't support it, and Ontario reps like [Bruce] Elder felt it would be 'irresponsible' given the costs it would incur. The Atlantic region had a broader view."[160] Sensitivity to these disagreements led the organization to adopt a flexible big tent mandate and avoid top-down initiatives that would alienate regions or media groupings. In addition to production co-ops, IMAA also includes distributors, festivals, and other associations, and has grown from around 12 member groups in 1980 to 45 in 2000 to over 100 in 2020, serving "over 16,000 independent media artists and cultural workers."[161]

In some ways, the vitality and stability of regional co-ops is a testament to their necessity outside major cities, especially for exhibition. Experimental film has historically flourished mainly in large urban centres in Europe and North America, making it an urban cultural phenomenon. In Vancouver, Toronto, and Montréal, there is little problem in finding and defining experimental film because there is a large enough film exhibition culture that one can differentiate mainstream venues (Famous Players or Cineplex) from art and/or underground film societies and/or programming series (historical examples include Blinding Light!! Cinema, 1998-2003, in Vancouver; Pleasure Dome, est. 1989, in Toronto; or VISIONS, est. 2014, in Montréal). Large cities generally have a major art gallery and/or an alternative cinematheque (sometimes affiliated with a film society) with film/video screening space (and audience). However, screening spaces and festivals in major cities compete with a multitude of cultural and entertainment options, which often disperses the experimental media community. Conversely, the reduced scope of cultural offerings in smaller centres helps bring the community together and integrate media arts with other artistic and cultural audiences.

Clint Enns at Video Pool, Winnipeg, 2010 (Lindsey Bond)

While government-supported co-ops and ARCs are a crucial piece of experimental film infrastructure in the history of Canadian experimental film, the history of more informal organizations established and run by artists but often without arts council support are also important. These "organizations" are often deliberately short term, informal, driven by the energies of the leaders and the communities they serve, and explicitly opposed to the bureaucracy incurred with arts council funding.[162] A good example is the Regional Support Network (2014-2017), set up in Toronto by filmmakers Clint Enns and Leslie Supnet as "a nomadic screening series started in Toronto, Ontario

out of a desire to show experimental moving images from other cities unmediated by a Toronto curatorial lens."[163] Explicitly challenging a "culture of moving image curation in Toronto," Enns and Supnet invited curators from outside Toronto to screen work. Other examples include Scott Miller Berry, Chris Kennedy, and Kathryn MacKay's no-budget screening series Early Monthly Segments (2009-2018); a highlight was a draw for donated used books, records, and other cultural goodies at the start of each screening.

Art galleries and museums

The art world of galleries and museums had a fitful relationship with experimental film in the 1970s and 1980s, as we have seen. This improved as film came under a media arts umbrella that had earlier covered video and electronic arts: since the 1980s, many experimental film and media artists have been trained in art schools, had their works screened and exhibited in art spaces, and received review coverage in art magazines such as *artscanada/Canadian Art*, *BlackFlash*, *Border Crossings*, *C*, *Parallelogramme*, and *Vanguard*. But the majority of experimental filmmakers in the 1970s and 1980s were overlooked by the art world in Canada, including the eclectic work that emerged from regional co-ops like the WFG or Atlantic Filmmakers Cooperative (AFCOOP). The divide also meant that some artists working with the film medium might be unknown to the experimental film networks of discourse, like John Massey's *As the Hammer Strikes* (1982), originally produced in 16mm film, an early example of a double-screen installation that details a real-time conversation between the artist and a hitchhiker he picked up in Southern Ontario. Meanwhile, experimental film is almost completely absent from histories of visual art in Canada. For example, a 2010 survey anthology, *The Visual Arts in Canada: The Twentieth Century*, states, "[T]he editors have limited the coverage to media uses in ways that have traditionally been contained by the umbrella of the 'visual arts.' For example, discussion of film is restricted to the use of that medium in conjunction with sculpture/installation work by artists such as Rodney Graham and Stan Douglas, whose practice is less that of movie-making per se than of gallery-oriented production."[164]

Although they acknowledge that these categories are "porous," the operating binary of gallery installation and "movie-making per se," that is, commercial feature narrative production, ignores the tradition of experimental filmmaking conducted at an artisanal scale. In light of the massive penetration of moving image and sound into galleries and museums in the last two decades, maintaining the historical art/film separation impoverishes both art history and film history. Moreover, such a distinction would separate artists like Janet Cardiff and George Bures Miller, Geoffrey Farmer, Rafael Lozano-Hemmer, and Althea Thauberger—who work in many media forms, including film, video, and digital media—from the tradition of experimental film when they were influenced by it (even as they engaged much less with artisanal modes of production and largely avoided co-op distribution).

There were exceptions. Barbara Sternberg curated exhibitions that combined visual art and film at the Dunlop Art Gallery in Regina and at Wynick/Tuck in Toronto, and her films were part of art exhibitions featuring the work of women artists (e.g., at MSVU [Mount Saint Vincent University] Art Gallery and Struts Gallery, an ARC in Sackville, New Brunswick). Some ARCs screened experimental films as part of exhibitions or would run a screening of a touring program from distributors like CFMDC. The 1982 *OKanada* exhibition in Berlin, sponsored by CCA, Akademie der Künste, and the Canadian Department of External Affairs, included a program of experimental films curated by Bruce Elder alongside a wide range of media, including painting, sculpture, architecture, video, and performance. The catalogue also included essays on narrative, documentary, and animated film along with music, dance, theatre, and literature; perhaps only in such a pan-arts exhibition would experimental film have a place.[165]

In *Dislocations*, a catalogue celebrating WFG's twentieth anniversary in 1995, Gilles Hébert suggested not only how WFG was out of the art loop but also how the division between film and video—so conspicuous during the 1960s, 1970s, and 1980s—was reflected in the preference for video in the art market:

> The Winnipeg Film Group was started by a group of Manitobans with no local access to film training, equipment, or funding. Over the years, the organization has grown into one of the largest film co-operatives in the country, creating a need, developing talent, and leading the public sector into investing considerable resources in the production and dissemination of a cultural product which is ever more limited by shrinking means of dissemination. Eclipsed to a great extent by video/inter-media culture which is found in more museums and art galleries, film as a personal, independent artists' tool continues to thrive in places like the Winnipeg Film Group.[166]

Some experimental film and video art aspired to a low-tech, anti-hip focus, closer to the garage than the art gallery. Filmmakers continued to celebrate the "hands-on" low-tech quality on analog media, seen in the rise of hand-processing in the 1980s and 1990s, achieving effects more immediately difficult to achieve with video.

A typical and illuminating example of the relationship between experimental film and the art world in this period was a film series at the Kitchener-Waterloo Art Gallery that ran sporadically from 1982 through 1986. The last event was appropriately titled *Practices in Isolation: Canadian Avant-Garde Cinema*, and included films by many of the major film artists working in the 1980s: Chambers, Elder, Hoffman, Razutis, Snow, Sternberg, and Wieland. The series was curated by another prominent experimental filmmaker, Richard Kerr, whose introduction to the catalogue reflects on the gap between film and art worlds. In it, he notes that, comparatively, by having four programs

of screenings over four years, "the Kitchener-Waterloo Art Gallery's programs are the longest running of any public gallery in Canada."[167] Kerr asks, "Why has Canadian avant-garde cinema been historically ignored by galleries and art journals?"[168]

> The reputation of our true film artists on the international front confirms the strength of our work. The obscurity of our film artists in Canada is tragic. The working situation in Canada for our film artists is equally tragic. But this has never halted production, only stunted its growth. Many promising artists have had to abandon this independent mode of production not just for lack of stipend, but rather for lack of recognition within the art community.[169]

Elaborating on the effects of "lack of recognition," Kerr notes the importance of critical writing to the visibility of experimental film:

> Without the insights and statements of the critics, our film artists would continue to work out of a theoretical void and thus be disadvantaged in comparison to artists working in the other visual arts. Historically art movements have been championed by critics and writers. This, in my opinion, has been the Achilles heel of the Canadian avant-garde cinema: lack of strong critical writing. Only in recent years with the writing of Elder and Bart Testa in Toronto, Tony Rief in Vancouver, and others has avant-garde criticism begun to emerge with the presence of the other visual arts.[170]

Program booklet for *Practices in Isolation: Canadian Avant-garde Cinema*, curated by Richard Kerr, Kitchener-Waterloo Art Gallery, 1986

Kerr correctly identifies another separation between experimental film and the art world, in the gap between art history/art criticism and the comparatively low status and smaller volume of publications in film studies (a relatively young academic discipline in the 1980s) and film criticism (almost wholly concentrated on narrative feature film). As mentioned above, video art in Canada has been better documented, partly due to its closer proximity to the art world and its publishing arms; because video art is exhibited in galleries, the likelihood of an accompanying exhibition catalogue is much higher than for an experimental film screening series. Some Canadian general arts writers might

AGO publications (clockwise from top left): *Spirit in the Landscape* by Bart Testa, 1989; *David Rimmer: Films & Tapes, 1967-1993*, by Catherine Russell and Kathryn Elder, 1993; *Presence and Absence: The Films of Michael Snow, 1956-1991*, ed. Jim Shedden, 1995; *Richard Hancox*, ed. Catherine Jonasson, 1990.

cover experimental film as part of a wider film review or arts review portfolio, and some filmmakers, curators, and university faculty wrote for arts or popular press, but there are few books or journals specifically devoted to experimental cinema.[171]

A handful of publications, including film retrospective and exhibition catalogues, were published prior to the 1990s, including Bruce Elder's *Image and Identity*. Bart Testa published a number of important essays, including *Spirit in the Landscape*, and the Canadian Encyclopedia entry on Canadian Experimental Film.[172] Cinematheque Ontario published monographs on the films of Joyce Wieland and Jack Chambers, while the AGO published exhibition catalogues on Michael Snow, Rick Hancox, and David Rimmer, in addition to the catalogue for the 1989 International Experimental Film Congress. Much of this writing concentrated on film interpretation, charting aesthetic patterns across an artist's work in relation to their milieu. Mike Hoolboom has published many books, including interview collections, microhistories, and personal reflections (e.g., *Plague Years: A Life in Underground Movies*), and his website is a treasure trove of historical information.[173] A number of ARCs have published histories of their activities, which expand to include wider experimental film and video art histories.[174]

Experimental film and the academy

From the 1960s through the 1990s, most experimental films were screened in classrooms, mainly in colleges and universities, but also in secondary schools and continuing education spaces. As Mike Hoolboom stated in his capacity as experimental film officer at CFMDC, university film rentals were "the bread and butter of the artist's film," making the academy one of the crucial institutions for Canadian experimental film. Film began to be taught in universities in the mid to late 1960s, and film departments were established in the early 1970s, which parallels the simultaneous rise of film co-ops and other ARCs.[175]

The university lacks the cultural capital of the art world: many filmmakers would rather put a museum screening than a university classroom screening in their CV. Schools also tend to be ignored in experimental film histories because, although the majority of filmmakers were first exposed to experimental film and media art there or had formal training in film and media, college is a way station, not the destination in most artists' careers. Yet, the pervasiveness of the academic context is remarkable. For example, at a 2017 AGO screening, "CFMDC Presents: Personal Perspectives 1971-79," the discussion among Janis Cole, Bruce Elder, Barry Greenwald, Michael Kennedy, and Scott McLaren revealed that all of the films screened were made with friends or people they knew in relation to university, whether they were studying film or involved in a campus film society or film club.[176] Universities served as de facto film co-ops in which students were exposed to experimental films in their film and media classes, or even took courses devoted to experimental cinema and media art. University film clubs and

academic programs are intellectual and social spaces for the production and exhibition of experimental film, with low stakes and an open invitation to experiment and take chances.

Universities also provide steady employment for some filmmakers, whether as faculty or technical staff, and provide access to equipment, academic grants separate from CCA and other arts councils, and student and/or colleague crews and assistants. SFU in the 1970s was a good example of a volatile but powerhouse hub for experimental film activity providing space and resources for collaborative film and media art making—and intense debate. Al Razutis embodies the contradictions that universities pose to experimental arts. On the one hand, he argued for alternative cultural structures, his formulation reflecting a common fear of universities institutionalizing alternative culture: "Alternative screenings are a necessity if the avant-garde is to resist being institutionalised by the government, grant agencies, commercial interests, etc....including the university!"[177]

On the other hand, Razutis recognized how his university employment was a way to use larger social institutions for radical purposes to set up alternative institutions:

> I have always (post 1977) argued for avant-gardes of disruption (of norm), ones that are dedicated to social and cultural change. So what the hell was I going to a university for? Well, I thought it would be possible to operate in this position from a university....For a while it worked; I used university funds to bring in visitors, films, used university facilities to make my own films (after the student work was completed), encouraged the production and study of experimental and avant-garde film and worked to increase faculty numbers....What did this mean for avant-garde film? During this time period (1978-1987), a marked increase in experimental and avant-garde filmmaking occurred in Vancouver, a number of screenings were held, graffiti everywhere, publications and debates, Cineworks was created, CFDW was created as a result of Toronto's centrist policies, and a lot of new ideas and expressions were seen....I'm not taking credit for everything but in all honesty must say that my strategy of turning to a university (for all its shortcomings and conservative attitudes it still has most of the $$) as a base of support was a necessary decision-move.[178]

Another effect of colleges and universities is to feed eager, trained people into other film and art institutions, whether collaborating on events or providing trained graduates (and some drop-outs) as co-op members or staff. Just as SFU was important for the Vancouver scene in the 1980s, York University was a feeder for festivals and screening series personnel in the 2000s, as student and alums became staff and board

members at organizations like aluCine, CFMDC, Pleasure Dome, and Toronto Reel Asian International Film Festival. Similarly, at different times, students, alums, and faculty at Concordia, Nova Scotia College of Art and Design (NSCAD University), Ontario College of Art and Design University (OCADU), Queen's, University of Regina, Western University, and other schools have fed into local community film and media activities.

Another important contribution of the academy, though more indirect, is to function as a source and conduit for the theoretical discourse that influenced filmmakers at different points in experimental film history. In the 1960s, the writings of John Cage, Buckminster Fuller, Allen Ginsberg, and Marshall McLuhan opened up utopian counterculture horizons. In the 1970s and 1980s, a heady mix of feminist film theory, semiotics, Marxism, structuralist and post-structuralist philosophy, and post-colonial theory influenced many filmmakers, many of whom literally included text, both written and spoken, into the textures of the films. As more and more experimental filmmakers came to film from university programs, their undergraduate and graduate reading became a baseline intellectual and creative formation, even as some would dialectically reject or at least question theoretical and philosophical doctrines.

Experimental film and censorship in Canada

Compared to arts councils, co-ops, and colleges, censor boards may seem a strange institution to consider in relation to the development of experimental film and media in the 1970s and 1980s. But censorship was a major factor, in terms of both the energies wasted in fighting it and its galvanizing force unifying (though sometimes dividing) the artistic community.[179] Indeed, a censor board might seem like the flipside of public support for the arts. Some might argue that, in light of government funding for the arts, it should bow to "community standards," usually code for conservative mainstream values. The overwhelming counterargument voiced by ARCs, and in colleges and universities, was for the value of artistic freedom, and its larger social and cultural benefit. One major function of experimental film and media is to provide communities with a medium to express themselves through alternative means. Experimental film, video, and media art was and is a mode of expression and articulation adopted by feminist, LGBTQ2+, racialized and Indigenous communities, who could access the artisanal and collective mode of production in independent film and media earlier than they could mainstream narrative or documentary modes. In short, experimental film helped redefine the term community in "community standards" at a genuinely grassroots level.

Censorship in Canada is largely enforced on a provincial basis, although federal customs officials have blocked films, videos, and other media at the border due to charges of obscenity. Experimental film has been central to many censorship cases,

including Hofsess's *Columbus of Sex* (1969), which was the first Canadian film charged with obscenity and was lost to Canadian film history due to its seizure by Ontario courts in 1970.[180] Taryn Sirove argues that Toronto's experimental film theatre the Funnel (est. 1977) bewildered the Ontario censorship authorities; as David Poole says, "[I]t was the first time that the government was dealing with a theatre that was dedicated to artists' [film] work [and coming up against] the position of the art community around film work."[181] Ontario saw the most tumultuous legal battles during the 1980s (which also witnessed the start of the culture wars in the US), as films like Snow's *Rameau's Nephew* (1974) and Razutis's *A Message From Our Sponsor* (1979) (also banned in Alberta) were suppressed by the Ontario Censor Board.

In 1982, the Ontario Film and Video Appreciation Society (OFAVAS), led by Anna Gronau, Cyndra MacDowell, and Poole, was formed out of the previous Film and Video Against Censorship organization to mount one of the first Canadian Charter of Rights and Freedoms–based challenges; it attracted massive support from the Ontario and larger Canadian arts community.[182] In April 1985, the Ontario Open Screenings: Six Days of Resistance Against the Censor Board protest was organized. After a series of court battles (mostly won by arts organizations) and counter-legislation by the Ontario government, a compromise was reached when exemptions for arts organizations were introduced in 1988, which permitted them to adopt an adults-only policy that restricted screenings to audiences nineteen years of age or older (of even the most innocuous work) without requiring submissions to the board. As Sirove writes, a persistent question for experimental film organizations thereafter was whether to submit films for approval and classification (an expensive and time-consuming activity) or restrict audiences to nineteen-plus, which was the easiest route but stuck in the craw of an artistic community dedicated to free expression. Different institutions took different strategies of resistance. Some festivals, like Images Festival, complied but under protest. Poole, then working at the CFMDC, put notes in film cans explaining that the films were never submitted to the censor board. In 2005, Linda Feesey of Pleasure Dome and Roberto Ariganello of LIFT spoke in the Ontario legislature protesting amendments to the censor board legislation, announcing that their organizations operate illegally.[183] Censorship regulations were arbitrarily enforced.

It is difficult to comprehend the energy and resources expended by the experimental film and video art communities fighting censorship in this period and after. While the activities of OFAVAS and anti-censorship events like the Ontario Open Screenings brought many artists and arts organizations together, they also created conflicts, as Sirove observes, between urban and regional ARCs, and generated resentments over the compromises some organizations made based on choosing whether to resume operations or die on the anti-censorship cross. The final irony was that despite the high-minded

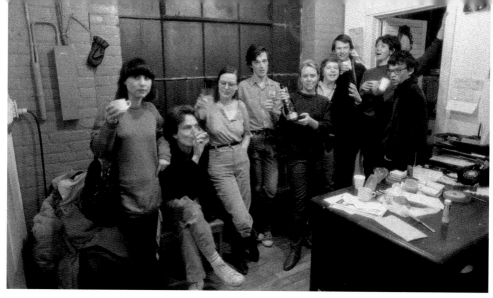

OFAVAS celebrates partial victory over the Ontario Censor Board at the Funnel, March 25, 1983.
L to R: Edie Steiner, David Bennell, Caroline Wuschke, Ross McLaren, Michaelle McLean,
Martha Davis, David Poole, Mikki Fontana, Jim Anderson (John Porter)

rhetoric of the Ontario Censor Board (later the Ontario Film Review Board) about protecting "community standards" of decency, the Conservative Ontario government of Doug Ford terminated the board in 2019 because it was losing money.[184]

1989: Tipping Point for Transformation into the 1990s and Beyond

Experimental film reached a crossroads by the late 1980s. An economic downturn was causing concern in the cultural sector, and the North American Free Trade Agreement being negotiated by Brian Mulroney's federal Conservative government prompted a defence of government funding for "cultural industries." In times of scarce resources, the danger of in-fighting dividing the media art sector was a real threat, recognized by Lisa Steele during her term as president of IMAA: "As we enter 'the Year of the Deficit,' we would be wise to remember that as independent film and videomakers, our boat is a small one, we may be tempted to turn on each other, to allow some to perish so that others can merely survive. This would be a grave tactical error. Our only strength is in our numbers. Our only effect comes from collective action."[185]

This sentiment did not stop IMAA from attacking Telefilm, the industry-oriented organization that had failed (at least to that point) to make Canada into Hollywood North. In the words of experimental filmmaker and subsequent IMAA president Ross Turnbull: "We must look forward to changing the attitudes of the powers that be, of forcing a recognition that throwing money at the creation of pseudo-Hollywood shit is no way to build a strong 'industry.' Only by fostering an environment where film and

video artists can work through their notions of what it is to live and create in this country will we see strong distinctive time-based art that is clearly identifiable as Canadian."[186]

Through the 1980s and 1990s, the NFB became more conservative in the face of funding cuts (by the mid-1980s its funding was half what it was in the late 1960s); artists seeking to make experimental films and media turned to CCA as the main grant source, which intensified the inter-media politics of CCA funding categories and budgets. In this period, throughout Canada and the US, many predicted the death of experimental film, and of film in general (a death knell which continues to toll despite evidence to the contrary).

The rise of MTV in 1981 (and its Canadian version, MuchMusic, est. 1984) popularized music videos, some of which appropriated experimental techniques like montage, image processing, and found footage. Many music videos were made by the generation of art school graduates who had seen experimental films in classes—and indeed some experimental filmmakers embraced the form as both art and employment (e.g., Conner, Kerr, Torossian). But MTV made some forms of experimental film seem mainstream, undermining its political, avant-garde claims. Debates over American cultural imperialism, anxieties about popular culture (not new but increased in pitch), and the real effects of creeping neo-liberalism (in the decade of Ronald Reagan in the US, Margaret Thatcher in the UK, and Mulroney) on the economy and civic structures all created a sense of crisis, coming to a head in 1989.

Mike Hoolboom's 1988 report, "Artist's Film Distribution in Canada: Some Thoughts About," filed in his capacity as experimental film officer of CFMDC, summarizes his bleak view of the prospects for experimental film exhibition:

> Conclusions: Festivals are nice for exposure but they cost money, materials come back damaged and often require that EXTRA print no one seems to be able to afford. Most people in the [CFMDC] collection have one print here. The most enlightened of TV programs is showing very brief excerpts, our theatres are run by Americans as well as our film press. Our major galleries are not providing the substantial support we need, the artist run centres are poor and not all that interested in film, the co-ops are mostly producing work [as opposed to exhibiting it] and mostly interested in non-experimental work anyways; our work is too difficult for the high schools who may have no $ to buy work in any event and the universities have money to rent but hardly any to buy. So where do we go from here?[187]

For Hoolboom, what he called "the appallingly low level of distribution/visibility" of experimental film meant that distribution co-ops like the CFMDC were on "life support," needing a boost to survive, let alone to thrive. Yet, this doom-and-gloom rhetoric may

have arisen in part from a recognition of unfulfilled potential earned through the advances that experimental film had seemed to make gradually during the 1970s and 1980s: they started with the establishment of what would become IMAA in 1980, but also through slowly increasing recognition from the art world and the growing field of academic film studies.

Bruce Elder was a vital if controversial figure in the 1980s whose prodigious energy brought experimental film recognition by major art, literary, and film cultural institutions, and provoked reaction through the increasingly strong stances of his aesthetic and philosophical approach. In the early 1980s, Elder published widely in publications as varied as the academic journal *Ciné-Tracts* (1982), textbook *Take Two* (1984), art magazine *Parachute* (1982), and trade journal *Cinema Canada*, which published a special supplement, "The Photographic Image in Canadian Experimental Film," in 1983. Elder was the first writer to propose a critical paradigm that unified a certain body of films, based on the importance of the photographic image for Canadian experimental filmmakers in relation to modernist and then emerging post-modern aesthetics. Like P. Adams Sitney's influential book *Visionary Film* (1974), which proposed a tradition of American film based on Emersonian romanticism, Elder's paradigm focused on some filmmakers (e.g., Chambers, Epp, Hancox, Rimmer, and Snow) and inevitably excluded others. In 1985, he issued a controversial manifesto, "The Cinema We Need," in *Canadian Forum*, a national literary magazine, which led to intense debate with other prominent figures in Canadian film culture: Piers Handling, Peter Harcourt, Geoff Pevere, Michael Dorland, and Testa.

While polemically effective in putting experimental film into the national conversation with dominant traditions of documentary and narrative, Elder's approach was explicitly narrow, dismissing narrative as being "the artistic structure of technocracy," and opposing then emergent New Narrative work, which had been blurring boundaries between experimental and narrative form, and artisanal and industrial production modes.[188] Elder's influence was also felt as a film programmer, selecting films for six programs at the massive *OKanada* exhibition in Berlin (1982-1983) and also the experimental films chosen for the 1984 retrospective of Canadian film at TIFF (then Festival of Festivals).[189] Canons are often strategically important in order to infiltrate major cultural institutions like museum collecting and classroom syllabi, but unless they are flexible and open to change, they can quickly become impediments to cultural, educational, and artistic development.

As Elder was making waves, other developments were also keeping experimental film culture active. As mentioned above, Barbara Sternberg had a regular column in *Cinema Canada* magazine (1985-1989), "On (Experimental) Film," its parenthetical framing of the word "Experimental" a sign of its uncertain status in the industry magazine. She also invited guest columns by writers like Hoolboom, Catherine Russell, and Leila Sujir.

In 1987, Sternberg noted the increase in the number of screening venues in Toronto, as experimental films were being shown at Royal Ontario Museum, Harbourfront, and IFS along with the Funnel and the AGO, and that festivals were screening selections of documentary, narrative, and experimental films together.[190] Joyce Wieland had a major retrospective in 1987 at the AGO that included her experimental films.[191] Sternberg also noted that filmmakers like Hoffman, Longfellow, and Gary Popovich were winning prizes at international festivals; external ratification was especially important to an insecure arts sector. Hoolboom, meanwhile, contributed to the change he called for by publishing a series of experimental film-intensive issues of the *Independent Eye* between 1988 and 1991, and has continued to be a major force in experimental film distribution, exhibition, and publication—in addition to his own prolific film and media art production.

There were many reasons that 1989 was a momentous year. Several events marked massive changes in geopolitics, including the Tiananmen Square Massacre in China on June 4, 1989, and the fall of the Berlin Wall on November 9, 1989. Two events dramatized long-standing issues: the Exxon Valdez oil spill on March 24, 1989, pointed to environmental degradation, and the Montréal École Polytechnique massacre on December 6, 1989, was a devastating index to the continued gendered violence that women suffered, including in academic spaces.[192] Other, quieter events would have direct consequences for experimental film and media in coming decades. Advances in technology included the invention of the World Wide Web (www) by Tim Berners-Lee and, in digital video, the development of H.261, "the first viable digital encoding standard for video."[193] Concurrently, David Yencken coined the term "creative city" to describe how the arts (including film and media) were central to urban economies.[194] In this ferment, three events in Canadian experimental film and media history in 1989 bear examination for how they embody changes and tensions that would transform and expand the sector into the twenty-first century: first, the International Experimental Film Congress, second, the establishment of the Images Festival, and third, the In Visible Colours conference in Vancouver.

International Experimental Film Congress

A major screening exhibition at the Art Gallery of Ontario, *Spirit in the Landscape* (with an accompanying catalogue by Bart Testa), toured many Canadian cities after its first run in Toronto in 1989. This followed the 1988 AGO exhibition *Recent Work from the Canadian Avant-Garde.*[195] Curatorial energy and institutional momentum, complementing the activities of Elder and Sternberg mentioned above, led to the organization of the International Experimental Film Congress in 1989 by a team that included Kathryn Elder, Catherine Jonasson, Doina Popescu (Goethe-Institut), Sternberg, and Testa, with Shedden as coordinator; Bruce Elder had been involved in the early planning. The event

was sparked in part by US film critic Fred Camper's 1986 polemical article announcing the "Death of the Avant-Garde," which mourned the loss of an individual expressive cinema to forces of institutionalization (including from art and film schools), but the congress was also self-consciously attempting to revive a tradition of international experimental film events that extended back to the Third International Avant-Garde Festival in London in 1979.[196] The congress organizers showed great ingenuity in fundraising large grants from every level of arts council, and smaller donations from multiple departments at three universities, several national ministries, and even the IMAX Systems Corporation.[197] It was a week-long event with practicums, curated and open screenings, panel discussions, and critics' sidebars, with visitors from Brazil, Canada, France, Germany, the Philippines, UK, and US, including major artists and curators like Bold, Brakhage, Simon Field, Birgit Hein, Pat O'Neill, Rimmer, Carolee Schneemann, Snow, Joao Luiz Vieira, and Wieland.[198] Presciently, the congress paid attention to issues of film archiving, which would intensify in future decades.[199]

No good deed goes unpunished. The most vocal reaction to the congress was highly critical, and included a protest manifesto, "Let's set the record straight"—although, since it was issued before the congress even took place, many of its complaints were unfounded. But the fact of the manifesto was a symptom of many pent-up frustrations in the sector and issues with congress planning visible to those excluded from it.[200] As William Wees notes, "The accuracy of its charges against the congress is less important today than its attempt to articulate—in aggressive, manifesto rhetoric—the ambitions, priorities and allegiances of the generation of experimental filmmakers who came into their own during the 1980s."[201] Some of the criticisms of the congress objected to the fact that it was more academic and historically retrospective than artist centred and forward looking, favouring the weight of a particular modernist aesthetic tradition more than the wider aesthetic and political concerns and structural problematics of a new generation.

Interestingly, the seventy-six people who signed the protest manifesto, "Let's set the record straight," were themselves symptomatic of the even deeper issues facing the experimental film community that would need to be addressed in the 1990s and 2000s. They were all North American, almost completely White, and the principles of complaint were mainly generational in nature, rejecting what it called the "Institutional Canon of Master Works of the Avant-Garde" in what was also a contradictory plea: I am marginalized by your institution; why wasn't I invited? The real cultural shifts that would re-energize experimental film after 1989 happened when experimentation in film opened up to multiple media (rejecting the film purism that, already strong in the 1970s and 1980s, would reach death-throe intensity in the 1990s); to multiple forms (re-embracing narrative, documentary, and whatever other form an artist found interesting); to popular culture (especially in the revival of the already strong found footage tradition in the 1980s and 1990s, now embracing television and music video);

International Experimental Film Congress, the Rivoli, 1989 (Bill Stamets)

and most importantly, to people whose identities were even further marginalized by dominant culture than experimental filmmakers: women and persons with non-binary gender identities embodying the full range of sexual expression; Black, Asian, and especially in Canada, South Asian persons with cultural heritages that included the complexities of first-, second-, and subsequent-generation immigrant communities; and Indigenous film and media artists. The unbearable Whiteness of Canadian (and American) experimental film was due to be challenged.

The concluding line of the manifesto was half right: "The Avant-Garde is dead; long live the avant-garde." The canon that had accumulated by 1989 needed revision, but the older generation of artists identified with the Avant-Garde—Brakhage, Frenkel, O'Neill, Schneemann, and Snow—continued to make challenging work for decades.[202] Indeed, in the 1990s and after, Schneemann finally enjoyed her due after being excluded from the film and art worlds due to sexism and because her insistence on embodied sexuality had made some art critics nervous. Perhaps the congress's major success was in dialectically sparking a resurgence of experimental film energies as a giant fuck-you to Camper's already controversial assessment of the state of the field. What emerged from the 1990s onward was not a new programmatic avant-garde but a flowering of experimentation with film and other moving image media too diverse to be corralled within earlier traditions of experimental film. The event seems to have helped provoke a generation of new filmmakers into new activist energies in exhibition and production, as the visibility of Canadian, American, and global experimental cinema increased during the 1990s.

The Canadian Avant-Garde program, 1988

Images Festival

But we should not give the event of the congress too much weight: the activist energies that exploded in future decades were simmering throughout the late 1980s, particularly in the video art, documentary, and emerging new media communities. The divide between the experimental film and video art scenes in Canada began to narrow at the end of the 1980s, first through their coexistence in organizations like IMAA, in ARCs like A Space and FAVA (Film and Video Arts Society – Alberta), and in festivals like Canadian Images in Peterborough. The integration coalesced in the establishment of the Images Festival of Independent Film and Video (est. 1988), which became the largest media art festival in North America at its peak.[203] Marc Glassman wrote in the introduction to the inaugural Images Festival catalogue: "[T]he evolution of film and video art in Canada has progressed along separate paths. This has created a formal 'two solitudes' which we expect to help bridge."[204] The festival foretold the more pluralistic experimental film and media scene that emerged slowly in the 1990s, ultimately driven by the ways in which, at the level of production, artists began to employ digital media formats to combine (or render irrelevant the distinctions between) film and video.

The Images Festival, or Images, is a barometer of the pressures on experimental film and media in Canada. A snapshot of the festival in 1988, 2000, and 2019 helps us gauge changes in the sector.[205] Images expanded from a weekend in 1988 to a ten-day festival with opening and closing weekends in 2000 but had contracted to seven days by 2019. Its catalogue expanded from twenty-four pages in 1988 to seventy-six pages in 2000; in 2019, the catalogue was ninety-eight pages, but in a booklet format half the page size of previous catalogues. A comparison of the festival sponsors listed in the catalogues reflects both continuities of institutions supporting experimental cinema and new developments. In 1988, sponsors included government bodies and arts councils (CCA, NFB, Ontario Arts Council, Toronto Arts Council), distributors (CFMDC, DEC Films, Vtape), co-ops and galleries (A Space, AGO, Art Metropole, LIFT, Trinity Square Video), and local media (*Fuse*, *CineAction!* and *Public* magazines, alternative radio station CKLN). Purely commercial sponsors who took out advertisements in the catalogue included IMAX Systems Corporation, the Festival Cinema group (a Toronto repertory cinema chain), Pages Bookstore & Magazines, and a few other bookstores, bars, and craft shops. By 2000, Images enjoyed twenty official sponsors and its catalogue featured seventy-eight advertisers (including most of the sponsors). Government sponsorship remained constant with the addition of new sponsors Telefilm Canada and the Toronto Film and Television Office. Sponsorship increased from distribution and production co-ops, galleries, and festivals, and there appeared new festivals (such as Desh Pardesh, Hot Docs, and Inside Out Lesbian and Gay Film and Video Festival of Toronto) and new co-ops (such as House of Toast and Public Access). Universities, colleges, and private film schools formed a new category of sponsors.

The most substantial increase in sponsorship, however, was from the private sector, especially commercial distributors and studios (e.g., Alliance Atlantis Communications and Warner Bros. Pictures), television, and major film labs like Kodak, in addition to many small production houses. Other commercial sponsors ranged from expected sectors like alternative magazines, radio stations, bookstores, and restaurants, to less-expected sectors like couriers, breweries, and real estate agents. By 2019, government sponsors were the same, although instead of the NFB, the Ontario Ministry of Tourism, Culture and Sport signalled recognition that even the small-scale cultural sector had economic importance. The number of official sponsors shrank to sixteen, although new categories of Presentation Partner (fourteen) and Community Partner (twenty-five) made the total rise to fifty-five, while nearly one hundred organizations are thanked in the festival catalogue acknowledgements page, reflecting the general growth and diversification of the media sector in Toronto and nationally, and the growth of connections among these institutions. The Images Festival was attracting new audiences that included international festival participants and also the massively culturally diverse generations of people living in Toronto and environs.[206]

The programming also reflected the changing times. The 1988 festival consisted almost entirely of screenings in theatres; the 2000 festival had an Off Site component consisting mainly of video installations with some film sculptures and a film loop instal-lation by Adrian Blackwell and Kika Thorne. Student screenings, a regular feature, were divided between F is for Film and V is for Video, though this division was no longer oper-ational by 2004, shifting to S is for Student and eventually to a combined International Student Showcase screening. By 2019, the festival consisted of a heterogeneous mix of On Screen programs at multiple theatres showing film and digital media, Off Screen installations of a variety of experimental media, and also music, theatre, performance art, and online media, accompanied by the artist talks, lectures, and educational work-shops that had long been part of Images. The height of the festival's success was in part attributable to its foresighted abandonment of exclusive medium categories that limited Canadian experimental film in the early 1980s to embrace instead a pluralism that was open to a vast array of local, Canadian, and international artists experimenting with moving image media and sound.

This eclecticism also means that the festival is not restricted to experimental work but includes narrative and documentary, alongside programs organized around political and cultural themes, formal issues, historical perspective, student filmmaking, and individual film and media artist spotlights. It doesn't always work; experimental curation can be as hit-and-miss as any experimental film. But by being open to a broad range of low-budget, independent artist media, it avoids the self-defeating parochialisms that had embittered much experimental film discourse in the 1980s. Thematically, a survey of Images pro-gramming shows a consistent reflexive concern with cultural parameters of changes in

media technology, and a focus on gender, sexuality, and LGBTQ2+ issues. Since 2000 and especially in recent years, the festival has increased its focus on media and disability, colonialism and Indigeneity, racialized identity, ecological issues, and the effects of global economic inequality.

In Visible Colours: An International Women of Colour and Third World Women Film/Video Festival and Symposium

Another milestone in 1989 was In Visible Colours: An International Women of Colour and Third World Women Film/Video Festival and Symposium, a Vancouver event organized by Zainub Verjee and NFB's Lorraine Chan that brought issues of gender, racism facing BIPOC persons, and a much more ambitious international perspective to bear on the experimental and independent film, video art, and media art worlds.[207] Verjee summarizes the stakes of the festival, which presented over one hundred works made by women from around the world: "*In Visible Colours* has etched three defining markers: first, it foregrounded the histories of struggle of women of colour and third world filmmakers; second, it brought forth the issue of race to the second wave of feminism; third, it created a new alignment in the emergent global politics of the third cinema."[208] These markers were signposts for how more intersectional notions of identity would add complexity to film and media representation and expression, and to how a global perspective would literally expand the world considered by art and media.[209] As immigration accelerated the increasing diversity of Canadian society, especially in cities, "emergent global politics" would become central to experimental film and media's long history of exploring tensions between apparent centres and margins in society.

Within the world of Canadian experimental film and media, gender and sexuality had been elements of identity explicitly addressed by women, expressed in film and video art, and also in the feminist and queer institutions established in the 1970s and 1980s to combat sexism and homophobia. Canadian nationalism, usually expressed in reaction to US culture, was another theme and focus of cultural policy activism. In personal cinema from the 1960s through the 1980s, ethnic and racial identity was often submerged under the ostensibly liberatory rhetorics of 1960s counterculture. On the one hand, the 1960s questioned what Dwight Eisenhower called the "military-industrial complex" that led to excesses of Cold War politics (and its colonial violence) and consumerist capitalism: the counterculture released a remarkable freedom of artistic exploration, and personal exploration was also released. On the other hand, this critical approach and freedom were rarely extended to examine the counterculture itself, especially its casual devaluation of women, and the failures of inclusion of LGBTQ2+ artists, and Black, Indigenous, and other "visual minorities" (beyond occasional awkward appropriations and romanticizing of Black and Indigenous cultures). The rise of the women's movement, gay liberation, and anticolonialism in the 1970s came late to the Canadian arts scene

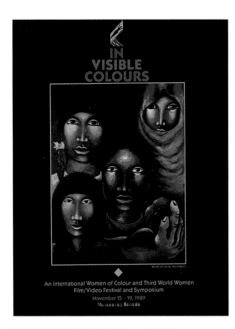

Poster for *In Visible Colours*, 1989

(Zainub Verjee Archives)

but sharpened focus through the 1980s and 1990s.

The 1990s constituted a period when euphemistic discussions of race by "well-meaning" White folks in Canada were confronted by writers like Dionne Brand. Monica Kin Gagnon quotes a pithy passage from Brand that both names the problem and the stakes: "Notions of access, representation, inclusion, exclusion, equity, etc., are all other ways of saying 'race' in this country. So it's made comfortable to talk covertly about race in this country without saying that we live in a deeply racialized and racist culture which represses the life possibilities of people of colour."[210] That Brand's words from twenty-five years ago remain pertinent in 2021 makes it clear that those in the arts and academic communities—myself included—are responding too belatedly to Black Lives Matter and Indigenous protests. Meaningful participation of BIPOC folks in experimental film and media culture has slowly increased, especially from the 1990s onward, but it has been an uphill struggle. Indeed, the inability of the national artists-run centres association ANNPAC/RACA to deal with a walkout in 1993 by its BIPOC caucus, Minquon Panchayat, led to the association's dissolution.[211]

One issue is that the politics of identity was often seen as more appropriate to documentary than experimental modes, which had, in some critical discourses, opposed historical reference to formal abstraction, or even more reductively, opposed activism and art. These oppositions are unproductive and impoverish our ability to see the fullness of an artwork in its cultural context. For example, a film like Peter Rowe's *Buffalo Airport Visions* (1967) is interesting both for its formal technique and as a document of (largely White) Toronto youth culture in the late 1960s. Like the films from the 1990s that would explore elements of identity through imagery or context, earlier films also expressed cultural identity, both consciously and unconsciously, in its homogenous and distinctive aspects. The expressive personal underground cinema of the 1960s explores identity just as much as a 1990s identity piece, but with different parameters of cultural marginalization (which also can retrospectively reveal their parameters of privilege). Every film is an index of its historical moment and reads differently when viewed in different historical times.

Filmmaker and programmer Lynne Fernie asserts, *"In Visible Colours* remains one of the foundational film events in Canada and its history is critical to our conversations today as we continue to struggle with post-colonial aesthetics, identity politics and power."[212] Gagnon writes that this event, along with a subsequent 1992 event, About Face, About Frame at IMAA (then IFVA), signalled the increasing importance of "people of colour and First Nations peoples working to address racism and cultural inequity in the contexts of national cultural organizations."[213] The 1990s and beyond were characterized in part by new organizations and festivals arising to fulfill the needs of communities.

That In Visible Colours should have taken place in Vancouver is not surprising. As Kathleen Ritter writes, Vancouver had become a hot spot in the international art scene and a centre for critical discourse: "With strong ties to the universities, artists were active participants in the academic conversations of the day, ones largely informed by issues of identity and representation, the problematization of the canon, and the attack on grand narratives associated with modernism—critiques emerging from feminist discourses."[214] Some in the experimental film community were suspicious of "academic conversations," and sometimes understandably (reacting against jargon and programmatic aesthetics), but many were energized by new writings in aesthetics, feminist theory, and philosophy. Whether it was the ferment of SFU or the experimentation at Western Front or the impact of "Vancouver School" of photoconceptual art, the interventions signalled by In Visible Colours in Vancouver found their way into national conversations. Indeed, as Gagnon suggests, these conversations reframed the idea of what nation means, especially within a sector that often denied the structural racism and inequity widespread in Canadian society, even in ostensibly progressive yet nonetheless "white-dominated cultural organizations."[215] Verjee was instrumental in taking these conversations east of the Rocky Mountains, partly in her capacity as a media arts officer at CCA.

1990-2020: Film Is Dead, So Is Video, Long Live Film and Video

The rise of festivals: explorations of community and diversity

Zainub Verjee participated in a panel at the 1991 Images Festival, a "Critical Frameworks Workshop," with curators and media activists Coco Fusco, Tony Gittens, and Betty Julian, tying together two important forces that would shape the experimental film world as it shifted to the experimental media art world in the 1990s: curator/programmers and festivals. As reported by Karen Tisch, a key part of the discussion was "the importance of audience development; of making work accessible to targeted communities; of having people from within those communities curate the exhibitions and of increasing the critical dialogue that surrounds the work."[216] Films come alive when they are seen. Festivals are spaces where films are exhibited and where critical dialogue can take place

with artists and experts and audiences. In the 1990s, a large number of festivals and media organizations arose from communities, whether emergent or previously ignored, to make films accessible to those communities, and with programmers being the people from these communities organizing the festival or organization. Both Hoolboom and Sternberg, while working as experimental film officers for CFMDC in the 1980s, had signalled the increasing importance of finding audiences for experimental work, noting that there was more arts council funding for production than for distribution and exhibition. In some cases, distributors organized touring screening packages, often accompanied by written material, for example, Vtape's sponsorship in 1991 of *Fresh Looks: Anti-Racist Film and Video*, co-produced by Richard Fung, which circulated widely as a VHS compilation and was acquired by libraries for sustained educational screening by individual students or in classrooms.

An increasing number of festivals from the 1970s onward screened experimental film as part of their offerings, especially the many festivals that arose devoted to films and videos by women. In the late 1980s and onward, the numbers of festivals expanded, now more than ever focused on particular communities, themes, and media forms. Just in Toronto, initiatives prior to 1989 include Desh Pardesh (1988-2001), from which grew South Asian Visual Arts Collective (SAVAC, est. 1997, which runs the Monitor festival, est. 2005), and Black Film & Video Network (1988-2003/4).[217] In 1991, the Inside Out Toronto LGBT Film and Video Festival began, followed by the REEL Aboriginal Festival (1992-1996) at Harbourfront in Toronto. Other festivals began to appear (some emerging from people or events at the Images Festival): Rendezvous with Madness (est. 1993)/Workman Arts; Toronto Jewish Film Festival (est. 1993); aluCine: Latin Film & Media Arts Festival (est. 1995);[218] Toronto Reel Asian Festival (est. 1997); Counting Past 2: Performance/film/video/spoken word with Transsexual Nerve! (1997-2002), founded by Mirha-Soleil Ross with Petra Chevrier; imagineNATIVE Film and Video Festival (est. 1999); Planet in Focus Environmental Film Festival (est. 1999); Regent Park Film Festival (est. 2003); MPENZI: Black Women's International Film and Video Festival (founded by Adonica Huggins, 2005-2009); and Toronto Outdoor Picture Show (est. 2011). Some festivals arise in reaction to others; for example, Toronto Queer Film Festival (TQFF, est. 2016) was started as an alternative to Inside Out, "providing a unique gathering space for marginalized and precarious queer and trans people."[219] (The widespread growth of festivals and screening series across Canada from the 1990s onward is documented in part 3 of this history, "From Sea to Sea to Sea.")

Indigenous media rising

While the rise of concerns with identity led to the formation of organizations that cohered around identifications as diverse as Asian or queer, the intersection of Indigenous identity and film and media arts has a longer history. Organizations

that have attempted to support Indigenous artists include the Association for Native Development in the Performing and Visual Arts (ANDPVA, est. 1974) and the Native Women's Association of Canada (est. 1974). In 1994, CCA established the Aboriginal Arts Secretariat in response to a report detailing the exclusion of Indigenous work from arts institutions in Canada.[220] Organizations like the NFB have made many films *about* Indigenous peoples, but films made *by* Indigenous filmmakers were rare (a noted exception being the prodigious output of Alanis Obomsawin). In 1991, Edmonton was the site of the New Visions conference, held by the Alberta Aboriginal Filmmakers Association, which inaugurated the Aboriginal Film and Video Art Alliance (1991-1996), whose key organizers included experimental filmmaker, activist, and community leader Marjorie Beaucage (Métis) and Loretta Todd (Cree/Métis).[221] Although the Alliance's focus was on narrative and television, it was an important "national organization operating on [Indigenous] self-government principles as well as a hub for the collection and distribution of information and resources relating to Indigenous artists and filmmakers."[222] At a 1993 conference held at the Banff Centre for the Arts, Indigenous visual and media artists like Rebecca Belmore, Cat Cayuga, and Shelley Niro were in attendance. Niro (*It Starts With a Whisper*, with Anna Gronau, 1992) and video artist Dana Claxton (*Grant Her Restitution*, 1991) are two Indigenous artists who started working in a more artisanal mode in the 1990s, and continue today across multiple mediums. In 1994, the imagineNATIVE festival was established out of the Centre for Aboriginal Media (through the work of Zachary Longboy and Cynthia Lickers-Sage with Lisa Steele), with the support of Vtape, although an earlier precedent was REEL Aboriginal (1992-1997).[223] Vtape had developed a substantial collection of Indigenous media, also through its connection to Isuma.

Other Indigenous media arts organizations followed, including Sâkêwêwak First Nations Artists' Collective (est. 1993, Regina); TRIBE: A Centre for the Evolving Aboriginal Media, Visual and Performing Arts (est. 1995, Saskatoon); Urban Shaman (est. 1996, Winnipeg); and Wapikoni Mobile (est. 2003), a mobile moving image media studio that travels to Indigenous communities in Canada and abroad.[224] A number of other Indigenous film festivals have arisen, though not concentrating solely on experimental media, for instance Vancouver Indigenous Media Arts Festival (est. 2011) and Asinabka Film & Media Arts Festival (est. 2012, Ottawa). IMAA/AAMI set up a distinct section for Indigenous organization in 2005, National Indigenous Media Arts Coalition (NIMAC), after several initiatives starting in 2001.[225] The rise of Idle No More (est. 2012) and release of the TRC calls to action in 2015 have increased the urgency for support for Indigenous artists.[226]

"It's the economy, stupid"

In the 1980s, one reason for conflict in the film community was competitiveness over limited space and programs to screen films, a situation worsened by the economic precarity of filmmakers and lack of screening spaces.[227] When festivals expanded in the 1990s, accompanied by more year-round exhibition venues and screening programs, battles eased. Chris Gehman summarizes a new move to "audience building" in the 1990s onward: "[M]embers of the media arts community changed gears from advocacy, polemical writing, and even a certain amount of ideological one-upsmanship, to practical organization- and audience-building in the 1990s and 2000s." Gehman attributes this change to "increased and stabilized arts council funding, which diminished somewhat the chronic pressure of competitiveness and scarcity in the field as a whole, as well as gradual expansion in the number of exhibition outlets for artists, which has made it easier to show new work to audiences."[228]

The early 1990s recession continued a general sense of austerity in the cultural sectors, although the arts scene was somewhat buffered. In 1993, the Liberal Chrétien government took over from the Progressive Conservatives; Chrétien's deficit reduction plan made 14 per cent cuts to the Department of Cultural Heritage (which funded the NFB, Telefilm, and CCA), but CCA was only cut 2.5 per cent.[229] Continued advocacy from organizations like IMAA led to a $25M increase in funding for CCA in 1997. Peter Sandmark writes, "In 1997, the Alliance organized a national protest against cuts to the arts, called 'Cultural Emergency,' with artists staging events in Halifax, Montreal, Ottawa, Toronto, Calgary and Vancouver, decrying the negative impact that cuts to the arts have on society. Penny McCann, President of the Alliance in 1996, recalls, 'The Cultural Emergency protest got onto the national news. Ontario was under siege at that time, with the Harris government'"—which had made severe cuts to the Ontario Arts Council.[230]

While there was a financial squeeze overall in this period, art as a cultural industry began to be taken seriously by municipal and provincial governments—partly because the grassroots media sector had demonstrated that it could survive. There was a growing recognition of the economic benefits of small-scale arts organizations and festivals, which had operated highly efficiently through decades of underfunding, often using volunteer energies (though not without high burnout among "cultural workers"). The idea of the *creative economy* and *creative class* that accompanied the expansion of media industries in major Canadian cities, coupled with the rise of the internet as a communication tool, supported the entrenchment of film and media arts in subsequent decades. (These developments had negative impacts on housing for artists and cultural workers and ARC office space affordability in rapidly gentrifying cities.)

"I'm not dead yet": film's persistence as a medium and artisanal form

The centenary of cinema in 1995 was the occasion for many elegies for the death of cinema. On the one hand, film was undeniably on the decline; although it took another seventeen years, Kodak filed for bankruptcy in 2012—leading to many film stocks used by experimental filmmakers becoming unavailable—and in that period, most commercial labs went out of business. On the other hand, once film stopped being used as a default technology for the industry, it became a prized artisanal medium taken up by filmmakers who embraced even more its materiality: scratching it, handling it, and foregoing professional lab developing in favour of hand-processing. Over the last decade at LIFT, a major supplier for independent filmmakers, orders of film stock have roughly quadrupled.[231]

Many filmmakers in Canada hand process film, including Carl Brown, Eva Kolcze, Alex MacKenzie, Mike Maryniuk, and Solomon Nagler. Hoffman's Film Farm has been influential in propagating hand-processing in Canada and beyond and has been proactive in responding to changes in the field. From its beginning, it emphasized the involvement of women, engaged with Indigenous artists and themes, internationalized the field of participants, and especially in the last decade self-consciously examined the ecological footprint of film chemistry and processes.[232] Film Farm is part of an international network of co-ops, including Montréal's Double Negative, that have branched out into film processing, taking over the role of commercial labs. In Canada, if you don't do it yourself, Niagara Custom Lab is the most prominent lab for artisanal processing. Notably, the Film Farm has also avoided fetishizing film for its own sake and has embraced digital technologies for how they can be part of the image transformation process (for example, few Film Farm films are completed as 16mm prints but are edited and released as digital files or streaming links).

Tess Takahashi has noted that, in the field of experimental film and media art, some artists have identified as strongly with a technology or medium as with an identity category like gender or nationality.[233] Super 8, in particular, has gathered an intense and loyal community, although similar communities have arisen around VHS tape and early gaming technologies. In Toronto, John Porter has been a leading figure in promoting Super 8 (his website is named super8porter) along with figures like Milada Kovacova, Marnie Parrell, and Jonathan Pollard, while artists like Barbara Sternberg have integrated it as part of their cross-gauge practice. Toronto has been home to several Super 8 festivals, including the Toronto Super 8 Festival (1976-1983), Splice This! Super 8 Festival (1998-2006), and the8fest Small-Gauge Film Festival (est. 2008). University of Regina Film alum Alex Rogalski started an important event, the One Take Super 8 Event (est. 2000), as a non-competitive festival in which filmmakers take a single reel of Super 8 film and shoot it in camera ("No cuts. No splices"), and then all of the filmmakers watch the films for the first time after the reels are developed. The festival concept spread from

Regina to multiple cities in Canada and the US, with over one thousand films screened at over fifty events in the last few decades, although it remains most active in Regina, Saskatoon, Winnipeg, and in Montréal.[234]

Another important analog tradition is the projector performance, whether using the film projector as an instrument, or using multiple projectors, or modifying them through mechanical means. Brett Kashmere and Astria Suparak have documented the tradition in Canada, noting early predecessors like Wieland's *Bill's Hat* and Expo 67, and artists like John Porter (starting in the 1970s) and Pierre Hébert (starting the 1980s).[235] Kashmere and Suparak identify Daniel Barrow, Shary Boyle, Karl Lemieux, and Alex MacKenzie (all mainly working from 2000s on, though Barrow starts in 1993) as the central figures in the contemporary tradition.[236]

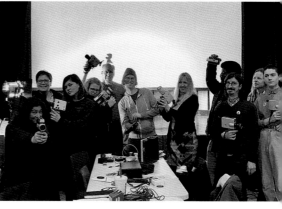

L to R: Janis Demkiw, Madi Piller, Rea Zala, Stefanie Weberhofer, John Porter, Clint Enns, Laurie Kwasnik, Stephen Djan jr., Ryan Ferguson, Laura Pitkanen, Rennie Taylor at John Porter's Super 8 workshop at the8fest, 2017 (Emma Roufs)

Into the twenty-first century

In 2000, CCA inaugurated the Governor General's Awards in Visual and Media Arts (GGAVMA), which finally provided the kind of recognition for visual and media artists that performing artists, architects, and literary writers had enjoyed for decades. That media arts was included in the title underscores the inroads that film, video art, and other media art have made in the art world since the 1960s. Some artists are more associated with a particular medium (film or video or moving image installation), while others work across multiple media, and the GGAVMA recognizes filmmakers working in and across documentary, experimental, and even fiction modes.[237]

In the twenty-first century, experimental film has transitioned into variants of artists' film or media arts; in terms of volume of production, access through online distribution, and exhibition sites (including online streaming), the field seems enormously healthy. As mentioned above, IMAA has grown from around 12 member groups in 1980 to over 100 in 2020, serving "over 16,000 independent media artists and cultural workers."[238] Consumer grade digital media is high quality and relatively accessible, leading to an explosion of digital experimental work made on an artisanal scale, even as analog film has thrived in a more niche sector. The 2000s and 2010s witnessed an enormous increase of moving images in the art gallery and museum world, breaking the barriers that the film rental market had set in place.

2021 and Beyond: Facing an Uncertain Future

As this book goes to print, a number of issues face artists' film and media art beyond those that have recurred or arisen in the last sixty years.

The first is the poor status of film, video art, and especially digital media archiving. Canada has one of the worst records of industrialized nations for film and media archiving due to underfunding of LAC and the exclusion of preservation activities from CCA funding. It's clear there is a massive history of experimental film and media production that, outside of a canon of noted artists—and even then!—may disappear due to lack of proper film, video, and digital media preservation. Distributors like CFMDC, GIV, Vidéographe, VIVO, Vtape, and WFG and documentation sites like Western Front have become, over time, de facto archives, as their film prints and videotapes, meant for distribution and documentation, have become precious originals in the absence of archiving by artists or public archives. Film stock, on the other hand, is relatively stable and, as long as it is kept safe, can continue to be shown if a projector is available (though some prints become unprojectable with deterioration over time), whereas magnetic tape and especially digital media require not only the preservation of computer files but also the software and hardware to play or even emulate the original. Similar challenges appear with archiving and remounting film, video, or new media installations: the newer the technology, the greater the chance it has become obsolete.

Distribution is another element of the film and media art world that is highly unstable. The drastic reduction of film projectors in theatres, colleges, and universities threatens the viability of film distributors. This has been compensated for, to some degree, by the expansion of the national and international festival, museum, and art gallery market, especially for touring shows and artist retrospectives. Distributors of experimental film and video art have adapted to the plethora of video and digital formats that have appeared over the years: 16mm, 8mm, Super 8, VHS tape, ¾" and 1" video, CD-ROM, DVD, Blu-ray, and DCP. A number of film and media distributors have joined the online distribution outlet VUCAVU (est. 2013), which is attempting to provide a streaming platform that will balance the ease of access and image quality desired by viewers with the need for artists and arts organizations to receive payment.[239] The tremendously disruptive force of the internet on artists' film and media art remains to be gauged by future generations.

In terms of exhibition, even before the COVID-19 lockdown of 2020-21, theatrical audiences had slowly been diluted, partly due to the ease provided by internet streaming. The advent of streaming digital moving images adds flexibility for experimental film viewing while simultaneously making image and sound quality as variable as the device on which one is seeing the film, whether in a theatre, or on a monitor, laptop, or smartphone. COVID-19 lockdowns accelerated the demand for streaming options,

forcing independent film and media organizations (and the school and university market) to adapt to new technologies without the resources that the fast-moving industry has (including dealing with still-in-motion legal frameworks around copyright). For example, the 2020 Images Festival moved its On Screen program to a live stream format, which increased its audience numbers but created problems of streaming reliability, image quality, and audience attention. Meanwhile, the Off Screen portion of the festival, incorporating gallery installations, live performance, and evening parties was cancelled. Museums and galleries have slowly adapted to the needs of film, video, and media art exhibition, whether through installing mini black box theatrical spaces (albeit with uncomfortable chairs) or maintaining film loopers or video monitor loops. Problems of film viewing remain: the loop is not the best exhibition mode for films with a beginning, middle, and end, and if the mobile spectator does not stay to watch an entire film, is the artwork compromised? There is promise in the integration of performance art into galleries and museums, which creates a sense of *event* rather than presuming that the gallery spectator will browse. The event is a model for such basic measures as designating and posting screening start times and setting up spectator seating.

A final, and more ambiguous issue for the future is that which draws people to experimental film, video art, and media arts in the first place: the quality of aesthetic and social experience for viewers of this time-based work. By "quality" I do not impose standards of high or low that would restore medium-based hierarchies that have happily expired. Rather, I want to flag the importance of the specific qualitative elements of the experience of moving image art that are, I suspect, specific to the historical moments and conditions of any viewing experience, and include medium, space, social context, and shared company. I have treasured the experience of seeing a freshly struck 16mm print of Michael Snow's *Wavelength* in Innis Town Hall, the classroom where I first saw experimental films, and going out for drinks to discuss the film afterwards; a packed the8fest screening at Trash Palace, an underground space where the décor and snack bar are as important as the temporary screen; opening night at Oakville Galleries of a Colin Campbell video show, *People Like Us: The Gossip of Colin Campbell*, curated by Jon Davies, at which the conversations in the room complemented the performances on-screen; binge-watching the videos in Midi Onodera's *A Movie A Day* (2006-2007) project on my home computer, and writing about them during and after; and most recently, sitting in my office under COVID-19 lockdown, watching and hearing, over Zoom, Deanna Bowen's artist's talk/walkthrough of her *Black Drones in the Hive* exhibition, curated by Crystal Mowry, at the Kitchener-Waterloo Art Gallery.

We will all have our own cinematic experiences whose intensity, interest, joy, or even displeasure were specific to what and how we experienced the art. I also do not want to wallow in nostalgia, nor bemoan the losses that change inevitably brings: as I hope this brief history shows, there were good old days and bad old days. Technologies will come

L to R: Kathryn Elder, Jim Shedden, R. Bruce Elder, Michael Snow, Roger Bourdeau, Paul Sharits, Bart Testa at the Innis Film Society's Paul Sharits screening, 1991 (John Porter)

and go; spaces will open and close; and audiences will grow and wane: the challenge remains for the institutions and organizations that people create, for those who love the art of moving image and sound, to continue to open up new experiences but also have a historical sense of what has preceded them.

Clockwise from top left: Halifax Independent Filmmakers Festival, 2019; Media City Film Festival, 2017; Pleasure Dome, 1990; Vancouver Underground Film Festival, 2000

PART 3: FROM SEA TO SEA TO SEA
Local Scenes and Histories from West to East to North

This section is a survey of the experimental film and media activities in major centres, moving generally west to east across Canada. It focuses on film, but it also glances at sibling video and electronic media arts co-ops and schools, since the rise of digital media in the 1990s has led to mergers and restructures of co-ops and other organizations. The survey is inevitably incomplete, given the often ephemeral and under-the-radar nature of much experimental film and media activity (and documentation). Each of these institutions deserves a much more detailed history: I issue an open invitation to add to and correct this partial history. It is also important to note that in those cases when an institution's own historical account is cited, it's likely there are additional stories out there that, taken together, would more fully capture the work, arguments, successes, and sometimes failures of these institutions.

British Columbia

Vancouver

Vancouver has long enjoyed an active film culture, with a Vancouver Branch of the National Film Society active since the 1930s, a campus film society at the University of British Columbia (UBC) since 1936, and an international film festival that started in 1958. The BC Archives has *And...* (c. 1939-1940) made by Wilson and produced by Fowler and Roberts, an example of early experimental films being made as amateur cinema through film societies.[240]

Through the late twentieth century, this active film scene was regarded by many Vancouver-based artists and experimental filmmakers as isolated from what is described as a central Canadian cultural base (Ottawa/Toronto/Montréal). As Christopher Régimbal writes, "Scholars of art history and literature in Canada have often applied the idea of regionalism to the study of Canadian culture with the understanding that because of the vast size of the country, and the distances between its urban centres, artistic and literary movements have often fermented in relative isolation from one another."[241] This sense of isolation, as in the case of many regional cultural scenes, generates both resentment in being ignored and a hometown pride in being independent from popular trends.

Filmmaker Kirk Tougas was an energetic presence in the film scene in the 1960s and 1970s, as he programmed experimental films at the UBC film society (Cinema 16) and at The Cinematheque, and was a film critic for the UBC student newspaper, the *Ubyssey*, and for the *Georgia Straight*, before becoming a cinematographer for filmmakers like

Sturla Gunnarsson and Nettie Wild.[242] Writing in 1980, Tougas argued that Vancouver independent film was unique compared to Toronto and Montréal filmmaking, due to more independence from large institutions.[243] Yet, if Vancouver felt itself estranged from central Canada, it shared many ties with the west coast of the US, in particular the experimental film scene in San Francisco, with filmmakers like Bruce Conner and Bruce Baillie (who co-founded Canyon Cinema Cinematheque and Co-op distributor in the late 1960s), music and poetry, and the psychedelic counterculture of that period. Zoë Druick notes that "a growing sense of West Coast cultural specificity, with influential artists and cultural industries traversing the Pacific coast," was connected in the 1960s to Vietnam War "migrant resisters" from the US.[244] People in the Vancouver film scene were more likely to be inspired by Gene Youngblood's *Expanded Cinema* (1970) than writing by New York critics like Jonas Mekas or P. Adams Sitney.

The countercultural energy of the 1960s made its way into the work of Vancouver independent filmmakers working in animation, like Al Sens, and in narrative, like Larry Kent, whose student film feature *The Bitter Ash* (1963) led him to a career outside Vancouver. In documentary, early production by Allan King and others for an innovative local CBC station, CBUT, led to recognition of a "West Coast school" of documentary production united by the work of editor Arla Saare.[245] Stanley (Stan) Fox produced two CBUT series, *Enterprise* (1967-1968) and *New World* (1969), which showcased short experimental films by local filmmakers like Sylvia Spring and David Rimmer, and two documentaries directed by Tom Shandel about youth culture, *What Happened Last Summer* (1967) and *Generations* (1969).[246] Fox also taught film workshops at UBC and SFU, a non-credit program that Rimmer says was his first training in filmmaking.[247] The local NFB office, led by Peter Jones, was also supportive to many independent filmmakers, donating discarded 16mm film for use in found footage films, and finding ways to provide small sums of money from end-of-year budget surplus. Another important early figure was Sam Perry, who organized light shows for the Trips Festival in 1966, which created imagery from multiple film, slide, and overhead projectors. (Alas, Perry died by suicide in 1966 and his films were lost.)

Many early films from Vancouver used found footage. Peter Lipskis says, "There's a West Coast tradition surrounding found footage…very playful. It's a form of collage, an ecology of images that recycles garbage."[248] Tom Braidwood, Chris Gallagher, Gary Lee-Nova, Lipskis,

Peter Lipskis, Vancouver, 1986 (John Porter)

Razutis, Rimmer, and Tougas made films in the late 1960s and early 1970s that used found footage, sometimes intercut with new footage (e.g., Lee-Nova's *Steel Mushrooms*, 1968), or using techniques like looping (Braidwood's *Backbone*, 1972), re-cutting (Keith Rodan), re-photography (Rimmer's classic *Variations on a Cellophane Wrapper*, 1970), or optical printing (Razutis built his own optical printer, on which he made films like *Aaeon*, 1970). One source of found footage was the literal piles of discarded 16mm footage donated by the NFB to the Intermedia Society (1967-1972).

Intermedia's first building offered four floors of open space for artists to occupy, and equipment for them to use. Filmmakers and media artists like Lee-Nova, Michael Morris, David Orcutt, Razutis, Rimmer, and Rodan were involved in Intermedia. Razutis had a short-lived distribution co-op, Intermedia Film Co-operative, on the open model of FMC and Canyon Cinema. Werner Aellen was an important figure at Intermedia, trained as an architect, but working at the NFB since 1963 before taking on the role of Intermedia executive director; later, he helped to found The Cinematheque. The loose set-up at Intermedia Society embodied the open spirit of the period, but also its instability, as Intermedia folded in 1972. Many of the denizens of Intermedia went on to help establish new ARCs, including The Cinematheque for film, and Satellite Video Exchange Society and Western Front for video, performance, and multimedia. One enduring legacy of Intermedia was Vancouver's healthy crossovers and coexistence between film and video/electronic arts (unlike the sharper separation found in Toronto and elsewhere). While these new ARCs formally widened the separation of film and video, many artists reported accessing multiple institutions.[249]

The Cinematheque, which started in 1971-1972 with Aellen as the first president, showed a broad range of films, including art cinema, documentaries, and experimental film. It was supported by figures like Tony Emery and Doris Shadbolt of VAG, Bruce Pilgrim of the NFB, Tougas (who became the first Cinematheque manager), and Mike Collier, who ran the film lab Alpha Cine (formerly TransCanada Lab).[250] Although The Cinematheque made some attempts at film distribution and film archiving (led by Tougas) and published the magazine *Reverse Shot* (1994-1995), it has been mainly an exhibition venue, with the unique addition of a film reference library.

The Satellite Video Exchange Society began in 1973, setting up a facility called Video Inn (a collective space), which published the periodical *Video Guide* from 1978 to 1992; it added a video distribution wing with Video Out in 1980. The renamed Video In and Video Out became the VIVO Media Arts Centre in 2007.[251] Video Out at VIVO is the largest West Coast distributor of video art and digital media, while VIVO programs events and exhibitions, runs workshops, and provides equipment and digitization services.[252] The Western Front (est. 1973) is an ARC supporting film, video, performance, dance, poetry, music, and electronic arts, formed when a group of artists purchased a building as a living/working space.[253] VIVO and Western Front are two of

the largest "accidental archives" of media art, VIVO through its distribution wing, and Western Front with its large collection of video and audio recordings of performances and other Vancouver arts activities. In 1999, Western Front had "a year dedicated to the experimental film image as a thematic, called *~scope*" and invited Alex MacKenzie to do film performance.[254]

The PUMPS Centre for the Arts (1975-1980) emerged as an edgier space "from the tradition of communal activity and performance associated with Intermedia and the Western Front, with whom they existed cooperatively."[255] Kim Tomczak, one of the co-founders, would become an influential figure in the Toronto video arts scene, involved in Vtape and other institutions. Like the other post-Intermedia organizations, PUMPS provided space, equipment, and resources for artists, and offered its large gallery for exhibitions, screenings, and performances. A notable film event was a 1977 experimental film series programmed by Gordon Kidd. John Anderson produced *The Gina Show*, a weekly cable TV program.

VAG exhibited experimental film, video, and media art in the 1960s and 1970s, especially when Emery (1967-1974) and Shadbolt were there (1967-1972), but film and media had less of a presence after Emery's departure. Like other major galleries in Canada such as the AGO and NGC, it did not collect experimental film in this period. In 1972, it hosted an important film series, *Form and Structure in Recent Film*, whose catalogue (edited by Dennis Wheeler, Western liaison officer for NGC) featured important essays on international experimental film. In 1983, VAG presented the exhibition *Vancouver, Art and Artists, 1931-1983*, whose catalogue included an essay by Razutis and Tony Reif (an important critic for experimental film in Vancouver), titled "Critical Perspectives on Vancouver Avant-Garde Cinema 1970-83."[256] In 1984, VAG cancelled Paul Wong's video installation, *Confused: Sexual Views*, calling it "not art," a sign of the growing divergence in the 1980s "between alternative video and institutionalized art," where the larger institution closes itself to art from the ARC scene.[257] VAG hired Judith Mastai as head of public programs in 1988, an important feminist force at the gallery, who brought Mary Kelly and Griselda Pollock there in 1989.[258]

The experimental film world in Vancouver from the late 1960s through the 1970s was almost exclusively a heterosexual men's club (Razutis and Reif's VAG essay mentions a single woman artist, Ellie Epp). Small wonder that women like Ardele Lister would co-found (with future CCA officer Renée Baert and others) ReelFeelings (1973-1977), a feminist film and video "collective of women with various skills (none of which included filmmaking) who wanted to make films. We borrowed equipment, took workshops and taught ourselves how to make films that represented our own experiences."[259] Peter Jones of the NFB, while supportive of experimental film at Intermedia, was dismissive of women filmmakers; when Lister interviewed Jones, "I asked him why the NFB made more films with fish in them than women. He said there were more fish than women."[260]

Nor is it surprising that the LGBTQ2+ community found a more comfortable home in Western Front and the more inclusive video art community of Video Inn and Video Out, especially when some filmmakers would openly complain about a hegemony of "gay video" at Western Front. Lister worked at VAG and taught at Emily Carr in 1976 before moving to a career as a video and media artist in the US. Peg Campbell and Marusya Bociurkiw were involved in the Women's Media Alliance, which documented feminist events in the city.[261] Ellie Epp made four remarkable films between 1976 and 1996, and also did performance art (e.g., "what will we know," 1982, Canada House, London, UK), poetry, and photography. Epp was part of the Women's Interart Co-op's first exhibition at the Helen Pitt Gallery in Vancouver. *Notes in Origin* was both a film and an hour-long performance that included film, tape, slides, and her writing.[262] In 2002, she completed a PhD in neurophilosophy, and began making video works from 2013 onward.

At the end of the 1970s, two other important film institutions were created, Canadian Filmmakers' Distribution West (CFDW) and Cineworks. In 1979, CFDW was formed by Natalie Edwards as a West Coast offshoot of the Toronto-based CFMDC before it became autonomous in 1982 after a dispute with CFMDC, eventually changing its name to Moving Images Distribution in 1994. In 1980, the film production co-op Cineworks Independent Filmmakers Society was formed by a group of experimental and documentary filmmakers, many affiliated with SFU, after an epic gestation that reflects the particular tensions of film culture in Vancouver. In founding member Peg Campbell's account, proposed names included the Vancouver Un-cooperative, Terminal Cine (Terminal City was an early name for the city of Vancouver), and Kino-fist, all of which testify to the differences between the experimental and documentary filmmakers involved (the first Board of Directors included Byron Black, Justine Bizzocchi, Campbell, Madeleine Duff, Gallagher, Kidd, Lipskis, Razutis, and Rimmer). In 1983, Meg Thornton moved from Trinity Square Video in Toronto to become executive director and helped provide stable leadership.[263] In 1986, the three major independent film institutions in Vancouver, The Cinematheque, CFDW, and Cineworks, came together in the same building, which allowed all to expand fundraising opportunities. Like most major film co-ops, Cineworks has supported independent filmmaking generally, and does not have an experimental film focus.[264]

Through the 1980s and 1990s, Vancouver's arts scene suffered familiar problems of underfunding with the rise of neo-liberal conservatism that undercut many independent arts organizations. The right-wing Social Credit provincial government in place during the 1980s ensured that British Columbia had a comparative lack of provincial arts and film funding, with the exception of Vancouver's Expo 86 and the increasing use of Vancouver and British Columbia locations for Hollywood North productions. Nonetheless, the major film, video, and multimedia organizations mentioned above continued to back experimental production, distribution, and exhibition, supported by

the academic film and media departments at UBC, SFU, and Emily Carr University of Art and Design (now ECUAD).

Many filmmakers and figures in the experimental film community were educated at UBC in the Fine Arts faculty, including Braidwood, Lipskis, Lister, and Tougas. Early faculty included artists like Tom Burrows, Glenn Lewis, David Lumsden, Joan Reytiertson and Glenn Toppings; Rimmer taught at UBC in 1973, and Gallagher joined UBC in 1988 as a full-time faculty member.

SFU's film program enjoyed a heyday from the late 1970s to mid-1980s, when an impressive faculty of theorists and filmmakers included Kaja Silverman (cross-appointed with Women's Studies), Michael Eliot-Hurst, Razutis, and, in 1982, Gruben; other instructors included Rimmer and Reif. Earlier in the 1970s, film workshops were taught and in 1973, a forum was held at SFU on independent filmmaking on the West Coast.[265] The 1980s were a heady period in the arts and humanities when emerging theoretical paradigms were an important ground for thinking critically about the cultural and political status quo; Mike Hoolboom describes the "fractious faculty," "With Kaja Silverman's rigorous feminist psychoanalysis, Michael Elliot Hurst's staunch Marxism, and Al Razutis's anarchic avant-gardism, a generation of students were torn between competing pedagogies."[266] The host of filmmakers and media artists who emerged from SFU included Penelope Buitenhuis, Mary Daniel, Oliver Hockenhull, Fumiko Kiyooka, and Valerie Tereszko, all of whom have diverse aesthetics.[267]

Razutis in particular is a key if sometimes controversial figure in Vancouver experimental film and media history. Tougas described him as a "mad scientist and inventor." Indeed, after his involvement with Intermedia, he set up Visual Alchemy Studio (1972-1977, inheriting space being vacated by Roy Kiyooka and Toppings), where Razutis set up a film optical printer, an early video synthesizer he named Felix, and conducted experiments in holography and other new media technologies. Razutis also co-founded a magazine on holography, *Wavefront* (1985-1986, 1992), in addition to publishing many essays.[268] At SFU, he was active as a teacher, curriculum builder, publisher, and organizer of conferences and screenings—like many figures in experimental film history, embodying the contradiction of being an anti-institutional institution-builder. For example, Razutis's intense investment in an avant-gardist formation led him eventually to resign from SFU in 1987. Meanwhile, Gruben's tenure at SFU has been more sustained and included setting up in 1987, with Colin Browne, the Praxis Centre for Screenwriters, a professional development program for Canadian feature films.[269] Gruben's turn away from the artisanal scale of experimental filmmaking to feature narrative paralleled other filmmakers who ventured into narrative in the 1990s.

ECUAD, which began as the Vancouver School of Art (later Emily Carr College), has been another school important for the experimental film and media scene in Vancouver. Rimmer, after teaching courses and workshops at UBC and SFU, became full-time faculty

at ECUAD; Peg Campbell, instrumental in the founding of Cineworks, has taught there since 1986. Prominent students include Ann Marie Fleming, who studied there from 1986 to 1989; *You Take Care Now* (1989) was her graduating film. Thirza Cuthand (Plains Cree, Little Pine First Nation) and Barry Doupé are other recent graduates.

Vancouver's proximity to the Pacific Rim allows it to enjoy strong representation from Asian Canadian film and video artists, although it was not until the 1980s that artists like Fleming, Fumiko Kiyooka, Paul Wong, and Wayne Yung became visible participants in the scene.[270] Su-Anne Yeo cites Paul Wong's 1990 exhibition *Yellow Peril: Reconsidered*, featuring twenty-five Asian Canadian artists, which circulated across Canada in multiple ARCs, as a show that "engaged Asian Canadian audiences on issues of memory, history and cultural identity, not only on the basis of 'race' but on gender and sexuality, and class, as well."[271] For Yeo, "artist-run activity in Vancouver has long been inter-ethnic and multidisciplinary."[272]

The "Vancouver School" of photoconceptual art (including Vikky Alexander, Roy Arden, Stan Douglas, Rodney Graham, Ken Lum, Jeff Wall, and Ian Wallace) has been a significant presence in the Vancouver and international art world, and has featured some work in film and moving image media.[273] Douglas is a prominent Black multimedia artist, who attended ECUAD and was engaged with film in early pieces like the installation *Overture* (1986), in which a 16mm projector shows turn of the nineteenth century early train footage of Rocky Mountains accompanied by a written text, and *Der Sandmann* (1995). Both Douglas and Graham have worked extensively with film, using film loopers in galleries.

In the 1990s, an important addition to Vancouver film scene was Alex MacKenzie's exhibition spaces. Originally from Montréal, MacKenzie saw experimental films in classes with Peter Harcourt at Queen's University and began his practice as a filmmaker and projection artist in Montréal and then Vancouver in 1995, when he started the Edison Electric Gallery of Moving Images (1995-1997). MacKenzie ran the Vancouver Underground Film Festival for five years and from 1998 to 2003 ran the Blinding Light!! Cinema screening space (and café).[274]

The Iris Film Collective (est. 2014) is a more recent exhibitor, "a Vancouver-based group of independent artists creating, exhibiting and touring film-based works—single channel, expanded,

Alex MacKenzie at The Blinding Light!! Cinema, 1998
(John Porter)

sculptural, installation — with the goal of increasing the visibility and accessibility of experimental media art" with an emphasis on "ciné film — actual celluloid — at a time when this medium is shifting to a post-industry model."[275] Vancouver hosts the annual international new media forum, New Forms Media Festival (est. 2000).[276] Amy Kazymerchyk founded the DIM Cinema screening series in 2008, its name inspired by American experimental filmmaker and poet James Broughton, and since 2014 Michèle Smith has continued curation with screenings at The Cinematheque.

Victoria

Victoria has a small independent film and media scene. Open Space, founded in 1972, featured early music performances by Don Druick (who made the soundtrack for Rimmer's *Variations on a Cellophane Wrapper*), and in 1978 organized Sat-Tel-Comp, an early "telematic video transmission utilizing satellite technology."[277] MediaNet (est. 1981) runs the FLUX Media Gallery, and supports the creative use of video and film.[278] The University of Victoria has a Film Studies program where Lianne McLarty, who has written on experimental filmmakers like Rick Hancox and Bruce Elder, taught.[279] In 1991, the CineVic Society of Independent Filmmakers began as a more industry-oriented film and media co-op. The Antimatter Festival of Underground Short Film & Video has run annually since 1998, organized by festival director Todd Eacrett and curator Deborah de Boer. Open Space was associated with early Antimatter festivals, and in 2001 Open Space worked with Interactive Futures, "an international symposium, art installation, and new media festival affiliated with the Victoria Independent Film and Video Festival."[280] Deluge Contemporary Art (est. 2005) has also shown some moving image installations in conjunction with Antimatter.

Prairies: Alberta, Saskatchewan, Manitoba

Alberta, Saskatchewan, and Manitoba are often grouped together as the Prairies. There have been some efforts to coordinate the film and media art co-ops across the region. For example, in 1985, Grant Poier, director of EM/Media Gallery & Production Society in Calgary, hosted the first Plains Canada Independent Film/Video conference, and in 1990, helped create PDI (Prairie Distribution Initiatives), a short-lived venture which included most of the major Prairie co-ops.[281] But as in British Columbia, most experimental film, video, and media art have arisen in cities across the Prairies, some intersecting with universities, most dealing with the same clashes found in other co-ops between artisanal and commercial aspirations, and weathering the funding fluctuations that faced all Canadian arts institutions from the late 1970s on. A few reports point to differences of style and theme across the region; for example, W. Scheff's brief 1989

article, "Flatland Films," suggests, "Within the context of film co-op production on the prairies, Saskatchewan films are quite distinctive in comparison with productions from Calgary and Winnipeg," with Regina "defining itself as the major centre for experimental filmmaking on the prairies," CSIF producing "narrative-based experimental/performance films," while "the Winnipeg Film Group is developing low-budget black comedies."[282] However, this characterization, while descriptive of the late 1980s, does not capture the full range of the multiple experiments in film, video, and media developed across the region by its many co-ops and schools.

Alberta

The film/video split of the 1970s and 1980s was reflected in the establishment of two institutions in Calgary, film at Calgary Society of Independent Filmmakers (CSIF) and video at EM/Media. CSIF began in 1978 with video and media artists Douglas Berquist, Marcella Bienvenue, and Leila Sujir as major figures in its early history.[283] CSIF innovated several long-lasting events, including the $100 Film Festival, formed by James Morrison in 1991-1992, now the Artifact Small Format Film Festival, which screens only Super 8 and 16mm film. In 1998, CSIF started Fairy Tales International Queer Film Festival, partnering with Gay and Lesbian Services Community Association in Calgary. EM/Media Gallery & Production Society began in 1979 and formally incorporated in 1983 as EM/Media.[284] Centre Art Video was an ARC that emerged out of Off Centre Centre (est. 1975), which organized Media Blitz I and II (1988-1989), two ten-day-long festivals of experimental film, video, and performance art by local artists. Ian Reid and Brian Rusted were also active in the 1980s, while artists like Nelson Henricks and Terrance Houle were involved in the co-ops. The Quickdraw Animation Society began in 1984, offering animation courses, workshops, screenings, and production resources.[285]

Coordination in the section increased by the end of the 1980s. In 1989, Sujir (with Hume) and EM/Media coordinated an exhibition, *Film and Video from the Heart of the Heart of the Regions—A Country?/Le film et la vidéo du coeur du coeur des régions : Un pays?* through what the catalogue calls the "Inter-Disciplinary Artists Promotion and Production Society of Alberta," screening both film and video by over eighty artists. Also in 1989, at the Hinton Independent Film & Video Festival, representatives of the major co-ops in Alberta met, leading to the formal establishment in 1991 of Alberta Media Arts Alliance Society (AMAAS), including CSIF, EM/Media, FAVA and the Quickdraw Animation Society. AMAAS, in addition to its work of advocacy, sponsored Prairie Tales, an "annual touring collection of short films and videos by Albertan artists."[286] In 1992, CSIF and EM/Media collaborated on a Youth Summer Media Arts Camp and co-operated subsequently on many projects, along with Calgary arts organizations like Alberta College of Art and Design, Art Gallery of Calgary, The New Gallery, and Calgary Underground Film Festival (est. 2004). CSIF also supported the transition of the herland

feminist film festival (1989-2007) to a video production and mentorship program in 2015.[287] Monograph (est. 2018) is an experimental film and media screening series that showed work by Broomer, Christie, Elder, Rollo, and Sternberg.[288]

The Walter Phillips Gallery (est. 1976) at the Banff Centre for the Arts has exhibited many video and media arts exhibitions. Although the Banff Centre has a long history going back to 1933, it was not until 1981 that courses in "Electronic and Film Media" were introduced; a Media Arts program was formalized in 1988 (more commercial industry events came earlier, like the Banff Festival of Mountain Films, est. 1976, and Banff Television Festival, est. 1979).[289] As the moving image entered the visual arts world, it found more and more of a place at the Banff Centre, accelerated by video and digital media artist Sara Diamond, who founded Banff New Media Institute in 1995.

An important early film co-op in Edmonton was Filmwest Associates, established in 1971 by Tom Radford, P.J. Reese, and Anne Wheeler as a genuine shared-role production collective that made documentaries, many on feminist and Indigenous themes. Radford led the North West Centre, the regional NFB office in Edmonton, which nurtured film production by filmmakers like Gil Cardinal, Linda Ohama, Anne Marie Nakagawa, Michelle Wong, and Mieko Ouchi, who made films about Asian Canadian experience in the 1990s.[290] A 1970 *artscanada* report on filmmaking in Edmonton cited experimental films by Philip Darrah, Mike Travers, and Roxy Travers.[291] The first co-op that concentrated on artisanal scale work was Film and Video Arts Society Alberta (FAVA), established by sixteen artists in 1982, a rare co-op that incorporated both film and video artists and equipment by the time its members found permanent space in 1985.[292] Liz Stobbe and Rick Gustavsen were organizational figures in the 1980s and Helen Folkmann was a long-time executive director; the Spirit of Helen Award, named in her honour, is given by AMAAS to reward community service to media arts in Alberta. Edmonton's Metro Cinema was an important exhibition space; its executive director, Marsh Murphy, wrote a short history of Canadian film co-ops.[293] Exposure: Edmonton's Queer Arts and Culture Festival was established in 2007. Graphical (est. 2015 by Mark Templeton) is a sound label that works with experimental filmmakers like Broomer, Dan Browne, Enns, Christine Lucy Latimer, Mani Mazinani, and Snow, making "sound recording created from images drawn directly onto film or paper that were then played back using a sound system."[294]

Saskatchewan

Saskatchewan points with pride to the fact that its Saskatchewan Arts Board (est. 1948) is the oldest public arts funder in North America, and the province has an active film and media arts history. The Saskatchewan Filmpool Cooperative (originally Kanata Filmpool Co-operative) was established in 1977.[295] Gerald Saul is a key figure for experimental filmmaking in Regina, a member of Filmpool since 1984, frequently on its board,

Filmpool 35th anniversary, 2013; Queer City Cinema Festival, 1996

and also involved in initiatives like The Cabinet Collective (2015-2016). Filmpool has published *Splice* magazine since 1978, one of the longest running co-op publications in Canada.[296] In 2005, Filmpool hosted a Regina Festival of Cinematic Arts.[297]

W. Scheff, writing in 1989, noted almost no representation of Indigenous peoples in Filmpool films, and urged "intercultural filmmaking" to develop.[298] The Sâkêwêwak First Nations Artists' Collective was founded in 1993 by Robin Brass, Reona Brass, Âhasiw Maskêgon-Iskwêw, Edward Poitras, and Sherry Farrell Racette; it runs an annual storytelling festival that includes film screenings.[299] Indigenous media artists who have appeared include Cheryl L'Hirondelle (Métis/Cree), Kevin Lee Burton (Swampy Cree), Trudy Stewart, and Janine Windolph. Sarah Abbott co-founded and led mispon: A Celebration of Indigenous Filmmaking festival from 2005 to 2010.

Two important spaces for Regina film arts are the Regina Public Library Film Theatre and Dunlop Art Gallery, conveniently located together in downtown Regina. The Dunlop Art Gallery has hosted many screenings, such as the 1990 program *The Woman's Voice: Feminist Films of the 1970s and 1980s,* curated by University of Regina film professor Sheila Petty. Cafés such as Digits have shown films as part of a tradition of screenings in unconventional spaces. Other Regina film organizations include the Antechamber Art Gallery and Cinematheque (1999-2001), organized and curated by Brett Kashmere, described by University of Regina film professor Christine Ramsay as "an unlikely, yet successful, convergence of art world sophistication and make-shift DIY aesthetics."[300] As part of its ambitious programming, Antechamber screened Bruce Elder's 40-hour film cycle, *The Book of All the Dead.* Independent Visions is a curatorial incubator co-founded by Mike Rollo in 2011 for independent and experimental media in Regina. Regina has

also hosted festivals: Artistic Director Gary Varro established the Queer City Cinema Festival in 1996; in 2015 artistic directors Dana Lesiuk and Jon Tewksbury established the Pile of Bones Underground Film Festival, which has a sister festival, Videodrunk.

An institution that has sustained artisanal film- and media-making is the University of Regina Department of Film, which has had many experimental filmmakers among its faculty; its students have the Regina Film & Video Students Society and have helped maintain the vitality of Filmpool. German émigré Jean Oser taught in the 1970s and contributed to art film culture in the city. Chris Gallagher taught until 1988, when he returned to UBC. Richard Kerr's twelve-year tenure from 1986 to 1998 helped give the department an experimental film profile in Canada. Kerr joked that when he applied for the position, his portfolio included both experimental films and some "rock videos I made for the Parachute Club," an important reminder that experimental film is not the only kind of film on students' minds.[301] Gerald Saul started teaching in 1997, after completing an MFA at York University with a paper on "Canadian Avant-Garde Film in the 1990s," and made numerous experimental films. Brian Stockton is another faculty member who has made a range of personal and often droll experimental, animation, and documentary work. Sarah Abbott has taught there since 2004, widening her media arts practice to environmental media, and co-founding the mispon festival. Rollo is another second-generation University of Regina experimental filmmaker who, after earning an MFA from Concordia University in Montréal (helping to found the experimental film collective Double Negative there in 2004), later returned as a faculty member. Ramsay, while not a filmmaker, has done significant historical and curatorial work on expanded cinema and Saskatchewan film history. Many Film faculty were affiliated with the New Media Research Laboratory, which closed in 2015.

If the experimental film tradition is strong in Regina, Saskatoon is known more for photography and video.[302] The Photographers Gallery (est. 1970), which has published *BlackFlash* magazine since 1983, has been a key site in Western Canada for still photography. It ran an annual Super 8 film festival in the early 1980s and a video workshop, through Nora Gardner, in 1984. In 1991, the Video Vérité co-op was formed (previously People's Video Centre 1989); in 2003, the Photographers Gallery and Video Vérité merged to become Paved Arts. This merger reflects the increasing dissolve of film and video technology; as Marsh Murphy writes, "the appropriate distinction is not between one capture medium and another, but between different kinds of work and modes of practice."[303] Paved Arts has arranged outdoor screenings and exhibited photography, installations, and time-based film and video work, such as *Isolated Landscapes: Videos by Prairie Women (1984-2009)*, curated by Kathy Rae Huffman from the Winnipeg Video Pool archives in 2018.

Manitoba

WFG (est. 1974) is one of the most active film co-ops in Canada, in a city with a history of supporting extremely eclectic forms of experimental film and other media. For example, an experimental film program from New York screened in 1964, and like other cities, Winnipeg had an NFB regional office from which occasional supports and equipment were used for experimental production. It is also highly self-conscious of its history, what Andrew Burke calls "the mythologies and meanings of the WFG": there is a feature documentary portrait of this history, *Tales from The Winnipeg Film Group* (2017), and it has released a number of commemorative anniversary programs and DVDs.[304] This activity is made possible by its distribution wing (est. 1981) and climate-controlled archive (est. 2011), and enhanced by its long-standing Cinematheque (est. 1982 by Executive Director Merit Jenson Carr, and programmed for decades by Dave Barber), which provides a space to screen work by WFG members and the work of other filmmakers for WFG members.

The impetus for WFG came with the Canadian Film Symposium held at the University of Manitoba on independent Canadian films and filmmaking, a symposium that voiced its dissatisfaction with the state of Canadian independent film.[305] Geoff Pevere famously dubbed WFG's output "Prairie Postmodernism," pointing to the diversity and mingling of cinematic styles, with artists like Guy Maddin and Deco Dawson following earlier filmmakers like John Paizs and Leon Johnson. Filmmakers have worked in a number of forms, including experimental documentary (Johnson), animation (Ed Ackerman [collaborating with Greg Zbitnew and Colin Morton], Brad Caslor, Richard Condie, Mike Maryniuk), short and feature narrative (Sean Garrity), and experimental films that cross documentary, narrative, and poetic forms (Dawson, Noam Gonick, Greg Hanec, Jon Krocker, Maddin, Matthew Rankin). Solomon Nagler's hand-processing workshops in the early 2000s influenced other filmmakers working in animation and experimental forms. (Nagler later moved to Halifax to teach at NSCAD.)

Maddin has achieved the most popular success, being the rare experimental film-maker comfortable in artisanal artist spaces, the art world, academic settings, and commercial film. He has a prodigious output of short and feature-length films spanning and combining experimental, documentary, and narrative forms, but also creating ballets and gallery installations, and publishing essays and books. He has worked collaboratively with many artists, including Dawson, Evan and Galen Johnson, Greg Klymkiw, Paizs, Isabella Rossellini, and George Toles. Toles teaches at the University of Manitoba (where Maddin has also been employed). Other University of Manitoba faculty include Brenda Austin-Smith and Steve Snyder, while Andrew Burke at the University of Winnipeg has been the central historian and critic for Winnipeg film and media arts.

Like most co-ops established in the 1970s, WFG's has historically been dominated by White men, but it has recently sought to celebrate the work of women and BIPOC film-makers. Winston Washington Moxam (1963-2011) was one of the few Black filmmakers

in WFG history (also its Cinematheque projectionist). In honour of his legacy of short and feature narrative production, the Afro Prairie Film Festival (est. 2017 out of Black Space Winnipeg) bestows the Winston W. Moxam Best Black Canadian Shorts Award. The contributions of women filmmakers have also been, until recently, overshadowed, including Norma Bailey, Danishka Esterhazy, Erica Eyres, Paula Kelly, Carole O'Brien, and Elise Swerhone. In 2015, WFG set up Womxn's Film & Video Network to support women and non-binary persons working in film in Manitoba. Cecilia Araneda, executive director from 2006 to 2017, helped WFG with these inclusivity initiatives and to celebrate its fortieth anniversary, coordinating the *Reflecting Light: 40 Years of Canadian Cinema* screening and symposium event, which addressed the status of women filmmakers, climate, and "Indigenous Views of Film Production Centres."[306] In 2019, Araneda received the CCA Joan Yvonne Lowndes Award for independent curatorial practice in visual and media arts. Araneda has been active in curating new video game design and digital artwork by emerging Indigenous artists (e.g., for Art Gallery of Southwestern Manitoba) and promoting Latin women artists from the Prairies.[307]

Burke notes that it was not until the 2000s that Indigenous makers like Darryl Nepinak (Salteaux) engaged with WFG, followed by artists like Caroline Monnet (now based in Montréal but a founding member of the Aboriginal digital arts collective ITWÉ), Kevin Lee Burton, and curator Jenny Western. WFG developed an Indigenous Filmmakers Distribution Catalogue in 2014 and collaborates with Urban Shaman in Winnipeg and imagineNATIVE (Toronto). Urban Shaman: Contemporary Aboriginal Art (est. 1996) is an Indigenous ARC that includes film and media art in its programming, which supports "artists whose work hinges on experimentation in form and content."[308] Nepinak served as treasurer from 2006 to 2008. A crucial figure in Urban Shaman's history is Âhasiw Maskêgon-Iskwêw (1958-2006), described by Steve Loft and Kerry Swanson as "one of the foremost thinkers and practitioners of Aboriginal new media art," who curated an online wing for Urban Shaman, "Storm Spirits—Aboriginal New Media Art" (2005-2008) that included work by KC Adams, Dana Claxton, and Archer Pechawis.[309]

Several organizations have expanded experimental film activities in Winnipeg and Manitoba in recent decades. Many artists involved in WFG formed WNDX Festival of Moving Image (est. 2005), governed by a curatorial collective.[310] L'atelier national du Manitoba (2005-2008, founded by Walter Forsberg, Marynink, and Rankin) was a three-year artists' project that engaged with the city of Winnipeg's history and self-image (especially in *Death by Popcorn: The Tragedy of the Winnipeg Jets*, 2005) through (un)popular culture sources like public access television, street posters, and urban policy activism. L'atelier fed off earlier work like Maddin and Klymkiw's mid-1980s cable access collaboration, *Survival*, preserved by Daniel Barrow in *Winnipeg Babysitter* (2009). The next generation of Winnipeg film and video artists and programmers

WNDX Festival of Moving Image, 2019

included Clint Enns, Heidi Phillips, and Leslie Supnet. Winnipeg Underground Film Festival (est. 2013 by Travis Cole, Scott Fitzpatrick, and Aaron Zeghers) has a strong tradition of showing experimental film and media art. Another Manitoba festival that shows experimental work alongside usual festival fare is Gimli Film Festival (est. 2001 from a local Icelandic Festival); in 2006, Nepinak curated "INDIANPEG: Shorts from Winnipeg Aboriginal Filmmakers" for the festival. The Winnipeg Aboriginal Film Festival (est. 2003) is another institution supporting Indigenous work.

Video Pool Media Arts Centre (est. 1983) is the largest video distributor on the Prairies. It emerged as part of the Plug In Institute of Contemporary Art (est. 1972), which had a Video Group from 1979. Video Pool, in addition to distribution, houses a production space and equipment, and has multiple programs. Reid Dickie, Ryan Takatsu, and Linda Tooley are early artists working in video from the late 1970s onward.[311] In 1993, Video Pool partnered with WFG to create RE:VISIONS – The Winnipeg Women's Film and Video Festival; an earlier women-centred video organization was The Women Artists in Video (WAIV, est. 1987).[312]

Ontario

Ontario has a history of experimental film production that goes back to the 1950s, usually feeding into or reacting against the gravitational force of Toronto, the province's art centre. The Media Arts Network of Ontario/Réseau des arts médiatiques de l'Ontario (MANO/RAMO, est. 2009) is an organization similar to AMAAS and IMAA/AAMI that advocates and coordinates ARCS and co-ops in Ontario. This survey of Ontario starts in London, acknowledging the historical importance of Jack Chambers and the formation of CARFAC, then moves through Hamilton (McMaster Film Board) to Toronto, and then surveys other Ontario cities.

An important rural outlier is the Fabulous Festival of Fringe Film (est. 2002), which presents "independent and experimental media art, showcasing Canadian and international artists to a rural audience" in the Grey Bruce region northwest of

Toronto.[313] Especially through the leadership of Debbie Ebanks Schlums, the festival has engaged productively with the Indigenous community at Saugeen First Nation, collaborating on workshops and screenings.

London

From the 1960s through the 1980s, the relatively small city of London was an art centre recognized internationally for a group of filmmakers, visuals artists, writers, and musicians often called London Regionalists, who made art collaboratively in the shadow of Toronto (and New York, the North American centre of avant-garde arts in the 1950s and 1960s). As Christopher Régimbal writes, "Being doubly provincial, not only vis-à-vis New York but Canada nationally, London artists embraced the provincialism that other art scenes within the country struggled against and assumed it as a practice."[314] Greg Curnoe was a central figure, co-founding the Nihilist Party of Canada and the Nihilist Spasm Band in addition to *Region* magazine and Region Gallery. A visual artist deeply invested in the stuff of ordinary life, Curnoe made films like *No Movie* (1965) and *Sowesto* (1969) in a documentary/home movie collage mode.

Jack Chambers, another central figure in London Regionalism, made a film about Curnoe, *R34* (1967), which Darrell Varga attests was one of the first films to be funded by CCA.[315] Chambers, in addition to being the first president of CARFAC, also founded the London Film Cooperative to distribute and exhibit films by local artist filmmakers.[316] Chambers's body of work is small but significant; *R34*, *Mosaic* (1965), *Hybrid* (1967), *Circle* (1968-1969), and his masterpiece *Hart of London* (1970) are central to the history of Canadian experimental film. His film *CCCI* was left unfinished upon his death in 1978.

Keewatin Dewdney made some important films in a concentrated period of time but then went on to other pursuits, becoming a professor of mathematics at University of Western Ontario, and math puzzlemaster for *Scientific American* (1984-1991).[317] Broomer notes that Dewdney made the classic *Maltese Cross Movement* (1967) while a grad student in mathematics at the University of Michigan.[318]

The premature deaths of Chambers and Curnoe and larger changes in the arts and film landscape in Canada sapped some of the early energy of the arts scene in London—and indeed the mythology of this Regionalist heyday in the 1960s and early 1970s casts a strong shadow on the city's art scene to this day. Many contemporary artists and filmmakers continue to work in London, including Jamelie Hassan (working in multiple media, including video), Charlie Egleston (film and digital media), and Wyn Geleynse (film and media art installation). Egleston teaches at Fanshawe College, which, along with Western University's film studies and visual arts faculty, helps sustain the local film and media art scene. Museum London (previously the London Regional Art & Historical Museums) has a theatre that has hosted experimental film series, e.g., David Clark's *Science Friction* "video/film series" in 1998, and *Jack Chambers Film Project*

Sebastian di Trolio with experimental film buttons at CineCycle, Toronto, 2013 (John Porter)

(2001), a symposium on his films. More recently, the London Ontario Media Arts Association (est. 2012) is an ARC supporting film and media artists; active figures include Egleston and Sebastian Di Trolio, who continues a long tradition of film screenings at London's arts high school, H.B. Beal Secondary School, with films he has rescued from public library discards and has bought himself.

Hamilton

Like London, Hamilton had a brief heyday of experimental film culture, around the short but vibrant life of the McMaster Film Board (1966-1975). As meticulously documented in Stephen Broomer's book *Hamilton Babylon: A History of the McMaster Film Board*, this university film society had an outsized role in developing several major experimental film institutions in Canada as well as started the careers of people as diverse as David Cronenberg, Dan Goldberg, Eugene Levy, and Ivan Reitman in the mainstream film and television industry. Filmmaker (and later critic and activist) John Hofsess was the driving force behind the film society; highly influenced by the New York underground, Robert Fothergill, Hofsess, Patricia Murphy, and Peter Rowe made films, organized underground film festivals, and set in motion what would become the CFMDC in 1967. Hofsess's *Redpath 25* (1966) and especially *Palace of Pleasure* (1966-1967) were highly accomplished films in the underground mode, with brilliantly colourful psychedelic imagery and multi-screen projection. *Palace of Pleasure* was screened at Cinethon and was one of the few films Clyde Gilmour did not dismiss (though he was usually more generous to the work of Canadian filmmakers).[319] Murphy organized a massive McMaster Arts Festival in 1966 that featured Warhol's *Exploding Plastic Inevitable* with The Velvet Underground and screenings of Canadian and US experimental films. After several censorship controversies, the Film Board was shut down in 1968, and then revived by Reitman and others, who took it in a more conventional student film society direction (though experimentation continued among the remaining filmmakers).

Hamilton continues to have a vibrant arts scene. Photophobia (est. 1999) is a festival of "short-format contemporary media, film, video and moving image...dedicated to the development of experimental time-based media" that works in partnership with two other important art institutions in the city, Art Gallery of Hamilton and ARC Hamilton Artists Inc. (est. 1975).[320] The Factory: Hamilton Media Arts Centre (est. 2004) is the main media arts co-op.

Toronto

As mentioned above, there was some experimental film activity in Toronto prior to the 1960s through the Toronto Film Society and the artists assembled at Graphic Associates.[321] Film appeared more forcefully in the art scene in Toronto in the mid-1960s, through screenings at Isaacs Gallery (which represented Michael Snow and Joyce Wieland). "In [Feb and Nov] 1964 on [Graham] Coughtry's suggestion, Isaacs had [Warren] Collins organize two public screenings of artists' films, mostly Canadian, including those of Dunning, Snow, Wieland, Collins, [George] Gingrass, Coughtry, Cowan, Arthur Lipsett, George Manupelli, Al Sens, Louis DeNiverville, Carlos Marchiori, and others."[322] Snow's *New York Eye and Ear Control* had a walk-out audience at a music event, "Ten Centuries Concert" (April 1965), but a more receptive viewing at Isaacs Gallery. The 1967 Cinethon event described above was the apex of a brief moment of awareness of experimental film in mainstream culture. John Porter notes that painter William Ronald, who had been part of Maya Deren's entourage at her 1950-1951 appearances in Toronto, returned from New York to host a CBC program on the arts, *Umbrella*, and in 1966 commissioned both Bob Cowan and the New York–based Kuchar brothers to make films for the program (Cowan's was a film introduction to an interview with Marcel Duchamp).[323]

In fall 1965, the Bohemian Embassy (under the leadership of Elizabeth Coleman) planned a series of Thursday night screenings, *Cinema Seven*, of underground cinema.

L to R: Sparkles, Bob Cowan, George Kuchar, 1996 (John Porter)

They had intended to show Jack Smith's controversial *Flaming Creatures* (1963) but decided not to after a pre-screening; it and Jean Genet's *Un chant d'amour* (1950) were cancelled due to what Victor Coleman later called "largely homophobia." The keen interest in the underground, especially from the press, was both censorious and salacious. Critics like Marshall Delaney (a.k.a. Robert Fulford), Joan Fox, and Gilmour were drawn to it but archly dismissed it as a fad, displacing their angst about youth culture, homosexuality, or artistic freedom onto the decadent imports from New York. Indeed, the relatively substantial amount of popular press writing during the late 1960s on the underground is rife with the homophobia and misogyny of the period. But it serves as a reminder, first, of the sheer presence of queer and women's perspectives in experimental

film compared to feature narrative, and, second, of why queer and feminist outrage and activism was sparked in the late 1960s into the 1970s.[324]

Other filmmakers active in Toronto in the 1960s and 1970s include Betty Ferguson (found footage films 1965-1976); George Gingras (*The Separatist*, 1964); Les Levine, who made a film adaptation of John Giorno's 1964 poem, *The American Book of the Dead*; Burton Rubenstein and Sara Bezaire (*The Hyacinth Child's Bedtime Story*, 1967); and John Straiton, whose 8mm *Portrait of Lydia* won best animation and best amateur film at the 1965 Cannes Film Festival.[325] Porter also reports that Jim Anderson and Keith Lock, important subsequent figures in Toronto experimental film culture, won prizes at the 10th Muse International Student Film Festival in Amsterdam, in October 1969 (Anderson's *Scream of a Butterfly* won the Grand Prix).[326] The Bohemian Embassy presented visual artist Richard Gorman's handmade *The War of the Worlds* in 1967 in an expanded cinema format with four projectors and electronic music by TV producer Jim Guthro.[327] In the late 1970s, multidisciplinary artists FASTWÜRMS (Kim Kozzi, Dai Skuse, and until 1991, Napo B.), began making Super 8 films before moving onto 16mm, video, and digital media. Phillip Barker has worked eclectically across the experimental and installation worlds, including work as a production designer in art cinema, often designing new apparatuses.[328] Peter Dudar has a large body of work, including his collaborations with dancer/choreographer Lily Eng (their collaborative work under the moniker Missing Associates).

The story of the Toronto Film Co-op (1971-1978) is a cautionary tale about emergent divisions within the film world in the 1970s between experimental and more mainstream filmmakers, a common battle we have seen within other Canadian independent film co-ops. Film production equipment and workshops were available at the Co-op, described by Rick Hancox as "a place run by and for filmmakers." The Co-op was originated by Sandra Gathercole and Patrick Lee, and the first chair of the Co-op board was Keith Lock.[329] In 1975, generous federal tax credits led to a short-term boom in feature film production of so-called "tax shelter films." Some members attempted to capitalize in this period, but when the Co-op invested in high-end equipment and a new location, it went bankrupt. For Hancox, this was a case of overreach due to mixed mandate: "They thought they could turn the co-op into a commercial venture as part of a feature industry."[330]

Rochdale College (1968-1975), a free alternative school that grew out of co-operative housing, housed the Toronto Film Co-op in its first years and was an important counterculture centre for independent film. The Co-op shared office space with the CFMDC and *Cinema Canada* magazine during the formative late 1960s-early 1970s moment and hosted many film screenings. Raphael Bendahan made *Rochdale College 1970* (1970) while he lived at the college, and the next year made *Black & White/Noir et Blanc* (1971), an

experimental film featuring a Black dancer, Joe Fletcher, intended, in Bendahan's words, to show "the culture in which someone who's black lives and how it feels."[331]

Patricia Gruben, during her time in Toronto during the 1970s, describes three distinct and separate cultures in Toronto, "too many worlds that didn't connect": first, a commercial film industry; second, the experimental film scene, which often named itself "avant-garde"; and, third, the video artists closer to the visual art world.[332] This disconnection between film, video, and commercial cinema was most prevalent in the 1970s and 1980s, and more extreme in Toronto than elsewhere in Canada. There were exceptions: film and video sometimes overlapped at sites like A Space (est. 1970), Centre for Experimental Art and Communication (CEAC, 1973-1978), AGO, Cinematheque Ontario, and YYZ Artists' Outlet (est. 1979), which housed a screening space that showed both video and film from 1987 to 2000 and had a publishing wing that issued several books on film, video, and media arts. But more often, film and video had separate institutional homes and scenes.

Toronto was one of the earliest major centres for video art, home to such artists as Colin Campbell, Vera Frenkel, General Idea, Lisa Steele, and Kim Tomczak. The video art scene in Toronto was active, with multiple institutions offering equipment and workshop instruction on the new technology to a generation of young artists interested in electronic arts and perhaps alienated from the masculinist culture of the film world. A Space, led by Steele and Tom Sherman, provided equipment for artists like General Idea, Hummer Sisters, Marien Lewis, Missing Associates (Peter Dudar and Lily Eng), and many others. In 1981, after a major shake-up, the video equipment was taken over by a new organization, Charles Street Video (est. 1981), with artists like Ross Turnbull and Rodney Werden involved.[333] Trinity Square Video (est. 1971 by Marty Dunn) was more activist- and community-oriented, and produced cable community television series. Its *Living With AIDS* series, led by Michael Balser and John Greyson, appeared on cable TV 1990-1991. Peggy Gale also lauds the work of Lawrence and Miriam Adams in providing video production and exhibition opportunities, especially for dance and performance.[334] From 1983 to 1987, Peter Lynch with Renya Onasick organized a video and new media festival, Video Culture International (at Harbourfront in 1983, and co-presented with the Whitney Museum of American Art at Ontario Place in 1984), which engaged with the art world, popular culture, and industry (e.g., IMAX, Sony), sometimes ruffling the feathers of those in the Toronto arts community opposed to industry and art market influences.[335]

Video distribution started with Art Metropole (est. 1974) selling VHS tapes and other art publishing, including the catalogue/artists book *Video by Artists*, designed by AA Bronson in 1976.[336] But it was soon superseded by Vtape (est. 1980), which has become a national and indeed world leader in video art distribution, preservation, and history.[337] Vtape has also sponsored production workshops, curated numerous significant exhibitions (often in conjunction with other galleries and museums), and fostered

younger generations in the media arts scene through its Curatorial Incubator programs, in which Vtape's massive collection and historical library figure prominently. A notable venture linking video art to then emerging digital media arts was an international biennale, TRANZ<--->TECH (1999, 2001, 2003).

Film distribution, meanwhile, remained largely in the hands of CFMDC, though DEC Films (1974-1991, Development Education Centre) was an important distributor of international films, including activist and documentary work. In 1984, DEC organized an important festival, Colour Positive: An International Anti-Racism Film Festival, a precursor of the wave of festivals and events in the 1990s that addressed racism and broader questions of cultural identity in Toronto. Films like Midi Onodera's *Ten Cents a Dance (Parallax)* (1985), Brenda Longfellow's *Our Marilyn* (1987), Annette Mangaard's *The Iconography of Venus* (1987), Katharine Asals's *Pretending We Were Indians* (1988), and Helen Lee's *Sally's Beauty Spot* (1990) were important early films that addressed gender, sexuality, indigeneity, and race, opening up experimental film's horizons when it seemed the dominant politics was devoted to critiques of American imperialism and capitalism.

In the wake of the dissolution of the Toronto Film Co-op, independent filmmakers had several options. In 1981, Liaison of Independent Filmmakers of Toronto (LIFT) was established as an ecumenical production co-op providing equipment and workshops to independent filmmakers of all kinds. In 1985, LIFT helped organize the *Toronto Film Now* series and many other screenings to foreground member films. LIFT has regularly published a newsletter (e.g., *Filmprint* magazine, 2005-2007) and also successfully earned grant funding for commissioned films, mentorship, and artist-in-residence programs. Although experimental filmmakers have been part of LIFT from its inception, it became even more essential for experimental filmmakers after the dissolution of the Funnel in 1988.[338]

L to R: Susan Norget, Kika Thorne, Edie Steiner, Annette Mangaard (with son Carson), Clare Hodge at LIFT screening, CineCycle, 1992 (John Porter)

In the 1980s, LIFT was home for what was called the "Toronto New Wave," a movement encompassing feature narrative filmmakers who emerged from or continue to crossover with experimental film and media art like Atom Egoyan, John Greyson, Janis Lundman, Ron Mann, Bruce McDonald, Don McKellar, Peter Mettler, Jeremy Podeswa, and Patricia Rozema.[339] In the 1990s,

Program poster, the Funnel, 1983 (John Porter)

a number of experimental filmmakers ventured into feature narrative production, generally with mixed results given the conflicting aesthetics and political sensibilities at play between artisanal and industrial production.[340]

The Funnel (1977-1988) was the dedicated experimental offshoot of the Toronto Film Co-op and has a rich if fractious history.[341] The history of the Funnel is often linked to CEAC, which included film (programmed by Diane Boadway) and video as part of its multidisciplinary activities; when CEAC disbanded, its equipment was divided between the Funnel and Trinity Square Video.[342] The Funnel fostered an artisanal and egalitarian experimental film community in Toronto, especially embracing Super 8, with many notable Toronto-based experimental filmmakers participating.[343] The Funnel provided standard co-op production equipment but on a membership-only basis, which was standard policy in most film co-ops that had CCA funding (members needed to put in a certain number of volunteer hours to maintain status). It was also highly active in programming and exhibiting films and performances at the theatres and spaces it inhabited, often engaging local critics and researchers to write for its published program notes and bringing in international artists for screenings. The Funnel created a vibrant centre of gravity for experimental film in Toronto during its decade of existence. An unfortunate move into then-quickly gentrifying Queen Street West in the late 1980s and battles over how to deal with the Ontario Censor Board were contributing factors in its demise. In the wake of the Funnel, collaborative experimental film production was dispersed to LIFT and to the many colleges and universities in Toronto. CFMDC took up film distribution and Pleasure Dome and others took up film and video experimental exhibition.

Toronto had a number of theatres and venues that often (though not exclusively) featured experimental film. Cinecity (1967-1971) was one such venue, followed by campus film societies at University of Toronto in the 1970s. In 1990, Toronto International Film Festival Group, now TIFF, assumed management of the Ontario Film Institute

(1969-1990) from Gerald Pratley, transforming it into Cinematheque Ontario and the Film Reference Library. After this change, more experimental film programs were shown, partly due to the presence of programmers, in chronological order, like James Quandt, Jim Shedden, Susan Oxtoby, Chris Gehman, and later Chris Kennedy.[344] In 1991, Greyson and Sternberg kicked off a screening series, *Carte Blanche*, in which Toronto artists would choose a program of usually experimental or art cinema work; in some cases, organizations like the Black Film & Video Network or CFMDC curated programs.[345] Shedden and Oxtoby began *The Independents* screening series in 1995 (later called *The Free Screen*), an eclectic program mixing Canadian and international work that was an important staple of experimental film screenings in Toronto, shown in AGO's Jackman Hall from 1992 until moving to the TIFF Bell Lightbox building in 2010. During the TIFF Festival, Oxtoby and then Andréa Picard programmed the *Wavelengths* (est. 2000) and *Future Projections* experimental film and media series. AGO, TIFF, and Innis Town Hall trained a generation of expert film, and later digital, projectionists that included Antonella Bonfanti, Andrei Gravelle, James King, Eyan Logan, Kathryn MacKay, and Alexi Manis. In the 1980s, in addition to the Funnel, cafés and bars like Daily Express and the Rivoli showed films at night. *New Waves in Cinema* (1987-1992) often had screenings at the Rivoli. Some short-lived theatres like the Cinema Lumière (1969-1978) and the Euclid Theatre (1989-1993) included independent and experimental films in their programming. The Royal Ontario Museum (ROM) theatre was available briefly, 1985-1989, while Harbourfront Centre showed film from 1984 to 1989, with occasional screenings thereafter.

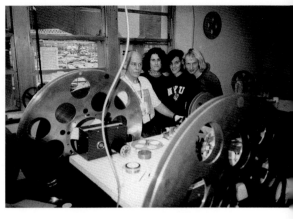

L to R: Projectionists Martin Heath, Kathryn MacKay, Alexi Manis, Andrei Gravelle, 2001
(John Porter)

A few individuals have been institutions in their own right. Reg Hartt is a legendary film exhibitor who showed film classics in a variety of Cineforum spaces, including his residence. In 1980, Hartt hosted a month-long punk film festival that showed Colin Brunton's *The Last Pogo* (with Patrick Lee, 1978), Suzanne Naughton's *Mondo Punk* (1978), and Bill Kucheran and Bruce Pirrie's *Ziggy* (1980).[346] Marc Glassman was an important figure who crossed many boundaries in Toronto's film world, partly through his ownership of Pages Books & Magazines (1979-2009). He started programming films at Ontario College of Art in 1980, the Rivoli in 1982 (as part of the Macadamian Film Society, 1982-1987), Forbidden Films (1984), the Funnel (1984-1987), Harbourfront Film Festival, and Hot Docs International Documentary Festival, while being a co-founder of

the Images Festival. He has also been heavily involved in film publications, including *Take One* (1989-2001), *POV* (est. 2001 as editor-in-chief), and *Montage* (est. 2002).[347]

The Pleasure Dome screening series (est. 1989) filled the void left by the closing of the Funnel and was dedicated to contemporary work, mixing video art and experimental film, including Super 8, in addition to hybrids involving performance and gallery installations. It intentionally used multiple venues to suit the particular medium and theme of the program. Many memorable programs engaged explicitly with politically subversive media around sexuality and identity (e.g., work by Gwendolyn, G.B. Jones, Bruce LaBruce, and Annie Sprinkle in the first two years) but the programming was most notable for its sheer eclecticism, infusing strong energy into the Toronto scene. Pleasure Dome was founded as a programming collective that first included Hoffman, Hoolboom, Jonathan Pollard, Gary Popovich, and Sternberg, adding filmmakers and programmers over the next thirty years that included many active participants in the Toronto experimental film, video art, and media art scene.[348] The changing membership of the Pleasure Dome collective reflects the increasing ethnic, racial, and sexual diversity of the Toronto experimental scene, especially its internationalism. In recent decades, alongside the acceptance of film and media art in galleries and museums, Pleasure Dome provided an important training ground for a new generation of curators.[349]

A number of Toronto screening series have been itinerant, sometimes intentionally and sometimes forced to move as low-budget screening spaces became unaffordable, changed landlords (e.g., Double Double Land, 2009-2018), or were lost to gentrification; indeed, a separate history needs to be written about how arts organizations and venues have been affected by changes in real estate prices and urban policy, not only in large cities but also across Canada.[350] Many of these venues were open arts spaces that required set-up of projectors, speakers, and screens, but whose informality allowed the community to mingle before and after the event. The pop-up screening series Early Monthly Segments (2009-2018) mainly used the Gladstone Hotel Art Bar, while ad hoc collective (est. 2017) moves around; Regional Support Network (2014-2017) called itself nomadic, but often used a storefront space in Kensington Market, Videofag. Winston Hacking set up *Film Fort* (2007-2009) as a collaborative itinerant screening scene in studios, on rooftops, or outdoor parks.[351] Trash Palace (est. 2007) had a literally underground venue on Niagara Street (a location that was another casualty of gentrification) that showed cult films and experimental programs. PIX Film Collective (est. 2015) has hosted a number of screening series, including Studio Immersion Program (with LIFT), Creative Conversation Series, ad hoc collective, Colectivo Toronto, and many "impromptu screening/performances"; filmmaker Madi Piller brings an especially international perspective to PIX's programming initiatives.[352]

In addition to the video art programs organized by Trinity Square Video and other artists organizations, some community cable (e.g., Rogers cable access) and TV Ontario

Pleasure Dome programs and photos (clockwise from top): *Skin Deep*, 2020; Fall 2013; Winter 1992; L to R: Liz Czach, Abigail Child, Andrew James Paterson, Tom Taylor, 1995 (John Porter)

(TVO) programs featured video art and some experimental films. In 1986, TVO's *New Directions* screened the work of independent and experimental Canadian filmmakers, followed in 1995 by *Independent Visions* on Rogers community channel 10, hosted and programmed by Jim Shedden, five hour-long segments that included Canadian filmmakers like Amy Bodman, Elder, Robert Kennedy, Kerr, Ron Mann, Snow, Veronika Soul, Iris Paabo, Straiton, and Wieland. Some local television seemed experimental by default, like CITY TV's *The All-Night Show* (1980-1981) and Global TV's looped *Night Ride, Night Walk*, and *Night Moves* (1986), in which a camera crew drove around Toronto showing nightscapes in the city.[353] The same impetus that sought broader public access to independent work was finally realized by the internet and YouTube (est. 2005) and other websites that allowed the public to post moving image work, largely free of censorship (and copyright protection and restrictions).

Animation has been an important part of experimental film in Toronto. It's included prominently in the CFMDC collection and has been part of Toronto Film Co-op and the Funnel programming. The Toronto Animated Image Society (TAIS, est. 1984) began as a community of practitioners but opened studio space in 2002 and has had an active residency program and screening programs, most recently in coordination with PIX Film, led by Piller. Sheridan College has developed one of the largest animation programs in Canada, and OCADU also offers courses in animation.

The AGO, the largest art institution in Toronto, has a fitful relationship with film. As with most large Canadian art institutions, film and video have not been emphasized as medium-specific collections at the AGO.[354] But after the "Canadian Artists '68" competition, experimental film appeared sporadically in the early 1970s (e.g., in 1973, series on Underground Film Classics and Independent Cinema Today were presented, the latter with CFMDC). Ian Birnie purchased films and coordinated several programs during his tenure (1974-1979) spanning narrative, documentary, and art education films, but also including experimental films, including series on Canadian filmmakers, Stan Brakhage, Women in the Avant-Garde, and Structuralist Film, in addition to several programs on animation and screendance. In 1975, Peggy Gale curated *Videoscape*, often called the first major survey of video art in Canada.[355] In 1978, the exhibition *Autobiography: Film/Video/Photography* included experimental work.[356] Birnie, Gale, and Jonasson were part of an innovative Education and Extension department at the AGO that programmed film, video, and performance. Jonasson was head of the E.P. Taylor Audio-Visual Centre from 1974 to 1989 and oversaw film programming at the AGO from 1989 to 1995, including Canadian film and video programs like *From the Co-ops* (AFCOOP and WFG), *Explorations in Super 8*, and retrospectives of Jean Lefebvre and Snow in 1981. Shedden became assistant curator of film and video in 1989 and took the lead in programming film and video at the AGO until 1998, including acquiring video by Frenkel, General Idea, and Sherman.

The year 1995 is usually marked as when, internationally, artists' film began entering the gallery and museum world. But in the decade before 1995, the AGO was ahead of the game in hosting a number of major experimental film exhibitions. A 1985 retrospective of the films of Bruce Elder was followed by a season of "Experimental Film from Three Continents" in fall 1986. In 1987, a comprehensive Wieland retrospective included screenings of all her films. In 1988, Jonasson and Shedden curated *Recent Work from the Canadian Avant-Garde* and in 1989, Kerr curated a major show, *Spirit in the Landscape*. This curatorial energy and institutional momentum led to the organization of the International Experimental Film Congress in 1989 (discussed above). A major renovation of the AGO in the early 1990s led to new spaces like the Rogers Film and Video Gallery; when the site reopened in 1993, this gallery screened films primarily from the gallery's collection, including work by Lipsett, Rimmer, Snow, and Wieland, as well as video by Rhonda Abrams, Michael Balser, Andy Fabo, Frenkel, General Idea, and Steele. In that brief period, a number of international experimental film programs were organized in addition to exhibitions on Canadian experimental filmmakers.[357] A highlight was the monumental 1994 *Michael Snow Project* (with the Power Plant gallery and other partners).

The mid-1990s recession was one factor that led the AGO to cut back on moving image programming in 1995. Thereafter, its main film commitment was an arrangement with Cinematheque Ontario (part of TIFF), which began using Jackman Hall in 1992, with regular experimental programs like *Carte Blanche* (1991-1995) and *The Independents*. Film continued to be screened at the AGO after 1995 but more sporadically, sometimes as part of exhibitions as artists' films were accepted as part of their visual art practice. For example, a 2012 Chambers retrospective included all of his major films alongside his paintings, and exhibitions for international artists like Hito Steyerl and Mickalene Thomas, along with the *Outsiders* and *Toronto: Tributes + Tributaries, 1971-1989* shows, screened film and media.

In addition to pioneers like A Space, other major art world institutions in Toronto that have exhibited experimental film and media art include Gallery 44 Centre for Contemporary Photography, Mercer Union, Museum of Contemporary Art (previously Museum of Contemporary Canadian Art, 1999-2018), Oakville Galleries, the Power Plant, Prefix Institute of Contemporary Art, Tangled Art + Disability, and YYZ Gallery. Goethe-Institut, especially under the leadership of Doina Popescu, was highly active before she left to become the first director of the Ryerson Image Centre (est. 2008). The inaugural Power Plant exhibition *Toronto: A Play of History (Jeu d'histoire)*, curated by Louise Dompierre in 1987, is notable for including film and video on par with visual art, including a number of artists who worked in multiple media (Judith Doyle, General Idea, Massey, Snow).[358]

In addition to the many video art institutions mentioned above, several digital media co-ops have arisen, especially InterAccess (est. 1983 by Nina Beveridge, Bill Perry,

Paul Petro, and Geoffrey Shea), which in turn sponsors the Vector Festival (est. 2013). Francophone artists working in media art and performance have a central hub with Le Labo (est. 2004), which collaborates with many other film and media art organizations. Toronto has been an important centre in the emergence of videogame arts and is home to three organizations: the Hand Eye Society (est. 2009), which claims to be "the first videogame arts organization in the world"; Gamma Space (est. 2011), for artists working in games and interactive digital media; and Dames Making Games (est. 2012), which supports women and non-binary persons working in experimental and independent video game arts.[359]

Toronto also has numerous colleges and universities that have been an integral part of experimental film culture, in addition to the non-academic experimental film teaching and workshop instruction at sites like the Funnel, LIFT, and InterAccess.[360] A more recent independent film workshop venture was Film for Artists—Site and Cycle (est. 2015, led by Zoë Heyn-Jones, Eva Kolcze, and Terra Jean Long), running summer handmade film workshops on Gibraltar Point on the Toronto Islands.

Porter notes that the University of Toronto (U of T) had a Film Production Club in the 1960s at which Cronenberg, Ewing, Fothergill, Sam Gupta, Glen McCauley, and David Sector made short films.[361] Although U of T never had a production department, the Hart House Film Board (est. 1974) supported student filmmakers like Egoyan, and there were numerous film societies and clubs affiliated with various colleges and departments. At Innis College, a Cinema Studies program developed at which experimental film scholars like Armatage, Kass Banning, Joe Medjuck, and Testa taught. The Innis Town Hall is one of the best-appointed film and media art theatres in Toronto and hosts many screenings for independent film festivals, including the Images Festival. In recent years, scholars like James Cahill and Brian Price have written on international experimental film, while the PhD program has nurtured experimental filmmakers like Blake Williams.

Testa was also part of IFS, which had a vigorous screening program from 1985 to 1993, gradually moving screenings off campus to venues like Jackman Hall and CineCycle, although for the purposes of ensuring continued funding from the Innis College Student Society, there were always some events at Innis Town Hall.[362] Shedden was the key organizational figure in IFS. Many other members went on to prominent careers in the arts (e.g., Lisa Godfrey, a producer at CBC *Ideas*; Tracy Jenkins at Lula Music and Arts Centre) and in film, for example, programmers like MacKay and Oxtoby (both of whom went on to Berkeley Art Museum and Pacific Film Archive, MacKay after a career as film programmer and master projectionist, and Oxtoby as experimental film officer at CFMDC and director of programming at Cinematheque Ontario). IFS brought in an ambitious slate of international guests, including Anger, Brakhage, Marjorie Keller, Lowder, Schneemann, and Sharits, and engaged with many cultural agencies,

Innis Film Society, 1991

university departments, and screening venues in what Shedden calls an opportunistic approach to "make events happen," despite lack of operational funding (all funding went to artists and event costs). Although IFS programmed a wide range of film, it concentrated on historical Canadian and US experimental film and screened a lot of Brakhage's and Elder's work, whereas programming collectives like Pleasure Dome emphasized more contemporary filmmakers, including more identity-based work. One IFS member, David Morris, developed a computer program to construct anagrams of the society name: two memorable (and apt) versions were "Leninism I Cosy Fit" and "Inn of Icy Elitisms."

York had the first university film department in Canada (though film had been taught earlier at other schools), but it was largely devoted to documentary and narrative film in its early decades. In the late 1960s, Michael Hirsh made several experimental films at York before co-founding Nelvana, which became one of the most successful children's animation studios in Canada.[363] Keith Lock was in the first cohort of the department but dropped out to make *Everything Everywhere Again Alive* (1975). Sternberg, only the second female instructor in the department, introduced some artisanal filmmaking in her production classes during her time teaching as a Film cross-appointment with Visual Arts (1986-1990), but the industry crew model dominated. For example, in the 1980s and 1990s, Daria Stermac and Torossian took some film courses but found the curriculum hostile to experimental film. While making her handmade *Visions* (1992) there, Torossian notes, "The teachers weren't supportive at all—they said it's impossible, it won't go through the projector, it's not a film. I projected it several times until it got caught in the machine and started burning. Nobody told me I could optically print it and have a negative made...Then I quit school."

The current strength of the university in fostering experimental film was jump-started by Hoffman's move from Sheridan College in 1999.[364] Many students currently active in the Toronto and Canadian experimental film and media scene have graduated from York, either as emerging filmmakers or as mid-career artists earning degrees, including a number of Indigenous media artists: Jennifer Dysart (Cree), Tracy German (Haudenosaunee/Dakota), Lisa Jackson (Anishinaabe), Cara Mumford (Métis/Chippewa Cree), and Parrell (Métis).[365] York University also houses the Art Gallery of York

University, which under curators Philip Monk and Emelie Chhangur included film, video art, and media in many exhibitions. A vital figure at York was long-time film librarian Kathryn Elder, who amassed a large collection of experimental film resources, rescued many film prints deaccessioned by other libraries, and edited several books on Canadian experimental filmmakers for the Cinematheque Ontario monograph series.[366]

In the 1970s and 1980s, Sheridan College developed a large group of experimental filmmakers, which has been identified as the "Escarpment School." Jeffrey Paull and Hancox (who taught there 1973-1985) were influential teachers whose students included Carl Brown, Janis Cole, Holly Dale, Hoffman (student 1977-1979, taught 1986-1999), Hoolboom, Kerr (student 1976-1979, taught 1982-1986), Popovich, and Steve Sanguedolce (student 1978-1981). For Kashmere, these filmmakers applied lyrical photographic methods to explore personal experience through a "process-based, formalist approach to nonfiction."[367] Kashmere also notes that this largely male group of filmmakers were more critically self-conscious in their exploration of "rituals of masculinity" than earlier generations of male filmmakers; many of the filmmakers engaged sincerely with feminist film theory emergent in the period and also with issues of cultural nationalism during a period when the prospect of American "cultural imperialism" seemed possible to resist. The strength of Sheridan's reputation for experimental film and media continues with teachers like German and Kneller.

OCADU is a downtown art school that has consistently taught a range of moving image media, including small-gauge film (Cole and Ross McLaren), video art (Susan Britton, Fung, and Steele), new media (Doyle) and history and criticism (Dot Tuer).[368] Filmmakers like Mangaard emerged in the late 1970s, and Wrik Mead emerged in the late 1980s; later alumni include Jubal Brown, Stephanie Comilang, Leslie Peters, Tasman Richardson, and Floria Sigismondi (all of whom work in multiple media). Since 1998, it has grouped moving image media under a program it calls Integrated Media.

Ryerson University offered courses in film production in the 1950s, in the Ryerson Institute of Technology Photographic Arts department. Like York, Ryerson focused largely on mainstream production, though it also developed a tradition of experimental film teaching from the 1980s on through the presence of Bruce Elder. He mobilized university resources to further both his voluminous scholarly research and his even more prodigious film output through academic grants, equipment, and computer labs. Several generations of students went on to make experimental films, starting with Peter Mettler (whose student film *Scissere* (1983) won the Norman McLaren Award for best Canadian student film), and including Stephen Broomer, Dan Browne, Kelly Egan (now teaching at Trent University), and Izabella Pruska-Oldenhof (now teaching at Ryerson). Campus radio station CKLN-FM hosted a program devoted to art cinema and experimental film, *Frameline* (1998-2008), whose most consistent host was one-time CFMDC Experimental Film Officer Barbara Goslawski; other hosts included Bruce LaBruce, Cameron Bailey,

Above: Richard Kerr at the Loop Collective with
Izabella Pruska-Oldehof, 2006 (John Porter)
Right: Program poster for *Lighthouse*, 2008

Sara Evans, Andrew Munger, and in an earlier iteration of the program, *The Funnel Broadcast*, Hoolboom and Sharon Cook.[369] Many of these students and alumni formed the experimental film community Loop Collective (1996-2009), which had an active screening series, *Lighthouse*, in the Image Arts Building.[370]

Other Ontario cities

Windsor, a border town with a major urban centre (Detroit) across the water, has a vibrant media arts scene, fed, as in many smaller Ontario cities, by a long-standing university fine arts department (University of Windsor). The prominent festival for experimental film is Media City Film Festival (est. 1994), in which figures like Deirdre Logue, Christopher McNamara, Jeremy Rigsby, and most recently Oona Mosna have built an energetic international festival that collaborates with the Art Gallery of Windsor, local ARCs House of Toast and Artcite Inc, and, in recent years, the Detroit Institute of Arts and the Museum of Contemporary Art Detroit. Since 2012, it has run a residency program, Mobile Frames.

Guelph's proximity to Toronto and the University of Guelph's Fine Arts program make it a kind of bedroom community for many artists like Eric Cameron and Noel Harding and the artist group FASTWÜRMS (Kim Kozzi, Dai Skuse). Ed Video Media Arts (est. 1975) was started by Fine Arts graduates as a video and media arts centre.

Media City Film Festival (MCFF)
Above: Greg de Cuir Jr. (stage), with audience
including Bruce McClure, Chris Kennedy,
Almudena Escobar López , Alexandra Cuesta,
Davani Virillas (Colectivo Los Ingrávidos), Oona
Mosna (hat) and others at discussion after
Yugoslav Structuralism lecture, 2018 (Jay Verspeelt)

L to R top: Oona Mosna, Jova Lynne, Marsha
Music, Jessica Allie, Tylonn J. Sawyer,
Scheherazade Washington Parrish celebrate
MCFF's Knight Foundation Challenge grant,
2019 (Marc Ngui)

L to R bottom: Filmmakers, including Sky Hopinka,
Ephraim Asili, Faraz Anoushahpour, Fern Silva,
Parastoo Anoushahpour outside Capital Theatre,
2018 (Oona Mosna)

In Kingston, Queen's was one of the
earliest universities to teach film, with
a tradition of nurturing independent
Canadian cinema. Faculty like Blaine
Allan, Gary Kibbins, Frances Leeming,
Susan Lord, and Scott MacKenzie have
made and/or written about experimental
film, video and media arts. The Agnes
Etherington Gallery at Queen's has often
screened experimental film and media.
The Kingston Canadian Film Festival
(est. 2001) and Reelout Queer Film + Video Festival (est. 1999) are two local festivals.

Peterborough is on the map of Canadian experimental film through the indefatigable
energies of Su Ditta. She was the executive director of the Canadian Images Film and
Video Festival (1978-1988), one of the earliest festivals to focus on Canadian film and
one of the first in Canada to integrate film and video screenings (even before the Images
Festival in 1988). Although the festival did not concentrate on experimental film and
video art, it programmed many, including retrospectives of Al Razutis and Michael Snow,
and Canadian cinema programs that included many works from AFCOOP, CFMDC,
the Funnel, and non-co-op affiliated filmmakers.[371] From 1987 to 1990, Ditta worked as
associate curator for Media Arts at NGC, where she brought new energy to film and video

acquisition, expanding the collection beyond already collected artists like Chambers, Snow, and Wieland; she subsequently served as the head of the Media Arts section at CCA. The Art Gallery of Peterborough has also screened some experimental films. Canadian Images emerged from Trent University and it is appropriate that a new artists collective, Canadian Images in Conversation (est. 2019), has arisen at Trent, working with the ReFrame Film Festival (est. 2005), "to fill the void of experimental, independent, artistic, and archival film exhibition in Peterborough, Ontario." Members include Egan, Jonathan Lockyer, and Amy Siegel.[372]

As the nation's capital, Ottawa has a larger concentration of significant arts and cultural institutions than a city its size would normally enjoy. In addition to serving as the national office of CCA, Ottawa is home to LAC, which has large film and media repositories, and NGC. There was much pressure on NGC to acquire, exhibit, and program experimental film and video art. In 1971, film was included in Joyce Wieland's *True Patriot Love* exhibition, curated by Pierre Théberge. In 1974, NGC assembled four short film programs for a *Canadian Filmmakers' Series*, including work by filmmakers like Michael Asti-Rose, Hancox, Jean-Claude Labrecque, Lorne Marin, Michael Ondaatje (*The Sons of Captain Poetry*, 1970), Rimmer, Razutis, Snow, Soul, and Wieland.[373] In 1980, Bruce Ferguson curated *Canada Video* for NGC at Venice Biennale, including work by Campbell, Pierre Falardeau/Julien Poulin, General Idea, Sherman, and Steele (Ferguson also curated video for *OKanada* in 1982). Sherman had an exhibition, *Cultural Engineering*, in 1983. In 1989, the exhibition *Rebel Girls: A Survey of Canadian Feminist Videotapes/Les Rebelles: Un aperçu des oeuvres vidéo de féministes canadiennes* took place. When Ditta left NGC in 1990 to head the Media Arts section of CCA, she was succeeded by Jean Gagnon (1991-1998), who also acquired some experimental films and curated several programs, including Frenkel's . . . *from the Transit Bar* in 1996. (Gagnon subsequently spent many years at CQ.)

The mandate of the Canadian Film Institute (CFI, est. 1935, the oldest film institution in Canada) covers all forms and aspects of film, but there is a strong record of support for experimental film, especially under long-time executive director Tom McSorley. Its Café Ex (est. 1998) "presents artist-curated evenings of independent experimental film and video."[374] The Ottawa International Animated Festival (est. 1976) is one of the oldest and largest animation festivals in North America. McSorley and Hoolboom have edited titles in the CFI Book Series, which often appear in relation to retrospectives of major Canadian independent filmmakers, including Broomer, Cockburn, Daniel Côté, Hoffman, Jorge Lozano, Torossian, and Ingrid Veninger. CFI hosts many festivals and events in co-operation with three other major art and film and media arts organizations: the Ottawa Art Gallery Alma Duncan Salon, Arts Court Theatre (site of Independent Filmmakers Co-operative of Ottawa (est. 1991), and Club SAW, the exhibition space for SAW Video (est. 1981), a long-established video co-op that

L to R rear: Jason St-Laurent, Phil Rose, James Missen, Dan Gainsford. L to R front: Carol Breton, Penny McCann at Available Light Film/Media Collective screening, Club SAW, 2001 (John Porter)

organized the Ottawa International Festival of Video Art in 1983 and 1986. SAW Video has an online Mediatheque (est. 2003), and runs workshops, commissioning series, and a screening series; Spark Lab (est. 2017) is a video training/creation program for deaf and disabled artists. Other film media organizations in Ottawa include Artengine (est. 1996), a media hub and programmer (including the biennial media arts festival, Electric Fields/Champs électriques, begun by SAW Video); Available Light Screening Collective (est. 1999), which shows experimental film, video art, and new media; and Windows Collective (est. 2008), which concentrates on Super 8, 16mm, and 35mm film installations (Pixie Cram, Paul Gordon, Dave Johnson, and Roger D. Wilson). Across the river in Gatineau, DAÏMÔN (est. 1986) is a media arts ARC.

Ottawa has two universities with traditions of teaching film studies (Carleton) and visual arts (University of Ottawa); students and graduates feed into the many arts organizations in the city. Carleton, in particular, through the efforts of film scholar and Canadian film advocate Peter Harcourt, stoked enthusiasm for Canadian experimental film; one of Harcourt's last published essays was "A Muted Trumpet from Afar: Ruminations on the Cinematic Avant-Garde," in which he advocated for the capacity of experimental film to continue the avant-garde tradition of provocation, "to fuck it up," while celebrating how experimental film "can create in spectators a wonderful sense of *eunoia*—the feeling of beautiful thinking."[375]

Quebec

The history of experimental film, video art, and media arts in Quebec follows somewhat different paths, and some institutional structures differ from the rest of Canada. The health and popularity of the French language fiction film and television industry from the 1960s onward is notable compared to the relative weakness of English-language feature film and television, which is always in competition with American entertainment. Some filmmakers are comfortable working across experimental, documentary, and narrative forms, like Paule Baillargeon, Claude Jutra, Jean Pierre Lefebvre, Jacques

Leduc, Léa Pool, and most recently Denis Côté have worked successfully across the industry and independent sectors that are more divided in English Canada. Forces of Quebec nationalism and separatism, in addition to language barriers, have separated some Quebec arts organizations from others in Canada. For example, when IMAA/AAMI first formed in 1980 as "Independent Film Alliance du Cinéma Indépendant," it deliberately chose a compound bilingual name to include French language organizations. In Sandmark's history of IMAA/AAMI, he notes, "As late as 1980, the Québécois centres could not support the formation of a national association with the idea that it would represent Quebec interests" but by the mid-1980s, "a spirit of co-operation and mutual support had grown." [376] At various times, provincial organizations parallel to IMAA/AAMI were formed in Quebec (e.g., the short-lived Association de la vidéo indépendante du Québec in the late 1980s) until the formation of Conseil québécois des arts médiatiques (est. 1998), which is comparable to AMAAS in Alberta or MANO in Ontario.

Montréal

Vancouver, Toronto, and Montréal are the three major centres of film, video art, and digital media art in Canada, and Montréal's history is as distinct as the other two cities, though all share a central tension between individual artists and institutions that have variously supported and constrained artistic and cultural industries. The major factor influencing the development of artisanal-scale experimental filmmaking in Montréal was the presence of the NFB, whose main office moved from Ottawa to Montréal in 1956. The NFB absorbed and directed much of the experimental film energies in Montréal before the 1980s. However, prior to the NFB's arrival, some films were made independently (e.g., Guy Borremans's *La femme image*, 1959), and Montréal had several active film societies, including the Underground Film Centre in 1968.[377] Jutra's *Mouvement perpétuel...* (1949), which won an award for best amateur film at the Canadian Film Awards, was influenced by his exposure to international avant-garde cinema in New York.[378] As mentioned earlier, the NFB had a major role in Canadian entries to international film festivals. For example, the four Canadian films entered in the 1964 International Experimental Film Competition at Knokke-le-Zoute, Belgium, were NFB shorts: Lipsett's *21-87* (1964), Louis Portugais and Léonard Forest's *Je* (1960), Clement Perron's *Jour après jour* (1962), and Jutra's *À tout prendre* (1964).[379] The NFB supported experimentation in animation and documentary, had important experimental filmmakers in its ranks (Lipsett, McLaren, and others), and its involvement in events like Expo 67 and technical experimentation continues to this day.

However, the expansion of underground film and independent film production co-op filmmaking happening in the rest of Canada was largely absent from Montréal until the 1980s. For example, Varga notes that Association coopérative de productions

Norman McLaren and Evelyn Lambart,
Begone Dull Care, NFB, 1949

audio-visuelles (ACPAV, est. 1971) "was set up to support independent production outside of the institutional constraints of the NFB in Quebec"—but it was a "co-operative of producers (rather than directors or craftspeople) dedicated primarily to independent narrative film."[380] Writing in 1978, John Locke compares the experimental film scenes in New York and Montréal, seeing the "lack of an experimental filmmaking community and the absence of an experimental filmmaking tradition" in Montréal.[381] In the same year, George Csaba Koller, writing a survey essay on experimental film across Canada, observes that "[t]he majority of Quebec filmmakers prefer to tackle social subjects rather than making experimental cinema."[382] In 1986, Michel Larouche wrote, "Few experimental Quebec films were made before 1980, but this genre has always been part of the evolution of Quebec cinema. Even today, the National Film Board (NFB) of Canada is a leader in this area."[383]

Some film institutions outside the NFB did support experimental film in different ways. The first film production co-op in Montréal was Main Film (est. 1982), supporting independent film of all kinds. Mary Armstrong, Marie-Hélène Cousineau, and Richard Stanford were important early organizational figures along with experimental film-makers like Jean-Claude Bustros, Richard Raxlen, Velcrow Ripper, Eric Sandmark, and Peter Sandmark.[384] The Cinémathèque québécoise (CQ, est. 1963) is the main film archive in Canada along with LAC, collecting all forms of cinema, including experimental film.[385] CQ programmed an immense retrospective of animation for Expo 67 and retrospectives of experimental animators like McLaren and Raxlen; it also hosts screenings by other organizations like Double Negative. Distributors that included experimental film in their catalogues included Coopérative des cinéastes indépendents (1967-1979), Cinéma Libre (1979-2004), and Film Film (est. 1983).[386] Serge Losique is best known for his World Film Festival (1977-2019), but he also started the Canadian Student Film Festival in 1969, where Rick Hancox won best documentary for *Cab 16*. There was a festival devoted to work by women, Femmedia: The Independent Film and Video Festival (est. 1973). Cinéma Parallèle (est. c. 1970), linked to Film Film, set up a permanent theatre/café, Cinema Parallel in 1978 that provided an intimate space for film events. It was eventually absorbed by Cinéma ExCentris (1999-2015), a space for digital media led by Daniel Langlois, an important figure in digital media in Montréal.[387] Cinéma

Parallèle also formed the Festival du nouveau cinéma (est. 1971), which has grown into a large and eclectic annual film and media festival that programs experimental film and media art in its "Les nouveaux alchimistes" section, which has the tag line, "Experimentation, Metamorphosis, Transcendence."[388]

If the independent experimental film scene was less active, the video scene was on fire.[389] The first video art co-op was Vidéographe (est. 1971), which emerged out of the NFB Challenge for Change program and became independent in 1973 with CCA funding.[390] Likely as a reaction to this largely male group, Groupe Intervention Vidéo (GIV, est. 1975) was formed to produce, distribute, and exhibit video art made by women.[391] The Vehicle Art Gallery began video production in 1972, but its video section became independent with the formation of Productions et Réalisations Indépendantes de Montréal (PRIM, est. 1981).[392] Another video co-op entered the scene in 1976, Coop Vidéo de Montréal, focusing more on documentary and activist modes, led by Robert Morin.[393]

The current scene in Montréal is vibrant, in addition to work continuing at Vidéographe, PRIM, GIV, Co-op Video, and Main Film. The principal centre for experimental film is Double Negative Collective (est. 2004), emerging out of students in Richard Kerr's classes in experimental film at Concordia University: Karl Lemieux, Mike Rollo, Daïchi Saïto, and others engaged in "a dialogue long-neglected in the independent artist-based filmmaking community: a benevolent conspiracy of ideas."[394]

Their founding manifesto captures elements of previous experimental and avant-garde film traditions, including a critique of the mainstream ("We locate cinema in human experience, in the eye, hand and heartbeat, not in the worn-out tropes that pass for meaning and feeling in conventional moviemaking"), but is open to all possibilities ("We provide no prescription for what film ought to be, but elucidate what it is: impossible pasts and futures in a trajectory of unraveling present, images pausing and passing from somewhere up there, in back of the head").[395] Double Negative's many exhibition activities included hosting an edition of the International Experimental Cinema Exposition (TIE, est. 2000), a festival "concerned with the preservation and continued exhibition of avant-garde film."[396] Another film-centred organization is La Lumière Collective (est. 2016), which has co-sponsored events with Main Film, and which

Double Negative Collective at Cinéma Parallèle, 2010

functions as a micro-cinema showing, among other programs, Benjamin R. Taylor's monthly VISIONS programs.[397] Other film-centred organizations include production co-op Les Films de l'Autre (est. 1988) and distributor Les Films du 3 Mars.

Montréal has become a major centre for digital media arts, including not only industrial production of computer-generated imagery (CGI), special effects, and video games, but also a growing independent media arts scene that includes new media hub Oboro (est. 1982); TOPO Laboratoire d'Écritures Numériques (est. 1993); bilingual feminist media arts centre Studio XX (est. 1996); digital arts network, distributor, and incubator, perte de signal (est. 1997/2001); exhibition producer Molior (est. 2001); digital media art centre Eastern Bloc (est. 2007); and Projetto – culture, nature, milieu (est. 2005).

Universities are an integral part of the independent film and media scene, while CEGEPs provide academic employment for many artists and scholars. At Université du Montréal, artists like Alexandre Larose have emerged in recent years while experimental film scholars like André Habib teach in the Département d'histoire de l'art et d'études cinématographiques. UQAM (Université du Québec à Montréal) has a large media school and a domed screening space, Agora du coeur des sciences de l'UQAM, that hosts experimental digital projection performances. McGill does not have a film school, but scholars Ron Burnett (who published *Ciné-Tracts*, 1977-1982) and especially William Wees, a key scholar in international avant-garde cinema and early champion of Lipsett's work, are important to its history, along with current scholars Yuriko Furuhata and Alanna Thain.

Concordia University has one of the largest film schools in Canada (Mel Hoppenheim School of Cinema) and a separate Communication Studies department with filmmakers like Hancox and scholars of Canadian cinema like Charles Acland and Monika Kin Gagnon. At the Cinema department, scholars like Mario Falsetto, Locke, and Catherine Russell have written on experimental work, while artists like Bustros, Kerr, François Miron (a master of the optical printer), and Marielle Nitoslawska, have taught many students.[398] Graduates include Bonnetta, Louise Bourque, Nelson Henricks, Monique Moumblow, Price, Saïto, and many others.

Quebec City

As the provincial capital and site of a major university, Laval, with a strong Département de littérature, théâtre et cinéma, Quebec City has a strong tradition of independent film and video art. The first major co-op was Video Femmes (est. 1974 by Helen Doyle, Nicole Giguère, Hélène Roy), followed by the film co-op Spirafilm (est. 1977); these organizations merged to become Spira: Independent Cinema Cooperative, which now functions as a production and distribution co-op. In 1977, under the name Centre populaire d'animation audiovisuelle de Québec, La Bande video et film de Québec

(est. 1977), a video and digital arts centre, began.[399] In 1993, ten independent arts organizations combined under the umbrella organization Méduse, including Spira; Antitube (est. 1995), which presents screenings and events; and Manif d'art – Quebec City Biennial (est. 2001), which presents media art in its exhibitions. To the north of Quebec City, the town of Rimouski has a media arts co-op and cinema, Paraloeil (est. 1999).

Atlantic Region

Darrell Varga's 2015 book, *Shooting from the East: Filmmaking on the Canadian Atlantic*, provides an important history of the range of filmmaking practices across New Brunswick, Prince Edward Island, Nova Scotia, and Newfoundland and Labrador. Like the Prairie region, there is less of an established film and television industry, which has meant that production co-ops have served a full range of narrative, documentary, and experimental production. The Atlantic region also has a high number of universities with art schools that have, as Varga notes, led to a strong concentration on animation in experimental production.

The Newfoundland Independent Filmmakers Co-op (NIFCO, est. 1975) has nurtured the production of a number of notable quirky narratives (e.g., *The Adventure of Faustus Bidgood*, 1986, *Extraordinary Visitor*, 1998). The St. John's International Women's Film Festival (est. 1989), one of the longest running women's film festivals, screens a broad range of narrative, documentary, and some experimental work.

In New Brunswick, Fredericton is the base for the New Brunswick Filmmakers' Co-Operative (NBFC, est. 1979), which has also had some outreach in Saint John and Moncton. A principal figure for NBFC is Tony Merzetti, involved since 1983 and executive director since 1986, and also an instructor in Film Studies at the University of New Brunswick (UNB), where NBFC runs a screening series. In 1997, UNB was involved in establishing Fredericton's first queer video festival. The *Femmes en Focus* video festival (est. 1987) is based in Moncton. In Edmundston, the heart of the French/Acadian community, documentary filmmaker Rodolphe Caron helped establish the Cinémarévie Coop (La Coopérative des artisans du cinéma en Marévie, est. 1980).

Students working in Super 8, video, collage, and animation in the Fine Arts programs at Mount Allison University in Sackville have made that small city a location for some experimental film and video art in New Brunswick. Colin Campbell taught there from 1971 to 1973, where he made *Sackville I'm Yours* (1972), while photographer Thaddeus Holownia ran film screenings at the local Vogue Cinema theatre. Since the Owens Art Gallery at the university concentrated on the fine arts traditions of painting and sculpture, the Struts Gallery & Faucet Media Arts Centre (est. 1980) was set up to provide

Outdoor screening organized by Umbrella Projects, a collaboration between Owens Art Gallery and Struts Gallery & Faucet Media Arts Centre, Sackville, NB, 2020 (Mathieu Leger)

a site for installations and performance art, while also screening experimental films in the gallery space (Faucet was established after Struts, providing film and video training and equipment for the region). Barbara Sternberg was a founding member of Struts, with Dyana Werden Asimakos, and lived in Sackville in early 1980s. Her film *Transitions* (1982) was shot in Super 8 and optically printed at AFCOOP, and her *Tending Towards the Horizontal* (1989) has a voice-over text by Acadian writer Frances Daigle.[400]

In Charlottetown, Prince Edward Island, Island Media Arts Cooperation (IMAC, est. 1978) was the main film and media arts co-op, "re-branded" in 2018 as FilmPEI befitting its largely industry focus (for example, IMAC hosted an annual Atlantic Film and Video Producers conference).[401] PEI media artists include Millefiore (Mille) Clarkes, Evan Furness, and Judith Scherer. Rick Hancox is a PEI native who recounts taking a course in 1968 from a visitor from New York underground film, George Semsel: "He taught PEI's first (and last) course in 16mm filmmaking," after which Hancox started a film club and continued to make films.[402]

Halifax, Nova Scotia, has been the main centre for independent film and video art in Atlantic Canada. The Atlantic Filmmakers Cooperative (AFCOOP, est. 1974) lays claim to being the "oldest English-speaking film co-op in Canada"; its oft-cited origin story is, "In 1973, 17 ambitious artists gathered at the Seahorse Tavern in Halifax to chat about filmmaking."[403] An important context for AFCOOP is its ambivalent relationship to more mainstream institutions. For example, the NFB opened a regional office in Halifax in 1973, providing both resources and an institutional foil for independent-minded filmmakers. After helping establish the Atlantic Film Festival (est. 1982), AFCOOP

organized an alternative Halifax Independent Filmmakers Festival in 2007 with some alternative work featured. Earlier, AFCOOP sponsored Wormwood's Dog and Monkey Cinema (1976-1998).[404]

James (Jim) McSwain is a key central figure in the Halifax media arts history, graduating from Mount Allison University in 1969 and working as an artist in multiple media (theatre, puppetry, poetry) before making his first film, *Kiss* (1979).[405] McSwain's film work has crossed animation, autobiography, and activism (he contributed to the AIDS Cable Project when working in Ontario for CFMDC in 1989). He was also highly active as an arts administrator and programmer; he co-founded, with Bonnie Baker, Canadian Filmmakers' Distribution Atlantic (which became Atlantic Independent Media) and worked there from 1983 to 1996 (Tom Fitzgerald was co-director).[406]

According to Varga, "Animation is the dominant form for experimental filmmaking in Halifax and, by and large, throughout the Atlantic region. In the case of AFCOOP, it may be proximity to a major art school that has offered traditional drawing as well as 16mm film animation in courses taught by Henry Orenstein long

Poster for Handmade Film Collective screening, in partnership with AFCOOP and MediaNet, 2020

before it began scheduling courses in live-action filmmaking."[407] An important figure in animation history is US artist Helen Hill, who moved to Halifax in the mid-1990s, teaching workshops at AFCOOP.[408] Her *Madame Winger Makes a Film* (2001) and widely circulated DIY instruction book *Recipes for Disaster* (2000, issued in 2001 with support from the SpliceThis! Super-8 Film Festival in Toronto) are popular teaching texts. Other experimental filmmakers and media artists who have worked in Nova Scotia include Janet Hawkwood, Penny McCann, Nagler, and Chris Spencer-Lowe.

The major arts school is NSCAD University. While the school may produce artists who have gravitated to animation at AFCOOP and elsewhere, its reputation primarily stems from being a centre for avant-garde arts in the 1970s, importing a roster of guest artists who were a Who's Who in the international arts scene (e.g., Joseph Beuys, Yvonne Rainer, Steve Reich, Michael Snow). Among filmmakers, Robert Frank and Peter Kubelka taught classes in the early 1970s. NSCAD was also a forerunner in video. "In 1969, Halifax, NSCAD established video facilities for art production, documentation and instructional video which continues to this day. NSCAD's academic video program was

one of the first in Canada that was not an artist-run centre."[409] NSCAD was a forerunner in feminist art education, holding the first feminist art history course, "Woman as Image and Image-Maker," in 1976.[410] The school ran the Lifesize Women and Film series (1981-1989). From 2002 to 2005, Gerda Cammaer, as part of La Femme 100 Têtes, "a curatorial collective dedicated to the presentation of independent film and video in a visual art context," curated three major programs of contemporary experimental film and video art at the Mount Saint Vincent University (MSVU) Art Gallery.[411]

The Centre for Art Tapes (CFAT, est. 1979) was established as an ARC to produce, program, and distribute video and media art. Early Halifax video artists include David Askevold, Edward (Ed) Slopek, and Douglas Waterman.[412] In 1989, NSCAD, CFAT, and the NFB office coordinated on an experimental film series, *The Act of Seeing With One's Own Eyes.*[413]

The North: Yukon, Northwest Territories, Nunavut

In Yukon, there is a Yukon Film Society in Whitehorse, established in 1984 to "exhibit and promote the appreciation of alternative film" (including the Available Light Film Festival, est. 2002) but adding in 1995 production support for "the creation of film and media art as a personal, cultural and artistic practice."[414] The Dawson City Arts Society (est. 1998) started the Klondike Institute of Art and Culture in 1999, and began the Dawson City International Short Film Festival in 2000. Filmmaker Lulu Keating, an active presence at AFCOOP in the 1980s, has been active in the Yukon film community since 2003, also writing criticism. In partnership with Yukon College and Tr'ondëk Hwëch'in, the Yukon School of Visual Arts opened its doors in September 2007, teaching media arts as part of its curriculum, and housing an active Artist in Residence program.[415]

Yellowknife, Northwest Territories, has a film co-op, Western Arctic Moving Pictures (est. 2006), which runs the Yellowknife International Film Festival and a Hackspace program, which runs video game workshops for Indigenous youth.

Igloolik, Nunavut, is the home for the Isuma collective, which, I argued near the beginning of this essay, could be considered a test case for a more capacious history of experimental film, insofar as the moving image artworks Isuma produced share the same aesthetic qualities, artisanal production scale, and independent film and media art circulation (through distributors and festivals) as what has been described as "Canadian experimental film" and its allied moving image art forms.[416] Isuma is one of the most important media art organizations in Canada for its production and impact over the past decades. On its website, Isuma makes the important claim, "In 1985, the Inuktitut-language video, *From Inuk Point of View,* broke the race-barrier at Canada Council for the Arts when Zacharias Kunuk became the first Inuit or Indigenous applicant ruled eligible

to apply for a professional artist's grant."[417] Kunuk as director has been the most visible member of Isuma, partly due to post-1960s film culture's (over)identification of the director as main "author" responsible for a film's artistic qualities. But Isuma has always been a group enterprise, with important figures like Paul Apak Angilirq, Norman Cohn, and Pauloosie Qulitalik involved in the original partnership that formed Igloolik Isuma Productions Inc. in 1990.

Lucy Tulugarjuk, *Tia and Piujuq*, Arnait Video Productions, 2018

Isuma produces "independent video art from an Inuit point of view," laying claim to a community voice that also found expression in the establishment of a youth media and circus group (Artcirq), and a web portal, IsumaTV, that allows online access to Isuma productions, in addition to those of other Inuit and Indigenous media, like the women's video collective, Arnait Video Productions (est. 1991).[418] Arnait was set up by Marie-Helene Cousineau, along with founding members Susan Avingaq, Mathilda Hanniliaq, Madeline Ivalu, Martha Makkar, and important subsequent member Mary Kunuk, after she helped Cohn and Kunuk set up the Tarriaksuk Video Centre.[419] Arnait has produced a range of media, including *Tia and Piujuq* (2018), directed by Lucy Tulugarjuk, about a friendship between a young Syrian refugee and an Inuk girl. At the start of the twenty-first century, Isuma made dramatic inroads into two worlds often separate from (and sometimes aspired to by) experimental filmmakers: first, the narrative feature film world, with the success of *Atanarjuat: The Fast Runner* (2001), which won the Camera d'or at the Cannes Film Festival; and second, the art world, when *Atanarjuat* and *Nunavut (Our Land)*, a 13-part TV series, were shown at Documenta 11 in Kassel, Germany, in 2002. Subsequently, "Kunuk, Cohn and the 30-year Isuma media art project represented Canada at the 2019 Venice Biennale, and shared new work at the 2019 Toronto Biennial."[420]

Early Monthly Segments screening,
Gladstone Hotel, 2012 (Aliza Ma)

Acknowledgements

In 2011, Martha Langford invited me to write an essay that would fill a gap in Canadian art history on experimental film. I could not complete it then and it has taken ten years to even begin to scratch the surface of the complex history of experimental film in the land called Canada. Along the way, I have learned much from colleagues and students with whom I've consulted and/or whose work I have read, especially Clint Enns, and Scott Miller Berry, Wendy Donnan, Chris Gehman, Phil Hoffman, Eli Horwatt, Chris Kennedy, Deirdre Logue, Janine Marchessault, Aimée Mitchell, Allyson Mitchell, Cam Moneo, Genne Spears, Bart Testa, and Haidee Wasson, although I take full responsibility for the approach and inevitable mistakes in this text. Parts have been previously published in "Toronto as Experimental Film Capital: Screenings, Schools, and Strong Personalities," in *Explosion in the Movie Machine: Essays and Documents on Toronto Artists' Film and Video*, ed. Chris Gehman (Toronto: YYZBooks, 2013), 90–110; and "A Report on Canadian Experimental Film Institutions, 1980–2000," in *North of Everything: English-Canadian Cinema since 1980*, eds. William Beard and Jerry White (Edmonton: University of Alberta Press, 2002), 392–401. At York University, Dean Sarah Bay-Cheng and Charlotte Whelan have provided invaluable material support. My thanks to James Harbeck, Paula Sarson, and the team at Goose Lane Editions. Thanks, as always, to Tess Takahashi, for being there. I am most grateful to the editors of *Moments of Perception*: to Barbara Sternberg, for her support and many excellent editorial suggestions, and especially to Jim Shedden, for his patience, and whose friendship, starting from the years of the Innis Film Society, nourished my appreciation of experimental film and media, and much more.

—MICHAEL ZRYD

Notes

1 Quoted in Philip Lewis, "Indigenous Renaissance: 10 to Watch at the NFB," *NFB Blog* (blog), June 19, 2019, https://blog.nfb.ca/blog/2019/06/19/indigenous-awakening-10-to-watch-at-the-nfb/.

2 In 2017, curator Wanda Nanibush programmed Dunn's film as part of a screening, Indigenous Freedom, at the Art Gallery of Ontario, part of the exhibition Peggy Gale, Stephan Jost, and Wanda Nanibush, eds., *Toronto: Tributes + Tributaries, 1971–1989 = Gchi-oodenaang : Ezhi-mina-waajimong Eni-naabiischigeng* (Toronto: Art Gallery of Ontario, 2018). Exhibition catalogue. See also Wanda Nanibush, "Cultural Sovereignty in Cinema: Beyond Tonto in Toronto," in *Explosion in the Movie Machine: Essays and Documents on Toronto Artists—Film and Video*, ed. Chris Gehman (Toronto: YYZBooks, 2013), 172–87.

3 Jerry White makes a case for Zacharias Kunuk as an auteur in "Zack Kunuk and Inuit Filmmaking," in *Great Canadian Film Directors*, ed. George Melnyk (Edmonton: University of Alberta Press, 2007), 347–60.

4 Katherine Quanz, "Preserving Ephemeral Aboriginal Films and Videos: The Archival Practices of Vtape and IsumaTV," in *Cinephemera: Archives, Ephemeral Cinema, and New Screen Histories in Canada*, ed. Gerda Cammaer and Zoë Druick (Montréal & Kingston: McGill-Queen's University Press, 2014), 256–72.

5 Nanibush, "Cultural Sovereignty," 185. Like Nanibush and others in experimental film and media, I question the current utility of the term *avant-garde*.

6 Nanibush, "Cultural Sovereignty," 185.

7 Canada has relatively active immigration policies (according to the United Nations (UN) Population Division, Canada ranks highly among Western nations in migrants per person). In the post–Second World War era, Canada supported UN attempts at international peace, including in the arts; for example, experimental animator Norman McLaren taught in China in 1949 and India in 1953 for UNESCO, and multimedia events like Expo 67 espoused the "one-world" utopian rhetoric of the mid-century era.

8 An interesting example of a response to this policy was Liz Park's exhibition *Limits of Tolerance: Re-Framing Multicultural State Policy* (2007), at the Morris and Helen Belkin Art Gallery (Vancouver), which included a number of key media artists: Dana Claxton, Stan Douglas, Laiwan, Paul Lang and Zachary Longboy, Âhasiw Maskêgon-Iskwêw, and Paul Wong.

9 Deanna Bowen, ed., *Other Places: Reflections on Media Arts in Canada* (Toronto: Media Arts Network of Ontario/Public Books, 2019) 470–71.

10 Bowen, *Other Places*, 472. Some elements of intersectional identity, including disability, gender, and sexuality, may seem unrelated to questions of how to define *Canadian*. Yet each of these elements, historically, has links to forms of legal discrimination administered by Canada as a state. The legal rights of women (to vote, to choose) have only gradually been granted, and freedoms from discrimination on the basis of sexual orientation or ability are relatively recent, achieved in the latter part of the twentieth century.

11 Bowen, *Other Places*, 473.

12 "Every Toronto Film Festival (Updated 2019)," *IndiefilmTO* (blog), December 20, 2018, https://indiefilmto.com/every-toronto-film-festival-2019/.

13 Marc Glassman, "Introduction: A New Showcase," *Images 88: A Showcase of Contemporary Film & Video*, 1988, 2.

14 Board of Directors of Northern Visions, "Introduction: Images 89," *Images 1989: Festival of Independent Film & Video*, 1989, 5.

15 An issue of the CFMDC's *Independent Eye* was devoted to German experimental film (Spring 1990).

16 See Scott MacKenzie and Janine Marchessault, eds., *Process Cinema: Handmade Film in the Digital Age* (Montréal & Kingston: McGill-Queen's University Press, 2019); and Kim Knowles, *Experimental Film and Photochemical Practices* (Switzerland: Palgrave Macmillan, 2020). In addition to Film Farm, Double Negative Collective (est. 2004) in Montréal has also been active in hand-processed cinema.

17 Due to my limited knowledge of the French language, I regret that this survey will not do justice to the different ways that experimental filmmaking developed in francophone Quebec. In addition, there are multiple languages and cultural traditions of Indigenous and immigrant communities that may also have separate discourses around independent and experimental filmmaking, which I am similarly unable to cover as well as they deserve.

18 Erika Balsom, *After Uniqueness: A History of Film and Video Art in Circulation* (New York: Columbia University Press, 2017), 15, 18.

19 Marc Glassman, "Seated Figures," *Vanguard* (Summer 1988): 39.

20 Gary Kibbins, "Bear Assumptions: Notes on Experimentalism," *Public*, no. 25 (2002): 148. This special issue of *Public* includes multiple texts that mediate on the term *experimentalism* in film and media art from the conference, Blowing the Trumpets to the Tulips, at Queen's University, October 19–21, 2001.

21 Quoted in Kibbins, "Bear Assumptions," 149.

22 See Bart Testa, *The Avant-Garde + Primitive Cinema* (Toronto: The Funnel, 1985); and Bart Testa, *Back and Forth: Early Cinema and the Avant-Garde* (Toronto: Art Gallery of Ontario, 1992), catalogues for two film programs in Toronto.

23 Gallons of ink have been spilled in aesthetic, film, and communications theory on the political impact of form. In practice, these theoretical prescriptions have usually been confounded by the resistance of spectators to following a programmatic message: for better or worse, we spectators tend to think we know our own minds, even though we are subject to false consciousness, ideology, and confirmation bias.

24 Like others, Hoolboom also objected to "experimental" for being "apolitical, academic, formalist and necessarily hermetic," objections symptomatic of the high temperature of debate in this period. Rose Lowder, ed., *The Visual Aspect: Recent Canadian Experimental Films* (Avignon: Editions des Archives du film expérimental d'Avignon, 1991), 11. Exhibition catalogue.

25 Mike Hoolboom, *Inside the Pleasure Dome: Fringe Film in Canada*, revised ed. (Toronto: Coach House Books, 2001); Hoolboom, *Practical Dreamers: Conversations with Movie Artists* (Toronto: Coach House Books, 2008).

26 R. Bruce Elder, *Image and Identity: Reflections on Canadian Film and Culture* (Waterloo: Wilfrid Laurier University Press in collaboration with the Academy of Canadian Cinema & Television, 1989), xiii.

27 The lineage of visual artists making just a few films before moving onto other pursuits includes Léger and Duchamp and in Canada, Greg Curnoe, Alexander Keewatin Dewdney, Betty Ferguson, Gary Lee-Nova, Andrew Lugg, and David Morris. (Dewdney, Lugg, and Morris went on to academic careers.)

28 The term *structural film* was coined by US critic P. Adams Sitney in "Structural Film," *Film Culture*, no. 47 (Summer 1969): 1–10, and elaborated in his influential book *Visionary Film: The American Avant-Garde* (New York: Oxford University Press, 1974). In the UK, filmmakers like Peter Gidal and

Malcolm Le Grice, more informed by political philosophy, made *structural/materialist films*.

29 Gene Youngblood, *Expanded Cinema* (New York: Dutton, 1970).

30 Laura Mulvey, "Visual Pleasure and Narrative Cinema," *Screen* 16, no. 3 (Autumn 1975): 6–18.

31 Audre Lorde's famous 1979 quotation articulated one side of a wide debate over the politics of form, which extended across the politics of gender, race, and sexuality: "For the master's tools will never dismantle the master's house. They may allow us to temporarily beat him at his own game, but they will never enable us to bring about genuine change. Racism and homophobia are real conditions of all our lives in this place and time," Audre Lorde, *Sister Outsider: Essays and Speeches* (Trumansburg: Crossing Press, 1984), 110–14.

32 Abigail Child, Cécile Fontaine, Ken Jacobs, Julie Murray, and Leslie Thornton are just some of the important international experimental filmmakers working with found footage from the 1960s onward.

33 William Wees, "Breaking New Ground: Canada's First Found-Footage Films," in Cammaer and Druick, *Cinephemera*, 112–36. The international journal *Found Footage Magazine* (est. 2015) has also published work on other Canadian artists like Louise Bourque, Dan Browne, Jean-Claude Bustros, Clint Enns, Walter Forsberg, Winston Hacking, Mike Hoolboom, Izabella Pruska-Oldenhof, Daïchi Saïto, and Kirk Tougas, suggesting the past and current vitality of the form.

34 Tess Takahashi, "Writing the World: Medium Specificity and Avant-Garde Film in the Digital Age," in MacKenzie and Marchessault, *Process Cinema*, 459–82.

35 Chris Gehman, "Toward Artisanal Cinema: A Filmmakers' Movement," in MacKenzie and Marchessault, *Process Cinema*, 172–93.

36 *Cinema Scope* was founded by writer and filmmaker Mark Peranson. *Opsis* was co-edited by Michael Eliot-Hurst, Al Razutis, and Tony Reif. *Incite!* was founded by Brett Kashmere, a Canadian writer and filmmaker now based in the US. Frameworks was founded by French-based American Pip Chodorov and has been the major international communication conduit for the English-language experimental film community, archived at http://www.hi-beam.net/fw/index.html.

37 Gerald Saul, "Canadian Avant-Garde Film in the 1990s" (master's thesis, York University, 1996), 29.

38 Peggy Gale, "All These Years: Early Toronto Video," in Gehman, *Explosion in the Movie Machine*, 58.

39 Kibbins, "Bear Assumptions," 150–51.

40 John G. Hanhardt, "From Screen to Gallery: Cinema, Video, and Installation Art Practices," *American Art* 22, no. 2 (Summer 2008): 2.

41 A notable exception is MoMA, the New York museum that was a leader in validating film in the art world, collecting film starting in 1935; its basement theatres are jewels in the city's art and experimental film and media landscape.

42 Balsom notes that the term *artists' moving image* is used more widely in the UK, and has been adopted by the international consortium DINAMO, the Distribution Network of Artists' Moving Image Organizations (*After Uniqueness*, 16). Another umbrella term used for film and video art in art history and visual arts that never gained much traction is *time-based arts*.

43 "About Us," IMAA/AAMI, accessed July 15, 2020, https://www.imaa.ca/about-us/.

44 Brett Kashmere and Astria Suparak, "In Pursuit of Northern Lights: Tracking Canada's Living Cinema," *Brett Kashmere*, accessed May 10, 2020, http://www.brettkashmere.com/in-pursuit-of-northern-lights.

45 Loopers are apparatuses used for film installations that allow films to be projected continuously, feeding a loop of film into a modified projector.

46 Standard 8mm used a 16mm piece of footage shot on one side and then flipped to expose the second side; after processing, the lab would split the film to create a single 8mm reel.

47 Milada Kovacova, ed., *POP OFF: The Regular 8 Faction* (Toronto: YYZ Artists' Outlet, 1998). Exhibition catalogue.

48 Haidee Wasson, *Everyday Movies: Portable Film Projectors and the Transformation of American Culture* (Oakland: University of California Press, 2020).

49 Peggy Gale, "Toronto Video: Making Waves," in Gale, Jost, and Nanibush, *Toronto: Tributes + Tributaries*, 178.

50 An exception is MoMA, which has a large film collection it conserves and a separate Circulating Film Library that it rents.

51 Peggy Gale, "Toronto Video," 178. For example, 3-gun video projectors often failed accurately to register colour, or simply to register together.

52 Even the term *installation* can be a stretch: some films and videos get renamed *single-channel installations*, a euphemism for a film on a looper, or a video monitor or projector attached to a DVD player in a gallery space.

53 Some galleries try to create mini-theatre spaces with temporary walls, curtains, and chairs to improve screening conditions, but sound bleed remains a persistent problem.

54 Heath went on to found, with Chrysanne Stathacos, Grange Arts and Performance Space (The GAP) in the late 1970s and CineCycle (est. 1991), one of Toronto's key sites for experimental film and media screenings, especially Pleasure Dome and Liaison of Independent Filmmakers of Toronto (LIFT). Janine Marchessault, "Of Bicycles and Film: The Case of Cinecycle," *Art/Culture/Ideas*, no. 40 (2010): 93–104.

55 Martin Rumsby, *Hidden Cinema: 1989 Saskatchewan Filmpool Co-Operative Western Canada Film Tour* (Regina: Saskatchewan Filmpool Co-operative, 1989).

56 Isabelle Rousset, "Film Trek," *The Independent Eye* 11, no. 1 (Fall 1989): 10–12.

57 Film preservation on film involves the creation of one film internegative for archival purposes and a second internegative used for making prints. Digital tools are used in preservation, and while standards and practices continue to evolve, film remains the most stable preservation format.

58 For example, David Rimmer's films were preserved by the Academy of Motion Picture Arts and Sciences Archive in Los Angeles, which has a long-standing record with experimental film, including non-US artists, through the work of preservationist Mark Toscano. Some Canadian university archives (e.g., University of Toronto and York University) have begun archiving film and media, along with museums like AGO and NGC.

59 Hollis Frampton, "The Invention without a Future," *October*, no. 109 (2004): 75.

60 Bowen, *Other Places*, 470–71.

61 Led by Janine Marchessault, the project includes many experimental film and media distributors (CFMDC, GIV, Vtape, VIVO, WFG, VUCAVU), community organizations (Hands On Media Education, Regent Park Film Festival), Indigenous organizations (Arnait Video Productions, imagineNative Film & Media Arts Festival, Urban Shaman), and LGBTQ2+ organizations (ArQuives, Queer Media Database, and Reelout), connecting them to larger organizations like CQ, LAC, MANO, NFB, TIFF, and provincial archives in Ontario and Nova Scotia, and researchers at Concordia, Queen's, Ryerson, and York University. "Welcome | Archive/CounterArchive," 2018, https://counterarchive.ca/welcome. Full disclosure: I am affiliated with the A/CA project.

62 Canadian video art, in particular, has enjoyed excellent scholarship. Peggy Gale is the premiere historian and critic for video art in Canada, editing books like *Video by Artists* (Art Metropole, 1976) and (with Lisa Steele) *VIDEO re/VIEW: The (best) Source Book for Critical Writings on Canadian Artists' Video* (Art Metropole, 1996). Janine Marchessault's

edited volume *Mirror Machine: Video and Identity* (Toronto: YYZ Books, 1995) and the exhibition catalogue *Magnetic North* (Minneapolis: University of Minnesota Press, 2000) are two other major anthologies of Canadian video art documentation and criticism.

63 Nonetheless, the focus remains on what has been called experimental film and its descendants, and there are many forms of independent film and electronic arts not included (e.g., holography, computer art, haptic digital arts).

64 See Internet Archive, including the Wayback Machine, https://archive.org/; and Andrea Fatona, *The State of Blackness: From Production to Presentation*, https://thestateofblackness.format.com/.

65 Deanna Bowen, "Berlin, Berlin," Keynote address, *Archive/Counter-Archive Symposium*, December 10, 2020.

66 Finally, while the broader ambit of this history aims to recognize the multiplicity of people involved in experimental film and media, it also means more people will be excluded who deserve special mention: apologies in advance.

67 John Porter, "Artists Discovering Film in Post-War Toronto," *Vanguard*, Summer 1984; Charles Tepperman, "Uncovering Canada's Amateur Film Tradition: Leslie Thatcher's Films and Contexts," in Cammaer and Druick, *Cinephemera*, 48.

68 Tepperman, "Uncovering," 50–51.

69 BC Archives, https://search-bcarchives.royalbcmuseum.bc.ca/and. Fowler married Oscar Burritt and both worked in the Vancouver Film Society before moving to establish the Toronto Film Society.

70 Jan-Christopher Horak, *Lovers of Cinema: The First American Film Avant-Garde, 1919–1945* (Madison: University of Wisconsin Press, 1995).

71 Stanley Fox, "Memories of Film Societies: The Pioneers—Dorothy & Oscar Burritt." Toronto Film Society, accessed November 2, 2019. http://torontofilmsociety.com/news/fifty-years-in-film-1947-1997/.

72 David Clandfield, *Canadian Film* (Toronto: Oxford University Press, 1987), 19.

73 Quoted in Clandfield, *Canadian Film*, 121.

74 "Caroline Leaf – An Interview," *Senses of Cinema*, accessed May 1, 2020, http://sensesofcinema.com/2003/feature-articles/caroline_leaf/. Thanks to Jen Martin-Cannon for this quotation.

75 Stephen Broomer, *Codes for North: Foundations of the Canadian Avant-Garde Film* (Toronto: Canadian Filmmakers Distribution Centre, 2017).

76 Quoted in André Martin, *Norman McLaren* (Annecy: Journées internationales du cinema d' animation; Montréal: Cinémathèque canadienne, 1965). Exhibition catalogue.

77 Guy Glover, *McLaren* (Montréal: National Film Board of Canada, 1980): 18.

78 The following are but a few of the animators whose careers have involved stints at the NFB, a legacy of McLaren's pioneering work as an administrator—and the many other NFB administrators and producers who have hired, sheltered, challenged, and shaped the work of filmmakers for decades: Don Arioli, Laurent Coderre, Sidney Goldsmith, Co Hoedeman, Wolf Koenig, Ryan Larkin, Bernard Longpré, Colin Low, Yvon Mallette, Pierre Moretti, Gerald Potterton, Marcel and Réal Racicot, Rick Raxlen, Robert Verrall, and Donald Winkler (some of whom worked in documentary as well). Louise Beaudet lists a number of women hired in the animation unit, including Francine Desbiens, Viviane Elnécavé, Suzanne Gervais, Judith Klein, and Clorinda Warnyo; other notable women animators at the NFB include Lambert, Leaf, Ann Marie Fleming, and Veronika Soul. See Louise Beaudet, "Animation," *Self portrait: Essays on the Canadian and Quebec Cinemas*, ed. Pierre Véronneau and Piers Handling (Ottawa: Canadian Film Institute, 1980), 106–21.

79 Norman McLaren, *Cameraless Animation*, Information and Promotion Division (National Film Board of Canada, 1958).

80 Non-theatrical film refers to film exhibition outside commercial movie theatres, and includes educational, industrial, documentary, and experimental film screenings in churches, schools, community centres, film societies, or travelling exhibitors.

81 Toronto Film Society, "Fifty Years in Film: 1947–1997," accessed January 19, 2021, http://torontofilmsociety.com/news/fifty-years-in-film-1947-1997/.

82 Anthony Ferry, "Your Taxes Finance Revolt in Quebec—but It's All on Film: The Award-Winning Young Turks of NFB," *Toronto Daily Star*, March 5, 1966, 23.

83 Toronto Film Society, "Fifty Years."

84 John Porter, "Maya Deren in Toronto, 1950 & 1951," *super8porter*, December 1983, http://www.super8porter.ca/MayaDeren.htm.

85 "Film Record: *Glub*," Amateur Cinema Project, accessed January 19, 2021, https://www.amateurcinema.org/index.php/film/glub.

86 Sarah Keller, *Maya Deren: Incomplete Control* (New York: Columbia University Press, 2014), 200.

87 Maya Deren, "The Poetic Film," *Canadian Film News*, February 1951. Deren's text is quoted by Peter Morris in his 1962 account of a screening of what was called "The Canadian Independent Cinema" for the Ottawa Film Society.

88 Toronto Film Society, "Fifty Years."

89 Toronto Film Society, "Fifty Years," original emphasis.

90 Porter, "Artists Discovering Film," 24.

91 Deanna Bowen and Maya Wilson-Sanchez point to the historical legacies of anti-Black and anti-Indigenous racism amongst the "social-political network of elite white men" who were at the centre of early and mid-twentieth-century Canadian arts institutions like the Royal Commission, "A Centenary of Influence," *Canadian Art* (Spring 2020), https://canadianart.ca/features/a-centenary-of-influence-deanna-bowen/.

92 These films included *Jazz Party at Mike Snow's* (1954); *Salada Tea Commercials* (1955/56) with appearances by Coughtry, Snow, Wieland; *A Salt in the Park* (1956, with Snow, Wieland, Cowan); *OCA Opening Ceremonies* (1956, with Snow, Wieland, Burton); and *Joyce Wieland's Opening at Here & Now Gallery* (1960). Lee Parpart, "Birth of the Toronto Beat Scene in the Collins's Archive," *POV*, no. 32 (1997): 19. Collins went on to a career at the CBC graphics department.

93 Porter, "Artists Discovering Film," 26.

94 Porter, "Artists Discovering Film." Wieland and Snow moved to NYC in 1962-1963 but had visited in the 1950s.

95 Lois Siegel, "A Clown Outside the Circus," *Cinema Canada*, no. 134 (October 1986): 10–14.

96 Lucas cites *21-87* as an influence upon his *THX 1138* (1971), first made as a student film titled *THX 1138 4EB* (1967), which won awards at the National Student Film Awards in the US in 1967-1968.

97 The four men debating experimental film are Toronto film and music critic Clyde Gilmour, New York film critic Herman Weinberg, Quebec film critic and sociologist Fernand Cadieux, and NFB producer Guy Glover.

98 Arthur Lipsett lecture at McMaster University, c. 1967-1968.

99 Other young filmmakers working at the NFB in the mid-1960s included Tanya Ballantyne Tree, Martin Duckworth, Peter Foldès, Pierre Hébert, Bruce Mackay, Christopher Nutter, Mort Ransen, Michael Rubbo, and Robin Spry.

100 *Star*, September 30, 1969, 26.

101 Catherine Fairbairn, "A Short Trip on Spaceship Earth: Intermedia Society, 1967-72" (master's thesis, University of British Columbia, 1991).

102 Robert Fothergill notes that the Canadian Filmmakers Distribution Centre originally also had the acronym CFDC but changed it to CFMDC to differentiate it from its mainstream

analog. Robert Fothergill, "Canadian Film-Makers' Distribution Centre: A Founding Memoir," *Canadian Journal of Film Studies* 3, no. 2 (1994): 81–85.

103 Gene Youngblood, *Expanded Cinema.*

104 Langlois produced Michael Snow's CD-ROM, *Digital Snow* (2002), and founded the cinema complex Ex-Centris (1999-2015) in Montréal.

105 US media arts centres, despite a lack of arts funding, have been invested in community documentary film and video to counter the force of commercial network television in that country.

106 Expo 67 was just one of a number of world fairs and expositions that featured experimental film and media, generally on a grand scale, including New York 1939, Moscow 1959, New York 1964-1965, Osaka 1970, and Vancouver 1986. See Orit Halpern, *Beautiful Data: A History of Vision and Reason since 1945* (Durham: Duke University Press, 2014); and Yuriko Furuhata, "Multimedia Environments and Security Operations: Expo '70 as a Laboratory of Governance," *Grey Room*, no. 54 (2014): 56–79.

107 Monika Gagnon and Janine Marchessault, eds. *Reimagining Cinema: Film at Expo 67* (Montréal & Kingston: McGill-Queen's University Press, 2014).

108 Johanne Sloan, "*Kaleidoscope*," in Gagnon and Marchessault, *Reimagining Cinema*, 56-68.

109 "Its construction combines existing newsreel footage and animated still images in a collage technique comprising a frenetic critique of war technologies, violence, and postwar consumer culture." Monika Gagnon, "*The Eighth Day*—Cinema Expo 67," *Cinema Expo 67*, accessed May 16, 2020, http://cinemaexpo67.ca/the-eighth-day/.

110 Two other pavilions were *Citérama*, a mixed and multimedia pavilion, featuring filmmakers Gilles Carle and Jacques Godbout, that referenced contemporary Pop and Op Art, and *Canada 67*, probably the most corporate experiment (produced by Walt Disney and directed by Canadian documentary director Robert Barclay) that featured nine screens in Circle-Vision 360.

111 Seth Feldman, "Labyrinth," in Gagnon and Marchessault, *Reimagining Cinema*, 25.

112 Janine Marchessault, "*A Place to Stand*," in Gagnon and Marchessault, *Reimagining Cinema*, 163.

113 Zoë Druick, "Vancouver Cinema in the Sixties," *Ruins in Process: Vancouver Art in the Sixties*, Belkin Gallery, accessed May 10, 2020, https://vancouverartinthesixties.com/essays/vancouver-cinema-in-the-sixties.

114 Ken Becker, "Not Just Some Canadian Hippie Bullshit: The Western Front as Artists' Practice," *Fillip* 20, Fall 2015, https://fillip.ca/content/bullshit#notes.

115 Michael Snow won a $15K grant from the CFDC for *La région centrale* (its working title for the grant was "Earth"). See Urjo Kareda, "Artist Puts All His Talents into Experimental Film," *Toronto Daily Star*, August 6, 1970, 58.

116 Lipowitz would change his name to Lorne Michaels and go on to found *Saturday Night Live*, which was, after all, originally an experimental form of late-night television.

117 Fothergill, "CFMDC: A Founding Memoir," 84.

118 Stephen Broomer, *Hamilton Babylon: A History of the McMaster Film Board* (Toronto: University of Toronto Press, 2016), 55–57.

119 Quoted in John Porter, "Toronto Artists' Film Activity 1950–1969," in Gehman, *Explosion in the Movie Machine*, 33.

120 The International Festival of Women and Film 1896–1973 toured across Canada to nineteen centres, and its organizers included Kay Armatage, Linda Beath, Marien Lewis, Sylvia Spring, Lisa Steele, Deanne Taylor. See NFB, "Studio D: Films by Women, for Women," https://www.nfb.ca/channels/studio-d-films-women-women/.

121 A modified performance also took place at the AGO in November 1967. Like many of the films in Expo 67, *Bill's Hat* also disappeared but was restored and made available by Monica Gagnon in concert with CQ.

122 Marshall Delaney, "45 Hours with the Underground," *Saturday Night*, August 1967, 26.

123 Although there are many differences, video art distribution largely adopted the rental model of film co-ops, with Vtape (est. 1980 in Toronto) following the lead of video art distributors like Electronic Arts Intermix (EAI, est. 1971 in New York), London Video Arts (est. 1976), Video Data Bank (VDB, est. 1976 in Chicago), and Montevideo (est. 1978 in Amsterdam). See Balsom, *After Uniqueness*, 13.

124 See Balsom's chapter on "The Limited Edition" in her *After Uniqueness*, 127–65.

125 For most of the twentieth century, film prints seemed endlessly and perfectly reproducible. Any attempt to limit this reproducibility with, for example, limited edition prints, would have seemed crass within the largely egalitarian culture of experimental film; as Balsom puts it, "It is a form of authenticity that is philosophically false yet enables the generation of market value" (*After Uniqueness*, 129). History has shown, however, that film prints are *not* endlessly reproducible, and scarcity has re-entered the equation.

126 The film rental market is taken from the commercial film world, wherein a film print from Hollywood would circulate from "first-run" release at major theatres to secondary runs in regional circuits; a common stipulation from studios for distributors was that film prints were destroyed at the end of their runs—such was the perceived low value of a film print. Fittingly, Bill Morrison made an experimental documentary, *Dawson City: Frozen Time* (2016), about a cache of discarded Hollywood films found in Dawson City, Yukon, the end of the line for the film distribution circuit.

127 *CFMDC Catalogue* (Toronto: CFMDC: 1972), 7.

128 "Moral Rights in Canadian Copyright Law," Wikipedia, last modified February 3, 2021, https://en.wikipedia.org/wiki/Moral_rights_in_Canadian_copyright_law.

129 In recent years, some filmmakers who have gallery representation have pulled their films from co-op distributors like CFMDC in order to control access to prints.

130 John Porter, "Consolidating Film Activity, Toronto in the 1960s," *Vanguard* 13, no. 9 (November 1983): 26–29.

131 National Art Exhibition Committee, *Canadian Artists 68* (Toronto: AGO, 1968). Exhibition catalogue. An exception is US critic Manny Farber, whose report, "Canadian Underground," confirms that "the films were privately shown" in "the basement room at the Art Gallery of Ontario." See *Negative Space: Manny Farber at the Movies* (New York: Praeger, 1971), 250; and his review, "Films at Canadian Artists '68," *artscanada*, no. 128/129 (February 1969): 28–29.

132 For example, the NFB had provided support for experimental filmmakers through the Program to Assist Filmmakers in the Private Sector (PAFPS, discontinued in 1996), and the Filmmaker Assistance Program (FAP). See Saul, "Canadian Avant-Garde Film in the 1990s," 30.

133 Darrell Varga, *Shooting from the East: Filmmaking on the Canadian Atlantic* (Montréal & Kingston: McGill-Queen's University Press, 2015), 71.

134 This principle also brought film in line with CARFAC directives for artist control over artworks.

135 Varga, *Shooting from the East,* 72.

136 Peter Sandmark, *Independent Media Arts in Canada: On the History of the Alliance* (Montréal: IMAA/AAMI, 2007), 15.

137 Varga, *Shooting from the East,* 72.

138 Richard Martin, "*Backbone* Extended Interview: David Rimmer," https://vimeo.com/channels/966891/114388039, 2015.

139 Goldberg was succeeded by Renée Baert in 1978, and artist/writer Tom Sherman in 1981. See Peggy Gale, "All These

Years: Early Toronto Video," in Gehman, *Explosion in the Movie Machine,* 53.

140 Sherman was succeeded by Glenn Lewis in 1987, followed by Su Ditta (1990–1994), Martine Sauvageau (1994–1998), and David Poole in 1998 (who had worked for the CFMDC in the early 1980s). Poole led the Media Arts Section until 2007, when Youssef El Jaï (formerly of Productions Réalisations Indépendantes de Montréal (PRIM)) succeeded him. Zainub Verjee was also a senior program officer for Media Arts (1999-2005).

141 Al Razutis complained that his work in what he called "video synthesis" was not considered art by CCA ("the film/video hybrid was not an acceptable form"). But his list of what was considered acceptable is also questionable: "They accepted conceptual video, the beginnings of narrative video, drag queen video and Toronto video." See Al Razutis, "Three Decades of Rage," in Hoolboom, *Inside the Pleasure Dome,* 59.

142 Sandmark, *Independent Media Arts,* 16.

143 Patricia Gruben, "Sifted Evidence," in Hoolboom, *Inside the Pleasure Dome,* 39.

144 I am using the term *co-op* as a shorthand to describe film, video, and media art organizations, but not all are strictly organized as co-operatives and/or their organizational structure may have changed over time.

145 Some production co-ops like the Funnel, GIV, Main Film, Saskatchewan Filmpool, Video Femmes, and Winnipeg Film Group also distributed members' work. See Liz Avison, *Distribution Guide for Non Theatrical 16mm Films and Video in Canada* (Toronto: L. Avison, 1987).

146 Figures involved in the lab's history include Christina Battle, Greg Boa, Derek Jenkins, Andrew Lennox, Alexi Manis, archivist Christina Stewart, and Ali Vanderkruyk. Niagara Custom Lab, "About," accessed January 31, 2021, https://niagaracustomlab.com/?page_id=6.

147 Penny McCann, "Forty Years @ 24 Frames per Second: Film Cooperatives in Canada," in *Reflecting Light: 40 Years of Canadian Cinema,* ed. Cecilia Araneda (Winnipeg: Winnipeg Film Group, 2015), 15.

148 Ellen Besen, Keith Lock, and Barbara Sternberg, *Through a Filmmaker's Eyes: A Guide to Teaching Film in Media Literacy* (Toronto: Canadian Filmmakers Distribution Centre, 1992); *Media Literary Mini-Catalogue* (Toronto: CFMDC, 1990).

149 As with film society screenings, membership was often required for attendance, making use of a common loophole in provincial censorship regulations.

150 Co-op publishing complemented the continuing work of film societies, which also published program notes and newsletters (co-ops and film societies might also collaborate on screening series).

151 McCann, "Forty Years," 15.

152 Quoted in Anthony Hall, "A Funnel for Talent," *Cinema Canada,* no. 52 (January/February 1977): 19.

153 Gruben, "Sifted Evidence," in Hoolboom, *Inside the Pleasure Dome,* 39.

154 For example, in 1992 a featured retrospective of CFMDC work in honour of its twenty-fifth anniversary (curated by Blaine Allan and Dot Tuer and coordinated by Elizabeth Yake) for TIFF (then the Festival of Festivals), used the ecumenical title *Independent Eyes.*

155 Cecilia Araneda, ed., *Reflecting Light: 40 Years of Canadian Cinema* (Winnipeg: Winnipeg Film Group, 2015), 5.

156 "Canada Council for the Arts: About," Canada Council for the Arts, accessed May 24, 2020, https://canadacouncil.ca:443/about.

157 "CARFAC Ontario: History and Milestones," CARFAC Ontario, accessed May 23, 2020, https://www.carfacontario.ca/History-and-Milestones.

158 ANNPAC/RACA dissolved in 1993. A more recent national body is Artist-Run Centres and Collectives Conference/Conférence des collectifs et des centres d'artistes autogérés (ARCCC-CCCAA, aka ARCA) founded in 2005, which includes 190 ARCs in sixty locations.

159 IMAA/AAMI, "History," accessed May 23, 2020, https://www.imaa.ca/about-us/history/.

160 Sandmark, *Independent Media Arts,* 11.

161 IMAA/AAMI, "About Us," accessed June 14, 2020, https://www.imaa.ca/about-us/.

162 One pitfall of grant-supported ARCs is that they can sometimes outlive their usefulness to their community. It is a genuine dilemma for ARCs, where precariously employed and underpaid arts workers may have to rely on a redundant organization for their living. In other cases, organization leaders intentionally "pull the plug" in order to move on to other ventures, for example, Jim Shedden's Innis Film Society (1985-1993) or Alex MacKenzie's Blinding Light!! Cinema (1998-2003).

163 Clint Enns and Leslie Supnet, "About—Regional Support Network," Tumblr, accessed September 18, 2020, https://regionalsupportnetwork.tumblr.com/about.

164 Brian Foss, Sandra Paikowsky, and Anne Whitelaw, eds., *The Visual Arts in Canada: The Twentieth Century* (Don Mills, ON: Oxford University Press, 2010), xiii.

165 Akademie der Künste and Conseil des arts du Canada, *OKanada* (Ottawa: Canada Council/Conseil des arts du Canada, 1982). Exhibition catalogue.

166 Gilles Hébert, *Dislocations* (Winnipeg: Winnipeg Film Group, 1994), 12–13. Exhibition catalogue.

167 Richard Kerr and Kitchener-Waterloo Art Gallery, *Practices in Isolation: Canadian Avant-garde Cinema: A Special Five-part Series by Independent Film Makers on the Contemporary Arts* (Kitchener: Kitchener-Waterloo Art Gallery, 1986), 4. Exhibition catalogue. Kerr mentions isolation as a virtue, relating it to regional, personal thematics: "The phenomenon of isolation in landscape, culture, and production is to be embraced as our avant-garde film makers have historically chronicled" (4). It is also notable that the foreword to the catalogue is written by Paul Blain, the "Extension Curator/Education Officer," and not by one of the gallery's central curators.

168 Kerr, *Practices in Isolation,* 4.

169 Kerr, *Practices in Isolation,* 4.

170 Kerr, *Practices in Isolation,* 4.

171 In 1984 and 1985, two issues of *Opsis: The Canadian Journal of Avant-Garde and Political Cinema* were published in Vancouver before it folded.

172 Bart Testa, "Experimental Film," in *The Canadian Encyclopedia,* Historica Canada, 2006, revised 2013, https://thecanadianencyclopedia.ca/en/article/experimental-film.

173 Other prominent writers and curator/programmers include Chris Gehman, Nicole Gingras, Dot Tuer, and William Wees. More recent writers include Aaditya Aggarwal, Scott Birdwise, Sarah-Tai Black, Deanna Bowen, Stephen Broomer, Jesse Cumming, Jon Davies, Clint Enns, Amy Fung, Cheryl L'Hirondelle, Brett Kashmere & Astria Suparak, Chris Kennedy, Jacob Korczynski, Steven Loft, Andrea Picard, Ben Portis, and cheyanne turions.

174 Toronto's Pleasure Dome, in conjunction with YYZ Gallery (which had a regular publishing series) issued *Lux: A Decade of Artists' Film and Video* (2000); Vancouver's Satellite Video Exchange Society published *Making Video "In": The Contested Ground of Alternative Video on the West Coast* (2000); WFG published *Place: 13 Essays, 13 Filmmakers, 1 City* (2009); and Calgary's EMMEDIA published *Expanded Standard Timeline—Artists and Electronic Media in Calgary—EM/Media 1980 Through 2005* (2009).

175 Michael Zryd, "The Academy and the Avant-Garde: A Relationship of Dependence and Resistance," *Cinema Journal* 45, no. 2 (2006): 17–42.

176 "CFMDC Presents: Personal Perspectives 1971–1979," Art Gallery of Ontario, March 9, 2017, accessed June 14,

2020, https://ago.ca/events/cfmdc-presents-personal
-perspectives-1971-1979.

177 Al Razutis, "Al Razutis: Under the Sign of the Beast," in *Al Razutis: Iconoclast*, ed. Mike Hoolboom (n.p., 2009), 14, mikehoolboom.com/?p=150.

178 Al Razutis, "Under the Sign of the Beast," 15.

179 See also Blaine Allan, "It's Not Finished Yet (Some Notes on Toronto Filmmaking)," in *Toronto: A Play of History (Jeu d'histoire)*, ed. Louise Dompierre (Toronto: Power Plant, 1987), 85–86.

180 For a detailed history, see Broomer, *Hamilton Babylon*.

181 Taryn Sirove, "Truce or Compromise? Censorship, Media Regulation, and Exhibiting Policies in Ontario," in Gehman, *Explosion in the Movie Machine*, 157.

182 Sirove, "Truce or Compromise?," 152–69; and Sandmark, *Independent Media Arts*, 16.

183 Sirove, "Truce or Compromise?," 155. Pleasure Dome screenings often began with someone asking, "Is anyone here from the police or censor board?"

184 The provincial government earned millions of dollars in review fees from the commercial industry, an income source that dried up with the increase in online film streaming (especially for pornography). Rob Ferguson, "Ford Scraps Ontario's Film-Rating System to Save Money," thestar.com, September 27, 2019, https://www.thestar.com/politics/ provincial/2019/09/27/ford-scraps-ontarios-film-rating- system-to-save-money.html.

185 Quoted in Sandmark, *Independent Media Arts*, 23–24.

186 Quoted in Sandmark, *Independent Media Arts*, 21.

187 Mike Hoolboom, "Artist's Film Distribution in Canada: Some Thoughts About," *Independent Eye* 9, no. 1 (Spring 1988): 8–9.

188 For Elder, "The cinema we need…will, therefore, be non-narrative." Bruce Elder, "The Cinema We Need," in *Documents in Canadian Film*, ed. George Fetherling (Peterborough: Broadview Press, 1988), 265.

189 R. Bruce Elder's *Image and Identity* was published in 1989, after Elder had completed three epic films, *Illuminated Texts* (1982), *Lamentations: A Monument to the Dead World* (1985), and *Consolations (Love Is an Art of Time)* (1988) that totalled nearly 40 hours in length.

190 Barbara Sternberg, "On (Experimental) Film," *Cinema Canada*, no. 140 (April 1987): 70; Barbara Sternberg, "On (Experimental) Film," *Cinema Canada*, no. 142 (June 1987): 48–49.

191 Marie Fleming, ed., *Joyce Wieland* (Toronto: Art Gallery of Ontario, 1987). Exhibition catalogue.

192 Heather M. Davis, ed. *Desire Change: Contemporary Feminist Art in Canada* (Montréal & Kingston: McGill-Queen's University Press, 2017).

193 "The Birth of the Web | CERN," accessed July 19, 2020, https://home.cern/science/computing/birth-web. Shedden notes several other events in 1989, particularly a marker of the US "culture wars" with the cancellation of Robert Mapplethorpe's show at the Corcoran Gallery in Washington, DC. Shedden, "From Art to Community," in Gale, Jost, and Nanibush, Toronto: Tributes + Tributaries, 174.

194 David Yencken, "The Creative City," *Meanjin* 47 (1988).

195 Catherine Jonasson and Jim Shedden, eds. with assistance from Bart Testa, *Recent Work from the Canadian Avant-Garde*, Catalogue to accompany the film series held at the AGO and the Innis Film Society 13 October–20 November 1988 (Toronto: Art Gallery of Ontario, 1988); and Bart Testa, *Spirit in the Landscape* (Toronto: Art Gallery of Ontario, 1989). Exhibition catalogue.

196 A previous "Second" festival took place in London in 1972. Fred Camper, "The End of Avant-Garde Film," *Millennium Film Journal*, nos. 16/17/18 (1986–87): 99–124. When Camper arrived in Toronto for the congress, he revised his polemic,

wisely recognizing the continued artistic energy of the experimental film community.

197 Shedden was the sole paid employee, and the rest of the money went to artists/speakers' fees, film rentals, projectionists, print revision, printing the catalogue and poster, distributing the poster, a few low-key receptions, residence costs at the University of Toronto, and participant per diems. The congress fee was $125 for the whole week, $75 for students and the unemployed.

198 Full disclosure: I was one of the sidebar critics, co-curated the Hollis Frampton retrospective, and smuggled films from FMC over the border into Canada.

199 Jonas Mekas, William Moritz, and Robert Daudelin (of CQ) presented at the congress.

200 Congress co-organizer Bart Testa wrote a tart response to the manifesto in the US-based *The Independent* that addressed some of these problems, which is reprinted in a dossier prepared by Canadian film scholar William Wees: "Ciné-Documents: 'Let's Set the Record Straight': The International Experimental Film Congress, Toronto 1989," *Canadian Journal of Film Studies* 9, no. 1 (2000): 101–16.

201 Wees, "Ciné-Documents," 102.

202 Brakhage matured, shaking off his angry young man persona, marrying Canadian writer Marilyn Jull (former experimental film officer at the CFMDC) and moving to Canada, writing on Canadian painting and music.

203 Another important Toronto organization established in 1989 was the year-round Pleasure Dome screening series, which combined not only film and video but also performance, new media, and other forms related to experimental moving image and sound.

204 Quoted in Andrew James Paterson, *Expanding Moving Pictures* (Toronto: Images Festival, 2012): 3.

205 These snapshots should not gloss over how the festival could change year to year, depending on decisions by the artistic director, board, or shared ventures with the many partner organizations with which Images worked.

206 One notable change by 2019 was the lack of commercial movie sponsors. The long-desired development of Hollywood North over the last two decades had led to immense growth of the commercial film and television industry, including production, post-production, and special effects companies in Montréal, Toronto, Vancouver, and elsewhere: the stratification of the industry left a gap between mainstream and independent sectors (even if aesthetic crossovers continued).

207 See Monika Kin Gagnon, "Building Blocks: Anti-Racist Initiatives in the Arts," in *Other Conundrums: Race, Culture, and Canadian Art* (Vancouver: Arsenal Pulp Press, 2000), 53. See also material in Bowen, *Other Places*. Verjee was awarded the 2020 Governor General's Visual and Media Arts in the Outstanding Contribution category.

208 Niranjan Rajah, "Zainub Verjee: From Signifier to Signified," in Bowen, *Other Places*, 125.

209 In 1990, New Initiatives in Film was established as part of Studio D at the NFB, a program for women of colour and Indigenous women, co-created by Sylvia Hamilton (Gina Badger, "Appendix: There Is No Feminism (A Love Letter) Or, A Working Chronology of Feminist Art Infrastructures in Canada," in Davis, *Desire Change*, 285).

210 Dionne Brand, "Notes to Structuring the Text and Craft of Writing," *Front* 6, no. 1 (1994): 13, quoted in Gagnon, *Other Conundrums*, 52–53.

211 Gagnon, *Other Conundrums*.

212 Quoted in Rajah, "Zainub Verjee," 124.

213 Gagnon, *Other Conundrums*, 51.

214 Kathleen Ritter, "Vancouver 1989," in Davis, *Desire Change*, 197.

215 Gagnon, *Other Conundrums*, 52.

216 Quoted in Rajah, "Zainub Verjee," 126.

217 Chris Gehman and John Porter compiled a comprehensive list of Toronto festivals for *Explosion in the Movie Machine*, 9–17.

218 Maria Alejandrina Coates's "Trazando Historias: A People's Story of the AluCine Film and Media Arts Festival," in Bowen, *Other Places* (334–45), is a model festival history, encompassing global, Canadian, and local politics, and especially "the vastly overlooked lives and circumstances of the people who organize, produce and carry the work forward year after year in often precarious and informal conditions of employment" (335).

219 "Mandate | TQFF," accessed May 26, 2021, https:// torontoqueerfilmfest.com/mandate/.

220 Karrmen Crey, "Indigeneity, Institutions of Media Culture, and the Canadian State since 1990" (PhD dissertation, University of California, Los Angeles, 2016), 83.

221 Karrmen Crey, "The Aboriginal Film and Video Art Alliance: Indigenous Self-Government in Moving Image Media," *JCMS: Journal of Cinema and Media Studies* 60, no. 2 (Winter 2021): 175–80. AFVAA was first called First Nations Film and Video Art Alliance (Crey, "Indigeneity," 91).

222 Crey, "The Aboriginal Film and Video Art Alliance," 177.

223 Nanibush, "Cultural Sovereignty," 183–84.

224 "History | Wapikoni Mobile," accessed July 19, 2020, http:// www.wapikoni.ca/about/who-are-we/history. Five thousand participants and over 1,200 films.

225 Sandmark, *Independent Media Arts*, 31–32.

226 A short list of important Indigenous filmmakers and digital media includes artists like Rebecca Belmore, Thirza Cuthand, Danis Goulet, Nyla Innuksuk, Geronimo Inutiq, Lisa Jackson, Zachary Longboy, Kent Monkman, Caroline Monnet, Darryl Nepinak, Skawennati, and Rhayne Vermette.

227 Carl Brown, for example, found himself alienated from the avant-garde film scene: "Everybody who I see who's in avant-garde film is so tightly wound up in it. It's a very tough life." Carl Brown, "Painting the Light Fantastic," in Hoolboom, *Inside the Pleasure Dome*, 32.

228 Gehman, *Explosion in the Movie Machine*, 4.

229 Sandmark, *Independent Media Arts*, 28.

230 Sandmark, *Independent Media Arts*, 29.

231 Correspondence with LIFT executive director Chris Kennedy, June 15, 2020.

232 "Histories & Pictures | Philip Hoffman," accessed July 20, 2020, https://philiphoffman.ca/film-farm/history/. Other long-time Film Farmers are Scott Miller Berry, Joshua Bonnetta, Rob Butterworth, Tracy German, Christine Harrison, Deirdre Logue, Janine Marchessault, Scott MacKenzie, and Karyn Sandlos (See https://philiphoffman.ca/film-farm/retreat-participants-1994-2013/).

233 Tess Takahashi, "Impure Film: Medium Specificity and the North American Avant-Garde (1965–2005)" (PhD dissertation, Brown University, 2006).

234 *One Take Super 8 Event* (blog), July 11, 2017, http:// onetakesuper8event.blogspot.com/2017/07/almost-there .html.

235 Other important projector performance artists include Liss Platt, Skoltz Kolgen; Jeremy Bailey, Alain Thibault; The League (Christina Battle, Sara MacLean, Juliana Saragosa, and Michèle Stanley, 2000–2003); and artists associated with the Loop Collective (Vicky Chainey Gagnon, Colin Clark, Kelly Egan, Angela Joosse, Erika Loic, Shana MacDonald, and Izabella Pruska-Oldenhof); and Double Negative (Christopher Becks, Amber Goodwyn, Karl Lemieux, Lindsay McIntyre, Eduardo Menz, Mike Rollo, Daïchi Saïto, Ithamar Silver, and Malena Szlam, most of who studied film production at Concordia). See Brett Kashmere and Astria Suparak, "In Pursuit of Northern Lights: Tracking Canada's Living Cinema," *Brett Kashmere*, accessed May 10, 2020, http://www.brettkashmere.com /in-pursuit-of-northern-lights.

236 Clint Enns points to a tradition in Montréal wherein musical bands have projectionists as members, for example, Godspeed You! Black Emperor (Karl Lemieux [2010–present], Philippe Léonard [2015–present], John Littlefair [1994–2000], Fluffy Erskine [2000–2003]); and Jerusalem in my Heart (Charles-André Coderre). Clint Enns, email correspondence, September 25, 2020.

237 GGAVMA-winning artists who have made films, video art, or media art include Michael Snow, Jacques Giraldeau (2000); Alanis Obomsawin, Jamelie Hassan (2001); AA Bronson, Charles Gagnon, Edward Poitras, David Rokeby, Barbara Steinman (2002); Iain Baxter&, Eric Cameron, Istvan Kantor, John Oswald, Ian Wallace (2004); Lisa Steele and Kim Tomczak, Paul Wong (2005); Vera Frenkel, Peter Wintonick (2006); Bruce Elder, Murray Favro (2007); Serge Giguère, Tanya Mars (2008); Nobuo Kubota, Rita McKeough, Robert Morin, Kim Ondaatje (2009); André Forcier, Tom Sherman (2010); Geneviève Cadieux, Michael Morris, David Rimmer, Barbara Sternberg (2011); Jan Peacock (2012); Rebecca Belmore, William MacGillivray (2013); Jayce Salloum (2014); Robert Houle, Rafael Lozano-Hemmer, Reva Stone (2015); Philip Hoffman, Mark Lewis (2016); Michèle Cournoyer, Mike Hoolboom, Glenn Lewis, Shelley Niro (2017); Wyn Geleynse, Midi Onodera (2018); Stephen Andrews, Ali Kazimi, Andrew James Paterson (2019); and Deanna Bowen, Dana Claxton, and Jorge Lozano Lorza (2020). Critics and administrators who were awarded a GGAVMA in the Outstanding Contribution category include Peggy Gale (2006), Tony Urquhart (2009), Philip Monk (2017), and Zainub Verjee (2020).

238 IMAA/AAMI, "About Us," accessed June 14, 2020, https:// www.imaa.ca/about-us/.

239 VUCAVU members include CFMDC, GIV, Les Films du 3 Mars, Moving Images, Paved Arts, Spira, Video Out, Video Pool, and WFG.

240 See BC Archives, https://search-bcarchives.royalbcmuseum. bc.ca/and.

241 Christopher Régimbal, "Institutions of Regionalism: Artist Collectivism in London, Ontario, 1960–1990," *ArcPost: A Project of the Pacific Association of Artist Run Centres* (blog), accessed July 15, 2020, http://arcpost.ca/articles/institutions -of-regionalism#note8.

242 In 2017, Tougas was given the Vancouver Film Critics association Ian Caddell Award for Achievement for outstanding contributions to the British Columbia film and television industry.

243 Kurt Tougas, "West Coast Filmmaking: Perspectives," in Véronneau and Handling, *Self portrait*, 140.

244 Druick, "Vancouver Cinema."

245 Tim Newman, "Mediating Collaborations: Arla Saare, the CBUT Film Unit, and the Emergence of the West Coast School," *Off-Screen*, December 2014, https://offscreen.com/view /mediating-collaborations.

246 Druick, "Vancouver Cinema."

247 Fran McGrath, "Film at SFU," *Ubyssey (Film Special)*, October 10, 1969: PF2.

248 Peter Lipskis, "I Was a Teenage Personality Crisis!" in Hoolboom, *Inside the Pleasure Dome*, 93.

249 An example of an event that crossed media lines is William Burroughs's appearance at The Cinematheque November 17, 1974, where the listing of co-presenters on the poster indicates the many art and college and university organizations involved in film and media art events: "Western Front, Vancouver School of Art, Capilano College Humanities Division Events Committee, Capilano College Student Association, and Vancouver Community College Langara."

250 Collier also made industrial experimental films, including *Water Colours* (1972), selected as the opening short for Pink Floyd's *The Wall* (1982), and advertising shorts for Expo 86, Vancouver's world fair. "Collier, Michael J.—City of Vancouver

Archives," accessed July 10, 2020, https://searcharchives
.vancouver.ca/michael-collier.

251 Allison Collins, "Opening the Video Inn," *ArcPost*, ARCLines,
accessed June 14, 2020, http://arcpost.ca/articles/opening
-the-video-inn.

252 See Jennifer Abbott, ed., *Making Video "In": The Contested
Ground of Alternative Video on the West Coast* (Vancouver:
Video In Studios, 2000); and "Vision, Mission + Values | VIVO
Media Arts," accessed December 12, 2020, https://www
.vivomediaarts.com/about.

253 Martin Bartlett, Hank Bull, Kate Craig, Henry Greenhow, Glenn
Lewis, Eric Metcalfe, Michael Morris, Vincent Trasov, and Mo
Van Nostrand were key early figures. Kate Craig invigorated its
video program with a residency program in 1976 that invited
artists with no expertise in video to explore the medium;
she and Margaret Dragu created the film *Backup* (1978), an
experimental process narrative. See Ken Becker, "Not Just
Some Canadian Hippie Bullshit: The Western Front as Artists'
Practice," *Fillip* 20, Fall 2015, https://fillip.ca/content/
bullshit#notes.
 In 1984, Musée d'art contemporain de Montréal, along with
the Art Gallery of Hamilton, curated an exhibition of Western
Front artists. See Musée d'art contemporain and Western
Front Video, *Western Front Video: une exposition organisée
par le Musée d'art contemporain de Montréal en collaboration
avec la Western Front Society: présentée au Musée d'art
contemporain de Montréal du 27 septembre au 11 novembre
1984 et à la Art Gallery of Hamilton* (Montréal: Le Musée,
1984). Exhibition catalogue.

254 "Alex MacKenzie: Blinding Light," *Practical Dreamers:
Conversations with Movie Artists*, ed. Mike Hoolboom (Toronto:
Coach House Books, 2008), 277.

255 Memory BC, "PUMPS Fonds," 1980, https://www.memorybc.
ca/pumps-fonds.

256 This essay mentions Braidwood, Gallagher, Lee-Nova, Lipskis,
Razutis, Rimmer, Rodan, Tougas, and other filmmakers like
Byron Black, Ellie Epp, Gordon Kidd, Richard Martin, Richard
(Rick) Patton, and Bill Roxborough. Other important Vancouver
video and media art makers not included in their essay include
Michael Goldberg, Ardele Lister, Kim Tomczak, and Paul
Wong, all artists more connected to the video and media arts
institutions. VAG also published the art magazine *Vanguard*
from 1972 to 1984, which included articles on film and media
art.

257 Su-Anne Yeo, "Vancouver Asian: West Coast Film Cultures,
on the Rim and at the End of the Line," in *Reel Asian: Asian
Canada on Screen*, ed. Elaine Kyung Chang (Toronto: Coach
House Books, 2007), 122.

258 Kathleen Ritter, "Vancouver 1989," in Davis, *Desire Change*,
197–219.

259 *So Where's My Prince Already?*, ardelelister.com, accessed
May 26, 2021, http://ardelelister.com/so-wheres-my-prince
-already/.

260 "NFB – Peter Jones," *Criteria* 2, no. 1 (February 1976): 10; see
also Laura Marks, "Ardele Lister's Divine Irony," *Millennium
Film Journal*, no. 70 (Fall 2019): 19.

261 Other Vancouver-based initiatives for women in film include
Women's Film and Video Festival (1973–1977); Women and
Film, a British Columbia–wide festival of media and visual
art, established by ISIS: Women and Film (est. 1974); Women
in Focus AV tape library and productions established by UBC
(Marion Barling [1974–1993], tapes donated to Video In),
which created Vancouver Women's Video and Film Festival
(est. 1978) and Women's Art Gallery (est. 1979); *Women
and Video Art* exhibition (1976) at Video Inn; and Vancouver
Women's Media Collective (est. 1978).

262 Ellie Epp, "what will we know (1982)," *Independent Eye* 10,
no. 1 (Fall 1988): 16.

263 Thornton received the Sachtler Ace Wayne Black Service

Award from Women in Film & Television Vancouver in 2017
for contributions "to the screen-based media community while
working 'behind the scenes.'" (See https://www.womeninfilm
.ca/2017_Award_Winners.html.)

264 Meg Thornton (Cineworks executive director), email
correspondence with the author, January 8, 2001. Other
independent filmmakers in the Vancouver scene include Gerry
Gilbert, Katherine Collins, Sandra (Sandy) Wilson, Kalle Lasn
(founder of *Adbusters* magazine), and Michael McGarry, an
SFU grad, whose *In Black and White* (1979) is about police
harassment of gay men).

265 George Csaba Koller, "The Future of Independent West Coast
Filmmaking Discussed at SFU Forum," *Cinema Canada*,
October 1973.

266 "Fumiko Kiyooka: The Place with Many Rooms is the Body,"
Hoolboom, *Inside the Pleasure Dome*, 83.

267 Later students included Ann Marie Fleming (MFA 1992).

268 Razutis has a comprehensive personal archive online at http://
www.alchemists.com.

269 Al Razutis, "Letter of Resignation from Simon Fraser University
—Al Razutis," March 9, 1987, http://www.alchemists
.com/visual_alchemy/sfu-orgs/SFUresignation.html.

270 Vancouver's Anglo White culture dominated most cultural
institutions, although strong multi-generational immigrant
communities with roots in Japan and China were in existence
through the twentieth century, with attendant legacies of anti-
Asian racism (e.g., Chinese Exclusion Act (repealed in 1947),
and the legacy of the Japanese Canadian internment camps
during the Second World War).

271 Yeo, "Vancouver Asian," 122. Much later, Cinevolution Media
Arts Society was "founded by a group of Pan Asian filmmakers,
artists and community organizers," linked to the New Asia
Film Festival (2008–2010) and Your Kontinent: Richmond
International Film & Media Arts Festival (est. 2011).

272 Yeo, "Vancouver Asian," 122.

273 Wall programmed films at The Cinematheque 1975–1976.

274 Brian McIlroy, "A Luminous Moment in the History of Canadian
Underground Exhibition: The Blinding Light!! Cinema in
Vancouver," *Canadian Journal of Film Studies* 23, no. 1 (2014):
128–32.

275 "Iris Film Collective," accessed July 18, 2020, https://
irisfilmcollective.com/?og=1.

276 "About – New Forms Media Society," accessed December 12,
2020, http://newformsmediasociety.org/about/.

277 "Open to New Ideas: the Development of Open Space," *ArcPost*,
ARCLines, accessed May 26, 2021, http://arcpost.ca/articles
/open-to-new-ideas-the-development-of-open-space.

278 Filmmaker Peter Sandmark, who wrote IMAA's history, is the
executive director.

279 Like many universities, it has a repertory film theatre
associated with its student association; at UVic, Cinecenta has
been in operation since 1971.

280 Open Space, "Our History."

281 PDI included Calgary Society of Independent Filmmakers
(CSIF), EM/Media, Film and Video Arts (FAVA, Edmonton),
Saskatchewan Filmpool Cooperative (Regina), Video Pool
(Winnipeg), and Winnipeg Film Group (WFG). See Grant
Poier, "(Non) Distribution of Film and Video on the Prairies,"
Independent Eye 12, no. 2 (Winter 1991): 12–16.

282 W. Scheff, "Flatland Film," *Independent Eye* 11, no. 1 (Fall
1989): 29.

283 Steven DeNure & Chris Lowry's *Ranch: The Alan Wood Ranch
Project* (1987) was nominated for a Genie award.

284 Founders included Charlie Fox, Deanne Monroe, Steve
Peterson, Poier, and Vern Hume. A comprehensive history can
be found in Grant Poier, ed., *Expanded Standard Timeline—
Artists and Electronic Media in Calgary—EM/Media 1980
through 2005* (Calgary: EMMEDIA, 2009). Poier was given
the inaugural awards for both the Echo Awards (EM/Media,

2003) and Spirit of Helen (AMAAS, 2005) in recognition of his community building in the film and media arts.

285 "ABOUT | Quickdraw Animation Society," accessed July 12, 2020, https://quickdrawanimation.ca/about/. An Edmonton chapter of Quickdraw closed in 1990.

286 Kristen Hutchinson, *Prairie Tales: A History* (Calgary: Alberta Media Arts Alliance Society, 2017).

287 "Home," accessed July 13, 2020, http://herland.ca/.

288 "About," Monograph Cinema, accessed December 4, 2020, https://monograph-cinema.com/about.

289 "History of Banff Centre for Arts and Creativity," accessed July 12, 2020, https://www.banffcentre.ca/history-banff-centre-arts-and-creativity.

290 Mieko Ouchi, "Albertasia: Asian Canadian Films on the Prairies," in Chang, *Reel Asian*, 174–75.

291 Norman Yates, "Filmmakers in Edmonton: An Interim Report," *artscanada*, no. 142/143 (April 1970): 46–48.

292 "FAVA | History," accessed July 12, 2020, https://fava.ca /about-us/history/.

293 Marsh Murphy, "Film Cooperatives," in *Canadian Encyclopedia*, Historica Canada, published 2006, last edited 2013, https:// thecanadianencyclopedia.ca/en/article/film-co-operatives.

294 "About," GRAPHICAL, accessed December 4, 2020, https:// www.graphicalrecordings.com/about.

295 Early figures included Charles Konowal, Donald (Don) List, Ian Preston, and Brock Stevens. Filmpool has been sustained by filmmakers like William (Will) Dixon, Spyro Egarhos, Angelos Hatzitolios, Gerald Saul, and Brian Stockton.

296 *Splice* editors included Joanne Reilly, Nora Gardner, Martin Rumsby, John Kennedy, Robin Schlaht, Ken Wilson, and Kelly-Anne Riess.

297 Christine Ramsay, "Made in Saskatchewan!," in *Self Portraits: The Cinemas of Canada since Telefilm*, ed. André Loiselle and Tom McSorley (Ottawa: Canadian Film Institute, 2006), 207.

298 Scheff, "Flatland Film," 30.

299 Sâkêwêwak is a Plains Cree word meaning "they are emerging" or "they are coming into view." "About Us," Sâkêwêwak First Nations Artists' Collective Inc., accessed July 13, 2020, https://www.sakewewak.ca/about.

300 Christine Ramsay, *Regina's Secret Spaces: Love and Lore of Local Geography*, eds. Lorne Beug, Anne Campbell, Jeanne Mah (Regina: University of Regina Press, 2006): 105.

301 Richard Kerr, "Last Days of Living," in Hoolboom, *Inside the Pleasure Dome*, 163.

302 The Broadway Theatre is the main repertory cinema in Saskatoon.

303 Murphy, "Film Cooperatives."

304 Victor Barac, Monika Kin Gagnon, Gilles Hebert, Patrick Lowe, Geoff Pevere, and Lisa Trofimova, *Dislocations* (Winnipeg: Winnipeg Film Group, 1995) Exhibition catalogue; Cecilia Araneda, ed., *Place: 13 Essays, 13 Filmmakers, 1 City* (Winnipeg: Film Group, 2009); Andrew Burke, "The WFG at 40," in *Reflecting Light: 40 Years of Canadian Cinema*, ed. Cecilia Araneda (Winnipeg: Winnipeg Film Group, 2015), 18.

305 "Winnipeg Film Group : History," accessed July 15, 2020, https://www.winnipegfilmgroup.com/about/history/.

306 Araneda, *Reflecting Light*.

307 See https://www.ceciliaaraneda.ca/about/.

308 "History | Urban Shaman Contemporary Aboriginal Art Gallery," accessed July 15, 2020, http://urbanshaman.org/site/history.

309 Steven Loft and Kerry Swanson, *Coded Territories: Tracing Indigenous Pathways in New Media Art* (Calgary: University of Calgary, 2015): xii; and Urban Shaman Gallery, "Storm Spirits— Curatorial Statements," November 3, 2006, https://www .stormspirits.ca/English/curatorial.html.

310 Co-founders included Araneda and Nagler and collective/ programming members have included Jaimz Asmundson, Irene Bindi, Divya Mehra, Rollo, Vermette, Western, and Collin Zipp.

311 Takatsu is a founding member along with Grant Guy, Alex Poruchnyk, Vern Hume, Gerry Kisil, and John Tupper. Ryan Takatsu, "Video Pool Media Arts Centre Origins," September 19, 2019, accessed July 15, 2020, https://www.videopool.org /vp-origins/.

312 "Winnipeg Film Group : History," accessed July 15, 2020, https://www.winnipegfilmgroup.com/about/history/.

313 Founders include Myke Dyer, Philip Hoffman, and Tony Massett. See "Home," Fabulous Festival of Fringe Film, accessed December 14, 2020, http://www.fabfilmfest.ca/.

314 Christopher Régimbal, "Institutions of Regionalism: Artist Collectivism in London, Ontario, 1960–1990," *ArcPost: A Project of the Pacific Association of Artist Run Centres* (blog), accessed July 15, 2020, http://arcpost.ca/articles/ institutions-of-regionalism#note8.

315 Varga, *Shooting from the East*, 71.

316 Members included Fraser Boa, John Boyle, Chambers, Keewatin Dewdney, Royce Emley, and John Patterson. Ross Woodman, "Artists as Filmmakers," *artscanada* 23, no. 2 (June 1968): 35.

317 Dewdney published numerous speculative books, including *The Planiverse: Computer Contact with a Two-Dimensional World* in 1984; unfortunately, he later became a 9/11 "truther."

318 Broomer, *Hamilton Babylon*, 8.

319 Clyde Gilmour, "The Underground Is Here," *Telegram*, June 16, 1967, 43.

320 "Photophobia," *Art Gallery of Hamilton* (blog), accessed July 15, 2020, https://www.artgalleryofhamilton.com/program /photophobia-2020/.

321 For a comprehensive survey of Toronto history see Chris Gehman, ed. *Explosion in the Movie Machine*, which includes my essay, "Toronto as Experimental Film Capital: Screenings, Schools, and Strong Personalities." The Toronto part of this historical survey is the longest, which on the one hand reflects the fact that I am based in Toronto, and have first-hand experience with the scene (I am aware that, *ipso facto*, I cannot capture the textures and nuance of the lived histories of experimental film in sites outside of Toronto). On the other hand, Toronto has unquestionably been the major centre for English Canadian experimental film distribution, labs, schools, production co-ops and commissioning, curation and exhibition, and critical writing, both journalistic and academic. A popular T-shirt monogram arose in 2014: "TORONTO -VS- EVERYBODY," likely a cheeky response to a well-known Canadian truism: Everybody Hates Toronto. Sorry.

322 Porter, "Artists Discovering Film," 26.

323 Porter, "Consolidating Film Activity," 28. Another CBC series that showed some experimental films was *New Film Maker*, created by Jack Vance, produced by Doug Gillingham, and hosted by Lyal Brown, from April 23 to June 23, 1969.

324 Censorship battles were frequent with the Ontario Censor Board, but not restricted to experimental filmmaking, and in the 1980s, there were battles within feminist, queer, and artistic circles around representations of the body, definitions of obscenity, and appropriate political strategy.

325 Gingras's film also showed at Montréal Film Festival. His other films include *Going Like Sixty*, *Commercials I Couldn't Sell*. See Porter, "Consolidating Film Activity."

326 Porter, "Consolidating Film Activity."

327 Interestingly, Gorman's work on film was covered in newspapers, a testament to public interest in underground film and the legibility of Gorman's practice: a painter painting on film strips makes sense. Peter Churchill, manager of the Embassy, recalls, "It was spectacular. The audience was so caught up in it that when it finished they demolished the whole screening apparatus, which was a fitting celebration." Quoted in Porter, "Consolidating Film Activity."

328 Mike Hoolboom, ed., *Strange Machines: The Films of Phillip Barker* (Toronto: Pleasure Dome, 2018).

329 Rick Hancox, "There's a Future in Our Past," in Hoolboom, *Inside the Pleasure Dome*, 188. Keith Lock tells his own remarkable story in "Adventures in Celluloid Gold Mountain," in Chang, *Reel Asian*, 224–39. Co-op members included David and Jim Anderson, Raphael Bendahan, Kirwan Cox, Bruce Elder, Clarke Mackey, Morley Markson, Don Owen, Rowe, Snow, Sylvia Spring, and Tom Urquhart. See Jerry McNabb, "The Toronto Film Maker's Co-Op," *Cinema Canada*, November 1972, 46–47; and Wyndham Wise, "Up from the Underground: Filmmaking in Toronto from *Winter Kept Us Warm* to *Shivers*," in *Toronto on Film*, ed. Geoff Pevere (Toronto: TIFF, 2009), 88–107.

330 Hancox, "There's a Future in Our Past," 188.

331 Interview with Bing Wang, April 21, 2015, quoted in T.J. Alston, Alex Jokinen, Chelsea Keen, Stacey Turner, and Bing Wang, "Take Two: Reflecting on Toronto Filmmakers from 1965 to 1972" (program note, Ryerson Film + Photography Preservation and Collections Management Program exhibition, 2015). Bendahan moved to Montréal in 1978 and completed his MFA at Concordia.

332 Richard Martin, *Backbone* interview with Patricia Gruben (2015), Vimeo video 18:27; and Gruben, "Sifted Evidence," in Hoolboom, *Inside the Pleasure Dome*, 38.

333 Peggy Gale, "All These Years: Early Toronto Video," in Gehman, *Explosion in the Movie Machine*, 53–71.

334 Gale, "All These Years." Other important video artists include Rhonda Abrams, Susan Britton, Christene Browne, Richard Fung, Noel Harding, Gary Kibbins, Glace W. Lawrence, Tanya Mars, Andrew Patterson, Paulette Phillips, Su Rynard, and Jayce Salloum, among many others. See Peggy Gale, "Toronto Video: Making Waves," in Gale, Jost, and Nanibush, *Toronto: Tributes + Tributaries*, 177–79.

335 Kass Banning, "Culture for Sale: Recent Toronto Works," *Cinema Canada*, no. 149 (February 1988): 11–12.

336 Peggy Gale, ed., *Video by Artists* (Toronto: Art Metropole, 1976), followed by Elke Town and Art Metropole, *Video by Artists 2* (Toronto: Art Metropole, 1986).

337 Key organizational figures included Steele and Tomczak, Britton, Colin Campbell, Gehman, Louise Liliefeldt, Logue, Clive Robertson, Wanda vanderStoop, and Werden.

338 Figures important to its more recent history include Roberto Ariganello, Deanna Bowen, Ben Donoghue, Chris Kennedy, Renata Mohamed, and Karl Reinsalu, among many others.

339 Wyndham Wise, "Toronto New Wave," Canadian Film Encyclopedia, accessed July 17, 2020, http://cfe.tiff.net /Browse/bysubject/toronto-new-wave; and Brenda Longfellow, "Surfing the Toronto New Wave: Policy, Paradigm Shifts and Post-Nationalism," in Pevere, *Toronto on Film*, 108–34. Greyson, Lundman, Mettler, and Podeswa all had short films and video included in the 1987 Power Plant exhibition, *Toronto: A Play of History (Jeu d'histoire)*. Lundman's *Las Aradas* (1984) is a powerful minimalist film about a massacre in El Salvador, and a reminder of the prominence of Central American politics in Canadian independent film and video during this period.

340 Jonathan Culp's essay, "Further Shores: Experiments in Canadian Feature Narrative" (in Gehman, *Explosion in the Movie Machine*, 188–209) charts this phenomenon, starting with Joyce Wieland's traumatic experience of making *The Far Shore* (1976). He includes the experience of Greyson (*Zero Patience*, 1993, and *Lilies*, 1995), Onodera (*Skin Deep*, 1995), Kerr (*The Willing Voyeur*, 1996), Lee (*The Art of Woo*, 2001), and Steve Sanguedolce (*Dead Time*, 2005), and notes the relative success of Daniel Cockburn's *You Are Here* (2010).

341 Mike Hoolboom, *Underground: The Untold Story of the Funnel Film Collective* (Canadian Film Institute, 2016).

342 The CEAC controversy helped bring arts sector activities to the attention of government authorities (Sirove, "Truce or Compromise?," 158).

343 Funnel directors included Anna Gronau, Gary McLaren, David McIntosh, Ross McLaren, Michaelle McLean, John Porter, and Melinda Rooke. Other members included David Anderson, Jim Anderson, David Bennell, Mike Cartmell, Peter Chapman, Sharon Cook, Martha Davis, Judith Doyle, Bruce Elder, Kathryn Elder, Greyson, Hoolboom, Patrick Jenkins, Mangaard, Paul McGowan, Onodera, Porter, Snow, Edie Steiner, Adam Swica, Villem Teder, Tuer, and Urquhart. Hoolboom, *Underground*.

344 TIFF presented the video art program Video/Vidéo (1981–1983), which was criticized by Lisa Steele for co-operating with the Ontario Censor Board ("Video/Video on the wall...," *FUSE* (Jan/Feb 1983): 227–28).

345 Other *Carte Blanche* programmers included Atom Egoyan, Vera Frenkel, Jean Gagné, Philip Hoffman, Mike Hoolboom, Bruce LaBruce, Helen Lee, Laurie Lynd, Bruce McDonald, Midi Onodera, Jeremy Podeswa, Michael Snow, Veronika Soul, Gariné Torossian along with Canadian Film Centre, Inside/Out, and LIFT.

346 Scalpel Webster, "Pure punk!" *Cinema Canada* no. 70 (December 1980): 26–29. Hartt also regularly showed films from the European historical avant-garde.

347 "Marc Glassman | Mike Hoolboom," accessed July 17, 2020, http://mikehoolboom.com/?p=13995.

348 For a complete list, see "Pleasure Dome Programming Collective/Board Members (1989–Present) – Pleasure Dome," accessed January 27, 2021, https://pdome.org/programming -collective/. Tom Taylor was the stalwart administrator for twenty-six years, who coordinated grants and the complex multi-venue programming. Scott McLeod went on to found Prefix Institute of Contemporary Art (est. 1999), which shows "photography and related arts" including film and media art.

349 Notable curator/programmers (many of whom are also filmmakers and/or scholars) include Scott Miller Berry, Amber Christensen, Liz Czach, Jesse Cumming, Jon Davies, Clint Enns, Chris Gehman, Alexandra Gelis, Eli Horwatt, Chris Kennedy, Jacob Korczynski, Samuel La France, Louise Liliefeldt, Nahed Mansour, Erik Martinson, Daniel McIntyre, Gabrielle Moser, Julia Paoli, Ben Portis, Bojana Stancic, Michèle Stanley, Carly Whitefield, and Melanie Wilmink.

350 Exhibition spaces that have hosted experimental film and media screenings include Bloor Cinema, Buddies in Bad Times Theatre, Cameron House, CineCycle, Drake Underground, Factory Theatre, Innis Town Hall, Japan Foundation, John Spotton Theatre/NFB, Latvian House, Music Gallery, the Rivoli, Royal Cinema, SPK Polish Combatants' Hall, Tranzac Club, and Workman Theatre.

351 Nadja Sayej, "Cozying up with Experimental Film," *Globe and Mail*, August 24, 2007, https://www.theglobeandmail.com /arts/cozying-up-with-experimental-film/article692649/.

352 "Pix Film Productions," PIX Film, accessed December 13, 2020, https://www.pixfilm.ca. See also Clint Enns and Mike Hoolboom, eds., *Shock, Fear, and Belief: The Films and Videos of Madi Piller* (Toronto: Pleasure Dome, 2016).

353 Ed Conroy, "The Birth of Late Night TV in Toronto," *blogTO* (blog), September 26, 2014, https://www.blogto.com /city/2014/09/the_birth_of_late_night_tv_in_toronto/.

354 Kathryn Elder, "Report from Toronto," *Millennium Film Journal*, no. 10/11 (Fall/Winter 1981–1982): 176–80. Even photography was a latecomer to the AGO: no photographs were acquired until 1977. (My thanks to Sarah Robayo Sheridan for this reference.)

355 Art Gallery of Ontario, *Videoscape: An Exhibition of Video Art, 20 November 1974–1 April 1975* (Toronto: The Gallery, 1974). Exhibition catalogue.

356 *Autobiography: Film/Video/Photography*, November 1– December 7, 1978 (Toronto: Art Gallery of Ontario, 1978).

Exhibition catalogue with introduction by John Stuart Katz and catalogue essays by Jay Ruby, John Stuart Katz, Peggy Gale, and Dennis Wheeler.

357 International filmmakers ranged from Chantal Akerman, Peter Greenaway, and Ulrike Ottinger through Hungarian, Japanese, and Chinese cinema; Canadian exhibitions included Curnoe, Hancox, and Rimmer (whose video work was included).

358 The lineup of Canadian moving image media artists who later enjoyed exhibitions at the Power Plant is comprehensive, including Colin Campbell, Janet Cardiff & George Bures Miller, Douglas, Geoffrey Farmer, Frenkel, Graham, Mark Lewis, Rafael Lozano-Hemmer, Maddin, Bruce Mau, Steve Reinke, Snow, Althea Thauberger, and Emily Vey Duke & Cooper Battersby, and a number of group shows that included digital moving image media art like the *Magnetic North: Canadian Experimental Video* (2002) and *Beat Nation: Art, Hip Hop and Aboriginal Culture* (2013).

359 "About Us," *Hand Eye Society* (blog), accessed July 17, 2020, https://www.handeyesociety.com/about/.

360 A comprehensive account of film teaching in Toronto is challenging given the number of schools; in addition to the institutions discussed already, Humber College, which started offering film courses in 1969, has hired many independent filmmakers as faculty; Centennial College and Seneca College also offer courses in film and media production.

361 John Porter, "Consolidating Film Activity," 28.

362 In its final year, IFS changed its name to Frames Per Second, reflecting its distance from a campus film society. Full disclosure: I was an occasional member of IFS.

363 Hirsh's student films included *The Greeks Had a Word for It*, *Lynette and the Hammock*, *Chinese Ball Game*, and *Voulez-Vous Coucher Avec God?*

364 Other faculty include Longfellow, John McCullough, and Sanguedolce since the late 1990s; later faculty whose work engages experimental film include me, Greyson, Ali Kazimi, and Janine Marchessault.

365 Emerging filmmakers include Sharlene Bamboat, Joshua (Josh) Bonnetta, Lesley Loksi Chan, Tess Girard, Taravat Khalili, Alexis Mitchell, Nicolás Pereda, while mid-career artists included Daniel Cockburn, Francisca (Franci) Duran, Gehman, Atefeh Khademolreza, Jorge Lozano, Isiah Medina, Michelle Mohabeer, Esery Mondesir, and Kelly O'Brien.

366 Kathryn Elder, *The Films of Joyce Wieland* (Toronto: Cinematheque Ontario, 1999); Kathryn Elder, *The Films of Jack Chambers* (Toronto: Cinematheque Ontario, 2002).

367 Brett Kashmere, "The Road Ended at the Beach and Other Legends: Parsing the Escarpment School," *Brett Kashmere*, accessed July 17, 2020, http://www.brettkashmere.com/the-road-ended-at-the-beach.

368 Recent faculty who intersect with experimental film and media include Selmin Kara, Jean-Paul Kelly, Min Sook Lee, David McIntosh, Wrik Mead, June Pak, Paulette Phillips, Michael Trommer, b.h. Yael; Sara Diamond was a long-time OCADU president after her tenure at Banff School for the Arts.

369 John Porter, "A Brief History of *Frameline*," super8porter, July 2008, http://www.super8porter.ca/FunnelRadio.htm. Goslawski continues to co-host *Frameline* online on Radio Regent (est. 2012), part of Regent Park's FOCUS Media Arts Centre (est. 1990). Bailey was a film critic who wrote about experimental film and art cinema for *Now Magazine* before becoming the head of TIFF.

370 Loop members included Stephen Broomer, Vicky Chainey Gagnon, Colin Clark, Egan, Ilana Gutman, Angela Joosse, Erika Loic, Shana McDonald, Ajla Odobasic, Pruska-Oldenhof, Jocelyn Statia, and Ty Tekatch.

371 Canadian Images press kit, February 29, 1984.

372 "About Us," *Canadian Images in Conversation*, February 12, 2020, https://canadianimagesinconversation.ca/about/.

373 Natalie Edwards, "Moving Art," *Cinema Canada*, no. 13 (April–May 1974): 54–55.

374 "Café Ex," Canadian Film Institute, https://www.cfi-icf.ca/cafe-ex-2021.

375 Peter Harcourt, "A Muted Trumpet from Afar: Ruminations on the Cinematic Avant-Garde," *Public*, no. 25 (2002): 53.

376 Sandmark, *Independent Media Arts*, 17.

377 "Underground Film Centre," *Filmmakers Newsletter* 1, no. 7 (May 1968): 6; Pierre Jutras, "Interview with Michel Brault," trans. Will Straw, *Cine-Tracts* 3, no. 2 (Spring 1980): 37–48. In 1970, a short article on New York experimental cinema was published in the Montréal-based film magazine *Séquences*. See Janick Beaulieu, "Connaissez-vous l'Underground?," *Séquences*, no. 62 (October 1970): 18–21.

378 Jim Leach, *Claude Jutra Filmmaker* (Montréal & Kingston: McGill-Queen's University Press, 1999), 14. Despite the importance of Jutra to Canadian film history, revelations that emerged after his death of his sexual abuse of children have forever tarnished his legacy.

379 Cinémathèque royale de Belgique, *Third International Experimental Film Competition* (Brussels: Royal Film Archive of Belgium, 1963), 111.

380 Varga, *Shooting from the East*, 71. It included former NFB makers like Pierre Falardeau, André Forcier, Roger Frappier, and Léa Pool.

381 John Locke, "Experimental Film 1978: New York/Montréal," *Parachute* (Spring 1978): 31.

382 George Csaba Koller, "Le cinéma expérimental," in *Les Cinemas Canadiens*, ed. Pierre Veronneau (Montréal: Cinémathèque Québécoise, 1978), 61–70.

383 Michel Larouche, "Le cinéma expérimental," in *Aujourd'hui le cinema québécois: Dossier* (Paris: Cerf/Office francoquébécois pour la jeunesse, 1996), 96–101.

384 Main Film, *Main Film: répertoire*. (Montréal: Main Film, 1989).

385 For example, Robert Daudelin accepted all of Weiland's film elements, including outtakes from *The Far Shore*.

386 Michel Coulombe, "Un nouveau distributeur: Film Film," *Ciné-Bulles* 3, no. 6 (May–June 1983): 12.

387 Cinema Parallel was the inspiration for Atom Egoyan and Hussain Amarshi's Camera Bar (2004-2006) in Toronto, which was taken over by the Stephen Bulger Gallery (2006-2020).

388 "Films," Festival du nouveau cinéma, accessed December 16, 2020, http://nouveaucinema.ca/en/films.

389 Important video artists in Montréal include Luc Bourdon, Jean-Pierre Boyer, Nathalie Bujold, Donigan Cumming, Lorraine Dufour and Robert Morin, Chantal duPont, Pierre Falardeau and Julien Poulin, Charles Guilbert, Manon Labrecque, Sylvie Laliberté, Serge Murphy, David Rahn, Sabrina Ratté, and Frank Vitale.

390 Founders include Michel Cartier, Robert Forget, Jean-Paul Lafrance, Louis Martin, and Robert Russel. "Mandate, Vision, and History," Vidéographe, accessed July 18, 2020, https://www.videographe.org/en/about/mission/. The Vidéographe collection has an online portal, Vithèque (est. 2010) to make available its collection of experimental, animation, video art, and documentary works.

391 Founders include Hélène Bourgault, Bernard Émond, Louise Gendron, Michel Sénécal, and Michel Van De Walle. "Historique/History—Groupe Intervention Vidéo (GIV)," accessed July 18, 2020, https://givideo.org/1/?page_id=12. Similar to Women in Film and Television (est. 1984), the organization Réalisatrices Équitables (est. 2007) advocates for gender equity, including an internet directory of Québec women filmmakers, Dames Des Vues (est. 2018).

392 Véhicule Art programmed experimental films in 1982. See Michel Larouche, "Films experimentaux," *Parachute*, no. 28 (1982): 36–37.

393 Serge Lamoureux, "Un pour tous…Coop Vidéo de Montréal,"

Ciné-Bulles 30, no. 1 (2012): 28–33, https://id.erudit.org/iderudit/65542ac.

394 "Double Negative Collective: Our Manifesto," *Double Negative Collective* (blog), September 3, 2007, http://doublenegativecollective.blogspot.com/2007/09/our-manifesto.html.

395 "Double Negative Collective Manifesto."

396 "Double Negative Collective: TIE, The International Experimental Cinema Exposition, November 2–4th," *Double Negative Collective* (blog), October 15, 2007, http://doublenegativecollective.blogspot.com/2007/10/tie-international-experimental-cinema.html.

397 "Info," La lumière collective, accessed July 18, 2020, https://www.lalumierecollective.org/info.html; and "INFO," VISIONS, accessed July 18, 2020, http://www.visionsmtl.com/info.html.

398 Miron, in addition to making experimental films like *The Square Root of Negative Three* (1991) and *The Evil Surprise* (1994), made a film biography, *Paul Sharits: Expanding Cinema to the Beyond* (2016). Le Festival Stop Motion Montréal (est. 2009) was started by Concordia professor of animation, Érik Goulet.

399 "La Bande Vidéo – Centre de création et de diffusion en arts médiathiques," La Bande Vidéo, accessed July 18, 2020, https://labandevideo.com/fr/.

400 Other New Brunswick film and media artists include Louise Bourque, Kira Daube, Dan Smeby, and Valerie LeBlanc, and Amanda Dawn Christie, who worked at Struts/Faucet.

401 "FilmPEI Building the Film Industry on Prince Edward Island," Film PEI, accessed July 19, 2020, https://www.filmpei.com/.

402 Rick Hancox, "There's a Future in Our Past," in Hoolboom, *Inside the Pleasure Dome*, 184.

403 Atlantic Filmmakers Cooperative, "About AFCOOP," accessed May 25, 2020, http://afcoop.ca/about-afcoop/.

404 Varga, *Shooting from the East*, 86.

405 MacSwain's films include *Amherst* (1984, Super 8); *Nova Scotia Tourist Industries* (1998, animation); *The Fountain of Youth* (2010, cut-out animation).

406 Varga, *Shooting from the East*, 91; Atlantic Filmmakers Cooperative, "About AFCOOP," accessed July 19, 2020, https://afcoop.ca/2007/05/about-afcoop/; "James MacSwain Fonds - MemoryNS," accessed July 19, 2020, https://memoryns.ca/james-macswain-fonds.

407 Varga, *Shooting from the East*, 93. At AFCOOP, animators have included Christopher Ball, Becka Barker, Helen Bredin, Siloën Daley, Heather Harkins, Lulu Keating (*Lulu's Back in Town*, 1980, and *The Jabbberwalk*, 1981), Ramona Macdonald, and Lisa Morse.

408 Tragically, Hill was killed in 2007 in New Orleans while attempting to help her Hurricane Katrina–devastated neighbourhood. Her final film, *The Florestine Collection*, was completed in 2011 by her husband.

409 Takatsu, "Video Pool Media Arts Centre Origins."

410 Badger, "Appendix: There Is No Feminism (A Love Letter)," in Davis, *Desire Change*, 277.

411 The other members of the collective were MSVU director Ingrid Jenkner and Barbara Sternberg; the exhibitions were in co-operation with AFCOOP and NSCAD. Gerda Cammaer, *Changing Times, Time Changes: Canadian Experimental Films & Videos of the 1990s* (Halifax: MSVU Art Gallery, 2002); Gerda Cammaer, *Placing Spaces, Spacing Places: Canadian Experimental Films & Videos since 1990* (Halifax: MSVU Art Gallery, 2003); and Gerda Cammaer, *Brisk Collages & Bricolages: Artistic Audits & Creative Revisions of Mainstream Media in Recent Canadian Shorts* (Halifax: MSVU Art Gallery, 2005).

412 Takatsu, "Video Pool Media Arts Centre Origins."

413 Ronald Foley Macdonald. "'The Act of Seeing with One's Own Eyes': New Films by Independent Filmmakers," *ArtsAtlantic* 9, no. 3 (Fall 1989): 65. Work by Brakhage, Carl Brown, Kerr, Snow, and Atlantic artists like Melissa Atkinson, Alex Busby and David Coole, Charles Clark, David Lanier, Melinda Sato, and Sternberg was included.

414 Yukon Film Society, "About YFS," accessed July 12, 2020, https://yukonfilmsociety.com/about.

415 "History of KIAC – KIAC KLONDIKE INSTITUTE OF ART & CULTURE," *KLONDIKE INSTITUTE OF ART & CULTURE* (blog), accessed July 12, 2020, https://kiac.ca/join-give/history-of-kiac/. The following film/media-makers have participated as artists-in-residence: Christina Battle, Deirdre Logue, Michelle Latimer, Madi Piller, Terrance Houle (Blood), Life of a Craphead (Amy Lam and Jon McCurley), Matthew Rankin, and Kyle Whitehead.

416 Michael Robert Evans, *Isuma: Inuit Video Art* (Montréal & Kingston: McGill-Queen's University Press, 2008).

417 "Isuma," IsumaTV, accessed July 18, 2020, http://www.isuma.tv.

418 Nunavut Independent Television Network (NITV) has shows both online and through local cable television.

419 Laura McGough, "Arnait Video Productions: A Conversation with Marie-Hélène Cousineau," *INCITE*, 2019, http://incite-online.net/arnait.html.

420 "Isuma," IsumaTV, accessed July 18, 2020, http://www.isuma.tv.

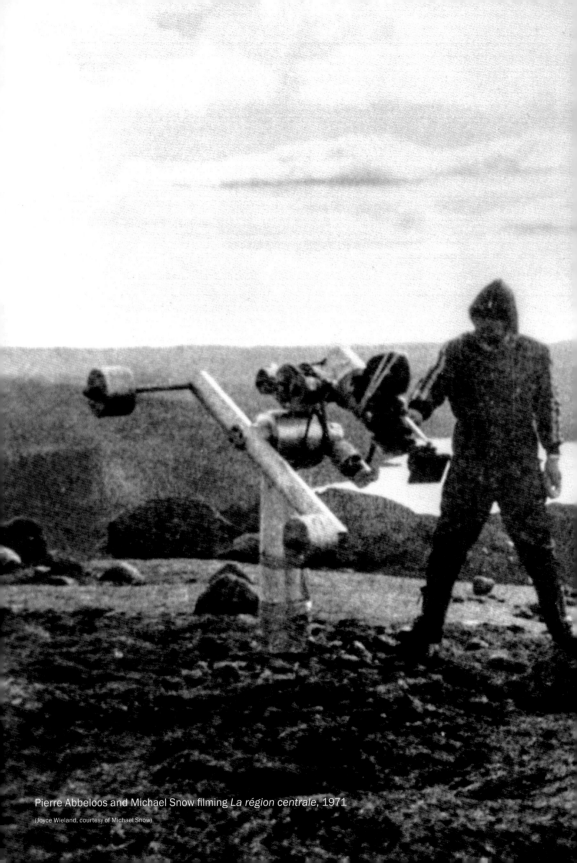

Pierre Abbeloos and Michael Snow filming *La région centrale*, 1971

(Joyce Wieland, courtesy of Michael Snow)

2

Moments of Perception

STEPHEN BROOMER

CHRISTINA BATTLE

Born Edmonton, Alberta, Canada, March 3, 1975

SELECTED WORKS

Cooper/Bridges Fight, 2002, 3 min., 16mm, b&w, sound
oil wells (sturgeon road & 97th street), 2002, 3 min., 16mm, colour, sound
fall storm (california, 2003), 2004, 3 min., video, colour, sound
paradise falls, new mexico, 2004, 5.5 min., 16mm (double screen), b&w, sound
buffalo lifts, 2004, 3 min., 16mm, colour, silent
following the line of the web, 2004, 2.5 min., 16mm, b&w, silent
nostalgia (april 2001 to present), 2005, 3.5 min., 16mm, colour, sound
the distance between here and there, 2005, 7 min., 16mm, colour, sound
migration, 2005, 5 min., 16mm, colour, sound
Behind the Walls and Under the Stairs, 2006, 3 min., 35mm, colour, sound
hysteria, 2006, 3.5 min., 35mm, b&w, sound
three hours, fifteen minutes before the hurricane struck, 2006, 5 min., 35mm, b&w, silent
Behind the Shadows, 2009, 17 min., 16mm/video, colour, sound
Tracking Sasquatch (series), 2010-, 18.5 min., 16mm/video, colour, sound
To reveal the fourteen windows, 2011, 9 min., video, colour, sound
when the smog-filled wind began to howl, 2011, 5.5 min., Super 8/video, colour/b&w, sound
on the day it started there wasn't a cloud in sight, 2012, 5 min., video, colour, sound
Forties 87, 2012, 4.5 min., video, colour, sound
Explorations of an Unexpected Time Traveler, 2013, 5 min., video, colour, sound
notes to self (series), 2014-, video, colour, sound
Δ (when the cities burn), 2015, 6.5 min., video, colour, sound
off this spinning rock, 2016, 3 min., video, colour, sound
Water once ruled, 2018, 6.5 min., video, colour, sound

Christina Battle, *buffalo lifts*, 2004

Christina Battle established herself in the early 2000s as an artist and community organizer, leading initiatives in media arts education, publishing, and curating. Battle had studied environmental biology before shifting her attention to the media arts; she pursued filmmaking while working at Niagara Custom Lab in Toronto, and through a series of degrees in Toronto and San Francisco. Her earliest work engaged with the politics and imagination of the West; with landscapes marked by industry, commerce, and trauma; and with material strategies that bear a furious momentum, dense with action, objects bursting from the frame.

This approach is evident as early as *oil wells (sturgeon road & 97th street)* (2002), in which oil well pumpjacks—an iconic sight of Alberta—cleave downward, pumping crude oil from the ground, the motion of the well a slow mirror to the camera's own intermittent mechanism; in the final minute, the pump is superimposed over itself with the frame line shifting, as if the damage being done to the earth is being done to the foundation of the frame itself. Such crossings of technique and theme continue in *buffalo lifts* (2004): Battle applies the technique of "emulsion lift" to found footage of a herd of buffalo galloping in profile. The material went through a long translation, from video to black-and-white film, printed to colour stock and then manipulated by chemistry. The emulsion is loosened on the film strip, lifted and rearranged, crumpling on the strip to dry; the effect of this

is an abstract collage, a redistribution of subject such that the buffalo are overtaken by a substructure of colour layers (a brilliant yellow emerges), and by the splintering texture of distressed emulsion. Within moments the frame itself is violently shrunken so that its edges seem to veer inwards in the composition, the herd subject to an "accordion bellows" effect that elasticizes their silhouettes and frays the source frame such that it becomes an intensely activated mass within the fixed boundaries of the composition.

This defiance of the frame's boundaries continues with *following the line of the web* (2004), in which a web pattern, splintered into kernels of light against a black background, restlessly tilts, shifting with each passing frame. The pattern has been photogrammed onto the film strip, and as such the dimensions of the image being cast do not fit the tiny frames of 16mm, forcing the eye to reconstitute the parts of this web as it leaps from frame to frame. The photogram became one of Battle's primary techniques for a number of years following this: in *the distance between here and there* (2005), another abstract work, Battle creates a discontinuous red and yellow pattern of horizontal bars and triangles that persist for the film's 7-minute duration, the fuzzy granularity of the film strip coming to the fore. *Behind the Walls and Under the Stairs* (2006) likewise continues Battle's interest in the photogram, this time with a shape that resembles a spider that maintains an unsteady focus in the centre of the frame, its viscera shifting between brown, pink, green, and yellow, offset by a dense black background. This frenzy of photogram animation is replaced in *hysteria* (2006) with static, re-photographed illustrations of the Salem witch trials, storybook illustrations of defiant women pointing fingers in protest at their Puritan judges. Although these images are stable and centred, Battle's hand-processing and solarizing of the image animates it: light courses through the face of a figure to shift between positive and negative. When the illustrations turn violent, so too does Battle's style, as silhouettes of hanging women shake through the frame, and images of the Puritan patriarchs are crumpled by way of emulsion lift.

Battle was no stranger to multi-screen composition when she made *Behind the Shadows* (2009), having previously created diptych works early in her career. But it expanded the stylistic turn her films had taken with *hysteria*, using re-photographed imagery, solarizing found images, which casts them between negative and positive and augments them with the dynamic, chance rhythms of rough hand-processing. The bulk of the diptych is mirrored, but at times distinct images appear to be in dialogue or relief; action also seems to cross from right to left, as in the forms of bats that seem to fly from one frame to the other, continuing Battle's subversion of the frame boundaries. It is in this same imagery that colour first begins to bleed into the image, as the photonegative bat silhouettes, clear against a black background, are tinted pink and later green. As the film ends, this selective colour gives way to a symphony of colour collisions, as bats of various hues are cast over one another, creating even more colours.

Christina Battle, *Tracking Sasquatch* (series), 2010-

Battle embraced video and installation early in her practice, but this direction became increasingly total in the 2010s. Her approach to video is distinct in its patient, clinical rhythms; in attending to the medium's inherent ability to communicate information; and in her manipulation of its plasticity. The *Tracking Sasquatch* series is notable in this regard, for its workflow transitioned over time from film to video. In the first part (2010), shot on 16mm, the camera surveys woods and fields, accompanied by text that speculates without skepticism about the titular Sasquatch, casually insisting, in text against a black screen, that the author has repeatedly witnessed these cryptozoological creatures (the text is taken from various Sasquatch field guides). The image offers no corroboration, suggesting that the apparatus's ability to verify information is not all-inclusive. That this work is playing with notions of visual evidence, technology as witness, and burdens of proof becomes explicit as the series continues. By *Tracking Sasquatch (field report #4)* (2016), Battle is using Google Earth images to survey landscapes where Bigfoot has been sighted; the satellite maps that she magnifies and drags are noticeable for their vacancy, with little evidence of human activity save for roads. As the video continues, Battle's narration offers a history of satellite imagery and its faults and inefficiencies, and further to that, speculates on the nature of gathering evidence to support the existence of what is doubted and hidden. That the Sasquatch eludes our most prized tools for factual verification speaks more to our perception of verification and what is knowable than it does to the particular facts of Bigfoot.

On-screen text played a greater role in Battle's work after 2010, and likewise the poetic character of Battle's films, shifted with her turn to video: a greater emphasis is placed on on-screen texts that are fragmented into verse. This arrives in hand with a redoubling of attention to landscape. In *To reveal the fourteen windows* (2011), she collaborates with the poet Julie Carr, whose text appears against static shots of telephone lines, treetops, buildings slated for demolition, and a clear white screen. This approach recurs with found text in *on the day it started there wasn't a cloud in sight* (2012), in which static shots of fields in Saskatchewan are overtaken with light, and animated beams of light travel between power lines, toward fields of still windmills and fields of glowing wheat. The plains are full of energy and menace, the sounds of industrial farming. The energy of Battle's earlier films has been changed by embracing a digital workflow. The resulting videos remain intense in their vision, but that intensity has gone from the harsh dispersal of forms that Battle pursued with film, to a probing stasis that draws from the more carefully machined illusionism of video.

Since 2012, Battle's output has often been defined by themes of information and transparency. What she composes for the white cube of the gallery tends to emphasize strategies of resistance that retain the recurring themes of her work, posing a broad inquiry against injustice. Much of this work is conceived for multi-projection and mixed media, but Battle has continued to pursue single-channel video, more often for looping in galleries than for screening in theatres. A number of ongoing series demonstrate this shift in her work from the chance operations of hand-processed film to the confrontation of conceptual art: her *notes to self* (2014-) is emblematic of this, an open series in which statements written on slips of paper are burned, a ceremonial, funereal act. The project arose as a response to the pithiness of social media "updates," and the featured statements range from the memorial, to the prosaic, to personal expression, to sloganeering.

The dominant themes of Christina Battle's films and videos—landscape, visibility, and the nature of truth—persist even as their ultimate forms change. In *water once ruled* (2018), Battle again occupies panoramic Google Earth images, appropriated news footage, and photography of Mars to draw parallels between the crisis of water and air quality on earth and the red deserts of Mars. As a camera careens through a digital model of Mars, text tells of the planet's transformation over time before images of terrestrial floods flash over it. In its final moments, a rolling matte makes direct visual parallels between terrestrial bedrock and antique illustrations of a human conquest of Mars. This is a central character in Battle's cinema: speculation on catastrophe, and through such anticipation and by bearing witness—of moving images, data, surveillance, illustration—she builds acts of resistance.

—SB

LOUISE BOURQUE

Born Edmundston, New Brunswick, Canada, February 2, 1963

Louise Bourque, *L'éclat du mal / The Bleeding Heart of It*, 2005

FILMOGRAPHY

Jolicoeur Touriste, 1989, 10 min., 16mm, colour, sound
Just Words, 1991, 10 min., 16mm, colour, sound
The People in the House, 1994, 22 min., 16mm, colour, sound
Imprint, 1997, 14 min., 16mm, colour, sound
Fissures, 1999, 2.5 min., 16mm, colour, sound
Going Back Home, 2000, 1.5 min., 35mm, colour, sound
Self Portrait Post Mortem, 2002, 2.5 min, 35mm, colour, sound
Jours en fleurs, 2003, 4.5 min., 35mm, colour, sound
L'éclat du mal/The Bleeding Heart of It, 2005, 8 min., 35mm, colour, sound
Remains, 2011, 5 min., 16mm, colour, sound
The Visitation, 2011, 3 min., miniDV, colour, sound
a little prayer (H-E-L-P), 2011, 8 min., b&w, sound
Auto Portrait/Self Portrait Post Partum, 2013, 13.5 min., 35mm, colour, sound
Bye Bye Now, 2021, 10 min., 16mm, colour, sound

Acadian filmmaker **Louise Bourque** began to make films in the late 1980s while a student at Concordia University in Montréal. The bulk of her films were made while living in Boston, Massachusetts, where she also taught at the School of the Museum of Fine Arts and Emerson College. From the mid-1990s onward, Bourque's films have dealt with plastic manipulation of the film plane in the form of scratches, chemical alteration, contact printing, and tricks of time created by re-photography. In 2010, she returned to Canada; she now lives in Montréal, Quebec.

Bourque's first film, *Jolicoeur Touriste* (1989), combines themes of interstellar travel, televisual signals, and a monologue about journeys taken in childhood. The monologue is repeated and with each repetition becomes stiffer and more self-consciously performed. In a hostel, a man grabs a beer from a nearby fridge, slumps in his chair, turns the radio dials, and watches late-night dial-flipping television broadcasts, all shown in tones of unnaturally saturated colour (the blue of the television, a green lamp near the fridge and radio, a red lamp hanging over the figure's armchair). Like the monologue, the sequence is repetitious, as if the man is suspended in the interminable attention of space travel. At the end, after the monologue recounts a visit to the planetarium, the figure is seated, his form optically removed and filled with scenery of movement from the television broadcast and Super 8 footage of landscapes in Ireland. The theme suggested by this final image, of the self riddled with the dust of the past, is one that would persist throughout Bourque's work.

Her next film, *Just Words* (1991), uses part of a monologue by Samuel Beckett (*Not I*, 1972, historically performed, as it is here, by an illuminated mouth), with an additional voice-over written by Bourque in elliptical phrases: "this world, into this world…before her time…so tiny…so no love…meant to be suffering…punishment…" The mouth image is intercut with home movies of her mother, sandwiching the menacing undercurrent of home movies to the mouth's declarations and denials. In this film, Bourque continues the theme of the past occupying the present, if we are to take the mouth as the present—as a surrogate for the filmmaker—and the home movie, inevitably, as a past that interrupts and illustrates or provides counterpoint.

The People in the House (1994) is the sole continuation of the style of *Jolicoeur Touriste*, in its use of primary-coloured light to develop a stylized, alien atmosphere. With exact control of the look of the image—saturated colour-coded parts of the house, pastel-tinted footage simulating old hand-coloured imagery—she denotes different time frames in an elliptical family story. Discontinuous scenes from various family dramas are enacted, presenting core emotion rather than anecdotal detail: a wartime letter read tearfully around the kitchen table, a passionate argument at the bedroom door between mother and daughter. The scenes seem to be following a script of half-whispered male voice-over quoting catechism instructions: "God made us to know him and serve him and reach heaven…passions…promised love…soul free…" This last quote is followed by

the mother smiling, dancing, the image glowing white. The routines that are performed by these figures, for the most part in slow motion, turn menacing with a sad-eyed patriarch carrying the seemingly lifeless body of a maternal figure in formal dress and long gloves up a turning stairwell. Bourque's optical effects include a slowed shutter that makes the space of the house all the more alien, staggering time, casting trails through corners and scenery in such a way as to create even more stylized colours and textures. These effects render the figures as spectral. The "people in the house" are ghosts of an inexplicit past. The film ends with the mother laid out on the bed as Bourque continues her questioning of the role of mother. Under the sway of the Catholic Church, this is the patriarchal home in extremis, one which must be dismantled. Bourque undertakes this in her next films, where the rupture of the idealized family home is paralleled with the ruptured image of the house.

Louise Bourque, *Imprint*, 1997

Bourque's work had, from its start, engaged with elaborate optical effects, but she had also balanced these effects with dramatic content in the forms of monologues and the presence of actors. With *Imprint* (1997), these narrative traits are shed in favour of a plastic experience. The film draws from footage of the edifice of a home seen, primarily,

in photographic negative, first in a pale-blue colour cast, which changes as Bourque's method of experimentation changes. Early in the film, Bourque's plastic manipulation involves cutting out a circle in the middle of the frame, leaving in the punched-out image so that it vibrates in place, replaced with different footage; later sections of the film use a photographic negative unconstrained by tints, the house surrounded by bleeding black forms. Finally, the windows are etched out, and with the image now in photographic positive, the faces of children running around the lawn become more visible. As the soundtrack shifts from gritty, restless noise to the sounds of Enrico Caruso singing "A Dream," a distant pastoral anthem of bygone days, the emulsion is rent from the frame, refiguring in quick bursts the shape of the house and making visible an underlying blue and pink of the filmstrip. These colours become more violent, more autumnal, as the section repeats, until the image is finally fully abstract, pulsating forms of cyan and magenta.

The themes and stylistic traits of this work—this newly plastic, abstract direction—continued in *Fissures* (1999), in which home movies are cropped, their frame lines shifting, their sprockets providing a continuous rhythm coursing through the frame, the image smearing, bleeding light and solarized, passing in a single composition from positive to negative and fading into darkness. *Going Back Home* (2000) likewise uses images of home, here in traces of catastrophe: in a sequence of eight shots we see a derailed train car, a sunken house, a dog on a roof, a raging inferno in a window, and the controlled collapse of buildings, all in a golden hue. With the comic aplomb of a jangling toy piano on its soundtrack, *Going Back Home* offers a series of homes to which no one can return. The film repeats for a second look. Bourque revisited the footage used in *Imprint* in *L'éclat du mal/The Bleeding Heart of It* (2005), this time with a soundtrack in which the filmmaker narrates the content of a terrifying dream of wartime that seems to be illustrated by the decay, the plastic *décollage* of the home. In her accompanying annotation, Bourque describes the role of such traumas explicitly: "the house that bursts; the scene of the crime; the nucleus." Between this description and the terrors described by Bourque on the soundtrack, the images of the family become deeply unsettling, even threatening. Bourque would revisit this same footage again in *Bye Bye Now* (2021).

Self Portrait Post Mortem (2002) is the first of two self-portraits, this one made from an image of Bourque as a young woman. She occupies the centre of the frame, in a sequence slowly advancing frame by frame. Her eyes are shut at first, then she stares into the camera. Each frame is eaten away at its edges by mould, each abstraction advancing manually through the shadow of the preceding one. Bourque repeated this gesture, the manual advancing of decayed frames, in *Jours en fleurs* (2003) and *Remains* (2011), films that largely eschew representational imagery in favour of non-objectivism and the experience of colour. In the case of *Jours en fleurs*, made using images incubated in menstrual blood for nine months, there are rich blues and browns, the patina of time

achieved by way of her blood; in the case of *Remains*, yellow and white pair with a brief glimpse of the maternal figure from *The People in the House*.

The second of Bourque's self-portraits, *Auto Portrait/Self Portrait Post Partum* (2013), has a three-part structure. Following a prologue of speech taken from a love letter, the first part begins: it is a long-take self-portrait, in a blue cast, trained on Bourque's tearful face, with close-ups on her eyes and lips, accompanied by songs ranging from Neil Young to the Supremes. The second part, in a red cast, involves the distortion of found scenes from movies and scratched texts and attributions; the scenes she has selected suggest violence inflicted by a man on a woman. The final sequence involves a further act of self-portraiture, of Bourque underwater, floating ethereally towards liberation from mourning and from yearning. Throughout, text communicates a devastating separation, in this case, from her former long-term partner, confessional filmmaker Joe Gibbons (who is credited as co-editor). *Auto Portrait/Self Portrait Post Partum* is an ultimate work for Bourque that lays bare one of her primary themes: catharsis, and the achievement of catharsis through objects (be they home movies, records, love letters).

In 2011, Bourque made *a little prayer (H-E-L-P)*, distinct from her prior work in the speed and aggression of its editing. It uses the rolling of a shutter, its opening and closing, to glimpse fragments of found and abstract (scratched) black-and-white footage of magician Harry Houdini trying to free himself from chains. The stroboscopic effect shuttles us from representation to non-objective imagery, mixing the shot of Houdini, scenes from Niagara Falls, lines of men in uniform, with images resembling the black-and-white slashes of Franz Kline paintings. The quick roll of the shutter leaves us in a state of unstable vision that cannot glimpse the whole of any single composition, such that the edges of each image are glimpsed only at the moment when the shutter rolls back, to close and open again on a new image. This is an opposite strategy to the one Bourque employs in *Self Portrait Post Mortem*, *Jours en fleurs*, and *Remains*, where the slow advance of a shutter allowed each image to be seen in full and to overlap with what preceded and followed. Bourque's work has always played with what was not visible, from her earliest use of the home movie and its surfaces, to her photochemical abstraction of the image; in *a little prayer*, that tactic achieves its apotheosis, demanding an engagement that tunes the eye, and through it the whole organism, to the flicker of the image.

—SB

STEPHEN BROOMER

Born Toronto, Ontario, Canada, July 8, 1984

SELECTED WORKS

Christ Church—Saint James, 2011, 7 min., 16mm, colour, sound
Brébeuf, 2012, 11 min., 16mm, colour, sound
Queen's Quay, 2012, 1.5 min., 16mm, colour, sound
Spirits in Season, 2013, 12 min., 16mm, colour, sound
Pepper's Ghost, 2013, 17.5 min., 16mm, colour, sound
Championship, 2013, 21.5 min., 16mm, b&w, sound
Conservatory, 2013, 3.5 min., 16mm, colour, silent
Zerah's Gift, 2013, 7.5 min., Super 8, colour, silent
Serena Gundy, 2014, 3.5 min., 16mm, b&w, silent
Jenny Haniver, 2014, 15 min., 16mm, b&w, silent
Hang Twelve, 2014, 24.5 min., digital, colour, sound
Dominion, 2014, 8 min., digital, colour, silent
The Season Word, 2014, 5.5 min., digital, colour, silent
Variations on a Theme by Michael Snow, 2015, 7.5 min., digital, colour, sound
Wild Currents, 2015, 6.5 min., 16mm, colour, sound
Landform (series), 2015-, 16mm, colour, silent
Gulls at Gibraltar, 2015, 3.5 min., 16mm, b&w, silent
Mills, 2016, 3.5 min., 16mm/digital, colour, silent
The Bow and the Cloud, 2016, 8 min., Super 8/digital, colour, silent
Potamkin, 2017, 67 min., 16mm, b&w, sound
Fountains of Paris, 2018, 9 min., 16mm/digital, colour, sound
Tondal's Vision, 2018, 65 min., 16mm/digital, colour, sound
Resurrection of the Body, 2019, 37 min., 16mm/digital (double screen), colour, sound
Phantom Ride, 2019, 68 min., digital, colour, sound
Lulu Faustine, 2020, 64 min., 16mm/digital, colour, sound

Stephen Broomer, *Phantom Ride*, 2019

Stephen Broomer shot his first movies on Super 8 film, as he was beginning his university studies at age eighteen. He studied filmmaking and film history at York University, where as a graduate student he pursued a novel, self-directed education in film preservation. In the 2010s, while completing a PhD on the history of Canadian avant-garde cinema, Broomer began to make short experimental films. Over the next ten years, he would make more than forty films, in addition to publishing on, curating, and preserving Canadian experimental cinema.

When Broomer began making films as an undergraduate in 2002, he was influenced by early experiences watching films by Kenneth Anger, Stan Brakhage, and Maya Deren. Discouraged from this path by his industrially oriented teachers, he trained in documentary filmmaking instead, completing a series of essayistic, educational documentaries on matters of social and environmental justice. He was inspired to return to experimental cinema through his friendship with and scholarly work on John Hofsess, a little-known but paradoxically legendary Canadian experimental filmmaker who believed in the emancipatory properties of film. In 2007, Broomer restored Hofsess's

cult classic *Palace of Pleasure*, long considered lost, a twin-screen film of psychedelic erotic imagery, black-and-white newsreel footage of the Vietnam War, and a soundtrack that includes poetry by Leonard Cohen and music by The Who and The Velvet Underground, among others. The major influence of Hofsess's film on Broomer's creative work was his emphasis on the power of cinema to liberate and the interplay of this with hypnotic, psychedelic experience.

Broomer's first films were environmental, psychogeographic portraits marked by his use of superimposition and imagery recalling Eastern mysticism (e.g., *Manor Road, Balinese Rebar*). Soon after, Broomer began to build his films on somewhat obscure underlying narratives, with rich intertextual references, drawn from history, visual art, cinema, and poetry, densely layered to produce a rapid and unstable shifting from representational imagery and abstractions created by cinematographic distortions, polyphonic superimpositions, and the complexity of the actual cutting. The *Spirits Series*, a trilogy of films exploring sites of spiritual trauma, is his first major work in this style. The first part of the series, *Christ Church — Saint James* (2011), was shot on the site of a church that was destroyed by arson and connected to an unsolved murder-suicide. Broomer filmed the granular character of the site itself—a ruin of charred cinders, crushed beer cans, abandoned clothes, and graffitied walls—comprehensively, even obsessively, but using his distinct aesthetic to capture the site's fundamental ambiguity and mystery.

The second part of the series, *Brébeuf* (2012), was shot in Midland, Ontario, the region where the missionaries Jean de Brébeuf and Gabriel Lalemant were tortured and executed by members of the Iroquois Nation in 1649. Expanding on the technique of *Christ Church — Saint James*, Broomer's footage becomes a symphony of superimposition. *Brébeuf* introduces a number of formal strengths that would inform his work to come, including a nuanced hand-held camera approach that goes from almost still to unmoored, to quite wild in capturing everything that appears to the filmmaker, including the snow, the trees, the river, and the sunbursts. Broomer layers the images, sometimes juxtaposing static shots with dynamic ones, an intricate dance of superimposed cinematic images that reminds us the film is not strictly about this place or its past. As Broomer describes it, "The programme becomes secondary to the gestural, improvisatory aesthetic of the work, and yet that aesthetic is deeply entrenched in the sublime and mysterious enigmas of these narratives."

The third and final part of the series, *Spirits in Season* (2013), adapts these techniques to a new setting, the Lily Dale Assembly, a Spiritualist commune in upstate New York that was home to the leaders of modern Spiritualism, the Fox sisters. What Broomer offers is an experience of passing through the empty village, a town marked as deeply by the earnest belief of its congregation as it is by accusations of fraud against its founders. The

major settings of their faith—a tree stump believed to be holy, a forest full of abandoned toys—are explored, often in dense superimposition.

As Broomer's work in 16mm filmmaking continued along this line, he simultaneously began to work in performance video, beginning with *Pepper's Ghost* (2013), in which the filmmaker and friends (Eva Kolcze and Cameron Moneo) use his office, a converted psychiatric observation room complete with a two-way mirror, to playfully create a series of optical illusions and abstractions by manipulating the ceiling lights and introducing curtains and gel filters. It was Broomer's first work with a DSLR; the camera is fixed on a tripod and the improvisations of Broomer, Kolcze, and Moneo are responsible for the montage and the manipulation of light and colour. This strain of performative video continued the next year with *Hang Twelve*, in which Broomer, Kolcze, and Moneo are joined by Emmalyne Laurin and Blake Williams, building a series of frames-within-frames out of painter's tape, suspended within Broomer and Laurin's apartment.

As a filmmaker with an extensive formal education in the history of modernist cinema, Broomer has balanced an awareness of film history with a more instinctual, improvisatory sensibility. Still, Broomer's films since 2014 often bear citations of underground and peripheral moments in the history of cinema. At least two films in his repertoire are explicitly inspired by Michael Snow: *Hang Twelve* (2014), the title itself is an anagram of *Wavelength*, and *Variations on a Theme by Michael Snow* (2015), in which the playful spirit of Snow's art is mirrored by Broomer as he interacts with a series of altars. *Fountains of Paris* (2018) was made using travel footage shot by documentary filmmaker Jacques Madvo in Paris in 1961. Out of Madvo's footage, Broomer divines a city symphony of superimposed images, mixing the optical characteristics of the city's iconic fountains with stained-glass cathedral windows. Broomer's most personal work to date, *Resurrection of the Body* (2019), is a long-gestating sequel, the final chapter, to Hofsess's *Palace of Pleasure*. Broomer's "speculative sequel and conclusion" is twin-screen, like the original, and runs the precise length of the original. The imagery is derived in part from the earlier film, only abstracted by Broomer using digital technologies, the erotic imagery transformed by funhouse mirrors, bent through illusions inspired by Ira Cohen's Mylar chamber. The film is personal not only in the role *Palace of Pleasure* played in Broomer's aesthetic sensibility but also as a eulogy for Hofsess, who took his own life in 2016.

It is in his long films since 2017, however, where Broomer's aesthetic proclivities come together most astonishingly. In these works Broomer finds a form that allows him to synthesize found footage (or "recycled cinema," a term he prefers) and abstraction, chemical and digital manipulations, history and poetry.

Potamkin (2017) was Broomer's first "feature-length film."[1] The film is a visionary account of the life and work of Harry Alan Potamkin, a critic and poet who died of

1 A term of convenience, and not meant to make normal something which is, in fact, arbitrary.

complications related to starvation in 1933. When he left us he was a bit of a legend; today he is essentially unknown. Potamkin saw that cinema might produce its own James Joyce, or many such artists who would embrace the polyphonic possibilities of the medium, while at the same time embracing film's inherent political potential. Broomer takes short fragments of films that Potamkin wrote about (e.g., *Battleship Potemkin*, *The Passion of Joan of Arc*, and *Metropolis*) and produces a work that imagines what a cinema that Potamkin advocated might look and sound like, almost ninety years after his death. Reshooting digital copies in 16mm, and then using chemical and digital means to superimpose, disintegrate, and distress them, Broomer pays tribute to Potamkin's poetic sensibility while also creating something that is both austere and violent. The violence is literally due to the layers of disintegration inflicted on the images and the intense montage, and also to the soundtrack composed by Broomer's father, the musician, composer, and music critic Stuart Broomer. The elder Broomer uses the sounds of gradient coils inside the MRI scanner to create a sense of the body's rhythm, as well as a sense of dread and restlessness. This dominates the first reel, and gives way to chakra bowls in the second half, signifying a shift to more spiritual awareness, the rhythm of the heavens. Stuart Broomer continues to collaborate with Stephen on his films of the present day.

In *Tondal's Vision* (2018) Broomer continues his creative engagement with found footage. Inspired by the obsession in our culture of representing hell—in works by Dante Alighieri, John Milton, William Blake, Stan Brakhage, and countless others—Broomer turns to *Visio Tnugdali* (which, over time, translates as *Tondal's Vision*). This twelfth-century religious text is quite possibly an inspiration for Dante's *Inferno*, and definitely a major inspiration for Hieronymus Bosch's fifteenth-century painting *Tondal's Vision*, which is, in turn, one of the many inspirations for Broomer's film of the same name. Indeed, the palette of Bosch's painting may have influenced Broomer's film, especially the deep yellows and reds, but, then, so do dozens of other poems, paintings, and films. Broomer acknowledges the tableau approach of Sergei Parajanov's *The Colour of Pomegranates*, for example. The physical source material for the film is Francesco Bertolini, Giuseppe de Liguoro, and Adolfo Padovan's 1911 film adaptation of Dante, *L'inferno*. Broomer re-photographed the original film, and then used chemical and digital processes to create a retelling of Tondal's image of hell and, perhaps more importantly, an explosion of colour, a push and pull between abstraction and representation, repetition and transformation, Earth and the afterlife. Tondal's anguish is further suggested by Stuart Broomer's sound design, a composition created primarily by distorting a recording of *L'Orfeo* by Monteverdi, that now sounds like screams and groans and, at one point, an electric guitar played through a volume pedal and broken amplifier.

In *Phantom Ride* (2019) Broomer mines the home movies of Ellwood F. Hoffmann, (1885-1966), an entrepreneurial mill owner from Philadelphia, to produce a complex visual symphony of superimpositions. One of the first uses of motion pictures was to

capture the effect of moving forward using a cameraman strapped to the front of a vehicle. Hoffmann retired when he was fifty and spent the rest of his life travelling throughout the US, always attaching his camera to the front of the car, and creating a personal, but somehow very recognizable, document of the first half-century of the automobile, the first half-century of cinema, and the USA from which Broomer takes this rich body of real-world source material, creating a legibly rendered and deftly choreographed montage of superimposed found footage, slipping in and out of representation through intense colour treatments, and rendering a ghostly, impressionistic response to the landscape and culture. Broomer's experience is at a remove from Hoffmann's, an image of America that was disappearing as Hoffmann filmed it. The phantasmagorical quality of the film is underscored by Stuart Broomer's soundtrack, which has the effect of slowing down what might otherwise be experienced as a bit of a joyride.

Broomer's most recent film as of this writing, *Lulu Faustine*, builds a sumptuous, kaleidoscopic riot of colour using footage from G.W. Pabst's 1929 silent classic, *Pandora's Box*, starring Louise Brooks. Broomer's film was, in fact, inspired first by the Argentinian novel *Morel's Invention*, by Adolfo Bioy Casares. Casares's character Faustine was inspired by Brooks. Pabst's film takes up the myth of Pandora, whose box contains the world's evils, and all the world's suffering can only end when Brooks's character is assassinated at the hands of Jack the Ripper. Broomer takes Brooks/Pandora/Lulu out of Pabst's narrative and the myth's narrative—out of her destiny as a prostitute who is responsible for all evil and sin—and recasts her as a muse of movement, a figure at the centre of a new film that emerges from the DNA of Pabst's film.

As with many of his films, Broomer is transparent about his source material, and pays homage to it in a certain sense, but he freely allows the technology at hand to liberate the characters, images, and visual qualities of the source material to create something new. In this sense, Broomer's work is aligned with Joseph Cornell, arguably the originator of found footage films. In his 1936 film, *Rose Hobart*, Cornell took footage of Hobart from a 1931 film, *East of Borneo*, remixing it with documentary footage of an eclipse and songs from Nestor Amaral's *Holiday in Brazil* album. Cornell created a kind of cinematic alchemy, paving the way for collage filmmakers. Broomer's transformation of the Brooks footage, seeing a side of her image and movement that was perhaps cloaked in the Pabst film, is similar to Cornell's mutation of Rose Hobart. Cornell is Cornell and Broomer is Broomer, and the latter's bank of influences is vast and diverse; however, there is a sense in which Broomer's films channel avant-garde pioneers: Cornell, Arthur Lipsett, Marie Menken, and Dziga Vertov, among many others.

—JS

CARL BROWN

Born Toronto, Ontario, Canada, 1959

Carl Brown, *Brownsnow*, 1994

FILMOGRAPHY

Mine's Bedlam, 1980, 8 min., Super 8, b&w, sound
Urban Fire, 1982, 15 min., 16mm, b&w, sound
Full Moon Darkness, 1985, 90 min., 16mm, b&w, sound
Condensation of Sensation, 1987, 73 min., 16mm, colour, sound
Drop, 1989, 4.5 min., 16mm, colour, sound
Cloister, 1989, 33 min., 16mm, b&w, sound
Re: Entry, 1990, 79 min., 16mm, colour, sound
Sheep, 1991, 7 min., 16mm, colour, sound
Brownsnow, 1994, 134 min., 16mm, colour, sound
Air Cries "Empty Water" Part 1: Misery Loves Company, 1993, 60 min., 16mm, colour, sound
Air Cries "Empty Water" Part 2: The Red Thread, 1993, 60 min., 16mm, colour, sound
Air Cries "Empty Water" Part 3: Le Mistral, Beautiful but Terrible, 1997, 117 min., 16mm, colour, sound
Two Pictures (with Rose Lowder), 1999, 12 min., 16mm, colour, sound
Fine Pain, 2000, 59 min., 16mm (double screen), colour, sound
Neige Noire, 2003, 64 min., 16mm (double screen), colour, sound
L'Invitation au voyage (with Rose Lowder), 2003, 33 min., 16mm, colour, sound
Triage (with Michael Snow), 2004, 30 min., 16mm (double screen), colour, sound
Blue Monet, 2006, 54 min., 16mm (double screen), colour, sound
Quiet Chaos of Desire, 2007, 3.5 min., 35mm, colour, silent
Memory Fade (double screen), 2009, 35.5 min., 35mm, colour, sound

Like many of his contemporaries, **Carl Brown** was trained in filmmaking at Sheridan College in the 1970s, at a time when personal documentary was the school's dominant form. While his teachers and classmates would take up forms of autobiographical filmmaking that simultaneously looked outward at worldly phenomena and inward for reflection, Brown explored the more aggressive abstraction and non-objectivism of destructive photochemical processes. This darkroom work began with his first film, *Urban Fire* (1982), an experiment in reticulation, that is, the breaking-down of an image into kernels of emulsion; and solarization, that is, a simultaneous and dynamic in-time transit between positive and negative that troubles dimensionality and perspective. His process-oriented films would inevitably bear markers of personal contemplation and autobiography, not put explicitly but made apparent through overarching analogies for suffering. Brown's films convey in their shattering emulsion, their infernal colouration, their titling and synopses, a burden of trauma and a desire to exorcise demons through creative action.

For the bulk of his career, Brown has made long-form films, beginning in 1985 with *Full Moon Darkness*, an assembly of interviews with former and current psychiatric patients, an anti-psychiatric activist, and a priest. Through its array of harrowing interviews, the film rejects the drugging and shock treatment that had become synonymous with psychiatric care. The interviews are often paired with spare, poetic illustrations, all of it shot in a black–and-white high-contrast style. While *Full Moon Darkness* announces Brown's central theme as mental health and its interactions with spirituality, individualism, and institutions, it is an outlier among Brown's films. His trademark style, that of photochemical abstraction begun in his years at Sheridan, resumes with *Condensation of Sensation* (1987), made during a period of transition in which he began to experiment with more aggressive forms of image manipulation. Through the course of subsequent years, with *Drop* (1989), *Cloister* (1989), and *Re: Entry* (1990), Brown demonstrated the extent of his control over abstract imagery, reducing landscapes and figures by kernels, silhouettes, textures, much of it achieved by way of corrosive chemistry, but always suggestive of painting and *décollage*, the act of subtracting portions of images either by selection or by chance.

Condensation of Sensation remains anchored in the psychodrama: against Brown's chemical abstraction, the work concentrates on a wandering figure whose journey is interrupted by advertisements. Church crosses and processions allow *Condensation of Sensation* to adopt and expand the themes of *Full Moon Darkness*, but now that Brown has shifted away from the documental, away from the presence of speaking subjects who might embody or contrast with the filmmaker's own ethos, the work's spiritual themes are cloaked in a fog of ambiguous symbolism. The film has been dyed and reprinted through many generations, giving it a density that reflects this ambiguity, composing with images that transcend the mysterious processes that bore them. Brown's next

long film, *Re: Entry* (1990), again develops around a figure, this time a swimmer whose laps are interwoven with potent metaphorical sequences of forests, cities, alligators, blazing idols, all while the submerged body is subject to transformations caused by light reflecting within the pool and by Brown's own chemical baths, which serve to underscore the menace and violence of Brown's lyricism. One of the darkroom techniques that Brown had mastered in school, and that he employs to great effect in this period, is the Sabattier effect, a phenomenon whereby a photographic negative or a photographic print is reversed in tone, in whole or in part, an act of pseudo-solarization that creates illusions of false depths, that dramatically and unnaturally offsets foreground against background, giving the image something resembling a bas-relief effect.

In the early 1990s, Brown began work on an epic series of long-form films, the *Air Cries "Empty Water"* trilogy. Through the course of its three parts—*Misery Loves Company* (1993), *The Red Thread* (1993), and *Le Mistral, Beautiful but Terrible* (1997)—Brown expands his exploration of tint, tone, the Sabattier effect, and rough, vibrant hand-processing. Brown's processes create images that recall psychedelia, but that, until this point, had been firmly planted in the psychodrama; now emancipated from that relation, his montage has become more anarchic and his colours more wild and vibrant. He has described the trilogy as dealing with "the interaction between the environment and the camera/eye," and his sense of the environment is not restricted to landscapes: the camera/eye settles also on performances that recall his early psychodramas; portraiture; confessions and anecdotes; found materials and re-photographed images from mass culture. As with those psychodramas, the figure persists and is often the most resilient subject for his chemistry, but in contrast to his earlier work, there is no protagonist, no central figure that serves as the filmmaker's surrogate. The mistral, that strong bitter wind for which his concluding sequence is named, is nearer to a surrogate, as Brown's chemistry casts his presence through the environment, coursing through urban and rural landscapes, lakes, figures. By the concluding part, the camera/eye has become so agitated and kinetic that Brown is often toning motion blurs and pixilation. And even in relatively sustained compositions, or in portions that loop, the ferocity of Brown's frame manipulations give the work a plenary restlessness.

Brown's work after *Full Moon Darkness* was largely solitary, as he toiled with his footage and techniques in isolation; however, from the 1990s onward, he began to engage in selective collaborations. While making the *Air Cries "Empty Water"* trilogy, Brown collaborated a number of times with Michael Snow, performing chemical manipulations for Snow's *To Lavoisier (Who Died in the Reign of Terror)* (1991) and documenting Snow and his visual art in *Brownsnow* (1994). The two would collaborate as equals ten years later, with *Triage* (2004), a double-screen film with each filmmaker shooting thirty minutes of film, without disclosing to one another the content of their work. The resulting reels are cast alongside one another in an act of chance association. Brown would also collaborate

with the French structuralist filmmaker Rose Lowder on two films: *Two Pictures* (1999) and *L'Invitation au voyage* (2003), films made by mail with Lowder shooting high-contrast film and sending the resulting rolls to Brown for processing and post-processing manipulation.

Following the completion of the *Air Cries "Empty Water"* trilogy, Brown began a series of films conceived for dual projection, beginning with *Fine Pain* (2000), made in an effort to "expand (his) lexicon on anxiety and panic attacks," casting two images simultaneously alongside one another, with each screen reflecting some state of an anxiety attack. The title is a code for the image: the left screen represents "feeling fine," being on the precipice of an attack, while the right screen represents pain, a recreation of an attack; the screens bear subtle distinctions of rhythm. This explanation, by way of Brown, demonstrates how his formalism is linked to the autobiographical impulse. The image is still abstract and yet still peopled with mysterious figures, whose faces and bodies are creased by wild colours and the crisp edges of Sabattier-effected silhouettes. By spreading two stations of intensity across the screens and allowing them to play out simultaneously, *Fine Pain* flattens out the experience while also taking the audience to a greater sensorial extremity. Brown's subsequent diptych films, *Neige Noire* (2003), *Blue Monet* (2006), and *Memory Fade* (2009), continue to explore the filmmaker's psychological interior using abstract, luminescent forms and allowing for polyrhythms to amplify the force of the experience.

Of all of Brown's double-screen works, *Memory Fade* feels the most ultimate in its pairing of re-photographed mass culture images, cityscapes, news footage from 9/11, the crash of the Hindenburg Zeppelin, the radioactive bloom of Trinity in the skies above Alamogordo. It remains a container for Brown's presence, still felt in that chemical wind that sweeps through his images, lighting them in kaleidoscopic colours, melting their lines, complicating any pure forms with reticulated emulsion and flaking tint. From his earliest films, Brown cast scenes of contemporary ruins—ruins of buildings, ruins of film material, ruins of the soul—as expressions of intimate, unspeakable turmoil, turmoil that escapes common language and that is communicable only in this beautiful violence, elaborated by passing frames. With *Memory Fade*, the artist's personal crises take their station in a stream of universal suffering; tragedies and catastrophes are not metaphors for interiority, but reflect a common thread in which all of humanity is implicated.

—SB

JACK CHAMBERS

Born London, Ontario, Canada, March 25, 1931;
died London, Ontario, Canada, April 13, 1978

Jack Chambers, *Circle*, 1968-69

FILMOGRAPHY

Mosaic, 1965, 9 min., 16mm, b&w, sound
Hybrid, 1967, 15 min., 16mm, colour/b&w, silent
R34, 1967, 26 min., 16mm, colour/b&w, sound
Circle, 1968-69, 28 min., 16mm, colour/b&w, sound
The Hart of London, 1970, 79 min., 16mm, colour/b&w, sound

Jack Chambers began his art education in high school under the artist and illustrator Selwyn Dewdney and continued at H.B. Beal Technical School, where he studied with the sculptor and painter Herb Ariss. The recent art of the period was increasingly dominated by painterly abstraction, but Chambers was becoming fascinated by the convictions of craft and indoctrinated in a traditional notion of art as a means of representation. He was stifled in this environment, soon seeking a more deeply felt life than he believed possible in London. He left in October 1953, in resistance to what Chambers described in an interview with Ross Woodman, the "utilitarian, puritanical, indifferent" Canada in which he had grown up. Chambers finally settled in Spain in February 1954.

Beginning that October, Chambers undertook studies at the Escuela Central de Bellas Artes de San Fernando, where pedagogical method emphasized a traditional approach to drawing. In Spain, Chambers underwent, in his words, "a series of births." As his approach and craft were maturing, other changes in his life would influence the course of his work, including his growing spiritual convictions and his marriage to a Spanish woman, Olga Sanchez Bustos, with whom he would have two sons. By the beginning of the 1960s, Chambers's development as an artist could no longer be charted in a causal history; the aesthetic that he had developed during his time in Spain would change, but his aggressive mastery of craft had granted him a freedom to explore the perceptual limits of painting. His vast knowledge of Spanish painting styles, and his induction into a Spanish life, served as the initial spiritual preparation for him to undertake his own work, and yet that influence had cast a pall over his work. The changes in his life and the regional aesthetic sensibilities evident in his work signalled his assimilation into Spanish culture, but Chambers still felt an alienation from the land.

Chambers returned to London in 1961 to care for his terminally ill mother. What was planned as a short visit would become a permanent return; what he was missing in Spain, he discovered in London. In the years following his return, Chambers's painting style, now dominated by figures, became strongly associated with photorealism. He used photography extensively in lieu of life models. The photograph served as an "accurate memory object," an ideal description of what he would later refer to as consensus reality, the realm of common perceptions. In spite of his relegation of photography to a process medium, Chambers began to work with motion picture cameras to make personal films. With cinema, he could pursue an art based in time, without the pressure of generating sales or participating in a market. In this sense, underground films, which were essentially unprofitable, gave him a new-found freedom.

Between 1964 and 1970, Chambers completed five films. These films resonated with the difficult strategies of his paintings, particularly his use of fragmentation and collage, his treatment of a subject as an assemblage of particularities, his adoption of found materials, and his greater pursuit of a memorial, pan-sensory aesthetic. Like Chambers's paintings, his films dealt with the life cycle, mortality, properties of light, and the crisis

Jack Chambers, *Mosaic*, 1965

of photographic representation. In both his paintings and his films, London was cast as a simultaneously paradisiacal and infernal garden. The treacherous qualities of nature assumed a particularly fatalistic connotation in Chambers's life and work, when spectres of war and illness hung heavily over him.

Themes of the life cycle run through Chambers's first film, *Mosaic* (1965), evident in contrasting scenes of pregnancy and its rituals and of the mundane rites of middle age. Chambers developed the film from 1964 to 1966, at a time when his wife Olga gave birth to their first child, and the film uses scenes of mother and child as its central pastoral gesture, surrounding them at various times with symbolic figures representing middle age and old age. In many ways the film resembles Chambers's other art from the same period, drawings and paintings in which the townspeople of London appear all together in a pageant of the living and the dead, figures performing a symbolic march from death into the present moment. *Mosaic* carries the marks of its mediation—visible splices, editorial tensions, and a general roughness of form—as both object and representation; this is in keeping with the objecthood of Chambers's photorealist paintings, which are never totally illusory like the kitsch work of the American photorealist movement, and he often used medieval techniques, for instance the brushing of rabbit's fur into the paint to add texture, in order to declare their material fact as paintings.

Chambers followed *Mosaic* with *Hybrid* (1967), the first of his films to use found footage. Chambers believed old films "should be just like earth that you pick up and use"; at the time, he was also beginning to integrate mass media photographs into his paintings. In the case of *Hybrid*, he combined two found sources: images of the effects of chemical warfare on Vietnam's civilian population, and scenes from an educational film about rose gardening. The film has three distinct sections. Each joins footage of horticulture with scenes from the war in Vietnam and the consequences of American aggression against Vietnamese civilians, primarily children.

In the first section, the image advances, in hard cuts, through footage of a gardener digging holes and planting bulbs, and tamping soil down with a shovel. He carefully prunes branches and thorns and inspects his irrigation system. Against this, still images are inserted of American soldiers arriving in Vietnam, of the daily life of its agrarian society, and increasingly ominous footage of soldiers in gas masks, an image specific to American aggression and the ambiguous image of invasion. The gas masks conceal their human faces and substitute something menacingly inhuman for their features. With the second sequence, the implicit violence of the preceding Vietnam War images becomes explicit, as torn bodies and scenes of active conflict begin to emerge. The gardener picks a rose and tears the petals away until there is only a bud. He collects the inner petals into a container. His harvesting is held up against images of dead children and children in flight. The inner petals are brushed against images of a dead mother and child. The third and final section of the film extends and concludes this analogy: two elements are contrasted, blooming roses, filmed in time lapse as an explosion of luminous reds, whites, and yellows, and still images documenting civilian victims of violence and chemical warfare, primarily children. These elements are joined through dissolves, and this gesture—cutting to a bud in bloom, dissolving into atrocities—repeats twenty times, each time restarting by a hard cut, before ending on a rose in bloom. The work does not create a contrast per se between the horrors of war and the beauty of the garden, but instead builds a complex parallel between two different acts of mastery over nature. As Agent Orange masters nature by disfiguring the bodies of a civilian population, so too does rose hybridization force something unnatural through human intervention, which, regardless of being less grotesque, is no less transformative.

Following *Hybrid*, Chambers returned his attention to the local level, making a film portrait of his friend the painter Greg Curnoe. Titled *R34* (1967), the film follows Curnoe through the construction of a major work of mixed media, *The Camouflaged Piano or French Roundels* (1965–66), in a structure that reflects Curnoe's own methods in assembling a cohesive whole from fragmented parts. In Curnoe's work, this manifested a Neo-Dada assemblage, a collision of pieces of everyday objects—cereal boxes, newspapers, and so on. In Chambers's film, fragmentary editing allows Curnoe's gestures to circulate, repeating. His words are truncated. He talks on the soundtrack

about "putting the whole thing together," and about nihilism, the perspective he had adopted in his art. The film is thus a merging of the fragmentary qualities of two artists: Chambers, working in time and often in portraiture, and Curnoe, working with the specificity of the present moment. With the thematic assembly of *Mosaic* and the binary montage of *Hybrid*, Chambers's films evince his interest in film editing. In *R34*, the editorial roughness, both in its physical application (in visible splices) and its staggering rhythms, is the work's defining feature. This impression of Curnoe's private and creative life is fashioned of many elements, some of profound dimension, others minutiae, from wedding photographs to spent tubes of paint.

With Chambers's next film, *Circle* (1968–69), also known as *Circle 4*, he returned to the subject of his own domestic life, last considered in *Mosaic*. Where *Mosaic* offers Olga and child as icons of motherhood and childhood, *Circle* turns to the family's backyard, not only as a symbol of familial settlement but as a laboratory of time and a portal onto the changing seasons. Its perceptions of light and time were made all the more reverent by the limitations that Chambers imposed upon himself, working from a fixed angle, aperture, and focus. This restricted lens emphasizes the interplay between space and changing light. *Circle* assumes a complex tripartite structure through which this backyard study is framed by creative action and records of a broader community. *Circle* begins with a dramatic scene of Chambers filming the credits, alternating camera-eye perspective with footage of him preparing and filming with the camera; the film ends with a series of found sequences, culled, it would seem, from television b-roll of labour and leisure in London. In between, Chambers photographs his backyard over the course of a year, through a hole cut in the rear wall of the Chambers family's Lombardo Avenue home. Those final sequences fit something wide, social, and spiritual to the humble dailyness of the Chambers family's lawn.

Chambers's early films were technologically primitive, compositionally and sequentially masterful impressions of his life, philosophy, and environment. This work, and the impulses that had simultaneously emerged in his painting activity, gave way to his final film, *The Hart of London* (1970), which served as an ultimate reckoning of his apocalyptic vision of man at odds with nature, a film of cosmic and spiritual immediacy, a reverie of childhood and fatherhood. *The Hart of London* marks the culmination of formal and social concerns that had dominated Chambers's earlier work as a painter and filmmaker. The film begins with the shooting of a deer that had wandered into town, seen in recycled television footage. It ends with an act of strange communion, mysterious and menacing, between the Chambers family and a group of deer in a meadow.

In *The Hart of London*, the ghosts of the past serve as an extended opening chorus, in a dense silver cast, and snapshots and found footage resurrect a century of London, Ontario, citizens. The anonymous polyphony of London's home movies and photographs bridges the slaughter of the hart (i.e., deer), with its mythic dimension, to intimate scenes

Jack Chambers, *The Hart of London*, 1970

from the Chambers family's life, and finally, to a series of dreams, a reverie culled from London's more recent past. Through the course of *The Hart of London*, the film moves from a portrait of fear to an urgent declaration of it. Visual and editorial tactics present a resistance to simple, clear-cut meaning. Rather than offer a narrow and didactic lesson, the film instead develops the relation between seeing horror and feeling fear. Such confrontation is felt in many of the disparate sequences—the birth of the Chamberses' second child, found footage of scenes from the city's local news station showing men arrested for swimming in the dead of winter, hunters proudly displaying the carcasses of wolves, rough games played at a veterans' picnic, the delivery of a bird as a Christmas gift for a severely disabled child, and the brutal, prolonged death throes that follow the slaughter of a lamb. Fear, first seen in the terrified and disoriented gallops of the deer, becomes the immutable core of the film, as the disjoined presences of haunted London emerge as a silver chorus, as the sheep bleats its prolonged death throes in the abattoir, and as the exchanges between animal and man (the deer, the sheep, the wolf, the bird) increasingly reveal the estrangement of the two. The anxiety of the film's final sequence, as the family encounters deer, refers back to the opening sequence: fear in the wild has moved from vision and allegory to a present, full-body perception of the menacing

exchange between man and beast. Olga warns from off-screen that her children must "be very careful."

In medieval superstition, the bone in the heart of the hart would prevent it from dying of fear. This imagined hart could endure extremities of fear unknown to man, whose weak and unprotected heart was prone to rapid beats in moments of terror. The children's confrontation with the harts shows a final estrangement of beast from man; the children approach the deer at their parents' behest so that they can see and interact with the beasts, but that interaction is fraught with the parents' fear that one of the beasts, territorial, sensitive to the sudden movements of predatory man, could be startled into biting or kicking the children, or to goring them with its antlers. The film's first sacrifice was this beast, host to potential ferocity, and its presence extends through interim scenes of the carcasses of hunted wolves, the silent bleating of a dying lamb, the pet bird, eyed apprehensively by its new owner, all sequences of man's essential otherness from beast.

Beasts are predators, pets, and meat, and man accepts them into a higher symbolic order as allegories of myth and faith. They commune with man by their consciousness, their fear, in which is seen a reflection of human suffering, and they are also his prey. By this, *The Hart of London* recalls the visionary poet William Blake's twinned *Songs of Innocence and of Experience*, "The Lamb" and "The Tyger." Man is entwined with beast in that they reflect the forms and machinations of a higher being. They become a mirror to Christ. Out of the same force that builds that symbolic communion comes a destructive and primal ferocity. The film ends with the scene of the children and the deer, beneath it the cautious pleas of Olga, an illustration of the blank question that Blake puts to his Tyger: "Did he who made the Lamb make thee?" Like Blake, Chambers builds a relation between the disparate symbolism of the beast, inhuman other, and spiritual icon. *The Hart of London* fearfully poses an unknown and unknowable future against a compromised present, a pall cast over it by the ferocious potential of nature, driven by instinct and hunger.

Jack Chambers passed away in 1978, almost a decade after his initial diagnosis with leukemia, defying expectations of a short life and contesting the illness through alternative medicine and spiritual therapies. The Chambers films remain as a record and expression of intimate perception, elevating his vision of his city, seeing its history from the fleeting present, his garden, his children, and his wife. He recognized the mystery of these things and attempted, in building symmetries and harmonies in his portraits of them, to draw mysteries out of nature and into the very stones of London's houses.

—SB

KELLY EGAN
Born Hamilton, Ontario, Canada, March 9, 1976

Kelly Egan, *Athyrium filix-femina*, 2016

FILMOGRAPHY
finger petals, 2002, 4 min., 16mm, colour, sound
cockroach, 2002, 4.5 min., 16mm, colour, sound
Bodies of Knowledge, 2002, 5.5 min., 16mm, colour, sound
breath, 2003, 3 min., 16mm, colour, sound
b(love)d, 2003, 4 min., 16mm, colour, sound
object/loss, 2004, 4 min., 16mm, b&w, silent
mary/me, 2004, 4 min., 16mm, colour, sound
transparent "c," 2005, 3 min., 16mm, colour, sound
c: won eyed jail, 2005, 5 min., 35mm, colour, sound
catalogs: wish list, 2006, 5 min., 35mm, colour, sound
A Firefly, 2007, 2 min., 35mm, b&w, sound
if there are any heavens my mother will (all by herself) have, 2007, 2 min., 35mm, colour, sound
Mornings (4.4.2010), 2010, 3 min., 16mm, colour, sound
ransom notes, 2011, 5 min., 35mm, colour, sound
Athyrium filix-femina, 2016, 5 min., 35mm, colour, sound

The cameraless films of **Kelly Egan** have drawn from found imagery, the graphic forms of text, and the possibilities of synthetic sound played upon the motion picture projector. Beginning in the early 2000s while pursuing graduate studies in the moving image, Egan has built a formidable body of work that encompasses 16mm and 35mm films, projector performances, and paracinematic quilts. And while her film work has also engaged the synapses through the violent force of discontinuous animation in both sound and image, much of it has also engaged playfully with the discourse of language and text: the potential of language as an aesthetic medium transcending its common role in communication, the graphic potential of text cast outside the realm of mere transmission of content. Egan's filmmaking also employs photogram techniques, casting rapidly shifting visions of the shadows of organic forms and the viscera of mass communication (several of her films use text that prominently features the op art patterning of newsprint halftone). Her interest in the creation of synthetic sound by optical means is not limited to the black box: in complement to her work in film, Egan has also performed with the band Fleischmopp, a trio with guitarist Colin Clark and keyboardist Alex Geddie, in which Egan uses projectors, synchronizers, and squawk boxes to amplify sound from film strips.

Egan's first film, *finger petals* (2002), is composed of photogrammed images of flowers, etching blue and green and gold against black. Their fluctuating size gives the composition added dimensionality. The soundtrack, created by directly animating the soundstripe area of the film plane, draws from the poetics of e.e. cummings, his emphasis on the aesthetic values of text itself, of the sound of speech, and the rhythms of pause. The film is inspired by cummings's "Sonnet 29," in which the poet declares his lover's ability to "open always petal by petal myself." The source is made explicit only to the quickest eye (or an analytical projector) in the final moments, when cummings's text passes vertically along the right side of the frame: "with the colour of its countries, rendering death and forever with each breathing." In *cockroach* (2002), the filmmaker uses newspaper, ink, and Kool-Aid on the film strip, generating soft, thready textures through which newsprint faintly registers. Eventually that newsprint, now crisp, begins a vertical climb up the film strip, and the structure of the piece thereafter alternates the crisp, strongly registered but horizontal text, with newsprint softened by intervening textures, in blue and brown. The text struggles in these obscurities, in addition to which it is reversed and magnified so that its case is shifting, conveying text not as the container of language but as a graphic force.

If the early evolution of Egan's work maintains some mystery to the violent, sonic punctuations of her soundtracks, the relation between text, image, and sound is offered lucidly in *transparent "c"* (2005). Against a black base, individual letters and concentrations of text, often bearing the graphic texture of newsprint halftone or the frayed lines of Letraset, appear as exclamations. Their appearances are initially

Kelly Egan, *transparent "c"*, 2005

tied to bursts of electronic tone; later, a rhythm is established of two short tones followed by a sustained one, and on that third, sustained tone, a solitary letter will fill the frame. No letter repeats: in the course of a minute, Egan goes through all twenty-six letters of the alphabet, starting with *a* but then thoroughly rearranged and ending with *x*.

The same year, inspired by the work of Joyce Wieland, Egan made *c: won eyed jail* (2005), existing in two components as a quilt patterned out of 35mm still negatives and found motion picture film, and a 35mm film print made from the same materials as the quilt to be played on a projector. In the parallel formed between quilt and print, Egan offers a critique of place of authorship in the medium, the quilt as a chart of the filmmaker's labour, something akin to a score, informing the viewer's understanding of how rhythms course through the film print. Thus the rhythm of the film is structured along the shape of the quilt, and that quilt is rigidly geometric, with tiles of dense colour film forming a border, and a box within that border, separated by pale—and consequently more translucent—photographic negative. Within the interior box, there are five squares of colour film, one near to each corner and a central square that joins the innermost corners of the other four; surrounding them is more photographic negative. In the film we see this rhythm play out: the colour sequences of the quilt's border, pixilation of photographic stills that are often horizontally composed, become little rhythmic bridges. These are separated first by long stretches composed, for the most part, of continuous movie negatives, and then by the rhythmic punctuations of colour provided by the interior box and squares, before returning to the initial pattern. The film plays out, by virtue of the quilt's patterning, in a perfectly symmetrical rhythm.

Egan's *ransom notes* (2011) was made in response to the 2010 G20 summit in Toronto, an event that inspired protests and riots and that led to mass arrests and widespread condemnation of Canada's Conservative government and the brutalizing of protestors by Toronto police. It expands on the interplay of sound and text found in Egan's earliest films, with bleating electronic tones under a black base, interrupted by eruptions of newsprint letters in various fonts and cases. The first rhythmic shift occurs when text overtakes the screen, with text plummeting as its lines are agitated left to right, with vibrant organic forms overtaking it; this will alternate with sequences of letters appearing and floating on screen, restricted to letters *A* to *G*, with sharps indicating these letters as those of the western musical scale. Electronic tones are again generated by laying text in the optical soundtrack area, allowing for an act of strange translation, with the projector "singing" the tones it has translated from the words; this takes on an uncanny parallel between sound and image when these clusters of "note" letters appear on-screen.

Kelly Egan, *ransom notes*, 2011

In 2016, Egan returned to the paracinematic crafting of *c: won eyed jail*, completing *Athyrium filix-femina* as the second part of her quilt film series. Where *c: won eyed jail* had taken inspiration from Joyce Wieland's coexisting quilt and film work, *Athyrium filix-femina* draws from the early history of photography, responding to the work of Anna Atkins, who, in the 1840s, made cyanotypes of algae via direct prints of plants. As Egan tells us, the cyanotype process "was relatively short-lived as a dominant form of photography, however, it found refuge in the domestic sphere where it was used to decorate fabric for pillows, drapes and clothing." Using this as an entryway into thematic parallels between art and domestic labour, Egan positions the work as an exploration of not only the formal possibilities of cinema but also the history of traditional "women's work." *Athyrium filix-femina* has an intense blue cast caused by the process undertaken: Egan made her own cyanotype emulsion using Atkins's 1842 recipe. She then used this material to make photograms of plants in homage to Atkins, the effect of which, in the rapid, discontinuous stream of Egan's film, is something akin to bas-relief, the shapes of plants showing clear, surrounded by a vivid blue. These effects are interrupted in their rhythms by repeating scenes from a fiction film of a young woman being tormented by a bully who holds a jar containing a spider to her face. In this restrained dialogue of abstract and figurative sequences, new aspects of Egan's quilt patterning become evident, as these fiction scenes flip on their axis, so that the film elaborates not only rhythmically (as it becomes increasingly violent) but in its casting of mirror images.

—SB

R. BRUCE ELDER

Born Hawkesbury, Ontario, Canada, June 12, 1947

FILMOGRAPHY

Breath/Light/Birth, 1975, 6 min., 16mm, b&w, sound
Permutations and Combinations, 1976, 7.5 min., 16mm, colour, sound
Barbara Is a Vision of Loveliness, 1976, 8 min., 16mm, b&w, sound
She is Away, 1976, 13 min., 16mm, colour, sound
Look! We Have Come Through!, 1978, 12 min., 16mm, b&w, sound
The Art of Worldly Wisdom, 1979, 54 min., 16mm, colour, sound
Sweet Love Remembered, 1980, 12.5 min., 16mm, colour, sound
1857 (Fool's Gold), 1981, 24 min., 16mm, colour, sound
Illuminated Texts, 1982, 174 min., 16mm, colour, sound
Lamentations: A Monument to the Dead World, 1985, 467 min., 16mm, colour, sound
Consolations (Love Is an Art of Time), 1988, 824 min., 16mm, colour, sound
Flesh Angels, 1990, 110 min., 16mm, colour, sound
Newton and Me, 1990, 110 min., 16mm, colour, sound
Azure Serene, 1992, 95 min., 16mm, colour, sound
Exultations: In Light of the Great Giving, 1993, 90 min., 16mm, colour, sound
Burying the Dead: Into the Light, 1993, 90 min., 16mm, colour, sound
Et Resurrectus Est, 1994, 135 min., 16mm, colour, sound
A Man Whose Life Was Full of Woe Has Been Surprised by Joy, 1997, 100 min., 16mm,
 colour, sound
Crack, Brutal Grief, 2000, 122 min., 16mm, colour, sound
Eros and Wonder, 2003, 106 min., 16mm, colour, sound
Infunde Lumen Cordibus, 2004, 22 min., 16mm, colour, sound
The Young Prince, 2007, 125 min., 16mm, colour, sound
What Troubles the Peace at Brandenberg?, 2011, 124 min., 16mm, colour, sound
Return to Nature!, 2012, 7.5 min., video, colour, sound
A Gathering of Crystals, 2015, 139.5 min., video, colour, sound

R. Bruce Elder began his career in the arts as a poet, publishing an eponymous chapbook in 1970, and poetry has served as a guiding force in his work since. His formative experiences at McMaster University in the late 1960s had introduced him to advanced readings in modernism, philosophies of technology, and underground cinema. His own start in filmmaking came later, through a summer institute held in New England, organized by American media arts pedagogue Gerald O'Grady. There, Elder and his wife, Kathryn, attended courses and talks given by artists such as Shirley Clarke, Ed Emshwiller, and Hollis Frampton. Elder found a presentation given by Stan Brakhage to be particularly convincing of the poetic properties of cinema; inspired, Elder undertook a modern epic, a cycle he called *The Book of All the Dead*. Like Ezra Pound's *The Cantos*, Elder's work would be occupied by the shattering discourse of the modern, overcoming the senses with a maximalist abundance of sensation and of information, all of it—visual, aural, intellectual—straining the bounds of the medium so as to break through to new forms of contemplation and understanding. By the time he completed this cycle, in the mid-1990s, it was more than thirty-five hours in length, intensely codified and allusive, uproariously funny and yet disquieting and tortured, a work ethic made plastic, edifying to the point of becoming an education in itself.

Elder's earliest films demonstrate his engagement with the moving image across media, what would become an enduring theme of his work: his first film, *Breath/ Light/Birth* (1975), is a film-video hybrid originating in a videotaped natural birth at a commune. The source footage is found material, traded from a communard at O'Grady's summer institute. As the birthing woman howls in pain, the camera lingers on her face and on the crowning skull of the baby. Elder reworks the black-and-white image using synthesizers and superimpositions, and the result is a low-contrast image in which details of faces and hands fade into a neutral grey. The noise of his video synthesis and its translation into a photochemical constitution regurgitates these forms out of an abstract blankness, the birth at once singular and multitudinous, as Elder puts it, "the gruesome confronts the holy in this most mysterious of events."

In the following years, Elder made dance films (*Barbara Is a Vision of Loveliness*, 1976; *Look! We Have Come Through!*, 1978) and films dealing with rhythm and counterpoint in editing (*Permutations and Combinations*, 1976; *She is Away*, 1976), but this soon gave way to more long-form and explicitly personal work, beginning with *The Art of Worldly Wisdom* (1979), an autobiographical film in which attention is split between three screens nested within the primary frame. A narrator recounts Elder's youth and school days, his maturation, a harrowing near-death encounter, and his then-recent struggle with an autoimmune disease, all while advancing a personal ethos informed by the glory and force of the spirit. As this is told—and, occasionally, drowned out by music and competing sounds—images of nature, nudes, and masturbation keep company with snapshots, re-photographed commercials, and poetic street photography.

R. Bruce Elder, *The Art of Worldly Wisdom*, 1979

The scale of Elder's work shifted dramatically with the release of *Illuminated Texts* (1982), a three-hour film dealing with suffering on both a historical and a personal level. Indeed, the scale of such work in length is matched only by its density, of speech and text, subversive drama, and meticulous optical printing. *Illuminated Texts* demonstrates Elder's integration of actors and performance, beginning with Elder and an assistant performing scenes from Ionesco's *The Lesson*, with focus guides interrupting them, at once achieving a comic effect and laying bare the film's estimation of cinematic artifice. Later in the film, photographer Jim Smith makes the first of many appearances in Elder's films, delivering an extended, semi-comic monologue in a single long take. Such scenes are tied together by fleeting, diaristic camerawork that explores quotidian phenomena (travels, encounters with nature, work, and home), and intertitles of quotations from philosophers and poets. This dynamic, to be at once intensely personal and to serve as a compendium of eclectic references, allows *Illuminated Texts* to expand upon the encyclopedic, enclosing nature of *The Art of Worldly Wisdom*; it announces that *The Book of All the Dead* will encapsulate the totality of its maker's mind and soul. The film's conclusion, in which scenes from a concentration camp are fractured tirelessly in colliding, optically printed geometric forms, places Elder's education, the pleasures of his life, and the insults he has suffered, in the most harrowing shadow of the twentieth century.

Elder's work got even longer, with the two-part *Lamentations: A Monument to the Dead World* (1985), running almost eight hours, and again integrating strange dramatic interludes, tableaux, on-screen text, and diaristic and anthropological photography; this time, however, Elder also began to more aggressively integrate footage of life models, harking back to the short dance films that he had made and allowing the epic interiority of *Illuminated Texts* to find a direct confrontation with the physical presence of another. The ruins of Auschwitz had served as a primary subject in the climax of *Illuminated Texts*, and in *Lamentations* Elder again explores ruins, albeit ruins of an older order, stone buildings in the Yucatán. The film's exploration of the Mexican landscape culminates in a cultural festival, where, in the film's final moments, a frantic glint of coloured textiles dances against blackness. *Lamentations* is full of drama and allusion, with appearances by figures such as Sir Isaac Newton and Franz Liszt keeping company with original scenes conceived by Elder (of a madman screaming in an alley, another man alternately begging and berating a stripper). Elder released *Lamentations* at the same time as his controversial manifesto, "The Cinema We Need," a rebuke of the "new narrative" forms that had corrupted and co-opted avant-garde cinema through the course of the 1980s. The manifesto spoke to the Canadian context but also to broader themes in Elder's citizenship, his interest in the distinctions of Canadian art and poetry, and the need for a cinema of sincere, exploratory, experiential immediacy, a search that is encoded in Elder's own films. He would explore such themes of Canadian art, poetry, and cinema in relation to common-sense philosophy in his monograph, *Image and Identity* (1989), the first of several tomes on cinema and modernism.

The Book of All the Dead at this point took the shape of a three-day event, each day presenting a "region," mirroring the timeline of Easter. *Illuminated Texts* and *Lamentations* formed the bulk of the first region, gathered under the title *The System of Dante's Hell*, while the second region was composed of Elder's next and longest film, *Consolations (Love Is an Art of Time)* (1988), a three-part film totalling more than thirteen hours and expanding upon the forms that had been introduced in the preceding works: an integration of tableaux, monologues both comic and tragic, elaborate optical printing, and masterful camerawork of a lyrical, romantic lineage. The film took its title from a combination of Boethius, whose *Consolation of Philosophy* was written from the station of a condemned man, and the poet Kenneth Rexroth, whose influence on Elder had been a source of explicit citation since *The Art of Worldly Wisdom.* Like both Boethius and Rexroth, Elder offered a work of energized, furious love. *Consolations* once again divides its form between semi-comic sketches, dramatic readings, and intimate photography. In Elder's own words, *Consolations* "is about resentment and its overcoming," a theme that is most evident in its third and final part, *The Body and the World.*

The third and final region of *The Book of All the Dead* is the *Exultations* (1990–94) is a series of six feature-length films composed of interconnected imagery, densely layered

R. Bruce Elder,
The Young Prince, 2007

with on-screen calligraphic text, diaristic photography, life model photography, and computer-sourced imagery of the filmmaker's own design. The computer-generated imagery is often simulacra of nature and art, from an image of a woman with an umbrella like a figure out of Seurat, to artificial faces miming ecstasy with their eyes and mouths. Themes of the menace of technology abound. If Elder's undertaking, from its debts to Pound, had a Dantean implication in its earlier parts, with *Exultations* that has become explicit as he hurtles in a naked descent, plummeting through simulations of medieval carvings on the walls of a cathedral. When Stan Brakhage's voice on the soundtrack commands him "to wander where thou wilt," their relation, too, is made explicit, Brakhage as Virgil to Elder's Dante.

A premise that underlies all of Elder's work is that the conception of time as history has had a harmful effect in promoting the paired ideas that human essence is freedom and that nature lies before humans as a standing reserve to be exploited by humans. The artistic form associated with this conception was narrative, which synthesizes moments in time into a linear form. This form is analyzed in *The System of Dante's Hell*, with *1857 (Fool's Gold)* and *Illuminated Texts* declaring the horror that follows from the idea of time as history. The *Consolations (Love Is an Art of Time)* region suggests the refreshment of consciousness, settling into a less relentless, less mechanically driven time and concomitantly a less goal-oriented experience, and even occasional ecstasy at release from time. The *Exultations (In Light of the Great Giving)* region offers the nearly continual eruption into consciousness of transcendent moments beyond time.

With the completion of *The Book of All the Dead*, Elder began a new cycle, *The Book of Praise*. He identifies this cycle as a Protestant work, a shift away from the Catholic sensibility (in iconography, in the aesthetics of ritual) that had been primary to *The Book of All the*

Dead, a shift away from wonder at the world created, toward the wonders of our interior being. Elder has written that *The Book of Praise* deals with the transformative properties of eros, image, history, montage, and self. It is through this theme of transformation that *The Book of Praise* takes on alchemistic qualities, meditating on symbol and colour to bring forth a higher self, in an echo of the alchemist's project to transmute base metal into gold. As of this writing, *The Book of Praise* contains six completed feature-length films and two shorter works. Among them is *Crack, Brutal Grief* (2000), a cathartic film made in the wake of Jim Smith's tragic and horrific suicide. Elder uses electronic image-processing techniques to alter images of suffering and sex, appropriated from the internet, transforming their colour and texture into abstract forms, returning them to "the full dignity of their horror."

While *The Book of All the Dead* is a work about history and its overcoming, *The Book of Praise* is a post-historical work in the sense that the entire field of experience is meant to be permanently contemporary, that anything from any of the temporal modalities (past, present, and future) and temporal regions (nearer or most distant) is available to be experienced in the here-and-now. In the later episodes of *The Book of Praise*, beginning with *Return to Nature!* (2012), Elder fully embraced digital video as both a production and exhibition method, and as such emphasized particular plastic traits of video that had manifested in his earlier films—the flexibility of digital forms, the tumult of digital layering, the exploration of pure colour. Shed of the constraints of film and its granular constitution, Elder's new films allow pure colour, rendered in fine, sheer pixels, to flash and fade, summoning artificial realms of pure, flat vision in a constant state of transit. *Return to Nature!* took its title from Adolf Just's philosophical tract on natural remedies, and this collision of themes—the warmth of pure computer-rendered colour and holistic treatment for the body, mind, and spirit—extended through the work that followed. In *A Gathering of Crystals* (2015), these themes and forms find an explicit parallel in images of the *Freikörperkultur* (free body culture) movement, a German naturist movement of the late nineteenth century that sought to separate the pleasures of communal nudity from sexuality. These black-and-white images are interspersed with oscillating colour, sliding panels of colour, and figures reading poetic texts against a felt collage backdrop.

Those themes that manifested in Elder's earlier cycle—his confrontation with the exhaustion of ideas and the burden and terror of history, of past acts and of past artists—persist in *The Book of Praise*, and its changing forms, its embrace of digital imagery, proves the resilience of these themes in that they transcend form. Such metamorphosis mirrors those acts of mystical conversion that dominate Elder's poetics, that bond their presentness to the very roots of poetic thought and creative action, to brave the last gasps of art and history.

—SB

ELLIE EPP

Born Sexsmith, Alberta, Canada, March 6, 1945

Ellie Epp, *Trapline*, 1975

FILMOGRAPHY

Trapline, 1976, 18 min., 16mm, colour, sound
Current, 1986, 2.5 min., 16mm, colour, silent
notes in origin, 1987, 17 min., 16mm, colour, silent
Bright and Dark, 1996, 3 min., 16mm, colour, sound
by the lotus, 2013, 3 min., digital, colour, sound
last light, 2015, 7.5 min., digital, colour, sound
here, 2015, 4 min., digital, colour, sound
o sea, 2015, 5 min., digital, colour, silent
ob pier 5, 3 movements, 2015, 8.5 min., digital, colour, sound

Ellie Epp was raised on a farm in La Glace, a small Mennonite community in northern Alberta. She left Alberta to study at Queen's University in Kingston, Ontario. There she explored a range of humanities disciplines, specializing in psychology, philosophy, and English. Upon finishing her studies there, she moved to London, England, to study filmmaking at the Slade School of Fine Art at University College London. While in England she became involved with the London Filmmakers' Co-op (LFMC), then the focal point of an energized art cinema movement that encompassed formally and socially progressive drama, influenced by the more vanguard directions of European new wave cinema, and experiments in structural-materialistic filmmaking and film performance typified in the work of Lis Rhodes, Stephen Dwoskin, Malcolm Le Grice, and Annabel Nicholson. As evinced in the film that she would make in England, and others she would subsequently make in Canada a decade later, she connected strongly with the minimalist, durational work being done around the LFMC. It was against this backdrop that Epp began work on her first film, *Trapline* (1975).

Trapline was filmed in an indoor pool in London. It is composed of only twelve shots that play out over the course of 18 minutes. Each shot is separated from the others by black, isolating them as discrete compositions. The shots are static, with the exception of one, late in the film, an image of the glass roof of the natatorium in which the lens zooms in towards the metal-and-glass grid of the windows. The early portion of the film lingers on the unbroken water in the pool and its reflection of the natatorium's architecture, its interaction with the sky mediated through the grid of the roof. This peace is broken by the presence of swimmers, who burst into a short shot; the waters fluctuate wildly, freeing the patterns of light refracted from the sky so that they break from the rigid grid of the roof. *Trapline* is surprising in what emerges as its wild treatment of light, inasmuch as it establishes expectations as to its shape and subverts them by human intervention (the swimmers breaking the surface). Such expectations are also established and broken in relation to time: the stillness of the water in the opening compositions consumes half the film's running time; the swimmers' lap is seen in a short burst. Epp would not make another film until a decade later, with *Current* (1986), a simple film that carries on the ineffable, poetic minimalism of *Trapline*. Light courses beneath a set of vertical blinds; for 2.5 minutes, the light's movement across the concealed window outlines the blinds.

Her third film, *notes in origin* (1987), speaks to the filmmaker's sense of poetic composition, light, sensual phenomena, and bodily sensations. The film was made around a farmhouse in the region of northern Alberta where Epp was born. The structure mirrors that of *Trapline* in its rhythmic sensibilities: ten static long shots are divided by black; here the shots are numbered. As with *Trapline*, this act of isolating individual shots leads to surprise, in that each subsequent shot supports not a full vision of this environment, but a vision of the act of being present in a landscape. Epp followed *notes in origin* with *Bright & Dark* (1996), a film about haptic sensation and eroticism

made by intentionally fogging the film, creating clumps of squirming grain; with this the filmmaker attempts to reach a "sixth sense," towards an esoteric and mystical eroticism. It was her first film since *Trapline* to feature a soundtrack, and at that, her first film to feature speech, in the form of brief stories of electric touch. In this two-decade period, Epp's themes transitioned from the metaphysical transformation of physical things (*Trapline* and *Current*) to the memorial and autobiographical (*notes in origin*) and, ultimately, the physical (*Bright & Dark*).

Between 2013 and 2015, Epp again returned to moving images, this time in the form of digital video, which lends itself to the style of her work by its ability to record long takes and thereby present a persistent, unbreaking attention. Each video she has made is a single-shot work; they play with duration and attention, but more importantly they linger on reflections and changing light. The first of these, *by the lotus* (2013), was described by the filmmaker as a "dip into another zone," and that notion of the video frame as a window on another world is borne out in the uncompromising attention of each of these works. Among the works finished in 2015, *ob pier 5, 3 movements* holds the greatest similarity to her earlier work, in that it is composed in three parts, with black separating the three parts, each part a static looking downward into the murky waters of a tide pool on the banks of the Pacific Ocean. The waters undulate and go through transitions of form over the course of these three movements, some affected by the natural changes occurring in the time observed, some by plastic manipulation; in the first and last movements the waters move fluidly, but in the middle movement, they are slowed down so that with each thrust of the tide they assume perfect bubbles and ripples, a billowing mass of ornamented water. In this, Epp has gone back to where she began, the deceptive mysteries of still waters.

—SB

CHRIS GALLAGHER

Born Vancouver, British Columbia, Canada, August 29, 1951

Chris Gallagher, *Seeing in the Rain*, 1981

FILMOGRAPHY

Plastic Surgery, 1975, 20 min., 16mm, colour, sound
Atmosphere, 1975, 10 min., 16mm, colour/b&w, sound
Santa, 1979, 6 min., 16mm, colour, sound
The Nine O'Clock Gun, 1980, 9 min., 16mm, colour, sound
Seeing in the Rain, 1981, 10 min., 16mm, colour, sound
Terminal City, 1982, 8 min., 16mm, colour, sound
Mirage, 1983, 7 min., 16mm, colour, sound
Undivided Attention, 1987, 107 min., 16mm, colour, sound
Where Is Memory, 1992, 97 min., 16mm, colour, sound
Mortal Remains, 2000, 52 min., video, colour, sound
Time Being, 2009, 88 min., digital, colour, sound

The films of **Chris Gallagher** explore time and the frame: the persistence of time's passing, the inflexible boundaries of the frame, the anticipation and reverberations of everyday moments and main events. In the mid-1970s, from his home in Vancouver, Gallagher began to make films that followed in the mode of structural cinema, using the camera as a tool for visual construction and planning his films around rules of operation. For the first decade of his filmmaking, Gallagher surveyed a number of styles of filmmaking, making a cosmic, semi-improvisatory outlier; a series of single-shot films; and a found footage film. He moved on to feature-length films dealing with themes of duration, grief, collective experience, and later, he developed digital work, reviving with it his minimalistic, structural path.

In one of his earliest films, *Plastic Surgery* (1975), Gallagher draws parallels, in his words, "between the cutting and suturing of the body and the reconstruction of the world through film." At times this is literal, with the filmmaker intervening through optical printing, inserting his own cutting instruments into images of surgical operations; or through televisual synthesis, forcing plasticity on the intangible transmission. More often, the film assumes a phenomenal pageant, for example intercutting between documental scenes of commercial fishing and abstract, optically printed images that bear symmetries, elaborately nested images-within-images, and psychedelic colour schemes; or intercutting between the horizontal journey of the open road and the vertical journey of a space shuttle. The plastic surgery of the film's title is therefore literal in its integration of surgical films, analogous to all fleshy acts of transformation, and a metaphor for the compositing operations of psychedelic filmmaking to exploit the plasticity of the medium. To this final point, the film staggers, overlaps, and even moves vertically a frame at a time, as if this surgeon has broken the machine. Gallagher's imagery shifts between observable phenomena and cosmic interior, ever atomized on the optical printer.

The wild abandon of *Plastic Surgery* stands in contrast to the controlled structures of the films he would thereafter make. Against the fussy interventions of *Plastic Surgery*, *Atmosphere* (also 1975) represents a structural experiment of clearly definable, minimalistic boundaries that play on duration and expectation. Throughout its 10 minutes, the camera glides steadily across a seascape with mountains rising in the distance; its movement is a back and forth pan that comes to standstills and that pivots in its rhythm, giving the illusion of a dance between filmmaker, instrument, and subject. Only when it is over is it revealed that the dancer/filmmaker is not a subjectivity at all, but a wind vane, and that the preceding interplay, underscored by a primal drumbeat, results from natural force acting upon the camera mount.

The Nine O'Clock Gun (1980) sees Gallagher extending his interest in a minimalist structure that deals with time and the frame, duration and attention. In it, Gallagher takes as his subject the nine o'clock gun, a cannon on the shores of Vancouver that is

fired nightly. The gun is framed in a static shot, dead centre, and as the viewer awaits its shot, a parallel forms between the gun, suspended in anticipation; the audience, likewise suspended in Gallagher's continuous, long-take shot; and the camera, as its potential is spent continuously in anticipation of the event. Once the event happens, the crowd gathers around the cannon with curiosity and gradually disperses, again drawing parallels between the documented event and screening room experience. *Terminal City* (1982) repeats this structure: it records a violent, controlled event (the demolition of Vancouver's Devonshire Hotel) in such a way as to emphasize duration and anticipation. *Terminal City* contrasts with *The Nine O'Clock Gun* in that, rather than anticipate a brief eruption to a calm scene, it forces calm into a scene of eruption by way of a slow motion (two hundred frames per second) camera, elongating the moment of demolition so that the billowing clouds of concrete dust achieve an uncommon beauty. This experience, of anticipating a moment of impact and resting in its aftermath, carries through both works.

Seeing in the Rain (1981) continues the filmmaker's inquiry into time and the frame established in his earlier films. A camera is aimed out the front window of a bus travelling through a rainstorm on Granville Street in Vancouver. The windshield wiper demarcates the frame. The bus moves forward along its route, stopping for passengers. At the left end of the wiper's swing, it acts as a trigger that rearranges the bus's position on this route, lurching it backward and forward, the otherwise linear path subject to gaps, fissures, and retreats in time. Figures and vehicles are glimpsed through a veil of rain, becoming focal points on a journey of accelerating discontinuity. The comic stagger of the ride is emphasized by the late chance appearance of an ad on the back of another bus that asks, "What's stopping you?" This unexpected question, posed by an obstruction, resonates with the overarching temporal obstructions that have caused this linear path to become erratic.

Here, time begins as metronomic, evenly measured, the clicks of the wiper sounding at the left and right limits of the wiper. This wiper, which structures the film, varies its speed. The metronome click is likewise variable, always sounding on the left swing but its rhythm changing and lagging with the wiper. The clicks are mixed with street noise, atmosphere, and the voices of riders. Sound, like vision, is marked by structured conceits, but both embrace chance occurrence. Gallagher maintains an illusion of measured time, of the scientific distance of predetermined structure, but against this a time signature emerges. Metronomic time is misdirection, a foundational system of time that the film endorses, but that it gradually passes beyond. *Seeing in the Rain* accepts that click as an underlying rhythm, but poses a freer system against it. The stagger becomes unpredictable. The fissures expand and contract. They expand, widening the gap between shots, creating dramatic spatial discontinuities; they contract until the sequence becomes a study of motion and space in minutiae, where passing cars, figures, and

receding pavement appear to repeat and stutter. The image skips across time and space, but always forward, toward that horizon, around the elusive present.

With *Mirage* (1983), Gallagher returns to the formal elaborations of *Plastic Surgery*, this time within the restriction of a loop, of a nude Hawaiian woman dancing with a flower in her hair and a lei around her neck. Superimposed atop this loop are scenes of resort life in Hawaii that gradually turn to menacing wartime footage, evoking Pearl Harbor; and the whole ritual is accompanied by a ceaseless, parallel loop on the sound-track of a short passage of Elvis Presley singing "Blue Hawaii." The film thus operates on the level of cultural commentary, with suggestions of an impossible ideal (suggested by the woman and the song) and contrasting advertised ideals of recreation with records of war, and also on an ecstatic formal level, with a convergence of dreamtime (the girl, the resort, the song) and memory (the war, metamorphosing into the nightmare image of an erupting volcano).

Mirage was Gallagher's final short film. In subsequent years, he made a series of feature-length films that extended his earlier themes of plasticity, duration, and medium reflexivity, beginning with *Undivided Attention* (1987), an epic rumination on the nature of time and attention, composed of vignettes that are alternately comic and menacing, developing around camera movement and prolonged attention. These are presented within a "narrative" frame of a couple on a journey. This was followed by *Where Is Memory* (1992), a hybrid fiction and non-fiction film that confronts the relation of truth and memory in postwar Germany, reflecting on complicity and denial in the ominous, lingering presence that the past exerts over contemporary German society. The camera can roll back time, a gesture toward an impossible wish. Gallagher next made *Mortal Remains* (2000), a poetic documentary on the subject of the evolution of the cemetery in North America. Both *Where Is Memory* and *Mortal Remains* demonstrate the broadness of Gallagher's inquiry into time, in that memory and the memorial are acknowledged for intensifying the murky patina of time.

Gallagher returned to a reckoning with time in *Time Being* (2009), an exploration of the visual representation of time and its passage. Unlike his earlier films, *Time Being* is accompanied by a spoken narration on time's flow and its interactions with love, death, pleasure. With crisp digital video, Gallagher's eye is trained on images demonstrative of the circulation of time: whirlpools and waterfalls, clocks, buildings at sunrise, war games, Ping-Pong, trains. Through the narration, Gallagher draws together his formal interests in charting time's passage with profound, philosophical reflections on the character of time. In a final montage of all this earthly, temporal phenomena, Gallagher enjoins life and death, pleasure and pain, and distinctly twentieth-century technology and recreation, signalling an eternal continuity to time, in its elusive, multi-faceted character.

—SB

VINCENT GRENIER
Born Québec City, Quebec, Canada, January 1, 1948

SELECTED WORKS

Shut Up Barbie, 1974, 14 min., 16mm, colour, sound
Catch, 1975, 4.5 min., 16mm, colour, silent
Light Shaft, 1975, 6.5 min., 16mm, b&w, silent
While Revolved, 1976, 9 min., 16mm, colour, silent
X, 1976, 8 min., 16mm, b&w, silent
Interieur Interiors (to AK), 1978, 15 min., b&w, silent
Mend, 1979, 6 min., 16mm, b&w, silent
Closer Outside, 1981, 9.5 min., 16mm, colour, silent
D'Apres Meg, 1982, 17 min., 16mm, colour, sound
Tremors, 1984, 13 min., 16mm, colour, sound
Time's Wake (once removed), 1977-1987, 12 min., 16mm, colour/b&w, silent
I.D., 1988, 56 min., 16mm, b&w, sound
You, 1990, 12 min., 16mm, colour, sound
Out in the Garden, 1991, 14.5 min., 16mm, colour, sound
Surface Tension #2, 1995, 4.5 min, 16mm, colour, sound
Color Study, 2000, 4.5 min., digital, colour, sound
Tabula Rasa, 1993-2004, 7.5 min., 16mm/digital, colour, sound
This, and This, 2006, 10.5 min., digital, colour, sound
Straight Lines, 2009, 4.5 min., digital, b&w, silent
Travelogue, 2010, 8 min., digital, colour, sound
Armoire (4 parts), 2007-2011, 9 min., digital, colour, sound
Waiting Room, 2012, 8.5 min., digital, colour, sound
de-icing, 2014, 8 min., digital, colour, sound
Pending, 2016, 10 min., digital, colour, sound
Commute, 2018, 6 min., digital, colour, sound

Vincent Grenier began to make films while completing his MFA at the San Francisco Art Institute in the 1970s. He turned to experimental film in the wake of a major shift in underground cinema between two forms of improvisational filmmaking: on the one hand, the entrenched fields of the psychodrama and lyric film, and on the other, the stark minimalism of films made within and around predetermined structures. Grenier settled firmly in the latter camp, his films fixed on the tensions between improvisation and structure. Operating between New York City, his job at SUNY Binghamton, and Montréal's art scene, Grenier had little common ground with Québécois filmmakers of the era, many of whom were focused on the relatively conventional forms of new narrative and observational documentary filmmaking. The closest stylistic correspondents to Grenier's films were those of Toronto structuralist filmmaker Michael Snow and his peers in Binghamton's structuralist vanguard, Ken Jacobs, Larry Gottheim, and Ernie Gehr. Grenier's work is distinguished in its emphasis on personal rather than mechanical vision, often employing close-up photography to abstract his subjects; and for its emphasis on quotidian, even diaristic experience, his films often taking on family, friends, and intimately known environments as subjects.

Grenier's first experimental films, made in the mid-1970s, quickly established the minimalism, patience, self-reflexivity, and uncommon playfulness of his style. In *Catch* (1975), the camera pans and racks focus over a series of objects encountered in Grenier's apartment. The editing style is exclamatory: a sudden movement, of focus or framing, will then settle and linger, but such lingering is cut short by the restlessness of the editing. The filmmaker's subjects range from the plainly comprehensible to abstractions created by soft focus and close-up framing. For *Light Shaft* (also 1975), Grenier amplifies his minimalism, his subject a high window seen from a low angle; Grenier takes advantage of the dimensionality of his vantage point, the window becoming a parallelogram; the walls that frame it mask the light from the outside, allowing Grenier to control this fluctuating light, reducing it to a piercing beam or expanding it to a flatter and more dispersed plane of light. By the end, Grenier has surveyed many variations of light made possible through camera movements, changing focal length, and the refractive potential of his lens.

While Revolved (1976) goes even further in its minimalism, building rhythm out of soft white light and darkness, while *X* (also 1976), like *Light Shaft*, exploits the pre-existing geometry of its subject, a slow study of the triangular shapes that form a stylized *X*. In these short years, Grenier evolved his style from a probing curiosity about light and movement (*Catch*) to acts of geometric abstraction (*Light Shaft*, *X*) and abstractions of pure, solid light (*While Revolved*). By the end of this productive period, Grenier was combining these characteristics in *Interieur Interiors (to AK)* (1978), in which bright, artificial light and shadows cast by a figure are thrown onto the empty walls of a room, and subsequent interplay between the light and camera introduces a rolling vertical line

Vincent Grenier, *I.D.*, 1988

of light; the dulling edges of the light introduce a heavy grey cast to the image, and the film becomes a play of contrasts between bright and dark. The mystery of the film lies not exclusively in Grenier's use of light, but in his use of space, as the blank walls of this room bounce and absorb light, and the spatial relationships at play are steadily de-familiarized.

Through the course of the 1980s, Grenier expanded the vocabulary of his films beyond the confines of a disciplined minimalism. This is first demonstrated in *D'Apres Meg* (1982), freer in shape than his earlier films in its episodic structure, with changing subjects (a garden, a construction site, an art gallery). *D'Apres Meg* represents a contribution to the improvisatory stream of the structural film, still anchored in the close-up, a film that emphasizes small gestures and repetitions of gesture. With *Tremors* (1984), Grenier makes a flicker film, that is, a film of rapidly flickering images, even as he maintains a compositional minimalism. The film is presented in the context of being an experiment with Kinemacolor, an early film process in which black-and-white films were projected through alternating red and green filters to simulate the illusion of colour. The film is composed of scenes from city life in Greenwich Village, shot from the curb looking out into traffic. This material is turned into a flicker film with rapid alternations of red and green filters. As the film concludes, the image is in full colour, distorting through glass; it has achieved the mirage-dream of Kinemacolor.

Time's Wake (Once Removed) (1977-1987) represents an entirely new direction for the filmmaker, an assembly of home movies he shot of his parents and of the landscape surrounding their Île d'Orléans home, with double exposures that elaborate simple gestures, collapsing figures and landscape. It is memorial, lyrical, spontaneous, and explicitly personal in a markedly different manner than Grenier's other films. Grenier's longest film to date, *I.D.* (1988), follows in the observational content of *D'Apres Meg* and the diaristic, overlapping images of *Time's Wake*. In *I.D.*, human subjects have conversations, some of which have an interview subject, others the spontaneous flow of eavesdropped conversation. The film is at once a collective portrait, conveyed only in glimpses and snippets, and a notebook of observations, gathered in superimposition, high-contrast black-and-white and close-up photography.

Following *I.D.*, Grenier's work became more firmly rooted in the documentary subject — that is, the subject that commands attention that transcends the artist's visual expression — in a series he titled his "talking portraits." In the first of these, *You* (1990) and *Out in the Garden* (1991), Grenier's style remains dominant; with this work he finds a path for combining his abilities at minimalist abstraction, metaphorical composition, and discreet observation. *You* takes as its primary subject a monologue given by the primary subject, Lisa Black, transitioning over the course of ten minutes from a static, sepia-tinged image of the subject speaking to an image of her shimmering reflection in water, composed so that the reflection appears upright, as if consensus reality is merely the reflection of this distorting figure. *Out in the Garden* takes as its subject a man recently diagnosed with HIV, and develops a portrait of him by pairing his voice with a series of spare scenes from his house and backyard, his voice complemented and further defined by the environment of his home.

This documental emphasis magnifies Grenier's overarching interests, from *Catch* onward, with reality and subjective experience, and carries on his use of abstracting and obscuring vantage points, in the form of reflections, superimpositions, the beam-splitting of windows, and close-up photography where objects contravene the minimum-focusing distance of the lens — an infant's vision of worldly phenomena. *Feet* (1994), shot in Hi8 video, demonstrates the early translation of the artist's style, which had been fixed in the technologies of 16mm filmmaking, into video; the primary differences between the two media are evident through Grenier's transition, in that Hi8 video maintains a harsh focus and does not allow easily for the translation of Grenier's play with light. Grenier elects instead to work with composition and the presence of his subjects to shape a relatively traditional cinéma-vérité study, albeit one that emphasizes quotidian experience.

Grenier's work assumes a stricter minimalism after this, embracing video, its surveilling nature and its distinct meta-plasticity. By the early 2000s, working with Mini-DV and digital effects, Grenier was making playful films that, while highly distinct from

Vincent Grenier, *Surface Tension #2*, 1995

the spatial abstraction of his early films, followed in his preoccupation with the everyday. *Color Study* (2000) is an example of such a work, a static image of dense trees in upstate New York that pulse in colour through animation; their pulsing turns to wild oscillation and signal breakup. *Material Incidents* (2001) demonstrates the endurance of Grenier's interests in shadows and cloth textures, while also using such fades that reveal the ways in which video can transform light. The particular relation between Grenier's work in both film and video is highlighted by *Tabula Rasa* (1993-2004). Shot in a South Bronx high school, *Tabula Rasa* began production as a 16mm film, and therefore bears all the operations particular to Grenier's work with the motion picture camera, and was finished in HD video, thus bearing all the plastic qualities of Grenier's video work. The result is a hybrid work that is as much about formal collision as it is a reflection of its subject, the spaces and corridors of education. Grenier's experimentation with video's plasticity includes experiments with non-objective imaging, as in *North Southernly* (2005), in which heavily layered digital video loses all traces of lens-derived imagery, forming instead a vortex of brown, green, and white, slowly shifting in colour, its underlying forms pulsing

with faint, slowed movement. Elsewhere, such interests are integrated, as they are in *Color Study*, with definite, unambiguous photographic imagery.

From 2006 onward, Grenier produced video work that combines quotidian observation and abstracting compositions with more subtle plastic manipulations and long fades. *This, and This* (2006) is composed of parallel camera movements, crossing contrails, a small dock, rainfall: a montage of natural phenomena influenced by human presence. *Les chaises* (2008) offers a pair of aging, red-vinyl-upholstered chairs, set on a lawn in the breaking shade of trees, as a prologue to colour fields of red that consumes and tints the image. *Straight Lines* (2009) is composed of the shadows cast on a table by window blinds and by the bars of a bird cage, the shadows bent across the table's surface by diverse concentrations of light. *Burning Bush* (2010) takes a matured euonymus shrub and uses it as the basis for colour field exploration, revealing the subject only after a prelude of the plant's leaves in soft focus, filling the frame with an uncommonly vivid, saturated red; once the plant is revealed in sharp focus and broad composition, Grenier uses strategies of soft-focus and colour oscillation to estrange the image from the subject. Against environmental and compositional minimalism, Grenier's digital work offers dramatic revisioning of his subjects, employing subtle, continuous transformation of colour and texture even as compositions may remain largely static and cuts spare.

Grenier's work has remained, from its origins in the 1970s to the present, focused on translating empirical experiences of light into the cinema space and on his fascination with environments both natural and constructed. Even as he transitioned into using Hi8 video and digital video, and the forms of attention and granularity particular to film faded out of his work, he maintained this commitment to environmental portraiture. The new dispositions of attention particular to video are evident in an increasingly prolonged gaze present from *Color Study* onward. In *Waiting Room* (2012), a waiting room at a medical clinic is subject to lingering observation, a commonplace trial of shifting attention—from one wall to another, from object to object—broken by the presence of ebbing fluorescent lights. Likewise, *Watercolour* (2013) transforms the mundane vision of a brackish creek bounded by bridges, barriers, and graffiti, and allows its reflections and currents to provide a rhythm against Grenier's surveying. *Pending* (2016) frames such surveying, of a home's interior, within the bounds of such currents, as water courses at the edges of the frame, creating strange deceptions, for instance, recasting the blue carpeting of a room as a sandy ocean floor. These collisions between natural phenomena and made environments, whether lived in intimately or transitorily, demonstrate one of the primary tensions of Grenier's work: that the scales and spheres of dailyness can accommodate our most confidential and intimate as well as our most public and communal experiences of space.

—SB

RICK HANCOX

Born Toronto, Ontario, Canada, January 1, 1946

Rick Hancox, *Moose Jaw: There's a Future in Our Past*, 1992

FILMOGRAPHY

Rose, 1968, 3 min., 16mm, colour, sound
Cab 16, 1969, 6 min., 16mm, b&w, sound
I, a Dog, 1970, 7 min., 16mm, b&w, sound
Tall Dark Stranger, 1970, 15 min., 16mm, b&w, sound
Next to Me, 1971, 5 min., 16mm, b&w, sound
Rooftops, 1971, 5 min., 16mm, b&w, sound
House Movie, 1972, 14 min., 16mm, colour, sound
Wild Sync, 1973, 11 min., 16mm, b&w, sound
Home for Christmas, 1978, 46.5 min., 16mm, colour, sound
Zum Ditter, 1979, 10 min., 16mm, b&w, sound
Reunion in Dunnville, 1981, 15 min., 16mm, colour, sound
Waterworx (A Clear Day and No Memories), 1982, 5.5 min., 16mm, colour, sound
Landfall, 1983, 12.5 min., 16mm, colour, sound
Beach Events, 1984, 8.5 min., 16mm, colour, sound
Moose Jaw: There's a Future in Our Past, 1992, 52 min., 16mm, colour, sound

Rick Hancox spent much of his childhood in Saskatchewan and Ontario. By the 1960s, he was studying at the University of Prince Edward Island. He had an interest in poetry, but by 1968, that had shifted to filmmaking. Through the influence of George Semsel, Hancox became involved in independent filmmaking and discovered experimental cinema; he did graduate work at New York University, and with Semsel at Ohio State. After completing his MFA in Ohio, Hancox began to teach at Sheridan College in Oakville, Ontario, alongside Jeffrey Paull. Hancox and Paull, with a shared interest in personal filmmaking, had a major impact on their students, and in the course of twelve years, Hancox mentored a handful of significant experimental filmmakers.

Hancox's earliest films demonstrate an emerging artist getting comfortable with the medium; they include found footage (*Rose*, 1968), observational documentary (*Cab 16*, 1969), and fiction filmmaking (*Tall Dark Stranger*, 1970). It was in this period that he made his first semi-autobiographical and poetic films: *I, a Dog* (1970) — in which a fable of going to the city to seek one's fortune is met with analysis of the accumulation of dog shit on shoes — and *Next to Me* and *Rooftops* (1971, respectively), both of which balance a direct cinema approach with intimacy of witness. The autobiographical elements in these works were not yet explicit, but, by the time that he began teaching at Sheridan, his work had shifted toward autobiographical filmmaking with *House Movie* (1972). Caught between editorial fragmentation and observational camerawork, breaking directly from his debts to cinéma-vérité, Hancox developed something of an environmental portrait, in the filmmaker's words, of a "rented house which never becomes home"—and a portrait of a relationship on the brink of separation.

For the remainder of his years teaching at Sheridan, Hancox alternated between autobiographical filmmaking and collaborations with his students and peers, work that was explicitly geared toward demystifying the filmmaking process (*Wild Sync*, 1973), that used extemporized oral poetry as an occasion for sound experimentation (*Zum Ditter*, 1979), and that used sustained attention and archival materials in the interest of documental witness (*Reunion in Dunnville*, 1981). Hancox continued the autobiographical themes of *House Movie* with *Home for Christmas* (1978), a record of a train journey across the country to spend Christmas with family, a common Canadian experience that is rendered here in a style that recalls the home movie. Where it differs significantly from the average home movie is technological: there are sustained compositions on faces as characters talk, emphasizing Hancox's use of synchronous sound. In another sense, like the home movie, the content dictates focus of attention, and in this the journey is conventional. Long periods are spent on-board trains anticipating arrival, and beyond that there is time spent visiting with relatives and opening presents. *Home for Christmas* is more documental than *House Movie* in that it is direct about its subject and does not engage in baroque intercutting, and yet it is also, by the intimate scale of its subject, a far cry from the social documentary filmmaking common in Canada.

The relation of Hancox's autobiographical work to poetic impulses became more explicit with *Waterworx (A Clear Day and No Memories)* (1982), which takes its parenthetical title from Wallace Stevens, and serves as an exploration of Toronto's R.C. Harris water filtration plant, known colloquially as the "Palace of Purification," distinct for its sprawling grounds and unique Art Deco buildings. Stevens's poem is printed atop dollying shots of the plant and its surroundings. For Hancox, the concrete architecture of the plant is something porous and metaphoric, its design so in contrast with the silence and emptiness of the place as to suggest a tomb, or the climax of a spiritual pilgrimage. Stevens invokes images suggestive of memories in his text—"No thoughts to people now dead, / As they were living fifty years ago"—and Hancox's film is wrestling, by his admission, with his own early memories of the palace, three decades before. This begins a series of films that Hancox made about the sites of his own past and formative years, continuing with *Landfall* (1983) and *Beach Events* (1984), both shot on Prince Edward Island.

In *Landfall*, Hancox sets his camera up to create dramatic motion blurs on a beach. Text appears throughout, small fragments and phrases, written by poet D.G. Jones. The film establishes movements with suspended points where the image freeze-frames, first on Hancox's shadow. By the final act of the film, the image is crossing over itself in superimposition, flipped as a mirror image, creating symmetrical movements, so that the landscape appears to be peeled apart, sky and earth parting in unison from their doubles. *Beach Events* concludes the series. In it, Hancox adapts a text of automatic writing by George Semsel that describes the phenomena encountered in a day at the beach; his adaptation adds gravity to the text, and on screen it is broken down into small morsels, couplets. The image illustrates the text but gradually slips out of sync with it, recasting the monologue as a subconscious remembering. These three films represent Hancox's strongest engagement with poetry. In them the autobiographical becomes a bit of background colour, while poetry, in the form of borrowed or adapted texts, becomes a primary force. Further to that, these films also represent Hancox's engagement with the technology of film and its potential, from the gliding dolly of *Waterworx*, to the freeze-frame suspensions of *Landfall*, to the ellipsis of *Beach Events*.

Over the course of the subsequent years, Hancox worked on an ultimate manifestation of this rear-facing autobiography. This culminated in *Moose Jaw: There's a Future in Our Past* (1992), a sprawling portrait of the Saskatchewan city in which he spent the bulk of his childhood, and which has transformed over the course of a century from a frontier boomtown to an ossifying town of museums; the film's own subtitle is an ironic citation of the town's motto. The film begins with snapshots from Hancox's childhood accompanied by a dial-turning soundtrack of contemporaneous songs. The songs persist throughout, interspersed with CNR train journeys and interviews with Moose Jaw residents about the local economy, forming a broader vision of Canada as a series

Rick Hancox, *Waterworx (A Clear Day and No Memories)*, 1982

of outposts and waypoints in decline, advanced with a comic tone—sunset in the Canadian west. Throughout, Hancox films himself in the Canadian, a coast-to-coast train, and in hotels watching late-night television. *Moose Jaw* furthers Hancox's suggestion that his own life force is tethered to that of the places he's from, an undercurrent in the earlier trilogy in which perceptual adventures link individual memory to place and shadow to landscape. The sustaining values of community maintain centre stage, even through ironic pageantry as the climax attests, when a civic parade marches through the main street of the town.

—SB

PHILIP HOFFMAN
Born Kitchener, Ontario, Canada, December 10, 1955

FILMOGRAPHY

On the Pond, 1978, 9 min., 16mm, b&w, sound
The Road Ended at the Beach, 1983, 33 min., 16mm, colour, sound
Somewhere Between Jalostotitlan & Encarnacion, 1984, 6 min., 1984, colour/b&w, sound
?O, Zoo! (The Making of a Fiction Film), 1986, 23 min., 16mm, colour/b&w, sound
passing through / torn formations, 1988, 43 min., 16mm, colour/b&w, sound
river, 1989, 15 min., 16mm, colour/b&w, sound
Kitchener-Berlin, 1990, 34 min., 16mm, colour/b&w, sound
Opening Series (series), 1992-2000, 34 min., 16mm, colour, silent
Technilogic Ordering, 1994, 30 min., 16mm, colour, sound
Sweep (with Sami van Ingen), 1995, 32 min., 16mm, colour, sound
Chimera, 1996, 15 min., 16mm, colour, sound
Destroying Angel (with Wayne Salazar), 1998, 32 min., 16mm, colour/b&w, sound
Kokoro Is for Heart (with Gerry Shikatani), 1999, 7 min., 16mm, b&w, sound
What These Ashes Wanted, 2001, 55 min., 16mm, colour/b&w, sound
Ever Present Going Past (with Gerry Shikatani), 2007, 7 min., video, colour/b&w, sound
All Fall Down, 2009, 94 min., video, colour/b&w, sound
Lessons in Process, 2012, 30 min., video, colour/b&w, sound
Slaughterhouse, 2014, 15 min., 16mm/video, colour/b&w, sound
Aged, 2014, 45 min., 16mm/video, colour/b&w, sound
By the Time We Got to Expo (with Eva Kolcze), 2015, 9 min., 16mm/video, colour/b&w, sound
vulture, 2019, 57 min., 16mm/video, colour/b&w, sound

The autobiographical turn that had entered Canadian experimental film practice through works such as Rick Hancox's *Home for Christmas* expanded through the films of Hancox's student **Philip Hoffman**. Since his time at Sheridan College in the late 1970s, Hoffman's films have attended to family legacies and wrenching losses, have surveyed a broad range of handmade and artisanal approaches to the moving image, and have explored the inherent dubiousness of visible evidence. The work that he has developed in this mode has helped to shape formal approaches to diaristic experimental filmmaking particular to Canada: the self-conscious markings of chemical hand-processing, the use of high-contrast film stock, the manipulation of said chemistry and stock to tender dense and soupy blacks, confessional narration, and a culling of materials from archives both private and official. In Hoffman's style the earnestness of the filmmaker's intimacy is held in contrast to nagging doubts as to the veracity of personal knowledge.

Philip Hoffman with Bolex camera during production of *The Road Ended at the Beach* (1983) (Richard Kerr)

The memorial dimension of his work is present in his first film, *On the Pond* (1978), in which scenes of a casual hockey game on the filmmaker's childhood rink are intercut with a slide show of family photos, accompanied by the joyful chortles and observations of the Hoffman family. Hoffman followed this with a film of a road trip, *The Road Ended at the Beach* (1983), in which Hoffman and friends travel from Ontario to Nova Scotia in search of Beat generation photographer and filmmaker Robert Frank. The journey is presented with a combination of still photographs; casual, from-the-hip cinéma-vérité camerawork; and intertitles that complement Hoffman's narration. The dial-turning soundtrack ranges from home recordings, blues records, casual banter, and interview audio. The stylistic flexibility of the film has a spontaneous energy and introduces what would become the hallmarks of Hoffman's style. This continues in *Somewhere Between Jalostotitlan & Encarnacion* (1984), a film in which the idols and rituals of Mexican Christianity offer little comfort against the mournful wail of a saxophone as text recounts the sudden death of a young boy, struck down in the street by a car. A somber Easter parade in Toronto arrives to shorten the

distance between home and elsewhere, reminding us that spiritual knowledge of death is omnipresent in life.

Much of Hoffman's early work is concerned with bearing witness to rituals (the family slide show, the road trip), and at that, rituals with their roots in childhood that linger long in the memory. But the notion of verifiable, objective truth comes under fire in Hoffman's films beginning with *?O, Zoo! (The Making of a Fiction Film)* (1986), a film full of myths. It claims to contain footage of zoo animals shot by the narrator's grandfather, a newsreel cameraman (a fiction in itself; the footage is Hoffman's), and the filmmaker's own narration (spoken by an actor) sets as its backdrop the filming of Peter Greenaway's *A Zed and Two Noughts* (1985). Fact and fiction become indistinguishable as this goes on, and much of the power of the film is in its photography and its soundtrack, which conspire around Greenaway's shoot to capture unrehearsed visions and communions. Following *?O, Zoo!*, Hoffman began to produce consistently long-form autobiographical work, beginning with a pair of films dealing with family history: *passing through / torn formations* (1988), a history of Hoffman's mother and her family; and *Kitchener-Berlin* (1990), a portrait of his father's hometown. Both works integrate Hoffman's cinematography with found materials, ranging from home movies and photographs to archival films.

For the remainder of the 1990s, Hoffman's films continued to deal with diaristic themes, and the filmmaker's search for the poetic properties of the everyday was often placed in dialogue with his formal interests. The style set by Hoffman in his diary films continued with the exception of one outlier, *Technilogic Ordering* (1994), an experiment in video art in which scenes of the conflict in the Persian Gulf (and general television dial-flipping) play out in freeze frames and staggered playback across a nine-frame mosaic. Around this time, Hoffman also began to pursue projects in collaboration with other artists, among them a fellow filmmaker (*Sweep*, 1995, with Sami van Ingen), a painter (*Destroying Angel*, 1998, with Wayne Salazar), and a poet (*Kokoro Is for Heart*, 1999, and later *Ever Present Going Past*, 2007, both with Gerry Shikatani). In each case, Hoffman's collaborations demonstrate both his technical skill, to create films collaboratively that bear the definitive marks of his authorship, and his generosity, a generosity that is tied to his identity as a teacher. He later collaborated with his former student Eva Kolcze (on *By the Time We Got to Expo*, 2015), and in a related context, made a film about his summers teaching at Cuba's national film school, EICTV (*Lessons in Process*, 2012).

Hoffman's partner, Marian McMahon, passed away in 1996, and the aftermath of this loss led him to make *What These Ashes Wanted* (2001), a reflection on mortality and grief that draws from intimate records of his and McMahon's life together, his experiences with death from a young age, and other acts of soul-searching that provoke contemplation on love, loss, and rituals of death. While grief had been a consistent theme in Hoffman's filmmaking, just as surely as all things memorial are inevitably

tied to grief, many of his later films assume mortality as their central theme. It casts a pall over the proceedings of *All Fall Down* (2009), in which colonial-era Indigenous history and the past of the filmmaker's new family converge on a nineteenth-century Southern Ontario farmhouse. It is present in *Slaughterhouse* (2014), which ties those same Indigenous histories to the abattoir, and the rise and fall of the Hoffman family's meat business. And mortality is at its most lamentably present in *Aged* (2014), about his father's declining years as he and his sisters served as the man's caregivers. From *All Fall Down* onward, Hoffman's work begins to integrate film and video, allowing him greater flexibility in working with archival material, including home video; his themes and rhythmic strategies are maintained, even as his integration of 16mm film drastically shifts from the colour mastery of his earlier cinematography towards purer forms of black-and-white imagery. He strips much of his filmmaking down to what were steadily becoming his primary teaching materials (high-contrast black-and-white film and a hand-processing workflow). This is not to say that such material collisions were new to Hoffman, who had earlier experimented with the combination of film and video (*river*, 1989), but his embrace of video as a production and finishing format became increasingly all-encompassing after *What These Ashes Wanted*. This material fact allows these films, so concerned as they are with fate and mourning, to combine the mythic stature of the film image with the casual, surveilling character of video.

In 2019, Hoffman released *vulture*, a record of farm life in Southern Ontario; more than his other recent films, it is a work of durational, structural conceits. The first half of the film involves a series of long zooming shots aimed at farm animals, and through the course of these scenes a great deal of interspecies coexistence is seen. Such coexistence among beasts finds a thematic contrast with the toxic legacy of filmmaking itself, an inherently selfish, careless act of engaging in environmentally harmful processes. This relation becomes evident in the second half of the film, when Hoffman's hand-processed 16mm photography is integrated, and is supported in the credits with the acknowledgement that he has embraced chemical processes derived from natural sources (with developer made from flowers, coffee, and other non-toxic materials). In a sense, *vulture* concludes the project of self-portraiture of the artist-as-teacher that Hoffman has returned to throughout his work, most explicitly in *Lessons in Process*; however, with it he is also taking an environmental stand on the materials of his work and laying plain his ideals. As he has through the self-interrogative, confessional autobiographies that came before it, Hoffman is again searching for his role within a process, at home in the world at large and in sympathy with the world of beasts.

—SB

MIKE HOOLBOOM

Born Toronto, Ontario, Canada, August 2, 1955

Mike Hoolboom began to make films while a student at Sheridan College in Oakville, Ontario, in the early 1980s, in a program that was focused on the possibilities of poetic documentary filmmaking anchored in humour, social concern, and an observational style. Among the filmmakers who came through Sheridan, Carl Brown, Michael Cartmell, Gary Popovich, Steve Sanguedolce, and Hoolboom were all beginning to experiment with the plasticity of the film image in ways that departed sharply from the strategies of their teachers.

Hoolboom's earliest films engage in Debordian integrations of text and space that complicate the exchange between maker and viewer. This approach begins with *Now, Yours* (1981), wherein text, television commercials, a film countdown, and a game show combine as a critique of the theatrical space and its distinctions of high and low culture. Such direct address continues in *The Big Show* (1984), in which fourteen intertitles appear in white on black with a shifting, hand-processed background; the titles demand viewer participation, or suggest to the viewer modes of presence and awareness of their role, from "please stand" to "please move both hands together," and bridge maker and viewer in a more direct union with such texts as, "make a sound only I can hear." Hoolboom's critique of the viewer experience evolves into *White Museum* (1986), in which the filmmaker delivers a 33-minute monologue on cinema, time, reality, and language, accompanied by an audio collage of pop songs and commercials; throughout, the projection is composed only of clear leader. When the monologue ends, an image finally appears, of light breaking through trees that have taken on a soft, inky texture.

This early trilogy of works is unified by its self-conscious attention to the experience of the audience, its declarations of self-awareness on the part of the filmmaker, and its intent to destabilize the traditional relation between maker and viewer in the suspension of a darkened theatre. In this, Hoolboom shares in the vanguard thread of disruption and resistance in postmodernity, an aspect that would remain dominant in his work even as it joined further with a heightened interest in social justice following his diagnosis with HIV in 1989. In his earliest films, Hoolboom spoke as a challenger to the norms of experimental cinema, but it was after his diagnosis that his work became more explicitly autobiographical and personal in nature, as he began to make work that shared in the documental and diaristic slant that had dominated much Canadian experimental film, but particularly that of his former teacher Rick Hancox and his contemporaries R. Bruce Elder, Philip Hoffman, and Barbara Sternberg.

While Hoolboom had begun by making films about formal self-consciousness, he soon began to integrate other aspects of hybridized fiction and documentary into his work—for instance, with *Frank's Cock* (1993), in which an unnamed, fictional narrator (Callum Keith Rennie) performs a monologue about his partner, Frank, who has been diagnosed with AIDS, an account that Hoolboom based on the life of a friend he had met through the PWA (People With AIDS) movement. As with *White Museum*, the

Mike Hoolboom, *Frank's Cock*, 1993

narration is met by a formal challenge, in this case the presence of several coexisting
projections breaking the screen into quadrants. This strategy draws Hoolboom's
docudrama back towards the disruptive, polyphonous forms of experimental cinema,
counterbalancing the cinematic realism of the monologue and performance. The
films that Hoolboom made in the 1980s had gravitated to minimalistic designs, and
his minimalism became most arch in *White Museum*. After his diagnosis with HIV,
Hoolboom's work moved in the opposite, maximalist direction, embracing polyphony,
the integration of many distinct parts. He had adhered to minimalism in a way that
grounded him in a late manifestation of the structural film movement; as his work
further transformed he sampled genres, making a critical, diaristic travelogue (*Mexico*,
1992, with Steve Sanguedolce), an archival documentary (*Letters From Home*, 1996),
and a transgressive, omnibus psychodrama (*House of Pain*, 1998).

Hoolboom continued to explore the AIDS crisis through a suite of works collected
as *Panic Bodies* (1998), which in its six parts integrates Hoolboom's personal voice, the
borrowed voices of interview subjects and scripted texts, and a rapid personalization of
mass culture images, a cohabitation of comedy, tragedy, and outrage. Component parts

function as discrete and individual works that combine to a thesis: for example, *1+1+1* (1993), in which a man and a woman perform comic, violent "repairs" on one another through a gauze of flickering red, is distinct from *Moucle's Island* (1998), in which more sombre photography of an aged female figure transitions into a montage of archival nudist footage as the woman's voiceover explores her feelings about memory, time, and the body. As an assembly of such contrasting, individual parts, *Panic Bodies* reconciles the transgressive and kinetic with the meditative and minimalist, often through dense images integrated by fades or by the steady pulse of solarized film processing. Hoolboom's emphasis on portraiture and storytelling, and the integration of his authorial presence with that of his subject, became a defining character of his later, increasingly documentary work.

Hoolboom soon followed *Panic Bodies* with more omnibus films: *Imitations of Life* (2003), a century-collapsing study of the interpolation of cinema, intimacy, and memory, and *Public Lighting* (2004), a wide-ranging critical assessment of culture in the context of isolation, authenticity, and community. For a time around the turn of the millennium, Hoolboom flirted with this scrapbooking approach, taking account of his work at intervals and building in the direction of modest cycles. He revisited this approach with his compilation feature *Father Auditions* (2019), which he has described as a "family choir," an integration of five films in which family, paternity, and the endurance of the body are all taken as broad signs of invisible, tangential, intimate histories. In such omnibus works, Hoolboom is able to blend the essayistic qualities that had defined his films since *The White Museum* with his documental, progressive sensibilities and his engagement with and subversion of mass media, thereby imbricating his work with a sense of his own probing consciousness.

By the early 2000s, a great deal of Hoolboom's moving image practice had migrated from film to video. While he continued to work with both film and video, his approach to the latter was often distinct, particularly as he began to make long-form documentary portraits, sometimes integrating found materials with his own footage. *Tom* (2002), on experimental filmmaker Tom Chomont, mixes mass culture images with the subject's films and Hoolboom's own stark portraiture of Chomont, footage that explores the artist's fragility, living with Parkinson's and HIV in his final years. *Tom* is confessional in its exploration of Chomont's life, his illness, his incestuous relationship with his brother, and his relation to the S&M scene; in all of this it is also loving, embracing Chomont and casting light on his life, work, and endurance, in the shadow of his struggles. Chomont's films were often portraits of friends, and consequently, *Tom* bears inevitable parallels to its subject's own work. Since making *Tom*, Hoolboom has completed a number of feature-length portrait films: *Fascination* (2006), on the video artist Colin Campbell; *Mark* (2009), on his friend and collaborator Mark Karbusicky; and *Judy versus Capitalism* (2020), on the feminist activist Judy Rebick.

Alongside a steady stream of short films, Hoolboom has also made a number of other long-form films that stand apart from the compilation features and his documentaries. In *Lacan Palestine* (2012), Hoolboom discovers in the erasures, losses, and placeless condition of Palestine both a thoroughly western metaphor for the alienation of contemporary life and a confrontation with such colonial solipsism. *Incident Reports* (2016) offers the premise of an amnesiac whose therapeutic use of video as a memory-aid becomes both a city symphony of Toronto and a series of fleeting portraits. *We Make Couples* (2016) is another broad and discontinuous collision of essayistic commentary and storytelling, one that extends Hoolboom's engagement with the metaphoric cinema of quotidian experience, mining the word *projection* from literal casting to its more symbolic, psychic occupation.

The prolificacy of Hoolboom's output is not restricted to moving images; he has also been a committed chronicler of the scene of Canadian experimental film, beginning with a magazine, the *Independent Eye*, which he founded in 1988 while working as the experimental film officer at the CFMDC. The magazine featured artist statements, commentary on new works, trade news, and debates on the nature, definition, and motives of experimental filmmaking. Hoolboom's contributions as a writer expanded from there to include thirty books, among them two collections of interviews with Canadian filmmakers (*Inside the Pleasure Dome: Fringe Film in Canada*, 2001, and *Practical Dreamers: Conversations with Movie Artists*, 2008); edited collections on filmmakers, for example, Deirdre Logue, David Rimmer, Jorge Lozano, and Christine Lucy Latimer; and *Underground* (2017), a history of Toronto's Funnel Film Collective. Like the essayistic narration that features in many of his films, Hoolboom's writing is often candid, evincing a personal style that balances familiarity and reportage, placing personal experience at the forefront but always in the service of underrepresented artists working at the margins of cinema.

—SB

RICHARD KERR
Born St. Catharines, Ontario, Canada, February 3, 1952

SELECTED WORKS
Hawkesville to Wallenstein, 1976, 6 min., 16mm, b&w, sound
Vesta Lunch, 1978, 11 min., 16mm, b&w, sound
Canal, 1982, 22 min., 16mm, colour, sound
On Land over Water (Six Stories), 1984, 60 min., 16mm, colour/b&w, sound
The Last Days of Contrition, 1988, 35 min., 16mm, b&w, sound
Cruel Rhythm, 1991, 40 min., 16mm, colour/b&w, sound
The Machine in the Garden, 1991, 20 min., 16mm, colour, sound
Plein Air Etude, 1991, 5 min., 16mm, colour, sound
Plein Air, 1991, 20 min., 16mm, colour, sound
McLuhan, 1993, 60 min., video, colour, sound
The willing voyeur, 1996, 77 min., 35mm, colour, sound
Never confuse movement with action...(the self-fictionalization of Patrick Hemingway), 1998,
 50 min., video, colour, sound
Human tragedy on a grand scale, 1999, 50 min., video, colour, sound
Pictures of Sound, 2000, 20 min., video, colour, sound
I was a strong man until I left home..., 2000, 27 min., video, colour, sound
Collage d'hollywood, 2003, 8 min., 35mm/digital, colour, sound
Hollywood décollage, 2004, 9 min., 35mm/digital, colour, sound
Le bombardement le porte des perles, 2004, 9 min., 35mm/digital, colour, sound
T/ Demi-Monde, 2004, 80 min., 35mm slide (double screen)
universe of broken parts, 2007, 10 min., digital, colour, sound
action: study, 2008, 5 min., digital, colour, sound
de Mouvement, 2009, 6 min., 35mm, b&w, sound
House Arrest, 2012, 18 min., digital, colour, sound
Morning...Came a Day Early, 2015, 9 min., 16mm/digital, colour, sound
wholly holy, 2017, 7.5 min., 35mm/digital, colour, sound

Richard Kerr studied filmmaking at Sheridan College in the 1970s, at a time when the school's sensibilities leaned heavily toward the experimental and poetic side of autobiographical non-fiction filmmaking. He came to cinema from a distinctively Canadian background, having pursued a career as a professional hockey player. Upon discovering photography, Kerr became interested in making art, which led him into filmmaking. After creating a series of films that explored an observational, documental filmmaking style, Kerr transitioned into a series of long films that dealt with storytelling, journeying, and national myth. Heavily influenced by the writings of Ernest Hemingway, and by compositional and reportage traditions of photography, Kerr took images of home, landscapes, and the territories and politics of America. Later, he pursued the materially self-conscious machined image and found footage. Kerr was keenly aware of the themes emerging in his peers' work, partly from his extensive exposure to his contemporaries through his work at the Canadian Filmmakers Distribution Centre. He did much to influence the critical and curatorial discourse surrounding Canadian cinema, evidenced in his programming of the Art Gallery of Ontario's landmark show of Canadian avant-garde film, *Spirit in the Landscape* (1989). His work in filmmaking has been complemented by his work in sculpture and craft, specifically his motion picture weaving project: totemic quilts fashioned from interwoven strips of commercial film, their frames forming tartan patterns on wall-mounted light boxes. This work, a unique integration of the methods of folk art and the traits of modern vision, has formed the bulk of Kerr's activity since the 2000s.

Kerr's earliest films come from the immediate influence of cinéma-vérité: *Hawkesville to Wallenstein* (1976), a portrait of an Amish farming community in southern Ontario in winter, a patient, at times meditative look at their lifestyle, suspended in pastoral memory; *Vesta Lunch* (1978), an exercise in stationary, observational filmmaking shot at night in a Toronto greasy spoon; and the more personal *Canal* (1982), a portrait of the Welland Canal dedicated to his brother, a study of "a place of our youth." His films moved in another direction with his first major work, *On Land over Water (Six Stories)* (1984), an omnibus of six episodes, among them a dramatized reading (paired with visually fragmented text) from Hemingway; non-narrative episodes that use improvisatory camerawork and optical manipulation; and spontaneous stories from figures encountered on the road. Much of this work remains anchored in observation, but it suggests the forms that will underscore Kerr's subsequent films: fluent transit between colour and black-and-white photography, a mixture of environmental and human portraiture, interruptions of texts and symbols printed into the image, a porous sense of what storytelling can mean.

He followed this with two more long films, *The Last Days of Contrition* and *Cruel Rhythm* (1988 and 1991 respectively). Both are road trips through the final days of Reagan's America. *The Last Days of Contrition* tours beaches, deserts, ballparks, and ruins

in a stark black-and-white, using motorized tripod heads to create breathless scans of an unstoried desert; radio broadcasts introduce the percussion of a march, jingoistic commentary on American democracy, a collage of looping speeches. The film ends with these forms coming together in a persistent spinning motion aimed at treetops as, in superimposition, military jets cross the sky. *Cruel Rhythm* continues these gestures, with a more explicit emphasis on themes of militarism in American life. On the soundtrack, Kerr continues his montage, a survey of distinctly American aurality: dramatized military drills; the national anthem; cheers at a baseball game; official statements from military personnel. Against this, Kerr poses images that, at first, extend the observational qualities of *The Last Days of Contrition*, but once colour arrives, in the form of a long abstract sequence of animated, agitated palm leaves, *Cruel Rhythm* enters into a more violent, intensely abstract space. Elemental phenomena come and go, composed in the abstract: a backlit indoor waterfall, billowing flames. The filmmaker goes further than compositional abstraction, engaging a rapid, mechanical movement that reduces palm leaves and landscapes into lines of light. From this is cast an America of fear and uncertainty, host to a blinding restlessness matched on the soundtrack by the sounds of war and the ponderous statement by a reporter that "something is happening outside."

Richard Kerr, *The Machine in the Garden*, 1991

The final sequence of machined abstraction in *Cruel Rhythm* foretells the next direction in Kerr's work, a total embrace of the camera's ability to abstract the photographic subject by force of motion. This piece, influenced by Michael Snow's work in camera motion, especially *La région centrale* (1971), disavows the narrative aspects of Kerr's work that had played a persistent role in his preceding long films. It also signals a departure from the photojournalistic qualities that had defined much of his work, moving further into a territory of difficult, experiential modernism, a move anticipated by sequences in his earlier films. In three works— *The Machine in the Garden*, *Plein Air Etude*, and *Plein Air* (all 1991) —Kerr uses the camera, motorized tripod heads, and vehicle mounts to explore a new approach to environmental portrait, one achieved at the scale of the individual frame.

Kerr's impulse toward narrative and storytelling was not altogether abandoned; rather, it led him to make *The willing voyeur* (1996), a feature in the new narrative tradition, affixing progressive, subversive, experimental forms to screen drama. The result is a highly unconventional fiction film that fits neatly alongside many works of its day in the North American new wave independent film movement. Kerr withdrew *The willing voyeur* from distribution after a debut at the Locarno Film Festival. It marks Kerr's only effort in relatively mainstream filmmaking, but it also serves as a central rift in his work, distinguishing what had come before (disciplined formalism that paired explorative treatments of landscape with an obscure approach to narrative) with what would follow (a continuing embrace of the machine's wildest and most kinetic possibilities and an integration of found materials).

After *The willing voyeur*, Kerr completed his first work in video, *Never confuse movement with action ... (the self-fictionalization of Patrick Hemingway)* (1998), a postmodern biographical documentary about a grandson of Ernest Hemingway. Kerr explores themes of inheritance, addiction, and the author's enduring themes of fact and fiction. A subsequent lawsuit led Kerr to produce an alternative version, *Human tragedy on a grand scale* (1999), a remix that placed greater emphasis on the community of homeless addicts in East Hastings, Vancouver, that had also featured prominently in the original. Kerr's approach to working with video is present here as well: at times he uses a slow shutter to create staggered movements and often retains the roughness of truncated sound. He followed this with a pair of poetic documentaries more divorced from language and focused on landscape and the transient nature of perception. One is *Pictures of Sound* (2000), in which interrupting, often grating sound is paired with elliptical edits of two landscapes, a mountain range and a waterbody. The other is *I was a strong man until I left home* (2000), the most diaristic of his films since *Cruel Rhythm*, which also uses ellipses as a running strategy along with fades that indicate passing time, and much of which is composed in abstract images that use soft focus and extreme close-up, in tandem with the forward-advancing elliptical cuts that move the viewer through a series of hotel

Richard Kerr, *Collage d'Hollywood*, 2003

rooms, cityscapes, airports, airplanes. Kerr describes this approach as digital sketching, and he continued it in *universe of broken parts* (2007) and *action: study* (2008).

All of Kerr's work prior to the turn of the millennium had focused on personal vision of one order or another, whether that personal vision was observational (external) or abstracting (internal). In the early 2000s, however, he began to work with 35mm commercial movie trailers, refashioning them into light box–mounted collages but also working with them to create new films. This marked the start of his work in installation, culminating in *Industry*, a show held at the Cinémathèque québécoise in 2003 that included works from his motion picture weaving project and his found footage films. In *Collage d'hollywood* (2003) and *Hollywood décollage* (2004) he uses chemistry, paint, and superimposition to chip away at the existing imagery and to fill in the gaps that he had dug out in a *décollage* mode. In *de Mouvement* (2009), a black-and-white collage of moving camerawork and jarring transitions suggests an undercurrent of menacing psychology in scenes from commercial films of the early talkie and wartime era. In *Morning…Came a Day Early* (2015), scientific films of the 1960s are revisited to ruminate on time and destruction. The acme of his work in this mode, however, is *T/ Demi-Monde* (2004), a 5-hour double-projector work of 35mm film strips, digitally scanned and slowly dissolving

into each other. The composition is of a rectangular strip of two consecutive frames. Kerr has distorted, decomposed, or otherwise distressed the emulsion of each frame to create abstract and occasionally non-objective imagery. For the most part, the root image remains, but in some instances Kerr has created new symmetries within the image, or has reticulated the image so that it breaks down into strands of fraying viscera, revealing underlying kernels of emulsion.

Kerr returned to his experiments of using the camera in tandem with other forms of machines with *House Arrest* (2012), in which he mounted a digital camera on the end of a power drill, giving an illusion that the camera can see 360 degrees. The image curves so as to cast some shape of the originating instrument, the rotating drill bit, and the wide angle of the camera lens bends the shapes it encounters—skyscrapers, paint cans, a garden—along that curve. At first, this act of abstraction forces the eye to recognize these objects; as it continues, the root environment becomes less discernible, as the drill speeds up and the resulting images metamorphose into mandalas. The power drill is again used in *wholly holy* (2017), albeit not as a mount but to make images through direct application to the film plane: Kerr drilled a hole into a roll of undeveloped film and let it soak up moonlight. Once processed and scanned, the drill's holes are pitch black with frayed, brown-gold edges, in contrast to the blue and dark-purple cast of the intact film strip. Kerr digitally manipulated the results, slowing and staggering the rhythm in which this circle moves across the frame.

—SB

ALEXANDRE LAROSE

Born Lebel-sur-Quévillon, Quebec, Canada, March 17, 1978

Alexandre Larose, *brouillard #14*, 2013

FILMOGRAPHY

930, 2004-2006, 10 min., 16mm, b&w, sound
Artifices #1, 2007, 3.5 min., Super 8, colour, sound
Ville Marie, 2006-2009, 12.5 min., 16mm, colour, sound
La Grande Dame (étude), 2005–2011, 3 min., Super 8, b&w, silent
Rue de la Montagne, 2012, 2.5 min., 16mm, colour, silent
Sackville Marshwalk, 2013, 2.5 min., 16mm, colour, silent
brouillard #1, 2008, 5 min., 35mm, colour, sound
brouillard #5-13-2-12-6, 2011-2013, 6.5 min., 35mm, colour, silent
brouillard #14, 2013, 10 min., 35mm, colour, silent
brouillard #15, 2013, 10 min., 35mm, colour, silent
brouillard #16, 2014, 10 min., 35mm, colour, silent
brouillard #19, 2015, 10 min., 35mm, colour, silent
scènes de ménage (études), 2013-2015, 7 min., 35mm, b&w/colour, sound
Saint Bathans Repetitions, 2016, 20 min., 16mm, colour, sound

For Montréal filmmaker **Alexandre Larose**, the camera's most magical, illusionistic properties support memorial explorations. His films have developed around spatial and environmental fascinations, and whether turning to urban architecture or the dirt pathways of a summer cottage, Larose's methods and strategies transform the scene, piling path upon path, stripping a train tunnel into graphic form, bending by speed of movement the registration of a cityscape upon a lens until it becomes a mass of shimmering lines.

Working in collaboration with engineer Ludovic Boily, Larose began to establish the dominant aesthetic themes and technological strategies of his work: symmetrical and blinking forms, the elasticization of time, separation of artist from instrument. In *930* (2004-2006), Larose transforms a CP train tunnel in Québec City into a dynamic, morphing Rorschach ink blot. Symmetrical waves of light course and gradually assume silhouettes. A portal—presumably the train tunnel—rapidly blinks between black-and-white. This gives way to a burst of light along a train track, which fluctuates like a great flame emanating out from a nearing horizon. The symmetrical distortions of *930* are reminiscent of the American filmmaker Pat O'Neill's *7362* (1967), a classic work of both structural and psychedelic filmmaking, named for the code number of the high-contrast film stock that O'Neill used. Larose is likewise using high-contrast film in his optically printed distortions and ruptures. Larose's printed images take on the aesthetics of ink-on-paper, and as the image departs into abstraction, the viewer's imagination is left to frame its fearful symmetries. A film of repeating parts, *930* is structured like a train track to return to its mysterious, blinking portal.

Larose's interests in symmetry and pattern persist even in films of vastly different technique, such as *La Grande Dame* (2005-2011), a film with no discernible image manipulation, in which skyscrapers, shot from fixed points on the ground, seem to become elastic and flexible, even as they retain an inescapable pattern. Likewise, the aspiration to abstraction persists in *Artifices #1* (2007), in which Larose's camera immediately establishes a clockwise rotation, as it aims out onto a city at night, zooming toward a distant, unclear horizon. This legible vista alternates with violent abstraction, composed in lines of light that are linked to the city view by colour and thickness and that are therefore recognizable as motion blurs, a smearing of light shaped by the curved surface of the lens, captured by speeding the camera's rotation. The blurs give symmetries, fully formed circles, lines of fine vibration, not unlike the Rorschach forms that had emerged from the abstract passages of *930*. In the final sequence of *Artifices #1*, the camera's carriage is revealed, in part, as the camera is aimed into a mirror and performs 360-degree rotations.

Even as it continues these themes, *Ville Marie* (2006-2009) represents a departure from pure structure. In it, strips of coloured light, receding to give perspective, flash across black. These give way to black-and-white images of spinning forms that suggest

skyscrapers, seen from ground level, spinning up toward a man perched at the preci-
pice of a rooftop (the man is Larose). As these images are recycled, they are tinted in
heavily saturated colours, which, by crossing each other, combine into new colours. The
film passes through a series of variations: the image of the man reappears as a tiled
mosaic; the skyscrapers coagulate as a simmering, granular, monochromatic field; and
finally, Larose's image combines in a series of rich, pulsating colours. At the end of
the film, Larose reveals the root image—he has dropped a camera from the roof of a
building—but he does so in reverse, the camera scaling up the building into his hands,
ending in self-portrait as he looks into the lens. Larose's first films were marked by a
transparency of gesture. In *Artifices #1* and *Ville Marie*, the machining act behind his
imagery is partially revealed. In both films, these acts remain strange: the mechanism
is still unclear (as in the distant reflection that closes *Artifices #1*) or has been further
obscured by form (as in the temporal reversal that ends *Ville Marie*).

The presence of the artist in *Ville Marie* announced an increasingly humanistic bent
to Larose's films, and in his next major work, he began to shift toward bodily rhythms,
of breathing and walking, as opposed to technologized rhythms. With the *brouillard*
series (2008-2015), Larose began a long-term project that elaborated upon a deceptively
simple act, of passing down a pathway at Larose's family cottage on Lac Saint-Charles,
flanked by bushes and trees, leading to a pier. For each film, Larose photographed the
same journey many times over itself in multiple exposures, directly to the same roll of
film prior to processing. The titular fog is produced through slight variations in both
the environment and Larose's actions, such as his speed and consistency of composition.
The earliest piece in the series, *brouillard #1*, is a prototype for what would follow. Shot
on Super 8, it is made of fewer exposures and has not yet settled fully in the familiar
environment of the rest of the series; it is instead shot mostly on a paved road, the
headlights of passing cars appearing in rounds. Like the latter parts of the series, the
same journey is travelled as to give the landscape an echo, and as with the rest of the
series, it ends at the edge of a lake.

Throughout the remainder of the series, the journey becomes consistent, as Larose
travels along the path to the pier. This landscape varies in saturations of light and
colour. By his multiple exposures, Larose deepens the shadows cast by the trees and
bushes, while the blue of the sky and water pales to the lush green of the path. The
work is spectral in its effect, the landscape taking on incorporeal aspects, phantom
traces of itself, an insistent reminder of Heraclitus's adage that "no man ever steps in
the same river twice, for it's not the same river and he's not the same man." The film is
also an absolute vision of physical reality, an illustration of the wide spectrum of light
and time upon this landscape, in an accumulation of brief intervals. Each time the pier
is approached, Lac Saint-Charles opens up before the camera; the camera leans down
to the water, and with it the distant hills seems to collapse, the landscape cast down

upon itself in multiple exposures. This is particularly pronounced in *brouillard #6*, as light refracted on water shimmers over the descending hillsides. In more recent parts, such as *brouillard #12* through *#15*, the density of exposures has gone further to embrace the spectral effect on the landscape, and the blurring of the trees and the land begins to distort them into new dimensions. In *brouillard #14*, Larose begins to integrate the human figure, in the form of a child who runs ahead on the path, and who will be seen again when the camera reaches its destination. This environment, revealed in extremely slow motion, has surrendered the presentness of earlier journeys, and is now fully realized as a monument to time.

 —SB

ARTHUR LIPSETT

Born Montréal, Quebec, Canada, May 13, 1936;
died Montréal, Quebec, Canada, May 1, 1986

Arthur Lipsett, *Very Nice, Very Nice*, 1961

FILMOGRAPHY

Very Nice, Very Nice, 1961, 7 min., 16mm, b&w, sound
Experimental Film, 1963, 27.5 min., 16mm, b&w, sound
21-87, 1964, 10 min., 16mm, b&w, sound
Free Fall, 1964, 9.5 min., 16mm, b&w, sound
A Trip Down Memory Lane, 1965, 12.5 min., 16mm, b&w, sound
Fluxes, 1968, 24 min., 16mm, b&w, sound
N-Zone, 1970, 45.5 min., 16mm, b&w, sound
Strange Codes, 1972, 23 min., 16mm, b&w, sound

Arthur Lipsett came of age through a combination of personal tragedy, as witness to his mother's suicide; social conditioning, as a regular target of anti-Semitism; and more general, widespread anxieties that came with the postwar era, the threat of atomic knowledge, and serving as an ear witness to the traumas of the Holocaust. His training in art began at the Montréal Museum of Fine Arts' School of Art and Design, under esteemed landscape painter Arthur Lismer, of Canada's Group of Seven. After graduating, Lipsett was enlisted into the animation division of the NFB. The first projects that Lipsett worked on were, like many of the NFB's short films of the era, citizenship propaganda and socio-historical portraits. His distinct, staccato editorial style gained the support of the board's producers, and he directed his first film, *Very Nice, Very Nice*, in 1961. Through the support of the NFB, Lipsett became a pioneer of found footage filmmaking. The form pre-existed his work in film by twenty years, beginning with Joseph Cornell's *Rose Hobart* (1936), but with few exceptions, found footage filmmaking was dormant until the late 1950s, when Bruce Conner in San Francisco and Lipsett in Montréal began to make films from found materials. Lipsett's work was distinguished by leading with its sound collage, following in the tradition of *musique concrète*. Lipsett's work balances sardonicism, gallows humour, and suffering humanism, characteristics that were for a time amenable to the social messages of the institution within which they were made.

Lipsett's work was often ambiguous in its meaning, beginning with his first film, *Very Nice, Very Nice* (1961), a film composed in large part of black-and-white still images of faces in crowds, photographs taken from *LIFE* Magazine, and ominous footage of mushroom clouds. The title recurs in motif, uttered on the soundtrack in the perfunctory, superficial style of show business, accompanied by a casual clap. On the soundtrack, Lipsett collages facile remarks and earnest pleas and reflections on the way of the world; they are edited so as to embrace contrasts, contradictions, disorientation, and the sudden turns of truncation and interruption, to an ambiguous end. These sounds, taken on their own, form complex associations and blunt rhythmic changes, gradually building in intensity. The image is largely illustrative; it also interacts with the soundtrack through texts that seem to conclude fragments of speech. For the most part, it is this illustrative mode that serves as messenger of the film's themes, steadily assembling the Family of Man, faces and figures joined through march rhythms, in crowds of faces seen in motion blurs fading into each other, merged and disintegrating in the fashion of the open crowd. It is to this point that the film develops its rhythmic sensibility. All percussive editing (hard cuts) is done to sound punctuations. Still images are further distorted and scenes respond to sound as illustrations or contradictions. The recurrent image of a mushroom cloud announces a fatal conclusion to all of this utterly human action, making explicit certain contradictions in the strange preachers of the soundtrack, and emphasizing the violence of the sound's dial-flipping truncations.

Very Nice, Very Nice put Lipsett in an enviable position at the NFB; the film received an Academy Award nomination, and at twenty-five, Lipsett had suddenly become one of the more celebrated filmmakers on staff. Lipsett's second film, *21-87* (1964), continued and extended his work in visual and sound collage. The subject matter spanned from the morbid (a skull, raw flesh, contorting human faces) to the comic oddity (a horse dunked into water at a fair; robotic arms pouring chemistry; a bizarre fashion show where elaborate eye shadow turns the models' faces into exaggerated masks), which together compose a menacing carnival. The human face is presented throughout, for the most part in unflattering poses, distorted, mouths agape, eyes staring, caught between seduction, paranoia, and hysteria. Much of the film deals in images of faces looking to the camera, through the camera, or staring off in another direction, wearing all manner of expressions. Lipsett's account of earthly misanthropy is met on his soundtrack by fragments of gospel music, voices speaking about the Book of Revelation, voices that condemn and plead. Scenes of Lipsett's own photography keep uneasy company with found materials. In one scene, presumably shot by Lipsett, men play with guns at a beach, and then play dead on the shore.

The apocalyptic tone of Arthur Lipsett's earlier films persisted thereafter, but that tone was no longer cushioned with moral implications. *Free Fall* (1964) begins with the sound of call-and-response gospel music, a structure that is steadily implicated in the film's editing. In the opening moments, the camera rushes to track, in close-up, the movements of an ant carrying food along the ground, and later, the camera repeats this frenzied motion across faces in a crowd and across leaves through which sunlight breaks. A visual system is formed out of call-and-response between disparate parts: these motion blurs, passing over animal, plant, and human life; still images, accommodating a variety of animal, plant, and human life; and representations, such as décollaged posters of stylized faces. The action is divided by caesuras: the probing face of an ape, the frozen gaze of a photographed face. These images are sustained on-screen, often in time with silence or with dissipating sound, as a counterpoint to Lipsett's more violent, kinetic camerawork.

A Trip Down Memory Lane (1965) is distinct from the work that precedes it in two ways: one, it features exclusively found materials, and two, it features sustained pairings of image and sound, albeit occasionally from disparate sources. Differing from any of Lipsett's preceding films, much of this footage includes sync-sound, in the form of direct address from filmed subjects, and it is not mediated by his sound collage strategies, such as rapid editing and truncation. As a result, entire scenes are allowed to play out, with some of their subjects rambling and stumbling through prepared statements. By description, this would place the work nearer to the comprehensible arrangements of the documentary, but the effect is an even greater alienation from dominant forms of filmmaking, giving it the impression of something raw, half-formed, and yet, a carefully

plotted whole. Still present are the comic and surreal juxtapositions; however, by his extended sync-sound passages, Lipsett allows an ordinary and unenhanced document to expose its own bizarre heart, as a labyrinth of loosely related ideas, never coalescing into lucid and didactic statement, and suggesting a brave new world, riddled with the beauty and terror of runaway fascinations.

By adopting a style of sustained, filmic marriages of picture and sound, Arthur Lipsett brought the work into closer relation with dominant documentary film form, even as it made his collaging act more odd, the rhythm less familiar, and the outcome of his sequencing far more bewildering. This style faded with *Fluxes* (1968), which was decidedly wilder in its sound collage than Lipsett's earliest films. Where *A Trip Down Memory Lane* had functioned as a survey-album of ephemera from before the Atomic Age, *Fluxes* is an act of transmutation, a patchwork of fragments that fluctuate, by "show magic," between spiritual and corporal understandings of experience. That "show magic" is, in part, Lipsett's editorial sequencing, de-contextualization, and image-sound opposition, and is met on-screen by footage of a wizard-comedian, who intermittently performs sleight-of-hand tricks and prop comedy. Apes, a recurring subject in earlier Lipsett films, form the central perspective on this dialogue between the cosmic and the earthbound: as the film begins, they are pressing buttons, serving as subjects in a lab experiment, and it is as if they are signalling the film sequences that follow; as the film ends, a monkey's head moves rapidly inside a glass helmet that reflects some indiscernible landscape, to the sounds of apocalyptic dialogue from the short-lived American science-fiction series *The Time Tunnel*, which announces that "our only morality is survival."

By 1970, Arthur Lipsett's status at the NFB had declined considerably. Reports suggest that the board producers had great difficulty understanding his proposals for films, and that by speaking of his films in experiential rather than didactic terms, he had alienated them. The NFB had supported his films when his formal innovations were readily comprehensible, and when they reflected prescriptive intentions and explicit meanings; but through the course of his "time capsules," *A Trip Down Memory Lane* and *Fluxes*, he had fallen from their graces. His eccentric disposition, which would, through the course of the decade, progress into a debilitating mental illness, further aggravated this disconnect between his motives as an artist and the mandate of the NFB. In 1970, he finished what would be his longest, strangest, and last film for the NFB. *N-Zone* (1970) was again a collage film, but it was a more personal undertaking than his prior works had been. It is Lipsett's first clear picture of his mature aesthetic beliefs, a work of wild and wide-ranging perceptual integrity, fastened against interpretation.

The film's soundtrack is composed of narration, sometimes repeating, with the characteristics of improvised speech; this, drawn from the casual conversations of Lipsett's friends, forms a spontaneous, stream-of-consciousness style reminiscent of Jack Kerouac's narration for *Pull My Daisy* (1959) and other artifacts of the beat generation.

This is collaged with found recordings, picture-synchronized sound (both incidental and spoken), and music, including a recording of a Peking opera that prominently, and surprisingly, features a piano. The image shifts between several types of footage. Lipsett and his friends, apparently a bit stoned, joke around in an apartment, at play, having discussions both personal and cosmic. At a tea party attended by a group of elderly men and women, the figures eat and turn through albums of photographs. Scattered throughout are scenes of Lipsett and his guests performing in various ways and fragmentary images invoking beasts, world politics, consumerism, nature, and religion (including a variety of Buddharupa). Toward the end of the film, there is a long sequence of re-photographed television signals, another marker of the mediated image. Masks and gag gifts in a joke shop anticipate a sequence in which a man dressed in a stylized paper skeleton costume dances for the camera. There is a logic to the sequencing, most strongly felt when an image of a zebra cuts to the graphic form of stripes, which are then revealed as the pattern of the lettering with which Lipsett spells out the film's title. Such associations run throughout.

What others at the NFB dismissed as incomprehensible can be easily comprehended within the context of the underground film, and of a rhythmic and ecstatic, rather than a persuasive, mode of filmmaking. Lipsett's film was distinct from those of his colleagues not only because of its rough-hewn assembly and its embrace of difficult modern aesthetics, its willingness to not merely depict, but to occupy contradictions. Through the integration of the party scenes and his found — and at this point highly symbolic — materials, *N-Zone* was simultaneously distant and intimate, public and private, a measured and logical, and yet occult and ritual, space. While Lipsett's earlier films could be accepted as critiques of Atomic Age consumer culture, *N-Zone*, with its personal content, its rambling, unfocused discussions, and its irreconcilable contradictions, represented a final point of maturation for Lipsett, a sign that his ambitions as an artist had outgrown his position at the NFB.

Arthur Lipsett's next and final film, *Strange Codes* (1972), was made in collaboration with Henry Zemel, and completed with a grant from the Canada Council for the Arts. In planning the film, he wrote that it "might be viewed as a game being constructed that could enable a human being to help make translations and connections from his inner world of feelings, to the world of day to day reality systems. [...] The film is operating at a midway point between the primitive ritualized world and the world of logic and science." But he concludes, turning back toward aesthetics and perception, that "perhaps it can be experienced, simply as a strange play." *Strange Codes* formed between ritual and calculation, placing the ecstatic vision of the primitive in relation to the sober fact of science.

Throughout the film, Lipsett performs a series of acts. Sometimes these acts repeat, slowly revealing a conscious arrangement of motifs. He performs as four figures: a Russian Cossack, a shaman, a Shriner, and the Monkey King of Chinese mythology —

a curious and arrogant rogue. In the guise of these various characters, Lipsett arranges objects, letters, and signs into sequences; examines collages and books; or does various things to either interfere with his assemblages or to put them to use. The content of the film oscillates between symbolic inquiry (he reads or studies), symbolic action (he arranges and performs), and symbolic resistance (in interplays, commentaries, and the games that he builds). Much of this action involves the collaging and contemplation of images and graphic forms drawn from ideograms, cosmograms, and other schema and charts. He magnifies Latin words on a roll of paper; he looks over a large collage that combines ornithological, anthropological, medical, and commercial images, with attention to Mr. Peanut; he turns the pages of a flipbook of the layers of the human face, planting symbols atop it. Throughout, he invokes compasses and timepieces and rotary charts for their imagistic and functional properties. In one of his oddest performances, he alternately rolls dice over an image of Nefertiti and places or draws the graphic forms of *vévés* or petipembas (symbols used in Vodoun and related religions of the African diaspora), on a large sheet of paper stretched out on the ground before him. There is no apparent correlation between his dice results and his drawings, but in between the two actions he seems to consult charts, his devotion pitched between that of an astrologer and a codebreaker, as if his dice rolls were throws of the *I Ching* and the *vévés* spelt his fortune.

At this stage of his filmmaking, Lipsett had set his gifts for sound collage aside and, by this, set aside his rhythmic sensibilities, his methods of shaping a film by an arc of energies and intensities. Once abandoned, these methods are remembered as ready pathways through his work to those closed meanings that had led it to be sanctioned and even celebrated. Lipsett's new minimalist approach, combining tableau and performance, demands the viewer to cut their own path through *Strange Codes*, a film dense with indefinable actions, enigmatic perspectives, and citations so individual to Lipsett that it becomes a coded self-portrait, a treatise on the act of questioning itself, from within and without.

By the time that Arthur Lipsett had made *N-Zone*, his superior mind and calling had at last allowed him to embrace mysteries and to damn explanation, had allowed him to approach that infinitude that takes root in great art. During his production of *Strange Codes*, Lipsett began to experience the signs of severe psychological distress and melancholy. Through the course of the next few years, he began work on two films, one in collaboration with Tanya Ballantyne Tree (*Blue and Orange*), the other a vignette for the National Film Board (*Traffic Signals*), neither of which was completed. Lipsett lived his final years in relative isolation, without a conventional creative outlet, under treatment of psychologists. He died by suicide in May 1986, by hanging himself in his apartment shortly before his fiftieth birthday.

—SB

JOSEPHINE MASSARELLA

Born Fondi, Italy, March 12, 1957; died Hamilton, Ontario, Canada, June 22, 2018

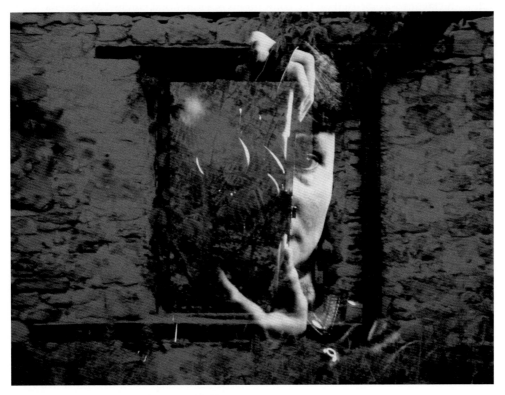

Josephine Massarella, *No. 5 Reversal*, 1989

FILMOGRAPHY

One Woman Waiting, 1984, 8 min., 16mm, colour, sound
No. 5 Reversal, 1989, 9 min., 16mm, b&w, sound
Interference, 1990, 20 min., 16mm, b&w, sound
Green Dream, 1994, 23 min., 16mm, colour, sound
Night Stream, 1996, 12 min., 16mm, colour, sound
Light Study, 2013, 12 min., 16mm/video, colour/b&w, sound
No End, 2015, 6 min., video, colour, sound
165708, 2017, 7 min., 16mm/video, colour/b&w, sound

Josephine Massarella's filmmaking career is marked by a long break. She began to make films in the early 1980s while studying at the University of British Columbia. While the faculty was focused on the conventions of Hollywood cinema, Massarella was more interested in the formally and thematically radical work she encountered at the Pacific Cinematheque and Western Front. She was inspired by these experiences to explore alternative forms. After graduating, she completed a number of films, ranging from structural experiments to psychodramas, before taking a seventeen-year hiatus in Hamilton, Ontario. Returning to film in the five years prior to her death in 2018, Massarella completed three more films that narrowed and articulated the major concerns of her work.

The laconic tempo of the era's art cinema and performance video had made an impact on experimental film, and Massarella's first film, *One Woman Waiting* (1984), embraced this minimalism. Hypnotic and patient, the film seems in pursuit of a mirage as it begins on a long take of wind coursing through sand dunes. Actions play out entirely in this one shot, as, over the course of 8 minutes, a woman enters, paces, and sits; another woman enters, approaching on the distant horizon, finally face to face with the first, ending with them embracing and parting. The notion of a sheltering, supportive womanhood continued in her work, but it is only after her debut that Massarella began to assemble the forms that distinguished her: spoken text that is full of intimacy and longing, contrasts of wildlife and industry, and a violent, rhythmic pursuit of the dynamic heart of nature. *No. 5 Reversal* (1989) joins themes of wartime and alienation with scenes of female intimacy, factories and waterfalls, domiciles and ruins riddled by space and silence. On its soundtrack, radio dial-flipping, dramatic accounts of wartime, and Ruth Brown belting out "Teardrops from My Eyes" (1950) are combined to evoke the world of Massarella's parents a decade before her birth. This sense of a historical past is challenged by the appearance of Massarella herself, as a young woman, Bolex camera to her eye, filming her own reflection.

Green Dream (1994) declares Massarella's fascination with the natural world. It begins with rapid pixilation of fields and slow-motion images of waterfalls; this soon gives way to an interspersing of scenes from highways, an infant's face, seals frolicking on rocks. Throughout, sequences are divided by excerpts from a poem by Toni Sammons. A dominant technique emerges after several minutes, of pixilation divided by black frames, giving a stuttering rhythm to the roads and to a figure on a beach. This rapid stream of interlocking single frames soon turns to contrasts of fire and ice, of the infant's face and the roots of a tree; later, of plants; of portraits of women; of fish and factories; of ancient statues and the arrival of night. *Green Dream* signals the beginning of a more aggressive formalism in Massarella's films, concerned as it is with the capabilities of the Bolex camera and of the optical printer. In contrast to this defiantly formal work, Massarella

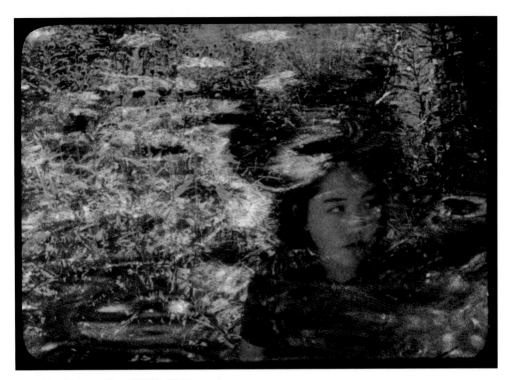

Josephine Massarella, *165708*, 2017

continued to make durational psychodramas in the vein of *One Woman Waiting*, with *Interference* (1990) and *Night Stream* (1996), the former a mostly silent character study of a woman typing and waiting for the day's mail in her apartment, the latter a balance of comic skits with occasional breaks into Massarella's stuttering pixilation. It was after *Night Stream* that Massarella took her hiatus from filmmaking.

Returning to filmmaking in the early 2010s, Massarella continued the frame alternation that she had begun with *Green Dream*. Her second wind began with *Light Study* (2013), in which a woman walks through a dense wilderness, images of her alternating with shots of flowers, butterflies, waterfalls. Massarella's fascination with pixilation continues, giving *Light Study* a vibrating energy. Midway through the film, the image shifts from brilliant colour to high-contrast black and white; the electronic score likewise shifts from calm sustain to quick and violent bleats as the pixilation becomes more fragmented, rapidly intercutting the movements of seabirds, the rush of a waterfall, and the stamens and pistils of flowers. That so much of the composition and imagery resembles both *Green Dream* and *No. 5 Reversal* indicates Massarella's dedication to her environment.

In spite of her love of nature, it is never sentimentalized; and as time has passed, her response to its sheer dynamic force, in her pixilated photography, has intensified.

In *No End* (2015), Massarella's only work to be shot in video, a young woman follows a forest path and discovers a book on the ground. The sequence that follows integrates on-screen text, a poem of grief and loss written by Massarella, with slow takes surveying waterfalls, rivers, fossils. While it is notably distinct from the dynamic forms of *Light Study*, *No End* shares common ground with *Green Dream* and the durational, dramatic work that Massarella had developed in the 1990s. It is, above all, an environmental portrait, with the young woman serving as witness to the environment and as heir to this book and its poetry.

Massarella's final film, *165708* (2017), takes its title from the serial number of her Bolex camera. It shares in many of the gestures in her earlier work: a woman walks in profile on a beach, flora and fauna are rapidly surveyed, all in a shimmering black and white. Single frames alternate; Massarella's new-found hybrid process, shooting with her Bolex and working with digital scans of her film, allow her to introduce digital tints, casting blue and red into images of waterlilies and bees on sunflowers. Another consequence of Massarella's work with video, is that her frame alternation is of heightened intensity, as the upper and lower fields of video compete along with the imagery. But for all of its formal trappings, thematic imagery remains at the forefront in *165708*, as this gesture that has repeated throughout Massarella's work—a lone woman passing through an environment—has, by its persistent recurrence, become less performative, has become the autobiographical core of the work. Her filmmaking began with an externalization of theme, with psychodramas of figures in states of crisis and contemplation. Although Massarella never again appeared on camera after *No. 5 Reversal*, it is difficult to imagine, in her enigmatic portraits of these women walking, anything but that image of her, filming her own reflection with her Bolex camera.

—SB

JOHN PORTER

Born Toronto, Ontario, Canada, August 5, 1948

SELECTED WORKS

Cinefuge (series), 1974-1981, 18.5 min., Super 8, colour, sound/silent
Santa Claus Parade, 1976, 4.5 min., Super 8, colour, silent
Landscape, 1977, 1 min., Super 8, colour, silent
Mother and Child, 1977, 2 min., Super 8, colour, silent
Amusement Park, 1978-1979, 6 min., Super 8, colour, silent
Firefly, 1980, 3.5 min., Super 8, colour, silent
Down on Me, 1980-1981, 4 min., Super 8, colour, silent
Scanning (series), 1981-2016, 27.5 min., Super 8, colour/b&w, sound/silent
Martha's Balloon Ride, 1982, 6 min., Super 8, colour, silent
Exams, 1982, 3.5 min., Super 8, colour, silent
Calendar Girl, 1981-88, 3.5 min., Super 8, colour, sound
Toy Catalogue (series), 1981-2010, 138 minutes, Super 8, colour, sound
Picture Pitcher, 1989, 4 min., super 8, colour, sound
The Secret of the Lost Tunnel, 1992, 3.5 min., Super 8, colour, sound
Pleading Art, 1989-1992, 3.5 min., Super 8, colour, sound
Shovelling Snow, 1992, 3.5 min., Super 8, colour, sound
The List of Bicycle Messenger, 1994, 4 min., Super 8, colour, sound
On the Street Where She Lived, 1995, 3.5 min., Super 8, colour, sound
Blade Sharpener, 1998, 3.5 min., Super 8, colour, sound
In the Gutter, 2000, 3.5 min., Super 8, colour, sound
City Hall Fire, 2005, 3.5 min., Super 8, colour, silent
Christmas Toy Lights Me, 2006, 3.5 min., Super 8, colour, silent
Light Sleeper, 2010-2011, 3.5 min., Super 8, colour, silent
Spadina Circle, 2014, 8 min., Super 8, colour, silent
Barred by Pleasure Dome, 2018, 3.5 min., Super 8, colour, silent

In the 1970s, **John Porter** emerged as a devoted advocate for the artistic possibilities of small-gauge filmmaking at a time when 8mm and Super 8 enjoyed little reverence in underground film communities. These formats were widely dismissed as amateur, for their long-standing affiliation with the home movie or as a format for sketches and minor, intimate works. Porter has been not only an activist, educator, and cheerleader for small-gauge film and filmmakers but a prolific maker of films in his own right, having completed more than three hundred films since 1968. These films are diverse in form and purpose, occasionally serving as documents of events and of his more idiosyncratic interests. Porter has also made films as collaborative performances—*Camera Dances*, as he calls them—between the filmmaker and the camera, with Porter serving as an on-camera subject partnered to the camera's automation and trickery. The performative aspects of Porter's work are not limited to documentation of his own on-camera performances: he integrates projector performance, live spoken accompaniment, and other forms of interactivity between himself, his work, and his audience. With the aid of a portable power unit and a portable screen harnessed to his own body, he has taken projector performances into the streets as a self-proclaimed "film busker." Further to this, Porter's films tend to focus on characteristics particular to the small-gauge camera: the ease of its inbuilt "tricks" (such as pixilation, variable frame rate, and the function of various accessories) as well as the light weight and portability of it. The bulk of his films embrace another trait of the format: the Super 8 cartridge holds fifty feet of film. Many of these films run the length of a cartridge and are made in-camera without editorial intervention. And they are primarily silent, although Porter has taken advantage of Super 8 sound film and of post-production sound-striping of Super 8.

Porter's body of work is of a formidable size, but much of it is concentrated in specific stylistic strands. Some works are formally grouped by the filmmaker as *Porter's Condensed Rituals*, time-lapsed films of events both focal (parades) and mundane (exams), made from an isolated vantage point ("single-shot film"). Others, such as the aforementioned *Camera Dances*, feature far greater interaction between filmmaker and camera. In *Firefly* (1980), Porter appears in the centre of the frame, swinging a bright light from a cord against a black background; through time-exposures, the light cuts streaks through the frame. In some of these *Camera Dances*, Porter tries to parallel aspects of the machine with his own actions. For instance, in *Shovelling Snow* (1992), he shovels snow along a street at a fast and steady pace, mechanizing himself and his scraping so as to be in-rhythm with the cartridge of Super 8 winding through the camera's gate.

The *Camera Dances* often maintain a centrifugal disposition: nowhere is this more clearly demonstrated than in works like the *Cinefuge* series (1974-1981), in which Porter spins the camera around himself by way of a long cord, keeping himself in the frame at all times as the camera veers around him. As his figure appears to spin clockwise and counter-clockwise, the background, a park with a clear horizon marked by trees,

Top to bottom:
John Porter, *Firefly*, 1980
John Porter, *Toy Catalogue*, 1981–2010

is blurred by the constant force of Porter's swinging. In *Down on Me* (1980-1981), shot in pixilation, Porter again serves as a focal point for the camera, as it looks down on him while being raised and lowered from roofs and bridges on a fishing line. The *Camera Dances* also include the *Scanning* series (1981-2016), in which Porter projects films of particular spatial movements—for example, following a beach ball as it's volleyed back and forth—and, moving the projector, mirrors the movements on screen.

Other films defy easy categorization, employing Porter's themes and techniques without fitting into a clear sequence or series. While *Martha's Balloon Ride* (1982), like the *Condensed Rituals*, uses a fixed position and time-lapse, from its fixed position it is set in motion: the camera is fastened to the top of a hot air balloon, mixing familiar Ontario topography (fields, houses, highways) with the antics of the balloon passengers who stretch out their hands and legs over the open air from a basket glimpsed at the top of the frame. Such exceptions clarify the themes of Porter's films, in their combination of performativity and centrifugal movements, but especially in their dedication to the characteristics distinct to the format and the instrument.

Porter has also made films that speak to his penchant for documentation, interactivity, and innocence, among them his *Toy Catalogue* (1981-2010), in which he shows his collections of plastic trinket toys and ephemera by spreading them out type-by-type and describing them. The social engagement of Porter's work is not limited to his ambassadorial attitude around 8mm and Super 8 film; central to many of his films are aspects of play and wonder that give his work an openness and invitation that is naive in contrast to

the dense, cryptic, decidedly mature forms and subjects common to experimental cinema. Many of Porter's films are social in another sense, having been made with friends (a number are co-authored with his collaborators, and many have friends performing or assisting), or with a particular exhibition circumstance in mind. For example, an entire body of his films (*Fifth Column Films*, 1983-1990) was made as visual accompaniment to Toronto new wave band the Fifth Column.

There are rare exceptions to the dominant aesthetics of Porter's films. For instance, in *Calendar Girl* (1981-1988), Porter uses his camera to make a Scopitone—a precursor to the music video—by filming his television set, edited to Neil Sedaka's title song. Porter scratches and paints on the resulting copy, scratching beams from Sedaka's eyes, blacking out the eyes of women models, connecting the scratched beams to the painted breasts of the models. The filmmaker's own annotation for the work explains that his "scratches and strokes exaggerate and comment on the sexism in 'music videos' of all generations." Another exception is *On the Street Where She Lived* (1995), in which Porter narrates the story of a bike ride he took with a friend in search of a girl's street in uptown Toronto, accompanied by snapshots, period memorabilia, and a map. These works fit neatly into discourses of experimental filmmaking, the "direct animation" film in the case of the former, the personal, memorial documentary in the latter, that are largely foreign to Porter's aesthetics. In the bulk of his work, Porter maintains an insistence upon minimalism, mechanism, and illusionism. In this, Porter's trick films continue the legacy of Georges Méliès and Segundo de Chomón's stage magic films.

John Porter's activism has placed him in dialogue with a number of controversies, with his resulting films serving as protests against censorship. This strain in Porter's work begins with his performance *Uncensored Movies* (1985), in which he interacts with the beam of a projector, casting shadows to create speculative cinematic events, a protest against the arbitrary targeting of media art by the Ontario Film Review Board (OFRB). Such protest continues in *Pleading Art* (1992), in which a paper puppet of Porter's likeness speaks against the OFRB. The film combines Porter's long-take style and his fascination with puppetry and toys with his challenge to the province's censors. While the bulk of Porter's challenges were put to the OFRB, he would later make another film, *Barred by Pleasure Dome* (2018), to commemorate a protest he staged to picket a Toronto film exhibitor who had banned him from attendance. Porter's defiance against censors and opaque discourse is consistent with the freedom he has found in the Super 8 reel. For all the complex staging and stylish illusions he employs, Porter's films maintain a steady, honest shape that begins with the fact of a fifty-foot Super 8 cartridge.

—SB

IZABELLA PRUSKA-OLDENHOF

Born Wałbrzych, Poland, February 12, 1974

Izabella Pruska-Oldenhof, *The Garden of Earthly Delights*, 2008

FILMOGRAPHY

my I's, 1997, 9.5 min., video, colour, sound
Vibrant Marvels, 2000, 22 min., 16mm, colour, sound
Light Magic, 2001, 4.5 min., 16mm, colour, sound
Song of the Firefly, 2002, 5 min., 16mm, colour, sound
her carnal longings, 2003, 9 min., 16mm, colour, sound
Scintillating Flesh, 2003, 6 min., 16mm, colour, silent
sea-ing, 2004, 1 min., 35mm, colour, silent
fugitive l(i)ght, 2005, 10.5 min., 16mm, colour, sound
Echo, 2007, 9.5 min., 16mm, colour, sound
Pulsions, 2007, 9.5 min., 16mm, colour, sound
The Garden of Earthly Delights, 2008, 8 min., 16mm, colour, silent
This Town of Toronto..., 2012, 4 min., 16mm, colour, silent
Font Màgica, 2015, 6 min., 16mm, colour, sound
Relics of Lumen, 2016, 12 min., video, colour, sound

Izabella Pruska-Oldenhof's films combine ecstatic formal inquiry with memorial and autobiographical themes. She has often emphasized the minutiae of close-up photography; the aggressive rhythmic punctuations of discreet, densely laid frames; and a summoning of phantasmal shadows, be they cast from one film strip to another (photograms are prominent in her early work) or found in the strange and vivid colours that she has often synthesized by digital means. Complementing her filmmaking with art historical scholarship, she situates her work in relation to surrealism, her interest in cinema being the creation of seamless worlds, an assemblage that takes as its heart phenomena of the natural world—in her editing, the skin and flesh of human and plant become pliable canvas, interwoven in a complex collage. In addition to her work as an artist and scholar, Pruska-Oldenhof is a professor and a community organizer, as co-founder of the Loop Collective, a Toronto experimental media art collective that has counted among its members several of her collaborators, including Greg Boa and Colin Clark, sound artists with whom she frequently works.

In the late 1990s, as an undergraduate student at Ryerson University, Pruska-Oldenhof began in an autobiographical mode with *my I's* (1997), a film made from home movies of the filmmaker as a child in Poland. In it, she runs along a dirt road, crouching in a pose for the camera, in an image that repeats as lapping waves swell on the soundtrack. This and other scenes of Pruska-Oldenhof as a child are held in contrast to her image as a grown woman, and her countenance, suspended in a still frame, oversees the proceedings. The images bleed together; they are overwhelmed by the shimmering refraction of light on water, and the lights of a church's interior, a chandelier, candlelight. Throughout, the filmmaker returns to images of nature—of birds in flight, of treetops—and holds these scenes in contrast to a modern city, its congestion seen both in wide surveying shots and on the ground level. In the final moments, Pruska-Oldenhof as a child dances in a field with her mother, as the porous montage becomes more complex, mixing together images of present and past, of light remembered and of light tirelessly modulated by kaleidoscopes, digital trails, and the natural mask of a canopy of leaves. The autobiographical traits of *my I's* do not overwhelm its formal exploration, nor can they be divided from the filmmaker's material contemplation.

Pruska-Oldenhof followed this with *Vibrant Marvels* (2000), a film that applied the formal explorations announced in *my I's* to images of the body, and which began her long engagement with the body as a subject and her involvement in the tradition of "cine dance." The hybrid modulations of *Vibrant Marvels*, the relation between its 16mm film source and finishing materials, and the digital compositing the filmmaker has performed at an intermediate stage, likewise declare a persistent method that will later assume a significant focus in Pruska-Oldenhof's process.

In the years immediately following *Vibrant Marvels*, Pruska-Oldenhof focused on porous and abstract forms achieved by re-photography, primarily through the act of

photogramming. Her first films had been wild in their forms, specifically in their dense abundance of representational imagery and their adventures in colour and texture; with *Light Magic* (2001) and *Song of the Firefly* (2002), Pruska-Oldenhof began to pursue cameraless means to develop rhythmic tensions and resolutions. What representational imagery exists in these films enters into them by way of the physical materials the filmmaker has laid upon the film strip—in *Light Magic*, there are flies, feathers, leaves, and soon there is an intense overlapping of these forms, tinted by glass to blue, gold, and pink. In *Song of the Firefly*, the only forms at play are plants, and the colours are stripped down to a gilded yellow-green, an evocation of the titular, luminescent insect. The violent entanglement of abstract, yet consistently organic forms casts an erotic charge through the latter film, which the filmmaker has described as recreating "the open field at night where sexual energy is transformed into light by these tiny insects."

This eroticism of this text was tuned again to the body in a sequence of films made by Pruska-Oldenhof between 2003 and 2008, beginning with *her carnal longings* and *Scintillating Flesh* (both 2003). In *her carnal longings*, nudes are filmed in extreme closeups, lending some mystery and ambiguity to their forms as the camera explores the stratum corneum, hair follicles, gooseflesh, pores. As it does so, the film is violently distressed, showing its own skin and scars as its emulsion peels up, and the smudged, creased, and veiling surface of the image draws parallels with the body. In *Scintillating Flesh*, Pruska-Oldenhof films herself, naked, in a darkened room, using a flashlight for illumination. The elements of a solitary self-portrait are given mystical significance by the process that follows, as she takes the resulting footage and imprints it through the photogram process. The final film is a blazing pink union between the filmmaker's body and her film, in her words, "a self-portrait, where the filmmaker is not so much its subject (content) but becomes equally its form."

With *fugitive l(i)ght* (2005), these explorations of the body on film take a decidedly retrospective turn, with the filmmaker taking as her central subject a series of early film recordings of Loïe Fuller's serpentine dances, performed by Fuller's imitators, that use layers of fabric to create illusory dramatic blooms of colour, evolving out of common movement an impossible transformation of the figure into pure colour. Pruska-Oldenhof has taken these early films, by Edison and the Lumière brothers, and applied her processes to simultaneously embrace the joyous abandon of Fuller's core gesture; to recreate wild vagaries of colour and light that were impossible in the root films (which pre-exist colour film and use hand-painting to synthesize the serpentine dance); and to isolate the flows and folds of the dress so that the act becomes further illusory, suggesting organic forms of nature.

A companion piece to *fugitive l(i)ght*, *Pulsions* (2007), uses underwater photography, photograms, and digital compositing to explore the interplay among natural elements: the body, insects, water, birds. *Pulsions* resumes the dense fusion of forms present in

Izabella Pruska-Oldenhof, *Pulsions*, 2007

Pruska-Oldenhof's earliest films, and like Fuller, the filmmaker achieves wild, impossible collisions of colour. Where much of her work in the 2000s had been restrained by a dominance of black and a spareness of forms, here the work has become bright in its vision, rapid in its editing. Pruska-Oldenhof's explorations of the historical collisions of artists, light, and colour continue in *Font Màgica* (2015), a rumination on the light fountains of the early twentieth century that extends the filmmaker's interests in light, water, and colour, but now breaking from the organic curve and shifting instead toward splintering, fractal patterns.

Pruska-Oldenhof's work with the body as subject continues in *The Garden of Earthly Delights* (2008), in which erotic nudes, filmed with a slow shutter so that the bodies seem to cast vibrant trails of light, combine with rapid images of insects, snails, flora and fauna, fish, and waves reflecting light. *The Garden of Earthly Delights* is an ultimate work for Pruska-Oldenhof, a culmination of the fascinations of her body films, the parallels she had established between the body and film, the body as a fount of light energy. And the body becomes especially miraculous here for not merely its parallels to forms found

elsewhere in nature, but for its implication in all of those forms: that bodily movement and erotic union do not merely resemble the external world but draw from a common life force.

While much of her work deals with the body and charts an evolving relationship to the self, Pruska-Oldenhof explicitly revisits the autobiographical themes of *my I's* with *Echo* (2007). In *Echo*, the filmmaker mouths the words to "Polskie kwiaty" ("Polish Flowers") a song of immigration, sung to hold the flowers of Poland in the memory of those called from home. The three-part structure of the film is built around repetitions of the song: first, in the silent rendition mouthed by the filmmaker, interspersed with motion blurs of the Polish countryside and of flowers; second, sung by the filmmaker, aged ten, on the soundtrack, without visual accompaniment; and finally, translated by the filmmaker and appearing as spare white, handwritten text against black. Although Pruska-Oldenhof's films had been deeply intimate, in their explorations of the body and sensuality, *Echo* reminds us of the primacy of personal experience in her films. It also signals a strain in her work that returns to the memorial and mournful traits of *my I's*. It was followed by *This Town of Toronto...* (2012), a city symphony in miniature, a reflection on the city's past through archival materials gathered from provincial archives, interwoven with the filmmaker's contemporary photography as her small acts of witness signal the continuing life of the city.

—SB

AL RAZUTIS

Born Bamberg, Bavaria, Germany, April 28, 1946

SELECTED WORKS

2 X 2, 1967-1968, 17 min., 16mm (double screen), colour, sound
Black Angel Flag…Eat, 1967-1968, 12 min., 16mm, colour, silent
Sircus Show Fyre, 1968, 9 min., 16mm, colour, sound
AAEON, 1968-1970, 24 min., 16mm, colour, sound
98.3 KHz: (Bridge at Electrical Storm), 1973, 13 min., 16mm, colour, sound
Vortex, 1972, 14 min., 16mm, colour, sound
The Moon at Evernight…, 1973, 9 min., 16mm, colour, sound
Le Voyage, 1973, 7 min., 16mm, sound, colour
Melies Catalogue, 1973, 8 min., 16mm, colour, silent
Sequels in Transfigured Time, 1976, 14 min., 16mm, colour, sound
Egypte, 1976, 12 min., 16mm, colour, sound
Lumière's Train (Arriving at the Station), 1979, 9 min., 16mm, b&w, sound
A Message From Our Sponsor, 1979, 9 min., 16mm, colour, sound
Ghost: Image, 1976-1979, 12 min., 16mm, b&w, sound
Excerpt from MS: The Beast, 1976-1981, 28 min., 16mm, colour, sound
Motel Row (series), 1980-1982, 27 min., 16mm, colour, sound
O Kanada!, 1982, 5 min., 16mm, colour, sound
For Artaud, 1982, 10 min., 16mm, colour, sound
Photo Spot / Terminal Cityscapes, 1983, 10 min., 16mm, colour, sound
Exiles, 1983, 10 min., 16mm, colour, sound
The Lonesome Death of Leroy Brown, 1983, 25 min., 16mm, colour, sound
Amerika, 1972-1983, 170 min., 16mm, colour, sound
Storming the Winter Palace, 1984, 16 min., 16mm, colour, sound
Visual Essays: Origins of Film, 1973-1984, 68 min., 16mm, colour/b&w, sound
Ghosts in the Machine, 1994-1996, 22 min., video, colour, sound

In 1968, after completing graduate studies in nuclear physics at the University of California, Davis, **Al Razutis** moved to Canada and settled in Vancouver. In the years before he arrived, there were great soundings of an interdisciplinary art movement in the city through the founding of the Intermedia collective. Inspired by the writings of Canadian philosopher Marshall McLuhan, the transformative power of the 1963 Vancouver Poetry Conference, and a new-found access to platforms and funding, an emerging generation of Vancouver artists pursued music, dance, cinema, and photography, often in collision or at least in dialogue. Razutis's sensibilities complemented that scene and his arrival invigorated it. His engagement with moving images consistently straddled photochemical and televisual forms from the early 1970s onward, but even earlier his films had invoked the psychedelic forms that a great deal of his contemporaries in the American West Coast avant-garde film scene, such as Jerry Abrams and Scott Bartlett, had discovered in their experimentation with optical printers. Razutis's work went yet further in his engagement with video synthesizers, developing media hybrids. He was an early proponent of the film-video hybrid, and his work in that area suggests an interpolation of the two aesthetics: an enhancement of the inherent traits of cinema (its inscription of light, the discretion of the frame) with video synthesis and compositing. In turn, the film image provided a signal-source full of data for video's exploitation.

As a masterful engineer of home-brew audiovisual technology, a shepherd of western Canada's media arts scene, a prolific maker of films and videos, and an engaged commentator on the work of his peers, Razutis had a leading role as a mentor to a generation of western Canadian filmmakers. This was formalized through his faculty appointment at Simon Fraser University in the 1980s. His leadership was further demonstrated in his work as publisher of the avant-garde magazine *Opsis*. Razutis's adversarial experiences with the critical climate of Canadian art, and a specific confrontation over obscenity accusations in Ontario in the early 1980s, furthered his outspoken beliefs that a true avant-garde could not be achieved within an institutional framework. Throughout the 1980s, he made moving image and performance work that challenged perceived abuses of authority in the Canadian experimental film community. The strength of his convictions eventually led to his resigning from his faculty position and moving away from Vancouver, first to Los Angeles, and then to British Columbia's Gulf Islands.

By the mid-1980s, a number of major shifts occurred for Razutis: as he was developing performative rejections of the discourse of Canadian art, he was also gravitating away from cinema and toward holography. Around this time, he completed two cycles, into which the bulk of his films are collected. The first, *Amerika* (1972-1983), was created, according to the filmmaker, "as a mosaic that expresses the various sensations, myths, landscapes of the industrialized Western culture through the eyes of media-anarchism and avant-garde film techniques." In the second, *Visual Essays: Origins of Film* (1973-1984),

Al Razutis, *98.3 KHz: (Bridge at Electrical Storm)*, 1973

Razutis revisits work from the origins of cinema, such as that of Georges Méliès, the Lumière brothers, Sergei Eisenstein, and Antonin Artaud; the filmmaker describes his second cycle as an attempt to reconstruct the vision of "cinematic creation occurring in the minds of cinema's primitives."

The films that compose *Amerika* are distinct from those of *Visual Essays* in their attention to lived experience, in the present tense, transmuted through video synthesis into something visionary, confrontational, and tangential. In works such as *98.3 KHz: (Bridge at Electrical Storm)* (1973) and *Cities of Eden* (1976), Razutis introduces a bas-relief effect that separates objects from background, carves out shadows as fissures, and combines this with colour to give *98.3 KHz* an iridescent, polychromatic character and *Cities of Eden* a sepia cast that gradually becomes, in the filmmaker's words, "fiery infernos of image and destruction." *98.3 KHz* is an essential example of Razutis's film-video hybrid technique: as the filmmaker crosses the San Francisco–Oakland Bay Bridge, it seems to melt, and the sky to shimmer with electricity, a visualization of the gathering energy of radio waves around the bridge as a kind of antenna. This film becomes a structuring element in *Amerika*, repeating throughout in variations. Elsewhere in *Amerika*, Razutis's approach ranges from video synthesis to conceptualism. *Vortex* (1972) uses video synthesis and feedback to achieve unnatural collisions of colour assembling around cosmic and water imagery. Works such as *A Message from Our Sponsor* (1979) and *The Wildwest Show* (1980) use found imagery to emphasize the disingenuous and fraudulent character of commercial media, fetishization, and runaway consumption. The *Refrain(s)* (1982-1983)

are interstitial works that lampoon popular film analysis of the era through a contrast between a vaudevillian comedy soundtrack and the central figure, an unresponsive ventriloquist's dummy of Bozo the Clown seen in medium close-up. Another work that makes interstitial appearances within *Amerika* is the *Motel Row* series, in which the cavernous, graffitied ruins of concrete buildings become a necropolis; the strips of Las Vegas and Reno expose themselves as ultimate expressions of eros and capital in the electronic mediascape; and decaying amusement parks are recast in photo-negative as shadow-memories of a vanished Eden.

In comparison to *Amerika*, the project of *Visual Essays: Origins of Film* is an interrogation of the medium itself, and Razutis's methods are of a structural bent that has its roots in an elasticization of the past. This stands most sharply in contrast to those episodes of *Amerika* that aim their satire at the fallacies of the present, but shares common ground with those episodes that espouse the vantage point of an angry, mournful future, that picture contemporary life in ruins and imagine it to be as unintelligible a mystery for that future as the pyramids are to the twentieth century (as in the *Motel Row* films). The series contains six films that reimagine the potential of cinema, and while Razutis casts these films, by their joining title, as essays, they remain principally experiential rather than analytic. The films span from the birth of the apparatus to the birth of intellectual montage.

The first is *Lumière's Train (Arriving at the Station)* (1979), in which that seminal arrival is disassembled into fragments, elasticized, and cast in photo-positive and, as its own shadow, in photo-negative. The legend of Méliès is invoked in *Melies Catalogue* (1973), in which stills from the magician-filmmaker's work are shown having burned through, enclosing and often obscuring their illusionism, and in *Sequels in Transfigured Time* (1974), in which portions of *A Trip to the Moon* (1902) are suspended as freeze-frames, slowly proceeding, cast in bas-relief and given staggered illumination. In *Ghost: Image* (1976-1979), Razutis uses Dadaist, Surrealist, and German Expressionist films, which in their root form extended the magical, illusionistic project of Méliès; Razutis expands the inherent fascination that many of these artists had for symmetry, using overlapping mirror images to suggest a Rorschach test. The final parts of *Visual Essays* deal with two masterful contributions to the visual rhetoric of cinema, and the first soundings that cinema was departing from the wildness and experimentation of those earliest progenitors: *For Artaud* (1982) occupies the close-up faces of Carl Theodor Dreyer's *The Passion of Joan of Arc* (1928) with sparkling fragments; and finally, *Storming the Winter Palace* (1984) fragments, inverts, and rearranges the Odessa Steps sequence from Eisenstein's *Battleship Potemkin* (1925), a sequence of visceral, enduring horror given added weight in Razutis's elastic treatment of time, reversing battles and victory marches.

—SB

DAVID RIMMER

Born Vancouver, British Columbia, Canada, January 20, 1942

SELECTED WORKS

Square Inch Field, 1968, 13 min., 16mm, colour, sound
Migration, 1969, 11 min., 16mm, colour, sound
Landscape, 1969, 8 min., 16mm, colour, silent
Surfacing on the Thames, 1970, 9 min., 16mm, b&w, silent
Variations on a Cellophane Wrapper, 1970, 8.5 min., 16mm, colour, sound
Treefall, 1970, 5 min., 16mm, colour, silent
Seashore, 1971, 10 min., 16mm, b&w, silent
Real Italian Pizza, 1971, 12 min., 16mm, colour, sound
Watching for the Queen, 1973, 11 min., 16mm, b&w, silent
Fracture, 1973, 10 min., 16mm, colour, sound
Canadian Pacific I & II, 1974-1975, 11 min., 16mm (double screen), colour, silent
Al Neil: A Portrait, 1979, 40 min., 16mm, colour, sound
Narrows Inlet, 1980, 10 min., 16mm, colour, silent
Bricolage, 1984, 11 min., 16mm, colour, sound
As Seen on TV, 1986, 15 min., 16mm, colour, sound
Divine Mannequin, 1989, 7 min., 16mm, colour, sound
Black Cat, White Cat It's a Good Cat if It Catches the Mouse, 1989, 35 min., colour, sound
Beaubourg Boogie Woogie, 1992, 5 min., 16mm, colour, sound
Local Knowledge, 1992, 33 min., 16mm, colour, sound
Under the Lizards (Pod Jaszczurami), 1994, 77 min., video, colour, sound
Codes of Conduct, 1997, 9 min., 16mm, colour, sound
Jack Wise—Language of the Brush, 1998, 45 min., video, colour, sound
An Eye for an Eye, 2003, 10 min., digital, colour, sound
Padayatra, 2005, 13.5 min., digital, colour, sound
Digital Psyche, 2007, 12 min., digital, colour, sound

A subtle and meticulous craftsman of observational and illusionistic films, **David Rimmer** began his work in the mid-1960s. He had studied economics and mathematics at the University of British Columbia, graduating in 1963, a watershed year for the local experimental arts scene: the year of the Vancouver Poetry Conference that introduced the poetics of Black Mountain College to a generation of Vancouver students. It was around that time that others in the West Coast scene began to establish Intermedia, a collective with an interest in staging multimedia happenings, and experimental cinema arrived in Vancouver. Rimmer, meanwhile, spent two years after graduating travelling throughout the world, and upon returning decided he was little interested in a career in business. At UBC, he had seen Stan Brakhage speak on the freedoms of vision afforded by cinema and, inspired, he decided to pursue filmmaking. His first films were observational documentaries made within the context of the national industry, with support from CBC producer Stan Fox.

By 1968, Rimmer had decided to follow the example of Brakhage wholeheartedly, making his first experimental films, *Square Inch Field* (1968), a psychedelic collage of images that declared a Buddhist sensibility of the oneness of all things, and *Migration* (1969), a vision of the western landscape, of organic matter and the cosmic forces acting upon them, and a survey of coastal phenomena overseen by a ghostly bird flashing its own shadow in photo-negative. Rimmer's interest in the environment as subject would prove an enduring theme in his work, continuing with *Landscape* (1969), a time-lapse of a Pacific coast mountain view that collapses 15 hours into 8 minutes, tracking changes of light, wind, and clouds; and *Blue Movie* (1970), in which images of rushing water and billowing clouds are reduced to two tones: blue and white.

Rimmer's development as an artist came through the social structure that had been developing in Vancouver in his absence, where many had embraced multimedia happenings that combined performance, live music, and projected images, and the Intermedia group had cultivated relationships with the Vancouver Art Gallery to host such events. In this context, Rimmer began to make projector performances using loops, performances that, like his first films, arose out of ecstatic communions of shared experience. Soon this brought him to a territory of self-reflexive filmmaking, his work increasingly engaged with found footage, the way in which images can be ordered and assembled, and how the persistence of a loop can give way to wild variations. This interest first becomes apparent in *Variations on a Cellophane Wrapper* (1970), which was made using a single, recycled black-and-white shot of a woman in a cellophane factory stretching out a sheet in front of the camera such that it becomes a canopy of streaming light. This image is looped, and with each successive loop it transforms, overlapping, between positive and negative, the light picking up colours by way of colour filters, the colours combining until the scene transforms into a totemic, psychedelic image; the

David Rimmer, *Surfacing on the Thames*, 1970

worker becomes many-armed, like Shiva, her face, arms, and the silhouette of her head incandescent with coloured light.

Rimmer went on to undertake similar, if more minimalistic, looping structures in *Treefall* and *The Dance* (both 1970). His subsequent films demonstrate a variety of film-time relationships, explored through the same principles and instruments but with a growing attention to material self-consciousness. For example, *Surfacing on the Thames* (1970) invites comparison to the meditations on light found in J.M.W. Turner's marine paintings. In Rimmer's film, the image, of a ship crossing the River Thames in front of the British Parliament, stutters a frame at a time, the frames slowly dissolving one frame into the next, advanced slowly by means of a viewing table from which they are being re-photographed. Rimmer used similar methods with *Watching for the Queen* (1973), albeit with careful calculation as to the time for which individual frames are held, slowly accelerating through a forty-eight-frame crowd shot, showing a sea of faces looking past and occasionally directly at the camera, taken from an antique newsreel.

The illusionistic aspect of Rimmer's work was evident in his manipulation of images through optical printing. In *Seashore* (1971), this mastery is displayed in stuttering rhythms, slow surveying pulses, and symmetries. Because of the influence of eastern

mysticism on Rimmer's work, symmetry is a special topic, coming as it does out of an awareness of mandalas, of symmetry within eastern art as a sign of resolution within an image. These notions, orientalist by contemporary standards, were a sincere, guiding, spiritual force in West Coast art in an era of cultural convergence. *Seashore* uses symmetry to generate a rough tableau, and to implicate that tableau in tropes of classical display. Rimmer employs a scene out of early cinema, showing women frolicking by a beach, with one standing off to the left, by a rock, partially obscured; a mirror image plays, the orientation flipped so that this figure is now to the right; finally, the two images play over each other, roughly, staggering, showing the edges of the frame, skipping in the gate, but such that this figure, in duplicate, frames the scene, a statue in motion casting solemn attention on the central action of the beach.

The patience of *Landscape* had been indicative of a durational fascination that periodically re-emerges in Rimmer's work. For example, in *Real Italian Pizza* (1971), scenes from eight months of sidewalk gatherings in front of a New York pizza parlour play out intermittently, in an observational style closer to social anthropology than to Rimmer's abstractionist impulses. *Canadian Pacific I* and *II* (1974 and 1975), a pair of films documenting the trains outside Rimmer's studio window, share more with *Landscape* than just an impulse toward environmental portraiture. Like *Landscape*, they were conceived to be shown in galleries, rear-projected into false frames, as landscape paintings in motion, enclosing the distance between new media and old media, a declaration of cinema as a fine art. The durational, minimalistic bent in Rimmer's work expands beyond the static one-shot film with *Narrows Inlet* (1980), filmed from the helm of a boat as a heavy fog lifts, slowly, scanning the log buoys that, in dark and fog, indicate the shoreline. These buoys come into vision through the fog, and their fading, in real time and by distance, gives them the presence of a mirage or an apparition. Once the fog lifts, the day is ordinary and its mystery recedes.

With the end of the 1970s, Rimmer's work broke in two directions. He began to make documentaries about art and artists, starting with *Al Neil: A Portrait* (1979), about the Vancouver free jazz pianist. This would lead him to later embrace video, and to make documentaries and performance films, such as *Black Cat, White Cat It's a Good Cat if It Catches the Mouse* (1989), a travelogue made in the People's Republic of China in the days leading up to the massacre at Tiananmen Square; *Under the Lizards (Pod Jaszczurami)* (1994), on the post-liberation Polish free jazz scene and its endurance under totalitarian oppression; and *Jack Wise—Language of the Brush* (1998), a portrait of the Canadian painter emphasizing the role of oriental calligraphy and mandalas in his work. At the same time, Rimmer continued his experimental short films, pursuing a strand of ornate, porous, comic illusionism. The mastery that Rimmer displayed in the 1960s was anchored in instruments and self-reflexivity, but the poetic dimensions of the work relied on the mystical suggestions of his imagery. While his work had developed

in the cool, clinical dimension of the American structural film, it was hard to shake the mystical, meditative, perceptual inquiries of *Square Inch Field* and *Migration*, qualities that had survived with subtlety through the course of his first loop films. That lingering spirituality had been met in his work with depth and a seriousness of tone. But the films Rimmer made in the 1980s revealed a humour that had been absent from much of that work.

Rimmer has described *Bricolage* (1984) as a deliberate parody of *Variations on a Cellophane Wrapper*, made exclusively from found materials: the film begins with looping found footage of a woman on an antique television saying, "Hello." This is followed by a scene of another woman removing her wooden leg as a party trick. The third and most substantial section of *Bricolage* comes from a film about juvenile delinquency: in this scene, a mob of teens has gathered outside a house, and their leader smashes a window with a hammer; a young man emerges from the house and strikes the leader in the face. As this scene is set to seamlessly loop (on an image of the hammer-wielding leader gathering his composure), the sound drifts until the smash of the window and the punch to the face have traded sounds — the glass breaking with a blunt thud and an "oof," the punch landing with the sound of shattering glass. In yet another act of complex symmetry, Rimmer has calculated with precision the distance of the two sounds and set them on a course of comic exchange. Throughout, a woman's face appears, overlaid with images of a collapsing stone wall; Rimmer uses the optical printer to flatten the sequence into a contrast of shifting colours, at first reduced to pink and white, adding fading and gradating colours along a range of blue, yellow, and red. *Bricolage* thus becomes a revisitation of *Variations on a Cellophane Wrapper*, but by setting up the sequence to follow these strange scenes of female objectification and macho confrontation, Rimmer has shifted away from self-reflexivity of the instrument, gesturing instead toward the ambiguous social meanings of his work.

Hints of social comment run through other films of Rimmer's from this time, for example, *As Seen on TV* (1986), for which Rimmer re-photographs scenes from a television screen with his 16mm camera and reworks the resulting image with film to exploit the distinct values of the televisual image. Shadows are blown out, replaced with glowing light; interlaced scan lines pulse; a dark, rolling horizontal line courses up and down the image throughout. While Rimmer had spent much of his first decade of filmmaking with single-shot films, the 1980s found him developing films with multiple sequences and motifs, and in *As Seen on TV*, the primary motif is a recurring image of a man laying on his side, masturbating with a comic stiffness of movement effected through optical manipulation.

Local Knowledge (1992) is a final stand for David Rimmer's ecstatic ecologist, an ultimate gesture that brings the Eastern mysticism of his earliest work in tune with the complex, omnibus structuralism and media hybridity he started to practice in the 1980s.

David Rimmer, *As Seen on TV*, 1986

He fluidly melds acts of visually scanning the landscape (British Columbia's Storm Bay) with synthesized geometries and re-photographed video, mixing the lyrical, exploratory aesthetics that he had first picked up a camera to practice; the stark, instrumental structuralism through which he had emerged in the early 1970s; and the possibilities of a videographic future. The film features frames within frames, re-photographed televisions, pixilated pans of lakes and mountain ranges, as if the folly of humankind is being weighed by a distant, clinical, non-human intelligence. Like *Migration, Local Knowledge* functions as a phenomenal catalogue of broadest comment, starting from marine terminology ("local knowledge" being what a skipper must know to navigate dangerous waters) but casting its eye to bullfighting, synchronized swimming, military executions, and a French lesson. It is an apocalyptic film, but its sense of the apocalypse is both terrifying and ridiculous, signalled by the repeating slow-motion explosion of a watermelon being shot to pieces.

In the early 2000s, Rimmer began to make digital works, explicit in their ties to Eastern spirituality (*An Eye for an Eye*, 2003; *Padayatra [Walking Meditation]*, 2005; *Digital Psyche*, 2007). After many years of working with found images, as well as manipulating

instruments like Bolex cameras, viewing tables, analytical projectors, and optical printers, Rimmer began to make images without a pre-existing photographic base, applying paint and chemistry directly to 35mm clear leader, scanning his results, manipulating them, and presenting them digitally. Such work had no precedent in Rimmer's filmmaking; while he had often engaged in vivid coloration, it was always effected through filters, bringing it nearer to the traditions of Op Art than to painterly abstraction, and the textures his filmmaking was associated with were those qualities that optical printing tends to draw out of an image: stillness, granularity, a slight softness, but never the brushstrokes and globules of paint and chemistry. Breaking out in this new direction in his sixties, he was following a line of non-objective vision tread by his first inspiration, Stan Brakhage. And as Brakhage had set out to do, Rimmer, with his painted film-video hybrids, chases a closed-eye vision, an inner vision, an experience of transcendence rooted in silent meditation and reflection.

—SB

DAÏCHI SAÏTO

Born Kashiwa, Japan, December 29, 1970

Daïchi Saïto, *Engram of Returning*, 2015

FILMOGRAPHY

Chiasmus, 2003, 8 min., 16mm, b&w, sound
Chasmic Dance, 2004, 6 min., 16mm, b&w, silent
Blind Alley Augury, 2006, 3 min., Super 8, colour, silent
All That Rises, 2007, 7 min., 16mm, colour, sound
Green Fuse, 2008, 3 min., Super 8, colour, silent
Trees of Syntax, Leaves of Axis, 2009, 10 min., 35mm, colour, sound
Field of View #1, 2009, 3 min., Super 8, colour, silent
Never a Foot Too Far, Even, 2012, 14 min., 16mm (double screen), colour, sound
Engram of Returning, 2015, 18.5 min., 35mm, colour, sound
earthearthearth, 2020, 30 min., 35mm, colour, sound

Since his earliest films, **Daïchi Saïto** has been concerned with the abstraction of figure and environment. He achieves this abstraction by way of fragmenting the composition, filming in or cropping the image to tight close-ups; by synthesizing currents of saturated colour to course through the image; and by editing or printing in staccato rhythms, with black used in rhythmic structuring, a visual rest. It is this abstraction that guides the co-penetration of form and subject in his work, which has simultaneously explored sensual engagement alongside the materiality of the film image. Saïto comes to film-making from a long history of engagement in the humanities: born in Japan, he studied philosophy in America and Hindi and Sanskrit in India before his arrival in Montréal, where he took up filmmaking. His experience in languages and philosophy has naturally guided his interests toward a poet's cinema, for which he has become a champion in Montréal, through his filmmaking, his mentorship of other filmmakers, and Double Negative, the collective he co-founded.

Saïto's first film, *Chiasmus* (2003), is in the tradition of experimental dance cinema, focused on the movements of a truncated figure seen in extreme close-up. The film announces a heightened sense of material self-consciousness in its structure. It begins with a projector's beam cast on a wall; the camera slowly approaches this and, in doing so, confirms the faint presence of image within the light; this is integrated with looming closeups of a stretching body in positive and negative, filmed so close as to give the curve of the spine or the flex of a thigh a certain ambiguity. Soon the body and its negative silhouette overtake the image, and a rhythmic intercutting of positive and negative follows. On the soundtrack, there is a confusion of mechanical sounds, like those of a projector or a camera, and distinctively human breathing—albeit breathing that loops in a mechanistic fashion. *Chiasmus* is a meditation on the nude, but it is also a meditation on the mysteries of the body and of movement; here the skin is a canvas for light, and truncation and obscurity in the composition can only deepen the mysteries of skin. The perfect black-and-white high contrast of *Chiasmus* continues with *Chasmic Dance* (2004), a film that is more violent in its editing and non-objective in its vision, but that shares *Chiasmus*'s affinity for interpolation of forms. Throughout, rigidly geometric and flexibly organic forms flit past in rhythm, the dominant black serving as a canvas for a riddling of these white forms. *Chasmic Dance* mirrors the rhythmic characteristics of much direct filmmaking—in which forms painted or photogrammed directly onto raw stock spread a subject across many continuous frames, forcing the eye to speculatively reassemble them. In Saïto's film, triangular forms seem to spread a course of action from one frame to another, broken by the intrusion of organic forms resembling petals and grass.

All That Rises (2007) marks the beginning of Saïto's work in colour filmmaking and his ongoing collaboration with violinist Malcolm Goldstein, whose staccato bursts and tense rests complement sensational interruptions of imagery. Saïto and Goldstein's parallel lines do not always align, and it is often in their misalignment that the film achieves its

greatest strengths, the image playing to silence, Goldstein's eruptions carrying through the visual rests. Saïto's imagery, described in his annotation as a "short walk in an alley-way," draws from refuse and infrastructure, steel fences and flowers, dead leaves and stray beams of light, a vivid blue sky, earth and pavement. The brief bursts that reveal these images, always in quick succession, are spaced out by long stretches of black. When they do appear, in rapid series, in obscuring compositions, they present as a stream of shifting textures and colours.

Trees of Syntax, Leaves of Axis (2009) continues Saïto's shift into colour filmmaking. While *All That Rises* had used rapid editing to effect colour fields and to synthesize an interaction among textures, here Saïto is effecting such interactions with static images that cross one another, that overlap in pulses, in fading bursts. The imagery is of trees and leaves and grass; the trunks of the trees become vertical mattes in the frame, and the fading in-and-out of images give these trunks an illusion of transparency, pulsing through to rich tapestries of leaves. Early in the film, colour casts of purple and blue seem to combine with verdant woods. As the film continues, the trunks assume more of the frame, and an increasing density of their black silhouettes drowns out the most dramatic colours. What remains is a spring green. As the colours again turn to unnatural casts of purple and gold, the imagery seems to smear vertically, as if the leaves are being tugged skyward. Once this gesture crescendos, the image begins to flicker more rapidly; the steady fading ceases, and it is instead proceeding in swift sequence, each frame revealing a new violent variation on the scene. The film reaches its most unnatural colour scheme as the trunks themselves turn a fiery red. Beneath this, Goldstein's violin sounds a repeating, grinding phrase, which elaborates through slackening and then regaining momentum like breath. *Trees of Syntax, Leaves of Axis* represents the arrival of a style of film printing that Saïto would employ over coming projects—the textures and unnatural coloration achieved by his optical printing. These methods would find direct continuity in *Never a Foot Too Far, Even* (2012), a double-screen film made using frames from kung fu movies.

Saïto's next film, *Engram of Returning* (2015), continues his interest in images of the natural world as fodder for material inquiry, and that search has turned towards the memorial properties and themes of cinema. For an annotation Saïto uses Robert Duncan's essay *Kopóltuš*, in which Duncan writes of the tension between contemplation of an experience ("image," "picture") and the act of reassembling such a thing from fragments. Saïto's film, made from found footage that has been magnified and cropped tightly, is again set against a repeating current of minimalistic music, this time by bass saxophonist Jason Sharp. Scenes of landscapes, seascapes, and sky are obscured in such a way as to suggest illusions. There are instances in which two layers, moving in contrary directions, simulate an altogether new landscape. Topographical photography is intercut with horizontal photography; shots taken from a moving car are held against

static landscapes. In fleeting glimpses, the landscape is upside down, occupying both the top and bottom of the frame. Here we encounter something of what Duncan suggests in his poem: a jigsaw of experience that might only linger in traces and sensations, the possibility of its reassembly left a burden unto us, its solution ambiguous. Saïto has retained the pulsing ellipsis that had driven his earlier work. Its use recalls *All That Rises*, in that the eye is given brief gasps of imagery to assemble into coherent representation, a task often made impossible by the layering and cropping of the image, a gesture that gives impossible colours and thick, impasto textures. These superimpositions also present us with glimpses of increasingly fantastic imagery: a tree, its leaves billowing in the wind, appears to be underwater; foamy waves striking a seashore seem to dwarf a distant row of palm trees.

If Saïto's earlier films had been preoccupied with earth and sky, he has shifted his elemental preoccupation to the sea, and much of the texture that he gathers is not only in the multiplication of the film's grain but also in the coursing of waves and the transcendent grace of things set afloat. In its final minutes, *Engram of Returning* resumes the painterly, inextricable collisions of brilliant colours that have become a familiar signature in Saïto's work, his blinkering forms drowning out the imagery. Whatever familiarity the landscape held, it is now defamiliarized and alien.

 —SB

MICHAEL SNOW

Born Toronto, Ontario, Canada, December 10, 1928

Michael Snow, *So Is This*, 1982

FILMOGRAPHY

A to Z, 1956, 7 min., 16mm, colour, silent
New York Eye and Ear Control, 1964, 34 min., 16mm, b&w, sound
Short Shave, 1965, 4 min., 16mm, b&w, sound
Wavelength, 1967, 45 min., 16mm, colour, sound
Standard Time, 1967, 8.5 min., 16mm, colour, sound
One Second in Montreal, 1969, 26 min., 16mm, b&w, silent
Dripping Water (with Joyce Wieland), 1969, 10 min., 16mm, b&w, sound
←→ or *Back and Forth*, 1969, 50 min., 16mm, colour, sound
Side Seat Paintings Slides Sound Film, 1970, 20 min., 16mm, colour, sound
La région centrale, 1971, 180 min., 16mm, colour, sound
Rameau's Nephew by Diderot (Thanx to Dennis Young) by Wilma Schoen, 1974, 270 min., 16mm,
 colour, sound
Breakfast (Table Top Dolly), 1976, 15 min., 16mm, colour, sound
Presents, 1981, 90 min., 16mm, colour, sound
So Is This, 1982, 43 min., 16mm, colour/b&w, silent
Seated Figures, 1988, 42 min., 16mm, colour, sound
See You Later/Au revoir, 1990, 17.5 min., 16mm, colour, sound
To Lavoisier, Who Died in the Reign of Terror, 1991, 53 min., 16mm, colour, sound
Prelude, 2000, 3.5 min., 35mm, colour, sound
The Living Room, 2000, 20 min., 16mm, colour, sound
**Corpus Callosum*, 2002, 92 min., 16mm, colour, sound
Triage (with Carl Brown), 2004, 30 min., 16mm (double screen), colour, sound
SSHTOORRTY, 2005, 20 min., 35mm, colour, sound
Reverberlin, 2006, 55 min., video, colour, sound
Puccini Conservato, 2008, 10 min., video, colour, sound
Cityscape, 2019, 10 min., IMAX, colour, sound

Michael Snow was born in Toronto in 1928, the son of an anglophone father—a civil engineer and surveyor—and a francophone mother who loved languages and music. Snow's dual heritage formed the bulk of his cultural experience and was complemented by a fascination with the senses. In Snow's words, "The two most important things in my life were that my father went blind when I was 15, and that my mother loved music." In his youth, Snow took up painting, drawing, writing, and music, but even then he did not set rigid divides between these pursuits, allowing the activity of one to inform another.

In his early twenties, Snow was hired by the firm Graphic Associates, an independent animation company founded by former NFB animators. At Graphic, Snow made his first film, *A to Z* (1956), an animated short that Snow describes as a "cross-hatched animated fantasy about nocturnal furniture love. Two chairs fuck." Snow made a number of short films in collaboration with Graphic co-workers, among them, Joyce Wieland (whom he would later marry), Graham Coughtry, Warren Collins: *Tea in the Afternoon*, *A Salt in the Park*, *Assault on Grenville Street*, and *Hamlet*. By 1960, Snow and his peers at Graphic were beginning to explore Neo-Dada and were featuring in local gallery shows of contemporary Canadian art. Snow wrote poems and texts sparingly, but one early text, "Title or Heading" (1961), served as a free-form statement of his ideas about art that included aphorisms, descriptive expressions, and lists of influences from Gustave Flaubert to Art Blakey. It was an inventory, a mode of speech, rife with enclosures and allusions, and it began with a statement of Snow's process that would declare the most enduring character of his work: "I make up the rules of a game, then I attempt to play it. / If I seem to be losing I change the rules."

In late 1960, Snow developed what would become the enduring sign of his work through the decade, a cardboard figure in the shape of a woman mid-stride. He would later write that this resulted after several years of "worrying about where the figure is or could be or would be." The Walking Woman, as he would call it, was first cut from cardboard, creating a positive-negative stencil that Snow used initially to reproduce the work, and as a model for later stencil reproductions of varying scale. The figure's contours remained fixed, or else elasticized in a consistent way, but it was cast on many surfaces—paper, wood, canvas, cardboard, even a car door—and in many media, including acrylic, enamel, ink, and spray and oil paints. It was a symbol synonymous with Snow and yet anonymous, an icon of marketing, manufacturing, and commercial culture, and was itself aware of these traits, assuming a semi-ironic presence within that culture.

In 1962, Snow and Wieland moved to New York, where they stayed through the remainder of the 1960s. In 1964, Snow was commissioned by Ten Centuries Concerts in Toronto to make a film, *New York Eye and Ear Control*, featuring a soundtrack of group improvisation. The film had elements of material self-consciousness uncommon even in avant-garde film at the time. In the film, the Walking Woman is moved from rustic, natural settings, shorelines and woodlands, to the city. The icon is insinuated into

Michael Snow, *Wavelength*, 1967

nature, on beaches and in forests, alternately standing upright and lying flat on the ground, obscured in trees, standing among rocks on the shore, and in one witty image, standing in water on the shoreline, walking on water. As the film ends, two figures, a Black man and White woman, are seen having sex, embracing nude, in a bed with white sheets. The Walking Woman has entered reality in the literal representation of the woman. And yet, the notion and function of that icon, as a positive-negative suggestion of form, one side black, the other white, is also present in the interplay of black-and-white forms, in skin tone but also in illumination and shadow, in all aspects of this final episode. This final sequence is at once image and theme, graphic form and realist form.

Snow's next film, *Wavelength* (1967), was shot in his studio loft on Canal Street. With it, he established a new approach to compositional and conceptual rules. His experiments were now becoming specific to film, its material being, its temporality, the boundaries of its picture plane, and the cinematographic apparatus itself. Snow began work on *Wavelength* in December 1966. As he described it, "I set up my camera at one end of my 80-foot loft and began shooting right to the other end," a gesture effected with a zoom lens. The camera was mounted at a high and wide angle, surveying the space; he

increased the focal length gradually, zooming in on a photograph of waves on the far wall until the photograph filled the whole frame. Its soundtrack is an electronic tone, a sine curve, one iteration of the titular wavelength, which like the zoom passes from its lowest pitch, fifty cycles per second, to its highest, 12,000 cycles per second, through the course of the film's length. Sound and image function as glissando, raising, narrowing, a contrast to the crescendo structure of a work that passes down a plotted path. Down the barrel of his lens, *Wavelength* becomes the apotheosis of film space and time: space and time become plastic material into which events can be inserted, in which spatial and temporal events, including brief intrusions of human activity, can echo and overlap, and where compositional values can be altered, in colour saturation, positive and negative interchange and a slow but unremitting plummet from first frame to last.

Back and Forth, or ←→ (1969) returned to an idea of space that Snow first arrived at with the original Walking Woman cardboard cut-out, the paired opposite, fitted puzzle pieces, the stencil and its fill. Almost all of the action in the film occurs within a ground-floor classroom, the door of which opens onto a summer day. Dramatic actions occur in the space, but throughout, the camera makes two movements repeating ad nauseam. The first, which forms the bulk of the film, is a back-and-forth pan bounded by the chalkboard and chairs to the left, windows to the right. For the second movement, the camera, now repositioned in front of a window, tilts rapidly, frenziedly, up and down, at the same high speed at which it had been panning. In the coda, Snow superimposes the results of the two motions, creating contrapuntal movement, a polyphony that, like *Wavelength*'s equivalences, ends in a mysterious simultaneity of movement and stasis, the shimmering mass of light.

After several years of splitting their time between Toronto and New York City, each maintaining studios in both cities through the late 1960s, Snow and Wieland gradually transitioned back to Canada, returning permanently in 1971. Wieland spent the better part of 1970 in Ottawa preparing a major exhibition of her work. For Snow, a return to Canada meant a new plain to test the physics of vision, a reflection on compositional space, the boundaries of horizon, and the absence in a landscape. His return to Canada was marked by the realization of a project he had developed over the course of two years, one that would literalize the remoteness of the structural film and would also serve as the supreme gesture of his conception of the lens as a tool for visual construction. *La région centrale* (1971) fulfilled Snow's informal suite of axial composition films, following *Standard Time* (made in his New York apartment, a film that spins like a record) and *Back and Forth* (with its ping-pong trajectory of vision). *La région centrale* offers a vision of Canada caught in an all-seeing, impossible eye, one that could at once encompass allusion to landscape art, modal incongruities, and a morphology in which shapes are stretched by lens and movement, coalescing in a harnessing of spirit, the mechanical eye a programmed ascent from the constricted, failing vision of man.

To find his "last wilderness on earth," Snow probed areas of familial significance to him, choosing between "the country north of Chicoutimi (my mother's birthplace) in Quebec," and an area where "in 1912 and 1914 my father was in surveying parties which mapped what are now partly the chief mining districts in Northern Ontario (Kapuskasing, Timmins)." The work would ultimately be shot in a wilderness 100 kilometres north of Sept-Îles, Quebec, an area reachable only by helicopter, which Snow would describe as "a mountaintop strewn with extraordinary boulders, it had some of the kinds of slopes I wanted and a long deep vista of mountains." By his choice of location, the film was attendant to Snow's ancestry, and it looked not only a generation back into the landscapes of his parents' youth but also to an undeveloped Canada, as it might have been seen by the first settlers of New France. Out of this encounter, not between man and wilderness but between machine and wilderness, the machine allows us, by its mediation, to "see as a planet does," to look out at that landscape from the varying curves of its spherical path.

With *La région centrale*, the mechanistic nature of Snow's greater project clarified its stance as to where the eye was, and what it was. It was not a human eye in any conventional sense, although his work conflated his viewer and his contraption, and it was not guided in its movement by human hands, as a metaphor for vision or a substitute sight. Instead, the lens was a tool for visual construction and entrapment. Repeating rhythmic figures, translated to camera movement, are not freeing. They entrap the spectator in restrictions of movement, like those inherent in any system of rhythm. *La région centrale* aspires to see as a planet does, but such vision is impossible; the nearest it comes is in the wild 360-degree fluctuations that cast the landscape as a thin cosmic strip, repeating, divided by sky. A vision of the world emptied of everything but form, *La région centrale* puts a challenge of endurance to its audience through its mechanical scrutiny. That this survey runs for 180 minutes is a testament to its mission, an absolute catalogue of this place and time.

The durational challenge, cataloguing, and material self-consciousness to which Snow's work had aspired through the late 1960s reached its apotheosis in *Rameau's Nephew by Diderot (Thanx to Dennis Young) by Wilma Schoen* (1974), a survey-investigation of all manifestations of sound in film, an exploration of the possibilities and relations of technology and content—with sound recording and playback—a total record of hearing to *La région centrale*'s total record of vision. *Rameau's Nephew* is composed of comic sketches in which figures perform scenes with sound as an active player: wordplay develops out of amateur readings of folksy speech and sloganeering; performers enact their scenes in spaces that change the nature of sound and hearing, for instance, inside an airplane; professional actors read their lines backward in a scene built around a fart. At one point, in a winking acknowledgement of a mainstream correlative, an LP of Beyond the Fringe performing their own comedy sketches plays on the soundtrack

at a variety of speeds. This episodic structure persists for the film's 4-hour duration, culminating in a house party at which philosophical conversations about sound and cinema mix with puns and pratfalls, a rebirth of the blunt smash that dominated the earliest sound comedies, in what Snow has called the "authentic 'talking picture.'"

Snow's subversion of cinematic rhetoric and the expectations surrounding narrative action continued with *Presents* (1981), a film in two parts: the first involves a drama unfolding on an artificial set, in which the players, a man and woman, must perform as the set moves around them. After a number of humorous disconnects between the dramatic scene that is playing out and the bizarre physicality of their performances in the swaying, mobile set, the camera, equipped with a Plexiglas cover, begins to drive into the set, crushing objects as it zooms through space. *Presents* becomes a comic response to the presumptions surrounding Snow's past structural frameworks, locking movement to a centre anchor (the camera's gaze around which the world—in this case, the set—must move, an idea with debts to *La région centrale* and "zooming" as a maniacal act (as per *Wavelength*). The second part of the film involves the camera moving across various scenes, often along patterns dictated by the content of the subject, its pathways, its bounce, its patterns and directions. Snow followed *Presents* with a number films through the course of the 1980s and early 1990s that explored the relationship between vision and action. In *So Is This* (1982) white lettering on black reveals a text, one word at a time, that becomes a communal interrogation of thought and meaning. In *Seated Figures* (1988) a camera mounted on a trailer hitch transforms earth and road into abstract forms, but also plays with the forms of attention it commands, using comic interruptions such as hands making shadow plays atop the image. And in *See You Later/Au Revoir* (1990), a simple and inconsequential gesture is expanded from 30 seconds to 18 minutes by use of a slow-motion camera.

Each of these films built upon the foundation laid by Snow's structural filmmaking that began with *Wavelength* and that became increasingly episodic from *Back and Forth* to *Presents*. With *Corpus Callosum* (2002), Snow created another ultimate work, one to occupy the spaces, in Snow's words, "between beginning and ending, between natural and artificial, between fiction and fact, between hearing and seeing, between 1956 and 2002." Bearing the episodic structure of *Rameau's Nephew*, *Corpus Callosum* found Snow working in new territory involving video compositing and an elasticization of forms made possible only by video. A series of tracking shots through an office space reveals increasingly elastic and comic forms. If *Wavelength* was a reflection of the artist's own nervous system, *Corpus Callosum* represents a totally artificial nervous system effected by electronic and digital means joining with the artist. This culminates in a return to Snow's origins in animation, as the camera eventually ends up in a movie theatre showing an early animation by him, with Snow's primary critical respondent, P. Adams Sitney, in the audience. It collapses half a century of distance into a new container.

Michael Snow, *Corpus Callosum, 2002

Following *Corpus Callosum, Snow's output as a filmmaker has included remixes (*WVLNT* [2003], a 15-minute version of *Wavelength*), collaborations (*Triage* [2004] with Carl Brown), performance documentation (*Reverberlin* [2006], an hour-long tape of a performance by CCMC, an experimental music trio featuring Snow, poet Paul Dutton, and visual and sound artist John Oswald). *SSHTOORRTY* (2005), expanding on the formal subversion of drama found in *See You Later/Au Revoir*, is a dramatic scene between three players that appears in superimposition, eliminating the traditional structures of a short story. Following *SSHTOORRTY*, Snow made a number of video projects (*Reverberlin*, *Puccini Conservato*) in conjunction with his ongoing sculptural and installation work, but he did not resume working with film until fourteen years later, with *Cityscape* (2019), commissioned by IMAX and made using IMAX's large-format motion picture film, in which a rotating image of the Toronto skyline is captured from the Toronto Islands. *Cityscape* revisits Snow's efforts in *La région centrale* to subvert the horizontal default of landscape art. Such an act declares an enduring commitment in Snow's work to interrogating the depth and orientation of vision, and his specific commitment to filmmaking as a tool for visual construction.

—SB

BARBARA STERNBERG

Born Toronto, Ontario, Canada, March 24, 1945

SELECTED WORKS

Opus 40, 1979, 14.5 min., Super 8/16mm, colour, sound
Transitions, 1982, 11.5 min., 16mm, colour, sound
A Trilogy, 1985, 46 min., 16mm, colour, sound
Tending Towards the Horizontal, 1989, 32.5 min., 16mm, colour, sound
At Present, 1990, 17 min., 16mm, colour, sound
Through and Through, 1992, 63 min., 16mm, colour, sound
Beating, 1995, 64 min., 16mm, colour, sound
What Do You Fear?, 1996, 5.5 min., 16mm/video, colour, sound
midst, 1997, 70 min., 16mm, colour, silent
C'est la vie, 1996, 10 min., 16mm, sound
Like a Dream that Vanishes, 2000, 41 min., 16mm, colour, sound
Burning, 2002, 7 min., 16mm, colour, silent
Surfacing, 2004, 10.5 min., 16mm, colour, sound
Praise, 2005, 24.5 min., 16mm, b&w, silent
Once, 2007, 5 min., 16mm, b&w, sound
Time Being I–VI (series), 2007-2014, 9.5 min., 16mm, colour, silent
After Nature, 2008, 10.5 min., 16mm, colour/b&w, sound
Beginning and Ending, 2008, 6 min., 16mm, colour/b&w, silent
In the Nature of Things, 2011, 44 min., 16mm, colour, sound
Far From, 2014, 17 min., 16mm, colour, sound
LOVE ME, 2014, 7 min., 16mm, colour, silent
COLOUR THEORY, 2014, 4.5 min., 16mm, colour, silent
The Earth in the Sea, 2017, 8 min., Super 8/digital, colour, sound
Untitled #1 (sun vision), 2019, 40 min., 16mm, colour, silent
Anything is Everything, 2019, 23.5 min., 16mm, colour, silent

Barbara Sternberg's earliest interests in making art developed from familial gift culture, first as a child creating handmade books for her family. Her interest in making films began from a similar impulse, in the late 1960s, shooting a "home movie" as a gift for her husband at the time, who had grown up without family records of the sort. From this origin point, Sternberg's filmmaking was always intimate, interior, and romantic in a manner that sharply distinguished it from mainstream filmmaking and from the clinical tone of much of the structural filmmaking that occupied her generation. She decided to formally study filmmaking at Ryerson Polytechnic Institute in Toronto in the early 1970s. The college's film program was known then for having an industrial focus, which had drawn Sternberg to it as, at the time, she wanted to make educational television. Her early films include *The Good Times* (1973-1974) and *(A) Story* (1975), both of which invoke her family's experiences as refugees from war and as storytellers of an Old World sensibility. This interest in history and lived experience would linger and reappear in her later work, albeit in increasingly plastic ways.

Shortly after graduating from Ryerson, Sternberg moved to New Brunswick, where she would live for nine years before returning to Toronto, and where she would make her first mature film, *Opus 40* (1979). *Opus 40* would serve as a marker of many of the themes she would go on to pursue; it retains Sternberg's interest in documentation, in its choice of subject and its non-interventionist approach to witnessing that subject (a team of moulders) in action, using this material to craft a filmic experience of repetition. Where the film diverges from documentary form is in Sternberg's exploration of multiplicity and cyclical repetition by means of a split screen, divided by a horizontal line, with the image vertically stacked. The daily rhythms of work in this Sackville foundry are met by the repetitive articulation of Gertrude Stein's *The Making of Americans*, read on the soundtrack by a voice that ebbs in and out, occasionally overtaken by the sounds of the factory. The mechanical sound of a projector draws attention to Sternberg's own labours, implicating filmmaking as a repetitive labour and indicating the forms of repetition built into its apparatus.

Sternberg's split-screen technique extends the complexity of the film's attention to repetition. In its conclusion, the rigid split-screen divisions break down further, as does time; the actions of the workers speed up, and the vertically stacked images begin to overlap in superimpositions. Sternberg extended a number of these techniques in *Transitions* (1982). Where *Opus 40* employed her polyphonic sensibilities (overlapping sounds, repetitions of image and sound, and multiplicity of image) to offer a formal parallel to the repetitive tasks of labour, *Transitions* is decidedly domestic in its vision, much of the composition focused on a woman tossing in bed, similarly possessed by repetition. Against this scene, dense layers of image feature the same figure in her waking hours, the layering an analog to the mind processing the events of a day, returning to thoughts

of past and of future, ideas from books, journals, memories, anticipations, all existing at the same time and repeated. *Transitions* is thus a palpable illustration of the process of moving in and out of sleep, a rumination on the double life of dreaming and waking.

The domestic frame of *Transitions* leads directly to *A Trilogy* (1985), a long-form film that uses a set of interspersed sequences to interrogate the relationships between individual memory, the trajectory of life and of narrative, and a traditional symbolic order. The trilogy of its title does not mark it so much as an omnibus but as a trinity of overlapping actions and filmic styles: a man running unceasingly, his panting on the soundtrack, in a continuous, long take; a couple eating their daily breakfast before work, cut in the rhetorical style of narrative cinema. These scenes are encroached upon by footage of a boy dressed in a formal school outfit with a suitcase in his hand, who is later seen climbing and rolling down a hill; landscape, in the form of a Neolithic fertility hill; home movies; and a birth in a hospital. At three set intervals, a scrolling text interrupts: the first, a list of statements of historical events, discontinuous but ordered by date; the second, a story about a rite initiating a boy into manhood, and finally, a list of questions, some existential ("Has man a soul and is it immortal?"), others deeply ambiguous ("Are you ready?"). The film gradually assumes much visual overlap. Between its component parts and its frames, the film sets out three ways of experiencing the world: alone, in societal time and place, and as part of a larger eternal order. The tradition of its symbolism and the porous integration of these parts situate it in relation to the creation-story mythopoeic epics of experimental film (Stan Brakhage's *Dog Star Man* [1964]; Ed Emshwiller's *Relativity* [1966]; Bruce Baillie's *Quick Billy* [1970]). Where those films positioned the male artist as protagonist in a cosmic opera of birth and death, *A Trilogy* dispenses with the heroic dimension of symbolism, embracing instead the inherent tensions between ordered, traditional storytelling (in scrolling text, in dialogue and narration) and the more transformative structures of the avant-garde. In the distinction of its perspective from this tradition, the film is defiantly feminist, explicating a subtle thread that would become dominant in much of Sternberg's later work.

In Sternberg's *Tending Towards the Horizontal* (1989), the filmmaker's imagery is accompanied by verbal images offered by Acadian writer France Daigle on the sound-track: "a bird flying…over the ocean…a figure sitting on top of a hill…a woman (in a library)…reading out of books others left lying about." The primary visual subject of the film is houses seen in passing out of a car window. This forms a continuous horizontal tracking that dominates the early sections of the film. When it stops to linger, it is often on related domestic scenes: clotheslines, doors, driveways, treelines, and fences. The horizontal tracking is further disrupted at times by more aggressive formal experimentation—for example, subjective photography of light abstractions and cutting-in of colour negative. At the film's midpoint, the imagery becomes more varied, with construction and destruction and the skyscrapers of downtown Toronto. As Sternberg

pans horizontally and vertically across the city's crowded skyline, Daigle speaks on the soundtrack about the irreducibility of poetry, holding the irrepressible growth of the city in contrast to the humble monument of the poem. In the final sequences, this contest of urban and domestic imagery gives way to scenes of bodies tempered by colour, architecture distorted by glass, flames made rapid by the camera's mechanism. This burst of free association aligns with Daigle's response to the film's title, and then, the image lingers on houses, no longer seen from a passing car, but static, through a window. Sternberg's approach to cinematography in *Tending Towards the Horizontal* would remain in her enduring contributions to observational film form, in the witness of *At Present* (1990), the restrained formalism of *Through and Through* (1992), and the lyricism of *Burning* (2002).

A more essayistic structure, akin to *A Trilogy*, governs several of Sternberg's long films. *Like a Dream that Vanishes* (2000) combines non-objective abstractions, images gradually emerging from the film's emulsion, with scenes of figures representing the stages of life, from childhood, to young adulthood, to middle age, and finally to old age. These stages, like the trinities of *A Trilogy*, appear in cyclical repetitions. And while, as the title suggests, these images vanish, the universal, durative rituals they represent are ever present. Cinema's temporal boundaries become a setting for reflection on the ephemeral nature of life itself, underscored in the film's intercutting of imageless emulsion, figures at rest and recreation, and an interview in which a philosophy professor speaks of miracles. The hypothetical miracle, that circumstance in which scientific knowledge splinters, is exceptional and elusive, while the stuff of Sternberg's film is determinedly quotidian, but they meet at the end of the film in the notion of "wonder." Later, such a structure again emerges in *In the Nature of Things* (2011), a film in which the setting and associated imagery of a forest acts as a beacon for many interludes, ranging from portraits of communal gatherings, staged scenes, and integrations of found images as pictures-within-pictures against dense woods. In such films Sternberg reconciles her interests in tactility, wordplay, and polyphony, tangling philosophical and aesthetic lines into a cohesive whole.

Beginning with *Beating* (1995), Sternberg's filmmaking departed further from the machined forms of structuralism, stressing instead physical intervention in the film's surface and the perceptual evocations that are particular to photochemical tactility. Combining her own texts with those of Virginia Woolf and Hélène Cixous, Sternberg builds a dialogue between personal, individual experience and the long shadows of history—historical oppressions of women, the Holocaust, colonization. After *Beating*, Sternberg's films often embraced non-objective traits to a greater degree, as can be seen in *midst* (1997), in which a long-form, silent, lyrical rumination on colour combines diaristic material and an exploration of Goethe's colour theory with formal gestures both tactile and mechanical; in *C'est la vie* (1996), in which natural phenomena and

Barbara Sternberg, *Beating*, 1995

images of bodies interacting and in repose are cast in the yellow and green of the flitting, non-objective abstraction of hand-processed colour emulsion; and in *Surfacing* (2004), in which heavily scratched, hand-processed film is layered with water imagery and crowd scenes as well as home movies of intimacy and recreation. The scratches collaborate with the shimmering water imagery, invoking the density of a forest. The abstraction of these films shifts them firmly away from any form of editorial commentary, and their empha-sis on texture would reappear, for instance, in *Far From* (2014), in which the haunting halftone textures of old newsprint and slow-moving, pulsing lights are layered atop pho-tonegative snapshots from another era and diaristic observations of houses and streets taken in the present. In their integration of documentary records, these films find a basis in quotidian reality, but they remain elusive, dense, perceptual, and ambiguous. At other times, Sternberg has employed these same techniques with a more univocal intention, as with *LOVE ME* and *COLOUR THEORY* (both 2014), in which texts appear that temper the nature of Sternberg's visual abstraction, pairing the force of her hand-processing and optical printing with evocations of heartache and racism. In speaking of the rela-tion between her images and their treatment, Sternberg says that she considers film's

Barbara Sternberg, *Surfacing*, 2004

emulsion analogous to the "stuff" of life, light as vision and pure energy, and film's temporality a parallel to lived experience.

In complement to Sternberg's self-contained films, she has also made a series, *Time Being I–VI* (2007-2014), a set of short reels dealing with, as Sternberg describes it, "brief moments of being, fleeting bits of the surrounding chaos." They are visual sketches that often distill images found elsewhere in her work, for instance, *Time Being V*, which anticipates *Far From*, and *Time Being VI*, which recycles footage from *Opus 40*. As per her synopsis, *Time Being* reflects the filmmaker's sense of the evanescent nature of experience, in which fugitive episodes command our attention and then disperse. This series demonstrates the strength and flexibility of Sternberg's imagery, in her ability to find a multiplicity of contexts for a given scene.

Beginning with *Opus 40*, Barbara Sternberg committed herself to a cinema that was anchored in repetition and variation, a form which announced her debts to Gertrude Stein, yet remained an idiosyncratic gift. Sternberg further individualized her approach as she interwove these inspired traits with her personal voice, one shaped by her engagements with philosophical enquiry, feminism, material tactility, Canadian identity, and the interplay of personal and historical narrative. Such repetition and variation, though dominant, could accommodate declarative, documental, and enigmatic traits, even as it remained a steady mooring throughout her political, aesthetic, and spiritual development. As her work became increasingly focused on the tactility of cinema and the potential of emulsion as an abstracting element, with such imagery serving as a dominant visual trait of much of her work, that abstraction was integrated and thematized through this underlying

structure of cycles and rounds. In spite of the omnipresent role played by such patterns in Sternberg's films, she has persistently developed in new directions throughout her career, seldom modelling new work on old work, often guided by uninhibited passion and curiosity that might be called restlessness. These films are unified not merely by formal hallmarks, but by Sternberg's impulse to chart the chaos of history, the defiance of memory, and those unforeseen, transformative encounters that come in moments of perception.

—SB

GARINÉ TOROSSIAN
Born Beirut, Lebanon, May 21, 1970

FILMOGRAPHY

Body and Soul, 1989, 12 min., video, colour, sound

Visions, 1992, 4 min., 16mm, colour, sound

Platform, 1993, 8 min., 16mm, colour, sound

Girl from Moush, 1993, 5 min., 16mm, colour, sound

Drowning in Flames, 1995, 25 min., 16mm, colour, sound

My Own Obsession, 1996, 30 min., 16mm, colour, sound

Passion Crucified, 1997, 22 min., 16mm, colour, sound

Find Your Holy Self: Scenes from an Unfinished Film, 1998, 10.5 min., video, colour, sound

Pomegranate Tree, 1998, 3 min., 16mm, colour, sound

Red Brick, 1999, 5 min., video, colour, sound

Sparklehorse, 1999, 9 min., 16mm, colour, sound

Dust, 2000, 6 min., video, colour, sound

Death to Everyone, 2000, 6 min., 16mm, colour, sound

Hokees, 2000, 25 min., 16mm, colour, sound

Babies on the Sun, 2001, 5 min., 16mm, colour, sound

Shadowy Encounters, 2002, 15 min., 16mm, colour, sound

Garden in Khorkhom, 2003, 14 min., video, colour, sound

Sandias Eustasy, 2004, 10 min., video, colour, sound

Come Around, 2007, 4 min., video, colour, sound

Stone Time Touch, 2007, 72 min., video, colour, sound

An Inventory of Some Strictly Visible Things, 2017, 7 min., video, colour, sound

La structure est pourrie, camarade, 2017, 10 min., digital, video, sound

Gariné Torossian's films have often been framed around diaspora, memory, and the search for identity, articulating these themes through found and heavily distressed footage, direct-to-the-film-strip lacerated collage, interruptions of photographic negative, and the reworking of rhythms through an optical printer. Born in Beirut in 1970 to an Armenian family, Torossian moved to Canada in 1979. As a teenager she took up photography, and in Toronto, an encouraging meeting with Atom Egoyan at the Armenian Community Centre led her to begin working with the moving image, first with performative videos made while she was still in high school, and later with 16mm film while studying English and philosophy at York University.

In *Visions* (1992), erotic and violent images appear in Super 8 strips that have been roughly adhered to a 16mm frame. As the strips run serially against scratched black film, they seem to skip, in some cases simulating motion where there is none, in other places staggering the stillness of the root images such that it seems to simulate motion. Against this, there is text that underscores the entwining of eros and brutality, reflected in the film's survey of moaning faces, masturbation, and the sudden appearance of a gun. Both the stills and the text are from Torossian's photography teacher Michael Semak, with her film serving as a tribute to the tensions in his work. *Platform* (1993) extends Torossian's use of creasing, rough-hewn frames around a single subject, dancer Kimberly Pike, in

Gariné Torossian, *Girl from Moush*, 1993

Gariné Torossian, *Visions*, 1992

a studio full of movie lights. The distress of the image becomes an undulating rhythm that counteracts the compositional uniformity. The film explores symmetries and mirror images as it switches intermittently between multiply exposed red and yellow photo-positive and the orange of colour photonegative. These symmetries are also directly counteracted by Torossian's compositions throughout, as the filmmaker reconfigures Pike's face through lacerating and repositioning her materials on the frame, so that the face is split, spread across a series of compartments within the frame. *The Girl from Moush* (1993) again uses roughly adhered images within images to develop a mythical, romantic impression of Armenia, a fantasy of antique images, hazy landscapes, exotic modal music, an expression of the imagined world locked in the filmmaker's childhood. For much of the film, lone frames of Super 8 dance in the centre of the looming 16mm image, a variation on the direct-to-film-strip animation that Torossian had established in her earlier films. The subject of Armenia and the Armenian diaspora would become a persistent subject in Torossian's later work in narrative drama (*Hokees*, 2000) and in poetic documentary (*Garden in Khorkhom*, 2003; *Stone Time Touch*, 2007).

From *Visions* onward, Torossian's work has often had a social dimension in her engagement with other artists either as subjects or as collaborators. *Drowning in Flames* (1995) is an unconventional portrait of the Starn twins, who, like Torossian, make

collages. Theirs are primarily made along a grid form, from reassembled fragments. *Shadowy Encounters* (2002) is a tribute to another pair of identical twin artists, the Brothers Quay, with Torossian reconfiguring images from their animated films in her collage style. *Red Brick* (1999) is a video of a performance by the Arraymusic ensemble, combining music and dance, which Torossian composes in fragments, freeze frames, and with a slow shutter to create motion trails; at times, she layers the image so that the figures overlap. *Dust* (2000) is an interpretation of the choreography of Julia Sasso, much of it composed in fragments, lingering in close-ups on faces, feet, and hands. *Come Around* (2007), a short animated film made in a collaboration with the poet Louise Bak and composer Peter Scherer, finds Torossian pairing Bak's poem and Scherer's score with her own rotoscoping of found images of an otherworldly whirlpool.

Torossian's feature documentary, *Stone Time Touch*, followed the line suggested in her earlier work—of a transcendent union between actual, lived identity and the elusive identity felt in an imaginary version of homeland. After completing it, Torossian took a break from filmmaking for a decade, resuming work in 2017 with *An Inventory of Some Strictly Visible Things*, commissioned for gallery installation. *An Inventory* is a list of readily discernible objects that Torossian can see from her desk in her apartment in Yerevan. In the final minute, she leaves her apartment and the descriptions continue, ending at the metro. While *An Inventory* is a far cry from the collage forms Torossian had explored in the 1990s, it remains focused on fragmentation. Within the apartment, her every act of identification forms a cohesive whole of her life in Yerevan. When she emerges, that isolation streams into a broader social experience; her actions in the metro—paying her token, steadily descending the escalator—become universal acts of communion, belonging, and continuity.

—SB

RHAYNE VERMETTE

Born Notre-Dame-de-Lourdes, Manitoba, July 25, 1982

Rhayne Vermette, *Tricks are for Kiddo*, 2012

FILMOGRAPHY

Tricks are for Kiddo, 2012, 2 min., 16mm/digital, b&w, sound
Tudor Village: a one shot deal, 2012, 5 min., 16mm/digital, colour, sound
J. Werier, 2012, 4.5 min., 16mm/digital, colour, sound
take my word, 2012, 1 min., 16mm/digital, colour, sound
Full of Fire, 2013, 2 min., 16mm/digital, colour, sound
Black Rectangle, 2014, 1.5 min., 16mm/digital, colour, sound
Scene Missing, 2015, 1 min., 16mm/digital, colour, sound
Rob What, 2015, 20 min., digital, colour, sound
Extraits d'une famille, 2015, 6 min., 16mm/digital, colour, sound
Turin, 2015, 7 min., 16mm/digital, colour, sound
Les châssis de Lourdes, 2016, 18 min., 16mm/digital, colour, sound
Domus, 2017, 15 min., 16mm/digital, colour, sound
Suzanne Ciani on Letterman, 2017, 2.5 min., Super 8, colour, sound

Rhayne Vermette emerged from Winnipeg's underground film scene in 2012. Her studies in architecture have informed her work, which has been posed at times in response to architects and to both everyday and exceptional architecture (*Tudor Village: a one shot deal* [2012]; *Turin* [2015]; *Domus* [2017]). In Vermette's improvisatory assemblage, the filmmaker treats found materials as an architect would treat their raw materials; more broadly put, Vermette's work extends and critiques the heritage in a modern vision that spans Russian constructivism, Italian futurism, and the spatial and memorial grammars of contemporary life. Beyond lineage and influence, much of Vermette's work begins from her fascinations with textures from textile to concrete, textures that are synthesized most acutely in her non-objective filmmaking (*Black Rectangle* [2014]; *Turin* [2015]), but which are nevertheless present in frayed, lifting edges, visible adhesives and medium translation throughout her work. In her films there is a merging of found images and the presence of the material markers of filmmaking: Vermette is often using the materiality of splicing tape adhesive, scratching, masking, hairs, and fingerprints, in ways that take on a pronounced role in the image, sculpting a pre-existing source into a new experience. The evidence of her process forces contemplation on the moving image experience as something material, rather than intangible.

Vermette's first film came out of scrap materials found at the Winnipeg Film Group: *Tricks are for Kiddo* (2012) pairs film strips that have been violently torn and reassembled so that the images overlap or are buttressed against one another. Home movie scenes of birthday celebrations, commercial documentaries, and chorus line dancers are put together, soon giving way to solid pastel colours, of transparent acetate, overlapping to show their harsh, torn edges; on the soundtrack, the steady clicking of a JK optical printer. Images are occasionally held in place, briefly, and this clicking reminds us of the relation of the individual frame to the stream. Vermette continued this engagement with found material in *take my word* (2012). Less than a minute in length, *take my word* casts a remarkable spell through its rapid montage of a woman with a tormented expression and a reverberating interior monologue, a child's drawings of a house and picket fence, and a photo-negative image of a house, all of which seem to merge through the intercutting of a zoom toward the woman's face, so rapid that the eye is deceived into seeing all three—her head, the house, and the fence—as a single image. The opening text card, translated from the German, reads, "The weapons are distributed among the Huns and the carnage begins." The closing card reads, "Treason! The Huns attacked us! The Huns are slaying our people!" This frame has a richly comic, combative suggestion in the context of the collage film: a social-political framework for the anarchic possibilities of found-footage filmmaking. *Full of Fire* (2013), in its parallel between the same tormented woman and firefighters hauling hose, extends this gesture by pairing comic symbolism with bemused irritation stated plainly in the torch song "Maybe," sung by the Three Degrees on the film's soundtrack.

Vermette's annotation for *Black Rectangle* (2014) quotes art historian Philip Shaw on the transformation over time of Kazimir Malevich's *Black Square*. The effect of time, in Shaw's description, is to crack and fracture the perfect form into the true imperfect form of paint—a breakdown from stylized icon to material fact. Vermette plays with forms that recall Malevich, and also with an image-sound relation that makes a much more immediate and intentional show of the destructive characteristics of time (the film is heard, on the soundtrack, being torn apart by the projector). *Turin* (2015) continues the formal approach of *Black Rectangle*, now oriented around triangularity, with stray plastic, photograms and etchings that summon the design sensibilities of Carlo Mollino. On the soundtrack, experts discuss the life of Mollino and his process, which is interwoven with slow and sweet torch songs. The songs transmute Vermette's admiration into an overture of romantic affection for her subject, which is simultaneously Mollino (his process, his modesty) and Mollino (the energy within the architect's objects). The triangular forms that the filmmaker casts become steadily more three-dimensional in their interaction, as they seem to dance around one another. A revelation in the commentary suggests that Vermette's gesture parallels the romance of Mollino's own dream life, the charting of a whole life in anticipation, the insistence thereby that forms serve to contain and to constrain, to necessarily inhibit freedom. This statement offers Mollino up as an ascetic whose dream life and work stood at odds with one another and cohered by their irreconcilable nature; something of this tension is suggested in Vermette's metaphors.

These aspects of time passing, and the character of patina and distance, come to the fore in Vermette's *Les châssis de Lourdes* (2016). In this work, the filmmaker combines intimate home movies of her family and of herself as a child with sounds of R&B, Muzak, snippets of home video dialogues, and dramatic dialogue performed from the script of David Byrne's *True Stories* (1986), pointed in its comic profundity and minimalism. These elements form what the filmmaker has called an "architectural threnody"; this mournful tune is aimed at the filmmaker's childhood home, the experiences therein that assemble as a personal architecture of the past or of the soul, the act of leaving behind a thing like a house that is built to be transformed by time. Vermette's use of found sound/dialogue is also present in *Scene Missing* (2015), in which Vermette draws from the soundtrack of Wim Wenders's *Paris, Texas* (1984) the tragic description given by a child upon seeing home movies of his mother, pictures of her "from a long time ago, in a galaxy far, far away." *Scene Missing* responds, first in using an intertitle that stands in place of a gap in the record, second in the provocative rearrangements of its text, conquering the impossible distances of memory: scene missing becomes "see me sing."

Vermette returned to Carlo Mollino with *Domus* (2017), a film built around Vermette's drafting desk, using archives of home and project photography, posited by the filmmaker as a "Pygmalion tale" that interrogates the relationship between cinema and architecture. The film deals with self-definition: Mollino's existential act of self-definition, in the

Rhayne Vermette, *Turin*, 2015

writing of his prophetic autobiography; and Vermette's searching self-definition dem-
onstrated in her articulation of the themes of Mollino's life in her narration, and in the
spatial explorations that animation makes possible. Mollino is often remembered for his
credo, "everything is permissible as long as it is fantastic." The same might be said of the
filmmaker's wild animations, a vision of the architect's studio set reeling by an unseen
hand. A late sequence builds in still images around a structural beam, which is animated
to dance, a central point of focus about which scenery changes. Vermette speaks of the
dream of a house, and the film animates interiors such that the dwelling exists both as
the architect's ideal and as host to its own dream life.

Domus embraces a series of varying definitions of domus, suggesting that a dwell-
ing can be many things, exterior and literal, interior and mystical. When finally it
announces "domus as butterfly," the film recalls a statement from *Turin*, about Mollino's
constrictions: "it's only about getting locked up and not being able to be a butterfly."
The most abstract sense of dwelling, then, is a haunting that transcends the physical
fact of architecture, broadcast in the film's final moments when an interviewee, at the
film's conclusion, says that Mollino is present and in all of us, his energies trapped, or
cast, into his creations. Here *Domus* is most lucid on the relation between cinema and
architecture—domus as film—for as with Mollino's creations, the film becomes
a dwelling for the filmmaker's spirit.

—SB

JOYCE WIELAND

Born Toronto, Ontario, Canada, June 30, 1930; died Toronto, June 27, 1998

Joyce Wieland, *Water Sark*, 1965

FILMOGRAPHY

Larry's Recent Behaviour, 1963, 16.5 min., 16mm, colour, sound

Patriotism, 1964, 4 min., 16mm, colour, sound

Water Sark, 1965, 13.5 min., 16mm, colour, sound

Barbara's Blindness (with Betty Ferguson), 1965, 16 min., 16mm, b&w, sound

Cat Food, 1967, 13.5 min., 16mm, colour, sound

1933, 1967, 4 min., 16mm, colour, sound

Sailboat, 1967, 3 min., 16mm, colour, sound

Handtinting, 1967, 6 min., 16mm, colour, sound

Rat Life and Diet in North America, 1968, 16 min., 16mm, colour, sound

Reason Over Passion/La raison avant la passion, 1969, 84 min., 16mm, colour, sound

Dripping Water (with Michael Snow), 1969, 10 min., b&w, sound, 16mm, b&w, sound

Pierre Vallières, 1972, 32.5 min., 16mm, colour, sound,

Solidarity, 1973, 10.5 min., 16mm, colour, sound

The Far Shore, 1976, 105 min., 35mm, colour, sound

A & B in Ontario (with Hollis Frampton), 1967/1984, 16 min., 16mm, b&w, sound

Birds at Sunrise, 1972/1986, 10 min., 16mm, colour, sound

Peggy's Blue Skylight, 1964/1986, 16mm, b&w, sound

Patriotism 2, 1965/1986, 16mm, colour, silent

Joyce Wieland first studied art as a teenager at Central Technical School. Among the faculty was painter Doris McCarthy, who urged Wieland to enrol in the school's fine arts stream, which was where she first developed a technical knowledge of drawing and painting. In her youth, Wieland had seen the collection of the Art Gallery of Ontario and attended the Toronto Film Society's screenings of films by Hans Richter and Maya Deren, an experience that connected cinema with modern art. In 1954, Wieland took up regular work at the animation firm Graphic Associates, where she met her future husband, Michael Snow, and began to make films communally with the rest of the staff. By the time that she and Snow married in the fall of 1956, they were both committed unequivocally to their painting practices, working at the heart of a loose Neo-Dada community to build something new, in a city with a history of closed, exclusive art scenes.

Ideals of love would take on a greater thematic design in Wieland's character, in her abstract paintings that were messy and dramatic in their sexuality, in paintings and installations that spoke explicitly of brotherhood and love, and in the repetitions of valentine card hearts and lipstick traces that would, in her mature work, become synonymous with her ironic expression of nationalism. Her work was not naïve, but indirect; even as she mastered the symbols and gestures of sentimentality, she cultivated a rich sense of irony. Her art could not be taken by its surface, whether of sentimentality or mere whimsy and joy, because that surface masked the work's greater investment in which whimsy and joy were subversive forces.

When Wieland moved with Snow to New York City in 1962, she began to work in film. New York introduced her to the rough and spontaneous fringes of cinema: her circle of friends included Ken and Flo Jacobs, Jonas Mekas, and the Kuchar brothers. The grammar of film was expanding, and forms as disparate as those of the Kuchars and Mekas were not merely coexisting but implicated in a fellowship of aesthetic freedom. Wieland's first film, *Larry's Recent Behaviour* (1963), was influenced primarily by the satirical fiction films of Jacobs, the Kuchars, and Jack Smith. The film plays out in a series of vignettes, exploring the titular Larry's aberrant behaviours (picking his nose, smelling feet). Wieland followed this with another film in the same comic vein. *Patriotism* (1964), made in a style recalling Norman McLaren's *Neighbours* (1952), combined stop-motion and live-action photography in the service of metaphor. In the film, a man (Dave Shackman) is conquered by an army of hot dogs, which are then consumed by the American flag napkin, a metaphor for American colonial–jingoism in the Vietnam era, complete with commentary on the commercialization of icons.

Wieland departed entirely from storytelling, using the camera to reveal an elastic and intimate vision of her home. *Water Sark* (1965) might be considered a flow of spontaneous observations, but it is also a constructed performance. In her synopsis, Wieland wrote, "I decided to make a film at my kitchen table, there is nothing like knowing my table. The high art of the housewife. You take prisms, glass, lights and

Joyce Wieland, *Sailboat*, 1967

myself to it." Throughout, Wieland plays with the contents of her kitchen table and sink, and her subjects include her breasts, a little toy boat, the fluctuations of ceiling lights glimpsed in a moving, mirrored surface, and the water upon that and other mirrors. Wieland's note for *Water Sark* concludes that it "is a film sculpture, being made, while you wait," an ironic borrowing of the language of advertising. Wieland's treatment of light in *Water Sark* continued with a body of sculptural collage work, a part of her "paracinema." work resembling or occurring alongside her films. This para-cinema, hanging assemblages that she called "stuffed movies," had debts to her earlier mixed media collages, but also resulted from her interests in sequential arrangement and in harnessing light, the work posed in a direct lineage from her sequential paintings and her films. Her "stuffed movies" made use of plastic forms, from inflatable waterproof swim paraphernalia to tinted plastic bags, arranging, framing, or containing objects and photographs.

Sailboat (1967) is a single, continuous composition, of minimal activity, extended in ten repetitions. Wieland described the film: "This little Sailboat film will sail right through your gate and into your heart," an oblique reference to the gates of the camera and projector, the frame itself. A sailboat snakes left to right across a horizon, the word

"sailboat" all in lower case emblazoned at the top of the screen in white letters. The sailboat crosses the horizon several times, and at one point, a bather obstructs the image. *Sailboat* declared Wieland's new interest in the durational dimension of film, its ability to repeat and elaborate on simple actions and to fracture activity, in order to magnify rhythms: the bather's brief interruption assures the viewer that this is not a loop, but it also shows that Wieland leaves room for the unexpected. The text is omnipresent, isolating this object from the sea and sky, identifying it as the central focus of the image, even as the colour of the sea and sky bleed into it. In *1933* (1967), another single-shot film, the image looks down on a busy street and the exterior of a restaurant, with the number 1933 superimposed over the image. Wieland described *1933* as "a speeded up shot out of a window/repeated/evoking the feeling of 1933/walking/window/repeat." This image, of or around 1933, is held against the blank frame and its silence, its depiction of street life coming under the influence of text that forces an assumption.

Handtinting (1967), a film assembled from outtakes of a black-and-white Job Corps documentary that Wieland had shot in 1965 and 1966, showing the recreational activities of poor women in New York City. *Handtinting* shows women dancing, preparing to swim and then swimming, clapping, laughing, smoking and waiting, some with rapt attention, some bored. They speak and sing but there is no sound. None of these actions are shown in full; they are fragmented into a terminal state of mid-action. This gives the film a nervous energy, as these fractured gestures are punctuated with black, which suspends the image, in this case to reinforce that the images will not assemble into a logical sequence. Wieland intercuts shots that have been dyed green, pink, orange, and blue. The dye has been inconsistently applied, so that its watermarks remain on and between the frames, revealing the film's material being, the dyes resting on the surface of the image. It is another wet dress, but unlike the droplets and wet mirror of *Water Sark*, the dyes cannot alter lines or refract light; they can only form other mysteries on the surface of the film, in their lack of coherent colour-relation and their loose communion with the images underlying them.

Joyce Wieland's alternately durational and fragmentary approaches to rhythm combined in *Cat Food* (1967), in which a cat consumes several fish over the film's length, its activity broken down and rearranged to pitch its consumption as an ambiguous metaphor. Again, the setting is Wieland's kitchen table. The cat gnaws on the fish; the fish is slowly eaten away; the amount of fish consumed fluctuates between cuts; the fish is substituted, alternating between a sardine, a rock bass, and an unidentified frozen fish. The camera's speed changes, altering the exposure. The pale underside of the fish and the paler fur of the cat lose definition and become pure light, merging with the white of the tablecloth and wall. The cat's eating is sped comically by a low frame rate. Eventually, the eating slows, and the image darkens with the changing speed. The composition,

aperture, and speed fluctuate, as if Wieland is punning on "scales," the scales of the fish, the scale of the composition, and the scales of technological rendering (camera speed, aperture) fluidly oscillating.

With *Rat Life and Diet in North America* (1968), Wieland continued her photography of critters, in this case cats and gerbils. Serving as an allegory for a radical left underground persecuted by a totalitarian regime, with gerbils as political prisoners and cats as totalitarian predators, the film reflects Wieland's concerns over the psychological effects of crowding, the fatal implications of crowding in American society, and the social-environmental gap between American and Canadian philosophies. The film combines close-up photography and wide-angle compositions with rich overexposure to create fissures between subject and light source, with text that was used extensively to build allegory, and with editing that reveals both the environment and the narrative at a rhythm that paralleled the frantic scurrying of the gerbil refugees. The interplay between sentimentality and irony in Wieland's work is most apparent in *Rat Life and Diet in North America*. The endearing faces and movements of the gerbils could inspire sentimental naivety and were offered with an implicit love for their cuteness. And yet, that cuteness, however sincere its rendering, was a Trojan Horse for the more substantial causes of the work, an environmental and emancipatory protest against the corruption of North America. In this context, the film becomes a work of Socratic irony, its naïveté a vehicle for outcry, its central device the allegory, used in a manner conscious of the two sides of the film's narrative.

The ecological panic that Wieland conveys in *Rat Life and Diet in North America* focuses on disparities between American and Canadian values. Her increasing attention to the Canadian political climate, and her fascination with the character of popular justice minister Pierre Trudeau, who was then running for the office of prime minister, extends from her past engagement with labour, social unrest, and political iconography, even as Trudeau's iconographic value finds a natural consonance with her semi-ironic ideas of marketplace sentimentality.

Reason Over Passion/La raison avant la passion (1969) is a suite of works by Wieland, including quilts and etchings (which represented the Canadian maple leaf flag) and a long-form 16mm film. The film takes the form of a journey outward from Canada's centre: the first half shows a journey from Toronto to the Maritimes, and the second half was made aboard the iconic train The Canadian, which travels through the prairies from Toronto to Vancouver. In between is a long interlude studying Prime Minister Pierre Trudeau's face. Trudeau's claim that "reason over passion" was the theme of all his writings had unsettled Wieland, whose enthusiasm for Trudeau's Liberal government waned into irony as they failed to address major issues of environmental despair and external cultural influence. This declaration was an affront to Wieland's own sensibility,

which called for reason and passion in tandem but her work was infused with many passions, from the erotic to the nationalistic. *Reason Over Passion* becomes a vast study of a vast nation seen from the touristic vantage point, from its unspoiled valleys to its pockets of civilization. The letters in the phrase "reason over passion" are rearranged into various permutations, steadily appearing on-screen throughout.

The first reel depicts the east as a veld of wonders, where encounters with moose and stops in small villages suggest a pastoral ideal. The second reel shows the exotic, wintery, sparsely populated Canada. Both are postcard visions complicated throughout by Wieland's own presence, the spontaneity of her methods, the frequent lingering on textures and reflections. These are not linear observational passages; they are inter-rupted at times—for instance, early in the film Wieland films her own reflection as she mouths the words to the Canadian national anthem. The interlude, of Trudeau's face, re-photographed in extreme slow motion on an analytical projector, is accompanied by a recording of an eight-year-old child giving a French language lesson, greeting, "Bonjour, je m'appelle Pierre." The significance, though ambiguous, suggests a juvenility to Trudeau, while also signalling his advocacy for legislating bilingualism and bicultural-ism. For Trudeau as for the child, language is functional, not passionate or poetic.

On the Atlantic side of her journey, from the sea, that landscape shows signs of animal and plant life, and while lakes and rivers serve as sites of human activity, they also reflect a healthy ecosystem. With her second journey to the sea, toward the Pacific, the majestic Canadian winter buries these features of the land. The Canadian winter pre-sents a sublime vision, by its great scale, its mystery, its white-and-blue emanations, and in its equal parts beauty and fearfulness. The whole of Canada—its eastern paradise, its chilling, empty west—is united in this sublime vision, boundless and passionate, from sea to sea. *Reason Over Passion* reflects Wieland's first steps toward what she wanted out of Canada as a subject, what she wanted also to give it: to comprehend its environmental and political needs, to construct a modern myth, to bring it into a state of unity. This desire to assemble a whole out of fragments is apparent in the film's insistent structure, its consciousness of film's materiality, not only in the presence of the filmmaker and the appearance of light-struck ends, but also in Wieland's tinting of entire sections of the film to the colours of those fogged ends. This acknowledges the material base and makes that base an essential part of the film's sense of unity.

Wieland's films following *Reason Over Passion* were less elusive in their politics and were strongly influenced by her friendship with Judy Steed. Together the two made a series of films: *Pierre Vallières* (1972), *Solidarity* (1973), and Wieland's only fiction feature film, *The Far Shore* (1976). Wieland's sense of compositional intimacy, her dislocation of image and sound, and her use of text were intact through *Pierre Vallières* and *Solidarity*. The former was an interview with the Québécois revolutionary Vallières, filmed in close-up on his lips. This narrow view maintains Wieland's interest in lips, in the intimacy of

Joyce Wieland and Hollis Frampton, *A & B in Ontario*, 1967/1984

close-ups, in subverting the expectations of such a portrait, but the film also extends her ideas of semantic dislocation, reducing Vallières's statements to their vehicle, making him the mouth or voice of a revolutionary vanguard. *Solidarity* was filmed on a picket line at Kitchener's Dare cookie plant, where the vast majority of striking workers were women. There Wieland filmed the strikers' feet, and later superimposed the text "solidarity," text that included the punning presence of the cookie company name (Dare) and that served a similar purpose of semantic disaffiliation between language and image as in her earlier films *Sailboat* and *1933*. While these strategies linked *Pierre Vallières* and *Solidarity* with Wieland's earlier work, her films would increasingly opt for direct political themes, resisting the creative ambiguities and subtle interrogations of meaning that distinguish *Reason Over Passion*.

The Far Shore had originated under the title *True Patriot Love*, planned in the spring of 1971. The film had no resonance with the challenging forms her art had assumed through the 1960s and instead resembled films made under the aegis of the Canadian Film Development Corporation. The notion of a mythic Canada endured, as its narrative was an allegory for the life of Tom Thomson, the Group of Seven affiliate who predeceased the formation of the group when he died mysteriously while canoeing on Canoe Lake in Algonquin Park in 1917. But *The Far Shore* represented the final disintegration of Wieland's stance, from an ironic militant sentimentality toward sincere sentimentality. In the years after *The Far Shore* was released, Wieland and Snow divorced,

and she moved away from filmmaking altogether, turning instead to figurative painting and drawing, now in a highly romantic style.

In the mid-1980s, Wieland began to show advanced symptoms of Alzheimer's disease. The condition ravaged her attention. She enlisted Snow's niece Su Rynard in completing a series of films that had incubated since the 1960s and early 1970s: *A & B in Ontario* (1967), *Birds at Sunrise* (1972), and a film that was worked on but never finished, *Wendy and Joyce*, about Wieland's friendship with Wendy Michener, whose sudden death in 1969 had caused Wieland tremendous and long-standing grief. These films did not bear the same critical irony as those completed in the 1960s. The films that Wieland revisited were sentimental portraits of her life in the 1960s as she would wish to remember it, following in the line of other films she had revisited and completed such as *Peggy's Blue Skylight* (1964), an assembly of Wieland's New York family, and *Patriotism 2* (1965), a eulogy for Dave Shackman. Of the films for which Rynard assisted Wieland, *A & B in Ontario* served as a eulogy for Hollis Frampton (with whom it was made), and *Birds at Sunrise* recapitulated some themes from *Rat Life and Diet in North America*, offered as an expression of solidarity with Israel, a sentimental allegory without her trademark irony.

—SB

Kyle Whitehead, *Four Vignettes*, 2009

More Moments

JIM SHEDDEN and BARBARA STERNBERG

Ed Ackerman and Colin Morton,
Primiti Too Taa, 1986

Ed Ackerman
Born Winnipeg, Manitoba, Canada, 1957

Ed Ackerman is an animator who uses materials he finds close at hand: Plasticine, photocopiers, typewriters. After a year at Ryerson's film school, he returned home to Winnipeg and in 1980 made two collaborative films with Greg Zbitnew: *5 Cents a Copy* and *Sarah's Dream*. He went on to make films for *Sesame Street*, IMAX, the National Film Board of Canada (NFB), and the Canadian Broadcasting Corporation (CBC). His *Primiti Too Taa* (1986), a collaboration with Colin Morton, was made with only a typewriter and based on the 1920s sound poem "Ursonate" (Sonata in Primitive Sounds) by the German avant-garde artist Kurt Schwitters. In it, the human voice provides the music for dancing words and syllables.

Blaine Allan
Born Toronto, Ontario, Canada, 1954

Blaine Allan has been engaged with experimental film as a professor at Queen's University, as an author of numerous essays and articles on the subject, and as a programmer and curator. He is also responsible for producing a number of exquisite experimental films in the 1980s, films that might be called structural or deconstructionist—although that could obscure their playfulness. In *Yukon Postcards* (1983), Allan slyly demonstrates how

snapshots can affirm our storytelling reliability, while pulling the rug out from under us at the same time. He writes, "Experience and memory are ongoing processes, without boundaries. However, we edit and organize on narrative principles in order to share our history and to make events meaningful to ourselves." In *V-2's Blues* (1978), Allan optically prints a fragment of film repeatedly, replacing the image with frames of pure colour, and performing a similar operation on the soundtrack. Allan explains, "The correspondences between the image and the sentence and the way visual and verbal order disintegrates in the film convey a kind of entropy to me." Allan's *3:48* (1987) remixes everyday Ontario footage in a way that taps into the mechanics of memory and dream.

Jim Anderson
Born Campbellford, Ontario, Canada, 1950

Jim Anderson began making films in the late 1960s, experimenting with animation by painting directly on leader with films like *Scream of a Butterfly* (1969) and *S-MO* (1973). Anderson is often cited as one of the founders and core members of the Funnel, Toronto's legendary experimental film co-operative. However, he made his mark as a film artist in Toronto well before the Funnel opened in 1977. In 1972, for example, he made *Yonge Street*, a simple city symphony of sorts, a walk down Toronto's main street at the time, capturing the energy of the people and texture of the buildings and the streetscape along the way. *Gravity Is Not Sad but Glad* (1975) is an ambitious attempt to use film to understand the nature of the universe, language, culture, memory, and the Other.

Anderson worked as a cameraman on Michael Snow's *Rameau's Nephew by Diderot (Thanx to Dennis Young) by Wilma Schoen*, and was presumably inspired by that film's encyclopedic approach to content and eclectic array of modes of representation. At the same time that Anderson was producing the works already mentioned, he was also partnering with Keith

Lock on a number of youthful but technically and formally accomplished films, including *Work, Bike and Eat* (1972), a cinéma-vérité/narrative hybrid, an attempt "to catch people and the relationships between things in as natural a way as possible, and to minimize the apparent intrusion of the filming process into the subject matter...a collection of vignettes from everyday life" (cfmdc.org). Today Anderson lives in Paris, where he draws, paints, and sculpts.

Kay Armatage

Born Lanigan, Saskatchewan, Canada, 1943

Kay Armatage was a programmer for the Toronto International Film Festival (TIFF) from 1982 to 2004, is a professor emerita at the Cinema Studies Institute and the Women and Gender Studies Institute at the University of Toronto, and is the author of numerous scholarly studies. As a filmmaker she is best known for her feature-length documentaries, including *Artist on Fire: The Work of Joyce Wieland* (1987). From 1977 to 1980, Armatage made three experimental short films, including two that embrace lesbian cultural history: *Jill Johnston: October 1975* (co-dir. Lydia Wazana, 1977) and *Gertrude and Alice in Passing* (1978).

Bawaadan Collective

Formed Neyaashiinigmiing (unceded territory of the Chippewas of Nawash, Ontario, Canada), 2019

Bawaadan Collective was formed by Hamilton-based Yuma Dean Hester with his siblings and wife to make films that, as he says, bring the folklore and mythic stories and knowledge of his Ojibway ancestors into the modern era: "It's not about going back." *Midland Motel Room 77'* (2019) is their first film. It effectively combines stills and moving images, fast cutting, and long static takes with voice-over in a Bonnie and Clyde–type narrative.

Raphael Bendahan, *Le Jardin (du Paradis)/The Garden*, 1982

Raphael Bendahan

Born Casablanca, Morocco, 1949

Raphael Bendahan lives and works in Montréal as an experimental filmmaker, photographer, choreographer, arts administrator, writer, and teacher of film production at Concordia University. He co-founded and co-edited *Impressions*, a Toronto photo magazine. Bendahan says, "The photographs and films I've done have dealt with the marginal person or point of view. *Le jardin*, for example, uses an immigrant's story as the voice-over narrative and images of insular immigrant views of life—their gardens and their views. At the same time, it is my story too. I chose to work in Super 8 for the intimacy of subject, the play on memory suggested by the often grainy, fuzzy-bright colour Super 8 could provide, especially in terms of the subject and typical 'home movies.'"

Michelle McLean wrote that *Le jardin (du paradis)/The Garden* (1982) "is a narrative

Bawaadan Collective, *Midland Motel Room 77'*, 2019

of displacement between cultures, between cities (Toronto and Montréal), between times, between languages (French and English). A sense of cathartic inquiry is underlined by the slow weaving movements of the camera as it explores the confines of a walled garden/jardin" (Canadian Images Festival, 1983).

Scott Miller Berry

Born Detroit, Michigan, USA, 1969

Scott Miller Berry has been active in the Toronto film scene as an administrator with both Images Festival and Workman Arts (which produces the Rendevous with Madness Film Festival, among other programs and series). With co-founders Chris Kennedy and Kathryn MacKay, he curated and ran, with enthusiasm and panache, an independent screening series of experimental films, Early Monthly Segments, and co-instigated the 8 Fest and *MICE Magazine*. Most of his films are shot on 16mm and/or Super 8 film and address themes of mortality, grief, memory, and collective histories, and some are processed by hand.

His black-and-white film *untitled (eleven years)* (2015, shot in 1988) is a diary film in which he comes out as a gay man to his mother at her graveside in Detroit.

Dan Browne

Born Montréal, Quebec, Canada, 1982

Dan Browne is a filmmaker and multimedia artist whose works explore patterns of nature through dense and kinetic forms. He has a master's and completed his PhD in the Joint Graduate Program in Communication and Culture at York and Ryerson Universities in Toronto. He has published writings on filmmaking in many journals. Browne lives in Toronto and is a board member of Canadian Filmmakers Distribution Centre (CFMDC).

Browne's media practices also encompass live performances in collaboration with

musicians, which have been presented at events such as MUTEK and Vector Festival, and video installations that have received multiple public commissions in Toronto and Vancouver. He has also collaborated with other artists, including Michael Snow, R. Bruce Elder, Carl Brown, Peter Mettler, and members of the Loop Collective.

Dan Browne, *memento mori*, 2012

Most of Browne's films are short (2–5 min.) views of nature (water, trees, the clouds seen from an airplane, reflections in window glass of the outdoors) mediated by his manipulations of the medium and some human event. *Waterfilm* (2007) presents two film strips illuminated by passages of water: one aboard a ferry crossing the English Channel at day, the other on the banks of the Seine river at night. The soundtrack is generated directly by the projector "reading" the images shot in Super 16mm. The work titled *memento mori* (2012) is a time-lapse layering of all Browne's photos taken over his lifetime—120,000 in total.

Jean-Claude Bustros

Born Cairo, Egypt, 1956

Jean-Claude Bustros teaches film at Concordia University, was one of the founders of Dazibao photo gallery in Montréal, and was actively involved in Main Film at its inception. He was the creator of the *Pierre et Lumière* photography exhibition as part of the 350th anniversary celebrations of the City of Montréal. He has made several experimental short films: *Zéro gravité* (1990), *Queue*

tigrée d'un chat comme pendantif de pare-brise (1989), and a three-DVD anthology of Canadian experimental film and video, *Contre-oeil: périphéries de la cinétique* in 2012. He is now exploring interactive media sculptures.

Gerda Cammaer

Born Leuven, Belgium, 1965

Gerda Cammaer has degrees in communication studies, film studies, and film production. She specializes in experimental and documentary film as a maker, curator, and scholar. She has directed her attention to various forms of ephemeral cinema, "orphan films." With Zoë Druick (of Simon Fraser University) she co-edited *Cinephemera: Archives, Ephemeral Cinema, and New Screen Histories in Canada* (McGill-Queen's University Press, 2014). Gerda is the co-director of the Documentary Media Research Centre in the School of Image Arts, Ryerson University. Her artistic work consists of experimental and found footage films and creative documentaries.

In *Struggling in Paradise* (2004), amidst information overload and mediated emotions, Cammaer sees Paradise as a fleeting promise, a state of mind impossible to achieve. "Along the road to Paradise," she believes "it is all about the drive." Cammaer writes about her 2009 film *Stardust*, "While others are quick to declare that film is dead, *Stardust* celebrates its dust and scratches, and its magic powers for time and space travel. It is an imaginary plea to preserve our dying celluloid past."

Gerda Cammaer, *Stardust*, 2009

Mike Cartmell, *In the Form of the Letter 'X'*, 1985

Mike Cartmell

Born Toronto, Ontario, Canada, 1953; died Ithaca, New York, USA, 2014

Mike Cartmell came to filmmaking from a cultural studies/critical theory background, hence his interests in the relation between theory and practice and in language. The fact of his being adopted led to his attention to naming, ancestry, and genealogy. Cartmell writes, "My filmmaking is concerned with the issue of its/my parentage, and often finds itself up against the problematic of origin/originality."

Regarding *In the Form of the Letter 'X'* (1985), Cartmell explained that it "is predicated upon the quasi-fictional discovery that Melville's name and my name mean the same thing: both came from an old French verb *'meler'* meaning 'to come together, to meet, to intersect' and both are names of towns at crossroads. By exhaustive translation, I reduce them both to 'X,' the Greek letter chi (as in chimera), and the rhetorical trope 'chiasmus.' The structure of the film is chiasmic (that is, it contains two parallel sections, but the second is reformed/deformed in reverse) and functions as a signature. The text is from Melville's *Pierre*."

Lesley Loksi Chan
Born Hamilton, Ontario, Canada, 1978

Lesley Loksi Chan transforms her everyday surroundings into socially charged narratives, drawing on film, video, animation, performance, and installation as formal strategies. Her wide-ranging topics include breakfast, compost, garment-industry sweatshops, Suzie Wong, old masters, Frank S. Matsura, lint balls, and children. Chan's framing and lighting are consistently distinguished across this range of low-fi, low-budget short pieces. In a blurb on Chan's 2007 piece, *Wanda & Miles*, Hoolboom writes that "few can match the one-light precision of these pictures, made with a lyrical and gently moving camera that illuminates one detail blooming after another. Perhaps it's because Chan is working with her son and sister, and so she can wait for the good light, or perhaps it is because she is busy shooting only in rooms she lives in, so she always knows when the good light will arrive."

Shawn Chappelle, *o/exp-city*, 2011

Shawn Chappelle
Born Toronto, Ontario, Canada, 1966

Shawn Chappelle has worked primarily in video, but has taken his inspiration as much from film—avant-garde cinema, classic Hollywood cinema, and European art cinema—as he has from Nam June Paik, Bill Viola, and Gary Hill. His work has been described as exploring the techno-collage and montage aesthetics. Chappelle captures the subtle and not-so-subtle shifts of light, colour, and movement through a variety of carefully composed and manipulated tableaux and constructions.

Amanda Dawn Christie, *3part Harmony: Composition in RGB #1*, 2006

Amanda Dawn Christie
Born Moncton, New Brunswick, Canada, 1977

Amanda Dawn Christie is an interdisciplinary artist working in film, video, performance, photography, and electroacoustic sound design. She holds an MFA from SFU in Vancouver. She worked at Struts Gallery and Galerie Sans Nom in New Brunswick and is assistant professor in Studio Art at Concordia University in Montréal. She has made numerous Super 8 and 16mm films using various DIY techniques and processes. Her most recent feature documentary was shot in 35mm.

The experimental dance film *3part Harmony: Composition in RGB #1* (2006) employs a version of the 1930s three-strip Technicolor process. Shot on black-and-white film through colour filters, the images were recombined into full colour through optical printing. "The gestures in this dance work explore the psychological fracturing and reunification in representations of the female body" (amandadawnchristie.ca).

In the beautifully shot *Spectres of Shortwave/Ombres des ondes courtes* (2016), about the RCI shortwave radio towers on the Tantramar Marshes, NB, themes of

regional identity, communication systems, rural myths, politics, climate change, and language are explored in a measured observational documentary style. The site was shut down and the towers dismantled during the filming. Complementing the film, Christie made several iterations of audio performance pieces: "Requiem for Radio."

Sharon Cook
Born Toronto, Ontario, Canada, 1958

Toronto painter and multimedia artist Sharon Cook exhibited films at the Funnel in the early and mid-1980s. Cook was introduced to experimental film by Ross McLaren at the Ontario College of Art (now OCAD University). McLaren had the students present their work at a student showcase at the Funnel, which was Cook's introduction to that community. Cook's *Forever Yours* (1983/85) derives its visual material from 3-D greeting cards of cats, and its soundtrack is composed of voices, which recite the trite poems that accompany the cards. The voices eventually converge in unison to underscore the occasions of birth, death, marriage, and sickness that suggest the need for these cards. Other films by Cook during this period include *Evinrude Outboard* (1982), *The Encyclopedia of Natural Defects* (1986), and *Y4JZ and the Mysterious Hidden Battle of the Introvolutions* (1986).

Robert (Bob) Cowan
Born Toronto, Ontario, Canada, 1930; died Toronto, 2011

After studying at the Ontario College of Art, and then under Hans Hofmann in New York, Bob Cowan spent much of his life in New York working alongside filmmakers like Jonas Mekas and Ken Jacobs, as well as other Canadian expats Michael Snow and Joyce Wieland. Cowan starred in, narrated, and wrote the electronic score for Mike Kuchar's *Sins of*

the Fleshapoids, one of the benchmarks of underground cinema. Cowan acted in many other films by Mike and George Kuchar, and was affiliated with New York's Film-Makers' Cooperative, Millennium Film Workshop, and the Film-Makers' Cinematheque, where he was the original projectionist for Andy Warhol's double-screen epic *The Chelsea Girls*. Cowan's own filmmaking began with 8mm films, shot on expired black-and-white stock, edited in-camera, and seemingly lost forever. Those films set in motion a career of artistic exploration, from autobiographical films like *Remembrance and Goodbye* (1968), psychedelia (*Rockflow*, 1968), and body films (*Moddle Toddle*, 1967; *Alone*, 1969). *Soul Freeze* (1967) is considered by some to be Cowan's greatest achievement as a director. The critic Fred Camper wrote on film-makerscoop.com that "Cowan's ideas are expressed most fully not by the presence of . . . things but by the way the whole film is shot and cut. To the subject of the film Cowan brings exceptionally violent feelings concerning the existence of human flesh; perhaps, concerning the physicality of all things. The violent cuts, images flashing on and off, throughout the film, partly expresses this. But it is also contained in the shooting style, which turns objects into blocks of light and dark."

Mary J. Daniel
Born Toronto, Ontario, Canada, 1963

Mary J. Daniel has been active on many fronts in the media arts community in Vancouver and Toronto. She wrote several television documentaries and directed a feature-length documentary on storytelling, *Connecting Lines* (1991). For almost twenty years, she has also been making a body of films that poetically document the everyday.

According to the fall 2007 Pleasure Dome program notes, Daniel's work is

characterized by subtle colourings of emotion and light, Daniel's films are like

haiku poems, compact and oblique. They are still and meditative yet vibrate with nature and drama. Her one-take films form moving paintings. They are painterly compositions, landscapes and portraits, which bend the screen into a vitrine to confound the conventional and unconventional beauty she finds in the natural and familiar. Her deceptively simple films untangle the melee of quotidian concerns into essential pleasures and pains. They clarify life. Perched on the edge of nothingness, they are forays toward pure being where knowledge falters and meaning no longer requires it.

Kira Daube

Born Toronto, Ontario, Canada, 1983

Kira Daube has made work through the auspices of Struts Gallery & Faucet Media Arts Centre in Sackville, NB, and Atlantic Filmmakers Cooperative (AFCOOP) in Halifax, NS, both for theatrical screening and for installations. Her works are strongly characterized by their sound treatment, from her laconic resigned poetic voice-over in *The Wind The Way* (2017) to the jazz score in the abstract film *grey, lines, axelrod*. *I AM COLOUR* combines her voice with music, as its images (green apples, cat in sunlight, etc.) single out the very essence of life and film—colour, light.

Martha Davis

Born London, Ontario, Canada, 1959

Martha Davis lives and works in Toronto. She received her BA(Hons) in Film and Drama from the University of Toronto and began her career as a still photographer. She served on the boards of directors of the CFMDC and the Funnel. As a public school teacher, she created videos with her elementary students; since retiring, she has created blue-screen "travel" photographs with seniors living in various retirement homes. Her short *Reading Between the Lines* (1989) was nominated for a Genie Award in 1990.

Davis's film work combines formal structures and found happenings on the street, exhibiting her sense of humour and love of people. *PATH* (1987) best exemplifies these traits. Employing a three-part structure, the film is a cross-Toronto exploration, taking in a wide variety of people, events, and situations. Davis is filmed connecting dots on a street map; next she walks that distance on the street, filming as she goes; then she recalls and interprets what she has seen in memory sequences. The street sequences vary and are filled with surprises.

Alexander Keewatin Dewdney

Born London, Ontario, Canada, 1941

Alexander Keewatin Dewdney is a prolific mathematician and computer scientist, who also made five rather different experimental films over a five-year period. *The Maltese Cross Movement* (1967) is the most influential. The film appears to be a scrapbook of images and sounds randomly generated by the mechanical operation of the projector. Film critic and historian William Wees suggests the film puts forward the notion that the projector, not the camera, "is the filmmaker's true medium. The form and content of the film are shown to derive directly from the...Maltese cross movement's animation of the disk." Made the same year, *Malanga* (1967) is a portrait of the poet Gerard Malanga reading for twenty-four frames (fps sound speed 16mm) dancing to The Velvet Underground for twenty-four frames, then reading for twenty-three frames, dancing for twenty-three frames, until he is reading and dancing one frame a second at a time. *Wildwood Flower* (1971), Dewdney's last film, is perhaps his simplest: an animated frame of a moving image of a woman riding a horse bareback to the Carter Family's "Wildwood Flower."

Francisca Duran, *Mr. Edison's Ear*, 2008

Jennifer Dysart, *Caribou in the Archive*, 2019

Francisca Duran
Born Santiago, Chile, 1967

Francisca Duran came to Canada as a refugee following the 1973 military coup. This event—the experience of exile—is integral to her artistic practice. Duran's work takes a critical view of social, political, and cultural issues through the use of archival material, both familial and public. Her first film, *Tales from My Childhood* (1991), recounts her family's flight from Chile after the coup. The film is made up of images of daily life in Kingston, Toronto, and a trip Duran took with her family to Chile, as well as optically printed found footage from the time of the coup.

Duran is constantly exploring different media and techniques as her interests and subject matter enlarge. *Mr. Edison's Ear* (2008), about Thomas Edison, uses archival footage and animation to explore the visceral nature of sound. *It Matters What* (2019) uses in-camera animation, contact prints, and photograms created by the exposure of 16mm film overlaid with plant material and dried for hours in direct sunlight. Duran writes, "I am always interested in the tactile qualities of media that are thought of as ephemeral, and I want to give a graphical representation to what is perceived as invisible, for instance, light, sound and memory."

Jennifer Dysart
Born Calgary, Alberta, Canada, 1977

Jennifer Dysart is based in Hamilton, Ontario, and has a master's degree in film from York University in Toronto. She is deeply engaged with archival found footage in both her documentary and experimental films. She has made commissioned films for imagineNATIVE Film and Video Festival. In *Caribou in the Archive* (2019), VHS home video of a Cree woman hunting caribou in the 1990s is combined with NFB archival film footage of northern Manitoba from the 1950s, pointing up the difference between homemade video and the official historical record. The story of how this bit of footage was saved is an important element of family history.

Clint Enns
Born Winnipeg, Manitoba, Canada, 1980

Clint Enns has lived and worked in Winnipeg, Toronto, and Montréal, earning an MA in mathematics from the University of Manitoba and a PhD in cinema and media studies from York University in Toronto. Enns's filmmaking is defined by eclectic and energetic spirit, taking inspiration from various pillars of avant-garde filmmaking and visual art, as well as the people and places of his various communities. For example, in *walking from sals to tims*

Clint Enns, *walking from sals to tims*, 2010

(2010), Enns finishes a meal at Salisbury's, a twenty-four-hour chain of diners in Winnipeg, but craving a good coffee, decides to walk one hundred blocks to a Tim Hortons, filming 1- and 2-second shots of the terrain along the way. This film recalls films in the avant garde promenade/travelogue tradition from Oskar Fischinger's *München-Berlin Wandering* (1927) to Joyce Wieland's *Reason Over Passion* (1969). Stephen Broomer has noted that there is a branch of Enns's work "that deals in documentation and community support, portraits of filmmakers, festival trailers, and regular experiments that come from daily engagement with this practice." Enns's *John Porter's T-Shirt Collection* (2014) is a recent instance of this engagement, a film that uses a whimsical visual method to literally celebrate Porter's T-shirt collection. In an interview on TheSeventhArt.org, Enns says, "I am a huge fan of John Porter.... I started making these artist portraits in order to spend time with my favourite artists."

Larissa Fan

Born Cleveland, Ohio, USA, 1968

Toronto-based Larissa Fan studied film at OCADU and York University in Toronto. She has worked at Liaison of Independent Filmmakers of Toronto (LIFT) and CFMDC and for Images Festival as well as writing on and curating experimental films. Her own short films explore the medium's possibilities. In *coming + going* (2005), she shot 8mm footage, edited in-camera, and subsequently uncut to get a split-screen effect. The film gives evidence of the city's power and energy.

FASTWÜRMS

Formed Toronto, Ontario, Canada, 1979

FASTWÜRMS is the cultural project of Kim Kozzi and Dai Skuse (original third member Napo B. left the collective in mid-1980s). In 1981, FASTWÜRMS began exhibiting at the Ydessa Gallery in Toronto. They are currently represented by Paul Petro Contemporary Art. Kozzi and Skuse are associate professors of Studio Art in the School of Fine Arts and Music at the University of Guelph. Their artwork is multidisciplinary, including Super 8 film, video, installation, and performance art. It concerns working-class aesthetics, queer politics, and witch positivity. The films are mostly used in installations and display their home movie–cum–mythological fantasy at play.

Linda Feesey

Born Toronto, Ontario, Canada, 1959

Linda Feesey was active in the 1980s and 1990s in Toronto with the Funnel and then Pleasure Dome, making raw, transgressive, low-tech 8mm and Super 8 films, with titles like *Fuckhead Film* (1989/90), which explored sexuality and violence. She went on to make documentaries in video and write film reviews, including "Homemade Porn: Do It Yourself" (*Broken Pencil*, Winter 2005) and "Untitled by Bruce Cockburn" (*Pleasure Dome presents Apotheoses of Everything*, 2003).

In *Cerebral Palsy and Sex* (2003), people with cerebral palsy speak frankly about their sexuality and demonstrate how they enjoy full sex lives.

Betty Ferguson

Born Toronto, Ontario, Canada, 1933

Betty Ferguson described her hour-long found footage collage film, *Kisses* (1976), as "a humorous dadaistic study of The Kiss in film." It is made up of images from feature films, newsreels, and old television series, and was screened at the legendary Manhattan nightclub Studio 54. In addition, Ferguson's works include *Barbara's Blindness* (1965), made in collaboration with Joyce Wieland, *The Telephone Film* (1972), and *Airplane Film* (1973), all similarly collage films from various media sources. Ferguson lives in Montréal.

Zachary Finkelstein, *BLACK HOLE MUSIC*, 2014

Zachary Finkelstein

Born Toronto, Ontario, Canada, 1981

Zachary Finkelstein is a film- and video-maker from Winnipeg, based in Toronto. He is currently a faculty member in Humber College's Film and Media Production BA program. His work deals with themes of perception and the confluence of science and art. *Still Life* (2013) is a stereoscopic 3-D film that explores the film-maker's personal joy and loss as he constructs a cinematic space where he can introduce his father (deceased 2000) to his infant daughter (born 2012). *BLACK HOLE MUSIC* (2014) uses "a unique light painting technique on 35mm film and a dense original sound design to imagine the effects of extreme gravity on light and sound waves. It is a visual and sonic feast" (winnipegfilmgroup.com).

Scott Fitzpatrick, *Zombie, Part 1*, 2016

Scott Fitzpatrick

Born Winnipeg, Manitoba, Canada, 1988

Scott Fitzpatrick is a visual artist from Winnipeg. He began conducting lo-fi moving image experiments in 2010. In addition to producing his own work, Fitzpatrick presents the work of others through the Winnipeg Underground Film Festival and Open City Cinema. As he said in an interview with Austin Meisenheimer, the world of experimental film was opened up to him by seeing films by Leslie Supnet, Clint Enns, and Mike Maryniuk. His *Fifth Metacarpal* (2018) is a "hyper-personal" essay film that was commissioned by the8fest in Toronto. *Zombie, Part 1* (2016) is the first of a trilogy shot on Super 8 that utilizes found footage, performance, pop music, and rhythmic editing to depict a speed-addicted Florida writer and photographer.

Ann Marie Fleming

Born Okinawa, Japan, 1962

Ann Marie Fleming works in a variety of genres: animation, experimental, documentary, and drama. Her films from the beginning have combined moving picture and animation techniques—and wit. Her work often deals with themes of family, history, and memory. *You Take Care Now* (1989), her graduating film from Emily Carr College of Art and Design (now

ECUAD), which is on the TIFF Essential 150 films list, uses slides and sardonic voice-over to tell a travelogue tale of violence to women. *Waving* (1987) chronicles her relationship with her grandmother. Through emotive imagery of floating, sinking, struggling in water, it is suggestive of the overwhelming power of grief.

Fleming went on to branch out to feature films, animations, graphic books, and documentaries. Her 2016 animated feature *Window Horses*, about a young Canadian poet discovering her family history received multiple awards. *Question Period* (2019) gives voice to the thoughts of a group of recent Syrian refugee women as they negotiate their life in Canada.

John Gagné
Born North Bay, Ontario, Canada, 1959

John Gagné made a number of experimental films in the late 1980s and early 1990s, exploring different forms in fairly rapid succession. His first film, *Rattle* (1987), is an exploration of the Massey Harris King Street factory, built in Toronto in 1879 amidst much controversy. Gagné describes his process as a "journey through the remnants of the factory which, for years, served as the pillar of the corporation. Seen from afar, and then spiraling in to the courtyard, signs of destruction lay everywhere. The camera moves into the buildings, travelling through torn corridors and vast chambers. Outside, the smash of a hammer leads to the demolition in progress, as tractors, trucks, cranes and bulldozers, like so many insects, systematically raze the structure. The sound/ title denotes a dying gasp; the violence of transformation."

Charles Gagnon
Born Montréal, Quebec, Canada, 1934; died Montréal, 2003

Charles Gagnon was a well-known Quebec painter and photographer who explored various media including sound, box constructions, performance art, and film. Parallel to his photography, Gagnon made three experimental films: *Le huitième jour / The Eighth Day* (1966), about seemingly unending war and violence, which was presented as part of the program of the Christian Pavilion at Expo 67; *Le son d'un espace* (1968); and *Pierre Mercure 1927-1966* (1970), in memory of a friend who had died tragically.

Chris Gehman, *Dark Adaptation*, 2016

Chris Gehman
Born Chicago, Illinois, USA, 1966

Chris Gehman is a film and video curator, writer, editor, teacher, and arts administrator. Since 1987, he's been making his films, originally taking inspiration from the surrealist animation, but tending toward abstraction in more recent years. His most recent film, *Dark Adaptation* (2016), screened at the Berlinale. In the Berlinale program, it was described as a continuation of Gehman's 2008 film *Refraction Series*: "Working with simple, everyday materials, Gehman produces rich and surprising images of pure prismatic color in motion. Rooted in the scientific experiments

and writings of Ibn al-Haytham and Isaac Newton, these films apply optical phenomena familiar from everyday life—such as thin-film interference, chromatic splitting, and refraction through glass—to the cinema. The results of Gehman's experiments in the studio are structured as a form of visual music, complemented by a soundscape composed by musician and composer Graham Stewart."

Tracy German, *a private patch of blue*, 1998

Tracy German
Born Toronto, Ontario, Canada, 1970

Tracy German has an MFA in Film Production from York University in Toronto; she teaches film at Sheridan College. Her media work is varied: from a 16mm film loop installation, *Impeded Streams and Stains*, to the 37-minute documentary *Restless Spirits*, about her stepmother's participation as a rodeo calf roper, to co-producing and directing the documentary *The Elders: Time Will Tell*, which was part of the Sheridan College/TVO Millennium Series. German has made short experimental films and videos that are often based on her life and rural experiences while growing up.

Mike Hoolboom describes *A private patch of blue* (1998) as "an auto-portrait of maternity [that] shows German quietly expectant, keening through winterludes of surprise before the birth of her first child....A dazzle of crimson flares ensue, miming the boy's closed-eye womb visions, before the filmmaker's face appears, softly turning in a patina of grain."

Anna Gronau
Born Montréal, Quebec, Canada, 1951

Anna Gronau was an active Funnel member in Toronto in the 1980s. Her work focused on communication, perception and a female voice. Gronau's film *Mary, Mary* (1989) was regarded as an example of "New Narrative." It features a woman trying to write a film script from myths, stories, and memories, attending to the long-silenced voices that have recounted these—the voices of Indigenous peoples in their quest for self-determination, of mothers and grandmothers, and of forgotten personal experiences. "Her own observation that 'the dead are not powerless,' that they live as potent fictions and accrued history, becomes the central philosophical motif of the film" (Elke Town, *Canadian Art*, 1990).

Patricia Gruben
Born Chicago, Illinois, USA, 1947

Patricia Gruben grew up in Texas, studied anthropology at Rice University, and attended graduate school in film at the University of Texas, where she made several short films. In 1972, she moved to Toronto and began work as a set decorator and art director for feature films and television. From 1975 to 1977, she worked at TVOntario and as a writer, camera assistant, and production manager on various independent films. Gruben returned to experimental work in 1977. She then moved to Vancouver, where she has made ten feature films and given workshops in script development.

Her work has been called feminist and has played a role in developing feminist media practices and "New Narrative," though, unlike other films with these designations, her work was not theory-driven but rather metaphysical in nature, asking questions such as, how does one trust one's own perceptions and how do we control a world we can't control? These questions are examined in her first

film, *The Central Character* (1977). Richard
Stanford describes *The Central Character* as,
"A woman's attempt to keep chaos at bay by
naming, classifying, and ordering her domestic
environment. This ultimately results in a total
loss of ego and verbal capacity. Through
the innovative juxtaposition of printed text,
graphics, step printing, and disintegrating
soundtrack, Gruben constructs a narrative
breakdown that parallels the unconscious
patterning of her character's mind" (National
Gallery of Canada).

Oliver Hockenhull, *Determinations*, 1988

Patricia Gruben, *The Central Character,* 1977

In her 1981 film *Sifted Evidence*, she
uses front-screen projection plus stills to
narrate a story of misunderstandings and
cross-purposes. In *Ley Lines* (1993), she
traces the Gruben family back to Texas and
then to Germany, ending up in Tuktoyaktuk, NT,
through an intuitive, associative journey, which
includes satellites, DNA, geomancy, dowsing,
Jimmy Dean, and Hitler.

Oliver Hockenhull

Born Montréal, Quebec, Canada, 1957

Oliver Hockenhull works across media, and
across genres, arguably always somewhat
"experimental," if that term is meant to suggest
films that transcend the visual and rhetorical
modes of traditional narrative, didactic, and
advertising uses of cinema. Hockenhull
seemed to emerge on the experimental film
scene with *Determinations* (1988), a film
that challenged what many saw as the formal

orthodoxy of experimental film at that time.
Writing in the *Chicago Reader*, Jonathan
Rosenbaum reflected on it: "Oliver Hockenhull's
experimental documentary—inspired by the
arrest and sentencing of the Toronto Five,
members of the Vancouver Direct Action
anarchist group— calls to mind the multi-
faceted questioning of media information and
language in general in some of Godard's more
radical works of the late 1960s—particularly
Le gai savoir—that featured different forms of
collage. All sorts of elements are woven into
the mixture, including documentary footage,
interviews, dialogues, punk rock, images
from TV, performance art involving slides and
silhouettes, and many different kinds of image
processing."

John Hofsess

Born Hamilton, Ontario, Canada, 1938;
died Basel, Switzerland, 2016

John Hofsess was a student organizer, who
was a co-founder of the CFMDC and the
McMaster Film Board. He directed *Redpath
25* (1966), *Palace of Pleasure* (1966-1967),
and *Columbus of Sex* (1969). His films were
inspired by Freudo-Marxist theories of Wilhelm
Reich, Norman O. Brown, and Herbert Marcuse,
and by the immersive media *Exploding Plastic
Inevitable*, "a series of multimedia events
organized by Andy Warhol in 1966 and 1967,
featuring musical performances by The Velvet

Underground and Nico, screenings of Warhol's films, and dancing and performances by regulars of Warhol's Factory" (Wikipedia).

His second film caused him to be put on trial for obscenity, after which he withdrew his films from public circulation. Stephen Broomer has described the film as critical of Western notions of authorship:

> With *Palace of Pleasure*, authorship is in willful crisis, even surrender. It is a communal film made under the rubric of the filmmaker's ideologies, but the social organization of the film emerges as its overwhelming characteristic. It eschews the auteur sensibility that largely defined the American underground, resonating instead with the smaller margin of those participatory films where authorship is a confluence of ideas shared between the filmmaker and participants (the films of the Kuchar Brothers, some by Kenneth Anger, Alfred Leslie and Robert Frank's *Pull My Daisy*). In this sense, it is the truest portrait one could find of its social caste, in this case, young Canadian intellectual misfits—it is a film of awkward youths, cast in coloured lights, staging erotic, violent, or domestic scenes in contrast to kaleidoscopic distortions.

Clive Holden
Born Nanaimo, British Columbia, Canada, 1959

Clive Holden refers to himself as an intermedia artist, filmmaker, and writer. His 2006 film *Mean* is a diptych made from Super 8 film and old video footage. Holden writes, "The pun of the title comes from the extra levels of 'meaning' we attach to nation, religion, sports teams, and even to art genres like film and video. The hockey players were shot in Super 8 off a TV set and then subjected to cheap and crude 'toy-like' effects—the result seems to capture the tragicomic nature of hockey (and of

artists arguing)....This piece isn't really a film or video, it's 'grain + noise.'"

Oliver Husain
Born Frankfurt am Main, Germany, 1969

Oliver Husain's approach to the moving image is without borders. He works with film and video, single-channel and installation environments, not to mention drawings and other creative mediums. In 2019, he completed *Garden of the Legend of the Golden Snail,* a 13-minute IMAX 3-D work that makes reference to Keong Emas (the Golden Snail) Theatre, Indonesia's first IMAX theatre, and its various cultural references and its strange architecture. Although the film is unlike anything else Husain has made to date, it bears witness to Husain's cosmopolitanism. In this way, the film is connected to Husain's 2005 trilogy, *Swivel*, *Shrivel* and *Squiggle*. According to Jon Davies in *Canadian Art*, "Each film revelled in the absurdities and perverse pleasures of intercultural mélange, combining to form a quintessential 21st-century pan-Asian travelogue."

Derek Jenkins
Born Monroe, Louisiana, USA, 1980

Derek Jenkins is based in Hamilton, Ontario; his practice is handmade, personal filmmaking with an interest in labour, ecology, and social institutions. He shows his work both in screenings and in gallery installations. In 2019, he returned as am MFA student in Documentary Media at Ryerson University while working at Niagara Custom Lab in Toronto and sitting as a board member for CFMDC. In Derek's work, strands of the personal, theoretical, and technical flow seamlessly and meaningfully together—his life, context, and artistic production in a merger of tech talk and poetry.

For *The Shouting Flower* (2018), Jenkins and his young daughter collected dandelions around the city of Hamilton in neglected public

Derek Jenkins, *The Shouting Flower*, 2018

spaces and near large public institutions, and processed the footage using dandelions (instead of Kodak chemicals). The connection between weeds, capitalism, and resistance is wonderfully built up and upon. Jenkins writes, "I finished this film specifically for a local event and in response to a 'riot' in a gentrified neighbourhood in Hamilton that resulted in the arrests of several local activists, as well as a couple rent strikes in nearby Stoney Creek."

Both *Contents* (2018) and *Livestock* (2019) continue his mixing of personal family history with social/political questioning, asking, how does bureaucracy order our lives and how is film's material production implicated in the slaughter of cattle?

Patrick Jenkins
Born Brantford, Ontario, Canada, 1956

Patrick Jenkins specializes in documentary and animation and is well known for his work with paint-on-glass stop-motion animation. From the beginning of his work in the late 1970s, Jenkins was associated with the Funnel with films like *Wedding Before Me* (1976) and *Fluster* (1978), which combined live-action and single-frame animation, suggesting early in Jenkins's career the fluidity of forms that would be a key characteristic of his work in the future, even as he became more and more committed to animation per se. Within that world, Jenkins became associated with the

paint-on-glass technique, as seen so strongly in *Inner View* (2009), an animated homage to the artist Kazuo Nakamura.

G.B. Jones, *The Lollipop Generation*, 2008

G.B. Jones
Born Toronto, Ontario, Canada, 1965

G.B. Jones is a founder and member of the Toronto postpunk group Fifth Column (1981-2002), and is currently a member of Opera Arcana. Jones was also one of the co-editors of *Hide*, a zine that debuted in 1981 and broke the mould as far as music zines were concerned, in that the *Hide* editors were just as likely to feature articles on feminism, Kathy Acker, and experimental filmmakers like Kenneth Anger and Ross McLaren. Jones eventually collaborated with Bruce LaBruce on *J.D.s*, a self-described queercore zine (it seems that they invented the term). With LaBruce, she put on *J.D.s* movie nights in Toronto, Buffalo, New York, and San Francisco, featuring no-budget underground films made in Super 8. In 1990, they showed *The Troublemakers*, Jones's first film, a short one featuring four outsider "gay rebels" who attempt to subvert the forces of capitalism and surveillance society. The film became a cult classic, as did Jones's next two films, *The Yo-Yo Gang* (1992) and *The Lollipop Generation* (2008). Jones performed in a number of films directed by Bruce LaBruce and others, notably *No Skin Off My Ass*, which was Kurt Cobain's favourite film (according to Gus Van Sant).

Chris Kennedy
Born Easton, Maryland, USA, 1977

Chris Kennedy has served as the executive director of LIFT, as a programmer with TIFF, the Images Festival, and Pleasure Dome, and as co-founder of Early Monthly Segments. This intense engagement with the medium is evident in his filmmaking, which embraces many of the aesthetic traditions that have emerged in the history of avant-garde cinema and visual art in general. For example, *Watching the Detectives* (2017) uses texts and images to reflect on group behaviour online. *Brimstone Line* (2013) is an exploration of the zoom, perhaps a meditation on Michael Snow's *Wavelength*. *Tape Film* (2007) uses five different film stocks and many different processing techniques to create a visually chaotic but compelling construction. Michael Sicinski called Kennedy a "conceptual vagabond...unlike so many others who stake out a particular plot of ground and till it for all it's worth...his films are quite different from one another in their surface effects, but at their core they share certain basic questions, in particular the relationship between organized vision and the chaos of the sensory world."

John Kneller
Born Geneva, Switzerland, 1965

John Kneller grew up in Hudson, Quebec, and moved to Toronto in 1985. He is a professor in the Media Arts Film program at Sheridan College, Oakville, and has recently guest taught in China. Kneller shoots his own films, often modifying cameras in order to push the expressive limits of the medium. He works painstakingly with optical printing, multi-layering, and matting techniques. His films often reveal the unseen layers embedded in images of urban and family life as in his 1988 *Toronto Summit* and his colour separation of old home movies of family holidaying in *Separation* (2008).

John Kneller, *Axis*, 2013

Axis (2013), a tour de force of optical printing, is a commentary on contemporary life. *Axis*'s subject matter is the urban landscape with its towers and factories—the workaday humdrum world. It was shot with his homemade Bolex "robot," a time-lapse motion-control machine capable of spinning through x-y-z axes continuously or in a stop/go pattern, which turns downtown skyscrapers into a seething, pulsing mandala. Kneller writes, "The hope is that the spectator experiences meditative, trancelike states. The message of the film is to open one's eyes and see the world in different ways. It is also an affirmation; to look at the world as a system of possibilities as opposed to a corporate, faceless façade. Even within the constructed façade artistic possibilities and invention abound. Revolutions!"

Eva Kolcze
Born Toronto, Ontario, Canada, 1981

Eva Kolcze is a filmmaker, visual artist, and educator whose work is intensely engaged with architecture, the body, and the land. The play of shadow and light, the qualities of different film stocks, and the dance of the film grain inform Kolcze's visual poetry in films like *Modern Island* (2012), *Badlands* (2013), and *Dust Cycles* (2017). Another important obsession of Kolcze's is the pliability of the film material itself at the level of the emulsion. In her 2014 film, *All That Is Solid*, Kolcze subjected footage

Eva Kolcze, *All That Is Solid*, 2014

of Brutalist buildings to degradation and decaying processes, in order to "warp, morph, dissolve and re-form" the images, according to Kolcze. The title is a reference to Marshall Berman's book *All That Is Solid Melts into Air* (itself a reference to a line in *The Communist Manifesto*), which Kolcze takes as inspiration to reveal the fluid and dynamic nature of concrete. Concrete may not be so concrete, in other words.

Milada Kovacova
Born Toronto, Ontario, Canada, 1963

Milada Kovacova has an MFA from Concordia University in Montréal; she is a visual artist who turned to filmmaking. Her first film, *The Dance of Life* (1990), began her sustained preoccupation with the lives of immigrants to Canada and their descendants. *Searching for My Mother's Garden* (1992), titled from the Alice Walker book of nearly the same name, is based on Kovacova's personal journey back to her parent's village of origin in Slovakia. The film puts forth the artist's concern that the disappearance of traditional ways of farming inevitably result in an erosion of cultural belonging. Kovacova has been regularly involved in the Super 8 Fest and has worked at *Fuse* magazine, Trinity Square Video, and Prefix ICA gallery in Toronto.

Bruce LaBruce
Born Southampton, Ontario, Canada, 1964

Bruce LaBruce is a filmmaker, actor, photographer, writer, and zine editor. LaBruce's first film, *Boy, Girl* (1987), was a rock video for the band Fifth Column. His second film, *I Know What It's Like To Be Dead* (1987), the first of his edgy Super 8 sex films, established the creative direction his work would take. *Bruce and Pepper Wayne Gacy's Home Movies* (1988) tells the story of the children of serial killer John Wayne Gacy through a series of deranged vignettes. The critic Amy Taubin describes *No Skin Off My Ass* (1991) as "sweeter than Warhol, subtler than Kuchar, sexually more explicit than Van Sant."

Christine Lucy Latimer, *Lines Postfixal*, 2013

Christine Lucy Latimer
Born Toronto, Ontario, Canada, 1980

Christine Lucy Latimer graduated in 2002 with a degree in Integrated Media and Photography from the Ontario College of Art and Design. She also has a background in music. Her many films are, for the most part, short and silent, and employ film and various low-tech digital media operating on found footage fragments—rescuing, translating old technology. She is an artist aware of experimental film history and she works consciously with the properties of her chosen media (*Lines Postfixal* gives the nod to Norman McLaren and *Focus*

to Gariné Torossian). Seen through her altering lens, we experience familiar scenes in a new and compelling way. In *Lines Postfixal* (2013), two found companion 16mm film prints (salvaged from the garbage at the NFB) are reunited. The image is worked in multiple generations through Betamax and VHS tape decks to weave threads of video artifact into the celluloid fabric.

Frances Leeming
Born Toronto, Ontario, Canada, 1951

Frances Leeming is a media artist and animator. She is associate professor in Film and Media at Queen's University in Kingston, Ontario. Her collage film animations explore the relationship between gender, technology, and consumerism.

"By animating three decades of LIFE Magazine, *The Orientation Express* [1987] humorously guides us through the sexism of North American media. Hosts such as The Quaker Oats Man, Colonel Sanders, and The Kool Aid Jug explore 'the feminine mystique.' This film highlights how attitudes towards women have changed and works to eliminate stereotypes that still persist today" (cfmdc.org).

Gary Lee-Nova
Born Toronto, Ontario, Canada, 1943

Gary Lee-Nova comes from a visual arts background in Vancouver, as many film artists of that time did (1960s), and he is known primarily as a painter. He was influenced by Bruce Conner and made films from a stash of found footage discarded by the NFB. His 1967 film, *Steel Mushrooms*, with images of industrial hardware, collage aesthetic, and fast cutting asks: How fast can one see?

Jean Pierre Lefebvre (Lois Siegel)

Jean Pierre Lefebvre
Born Montréal, Quebec, Canada, 1941

While not directly part of the experimental world and mainly known for his feature films (collaborations with his wife Marguerite Duparc, who produced and edited them), nonetheless, Jean Pierre Lefebvre had a great impact and involvement both with English and French indie filmmaking. He gave many screenings and talks, inspiring the young experimental filmmakers in the audience with his unique and personal style of low-budget filmmaking. In 1967, he joined the NFB/ONF, where he made two features and produced the films of a number of young Québec filmmakers. In 1969, he formed his own company, Cinak. Besides his many well-known features, among them *Il ne faut pas mourir pour ça* (1967), *Les fleurs sauvage* (1982)—which won the Critics Prize at Cannes—and more recently *See You in Toronto* (2000), he has also made short films and videos.

Peter Lipskis, *It's a Mixed Up World*, 1982

Peter Lipskis

Born Göttingen, Germany, 1954

Part of the Vancouver 1970s experimental film scene, Peter Lipskis cites as influences David Rimmer—he saw *Variations on a Cellophane Wrapper* in high school—and William Burroughs's "cut-up" strategy, which seemed a perfect fit for film montage. In *Spare Parts* (1975), scenes from old educational and propaganda films are cut up and rearranged in numerical patterns. Chance collisions occur. The final section consists of twenty-four variations of twenty-four frames in one second of film; to watch all 6.2×10^{23} possible permutations would take approximately 820 trillion years.

It's a Mixed Up World (1982) is "a Bruce Conner–style assemblage film consisting of shots from 1940s and '50s educational shorts spliced together, with synthesizer pop-music by Ron Smulevici. The result is a humorous but cynical view of modern civilized (?) life: a surreal cinematic Rorschach test in which 'meaning' is largely a result of the personal associations and subconscious anxieties which the individual view projects onto the images" (Funnel Catalogue Supplement 1987).

Keith Lock

Born Toronto, Ontario, Canada, 1951

Keith Lock has had a prolific career making documentaries, feature narratives, and short films. In the 1970s, Lock made two of the most highly regarded Canadian avant-garde films, *Work, Bike and Eat* (1972), a collaboration with Jim Anderson, and *Everything Everywhere Again Alive* (1975), a film that writer and filmmaker Bruce Elder, in his book *Image and Identity*, says "suggests that there exists an extremely intimate relationship between the filmmaker's personal life and the life of the natural world. The way the filmmaker handles the camera in the final passage reveals that along with nature he too is coming alive again. And the title of the film, *Everything Everywhere Again Alive*, suggests that all things share in a common life." Lock was a founding member of the Toronto Filmmaker's Co-op, which later morphed into LIFT.

Terra Jean Long

Born Calgary, Alberta, Canada 1983

Terra Jean Long holds a double-major BFA in Film Production and Women's Studies from Concordia University and an MFA in Film Production at York University in Toronto. Her films show her interest in biology, geology, the environment, and her exploration of different film techniques: *horses in the year of the dog* (2018) used hibiscus and lavender as developer and is saturated in deep blues.

Jorge Lozano

Born Cali, Columbia

Jorge Lozano is one of the most prolific media artists in Canada, and he continues to make Super 8 films, single-channel video, and film and video installations. His work is socially and politically engaged, but occasionally steps back to contemplate more fundamental

philosophical questions around the nature of being, beauty, and emotions. Lozano's Super 8 films work freely with found footage (*Discontinuity,* 2017); his own archive (*Cine Blanc*, 1980); remixed sound and image constructions (*dis-continuity*, 1987); hand-held shooting, overexposed footage, and chemical interventions (*punctuations*, 2017); and twin-screen projections (e.g., *Identically Different*, 2018). His most ambitious work to date is *MOVING STILL_still life*, a complex image of daily life in Siloé, a grim, violent suburb of Cali, Colombia. It is presented as an eight-channel video installation juxtaposing documentary interviews of the city's residents and their homes with fictional scenes involving younger people from the city. Overall, the effect is a disturbing, multivalent portrait of a city and its people.

Andrew Lugg
Born Reading, England, 1942

Many experimental filmmakers work for a short, intense period of time, creating a legacy with just a handful of films. Andrew Lugg is a case in point. Lugg has been a philosopher, teaching at the University of Ottawa for many decades, but from 1972 to 1976 Lugg produced six exquisite films engaged with the nature of photography. Three are performance-based films: *Plough, Skid, Drag* (1973), *Gemini Fire Extension* (1972), and *Trace* (1972). The other three—*Postcards* (1974), *Black Forest Trading Post* (1976), and *Front and Back* (1972)—use postcards for inspiration. Filmmaker and writer Bruce Elder has argued in *Image and Identity* that

> Lugg's postcard films confront...the issues associated with still photographic representation. In *Postcards*, for example, he re-photographed buildings of scenes depicted in postcards, placing a motion picture camera in the same location that the still camera had been placed when the original postcard photograph was taken.

As a result, the images in this film have an appearance that closely resembles those commonly found on postcards; in fact, some of the images in this film could, on their first appearance, be easily mistaken for reproductions of postcards since many seem at first to include no movement. Eventually...a movement is discovered—often near an edge of the screen—or the stasis is interrupted as a car or a person passes through the screen. The central concern of the film is to explore the effect of introducing movement into a static image.

Alex MacKenzie
Born Montréal, Quebec, Canada, 1966

Alex MacKenzie is involved in various aspects of the Vancouver media arts community: writing, publishing, teaching, curating. He is perhaps best known for founding the Edison Electric Gallery of Moving Images and the Blinding Light!! Cinema, two legendary spaces for presenting experimental and otherwise marginal cinema. Since 1991, MacKenzie has been making films in working with Super 8, 35mm, and digital, but primarily 16mm, and he has in recent years been presenting his work as multi-screen installations and performances. He often works with found footage, including NASA and other scientific footage, and abstract image-making using photograms and working directly with the emulsion. *This Charming Couple* (2012) is presented as "live cinema," wherein he uses two analytic 16mm projectors to manipulate a water-damaged instructional film about the perils of ill-conceived marriages, slowing down and freeze-framing the film, emphasizing the accidental beauty of the emulsion damage. *Apparitions* (2017), a 16mm double projec-tion inspired by early stereo imaging, is a cacophony of black-and-white and saturated colour footage, filtering techniques, projector movement, and representational images morphing into abstractions, shaped by a drone soundtrack.

James MacSwain

Born Amherst, Nova Scotia, Canada, 1945

James (Jim) MacSwain lives and works in Halifax, Nova Scotia. He received a BA in English from Mount Allison University in New Brunswick, studied drama at the University of Alberta in Edmonton, and has worked in theatre and arts administration. He helped to set up Atlantic Independent Media in Halifax and worked for the CFMDC in Toronto. Since 1980, he has worked in film and video as well as photography, specializing in cut-out animation and collage. His arch voice-overs relate historical events through fabulous fables, absurd tales, and personal stories. His films have a sardonic tone but come with a message—a moral to the story. MacSwain has lived an openly gay life, and as such he has advanced the cause of gay rights and acceptance, though his films do not explicitly have gay content. *Atomic Dragons* (1981) is a film that examines the disposal of nuclear reactive waste in a story that seems both fantastic and all too real. He illustrates his satiric fable using cut-out animation, live-action, and photographic techniques.

Guy Maddin

Born Winnipeg, Manitoba, Canada, 1956

Although primarily known as a feature narrative filmmaker, Guy Maddin has also made numerous short films and an ambitious video installation. Maddin's early films, like *The Dead Father* and *Tales from the Gimli Hospital*, took inspiration from the low-budget DIY aesthetic of his mentors and peers in his hometown, Winnipeg—especially Stephen Snyder, John Paizs, and George Toles—and Surrealist pioneers such as Luis Buñuel, as well as David Lynch and John Waters. More than any other feature filmmaker in Canada, Maddin's natural aesthetic inclination is one of hybridity: he eagerly and easily embraces silent film tropes, a horror sensibility, and operatic elements, but always ultimately guided by his personal vision.

Guy Maddin, *My Winnipeg*, 2007

Maddin's most obviously experimental film is *The Heart of the World,* a 4-minute short film shot in a style influenced by Sergei Eisenstein and Dziga Vertov, with hundreds of shots creating a kinetic and chaotic visual experience. After *The Heart of the World*, Maddin began a productive phase of his career, often making films that seemed conventional at first glance but revealed a more original and innovative modus operandi. With *Dracula: Pages from a Virgin's Diary* (2002), a dance film documenting the Royal Winnipeg Ballet's production of *Dracula,* Maddin opted to shoot and cut the film with many close-ups and jump-cuts, something unusual for a broadcaster like the CBC, who were the lead funder on the film. Maddin's *Cowards Bend the Knee* (2003) was shot entirely on Super 8 film. It was commissioned as a series of short films by the Power Plant art gallery in Toronto, and originally shown as part of an installation there. It was also the beginning of Maddin's autobiographical Me Trilogy, each of which stars a protagonist called "Guy Maddin" (played by Darcy Fehr). Critic J. Hoberman considers *Cowards, Bend the Knee*, the first in the trilogy, Maddin's masterpiece. The third film in the trilogy is *My Winnipeg* (2007), which he constructed taking a "docufantasia" approach that brought together "personal history, civic tragedy, and mystical hypothesizing." This involved bringing together facts, rumours, and myths about Winnipeg, "including the demolition of the Winnipeg hockey arena (during the period after the sale of the Winnipeg Jets had left the city without a national hockey team), an epidemic of sleepwalking, the ghosts of frozen horse

heads returning every winter when the rivers freeze over, and If Day (an actual historical event when a faked Nazi invasion of the city was mounted during World War II to promote the sale of war bonds)" (Wikipedia).

Annette Mangaard
Born Lille Vaerlose, Denmark, 1960

Annette Mangaard is a peripatetic filmmaker. Her first film, *Let me wrap my arms around you*, was shot in Baker Lake, Nunavut, where she lived for a year in 1981. Subsequent films have taken her to the Yukon, India, Mongolia, Japan, and Denmark for her documentaries on artists including General Idea, Arnaud Maggs, and the Coleman Lemieux and Compagnie dance troupe. Her documentaries have aired on television and at festivals. Her short experimental films include *The Iconography of Venus* (1987), *Her Soil is Gold* (1985), and *There is in power…seduction* (1985), which deal with issues of gender, corporate power, symbols, and values.

Alexi Manis
Born Toronto, Ontario, Canada, 1974

Alexi Manis draws on found footage, home movies, "optically printed fiascos and the sketches," re-photography, collaborations with painters and musicians, and other accidents and gifts that inspire her 16mm filmmaking. "*Lapse Lose All* both documents and obscures the collage painting process of Toronto artist Kathryn MacKay (now based in Berkeley, California). Time-lapse photography seems to speed up the activity of painting by concentrating the work of several weeks into a few minutes, concealing, more than it reveals" (cfmdc.org).

Lorne Marin
Born Toronto, Ontario, Canada, 1956

Lorne Marin has described *Rhapsody on a Theme from a House Movie* (1972) "as a purely formal investigation of the visual effect(s) of creating a constant rhythmic series of lap dissolves. My original expectation was that by dissolving together overlapping static-camera shots, an illusion of movement might occur. After viewing the initial film footage, I realized that, apart from the intended formal/structural context, there existed in the imagery a rich, detailed portrait of my street and its inhabitants" (cfmdc.org). *Winterlude* (1979) continues this synthesis of formal investigation with lyrical content. Like a number of filmmakers under consideration in this volume, Marin built his own optical printer, a device for re-photographing from one or more film projectors, and used for making special effects. In the case of *Winterlude*, it allowed Marin to juxtapose live-action and painted visual elements "through which trains appear, travel across the frame and disappear." Marin produced these films with the knowledge that he had retinitis pigmentosa, which would gradually deteriorate his sight to tunnel vision. As it progressed, Marin eventually abandoned his filmmaking practice. Recently, he collaborated with filmmaker Caitlin Durlak on a personal documentary, *Persistence of Vision* (2014), that revisits Marin's earlier films in order to get inside his creative mind, the nature of perception, and what the future, where he will most likely become completely blind, will bring.

Richard Martin
Born Vancouver, British Columbia, Canada, 1956

Richard Martin is a media artist living in Vancouver; he received his MFA from the University of British Columbia in 2013. He combines short experimental film work with directing mainstream film and TV. His work

straddles conventional and experimental cinema, blending convention with abstraction and personal trauma. In *Diminished* (1980), Martin slowly dissolves still images shot in a hospital; Gene Youngblood has described it in his book *Expanded Cineman* as "a delicately structured non-verbal poem about loss, time and memory.... Faded images lap-dissolve against 'small sounds' and enigmatic subtitles like voices from the past. A documentary of the heart."

Richard Martin, *Diminished*, 1980

Mixed Signals (2005) exposes the mixed messages of fundamentalism and politics. "A digitally scrambled broadcast, blurs televised images into a kaleidoscope of sound and colour, starkly portraying the co-option of religious dogma for profit and political gain" (cfmdc.org).

Daniel McIntyre
Born London, Ontario, Canada, 1986

Daniel McIntyre has an MFA from York University in Toronto. He works with film's chemistry, animation techniques, and photography; his work involves a crucial connection between visual structure and subject matter. Some of his work addresses the issue of homosexuality, others his deep concern with nuclear radiation.

The Weight of Snow (2014) presents a home movie trip to Chernobyl, a dying matriarch, and a set of troubling personal circumstances. Filmed at the Chernobyl Nuclear Power Plant and surrounding area in Ukraine, *The Weight of Snow*'s voice-over narration of a young man confronts the problem of radiation in the midst of death, cancer, and emotional turmoil. Static in sound and image conjure radioactive fear.

Lindsay McIntyre
Born Edmonton, Alberta, Canada, 1977

Lindsay McIntyre is an artist of Inuk and settler Scottish descent, working mainly with analog film. McIntyre has made close to forty short films, as well as several projector performances. She is drawn to hand processes, making her own 16mm film, hand-coating it with silver gelatine emulsion. This intense interest in the physical properties of film is balanced by an equally strong engagement with documentary forms, portraiture, and personal histories. Some of McIntyre's recent projects include the experimental documentary *Final Roll-Out: The Story of Film* (2018); an award-winning short, *Where We Stand* (2015), about the state of analog film in the digital age; and *If These Walls* (2019), a monumental projection-mapping public installation on the Vancouver Art Gallery about the legacy of residential schools. McIntyre is a member of the EMO Collection, and an assistant professor of Film + Screen Arts at Emily Carr University of Art and Design on unceded Coast Salish territories in Vancouver.

Norman McLaren
Born Stirling, Scotland, 1914;
died Montréal, Quebec, Canada, 1987

Norman McLaren's work in animation, done at the Montréal NFB/ONF, contributed in its inventiveness and sound/image relationships to the development of independent experimental film in Canada. McLaren joined the L'Office National du Film du Canada (ONF) in 1941. He was a pioneer in drawn-on-film animation, pixilation, and graphical sound (sound created by direct markings on the

soundtrack). His awards include an Academy Award for Best Documentary Short Subject in 1952 for *Neighbours*, and a Silver Bear for best short documentary at the 1956 Berlin International Film Festival. McLaren was also involved with UNESCO during the 1950s and 1960s. He travelled to both China and India for UNESCO, leading workshops to teach a range of animation techniques.

In *Neighbours* (1952), McLaren ingeniously employs pixilation principles to animate both live actors and paper cut-outs in the same scene. Two men create borders and come to blows over the possession of a flower, ending in destruction and death. This anti-war film ends with the text message "Love Thy Neighbour" written in many languages. For the film's soundtrack McLaren scratched the edge of the film strip, which the projector reads as sound.

Lines Horizontal (1962), made with Evelyn Lambart, is an experiment in pure design. Lines, ruled directly on film, moving against a background of changing colours, respond to music by Pete Seeger specially composed for the film.

Pas de deux (1968) is a cinematic study of ballet whose overlapping time-lapsed technique creates its own dance—and beauty.

Ross McLaren

Born Sudbury, Ontario, Canada, 1953

Ross McLaren's most celebrated, and most notorious, film is *Crash 'n' Burn*. The film is essentially 16mm black-and-white cinéma-vérité footage of the Dead Boys, Teenage Head, The Boyfriends, and The Diodes performing at Toronto's notorious punk club, the Crash 'n' Burn. McLaren was one of the co-founders of the Funnel, an experimental film production and exhibition co-op that was the centre of avant-garde film activity in Toronto in the 1980s. He studied at the Ontario College of Art and taught there, inspiring a generation of underground filmmakers with a special predilection for working with Super 8. In the mid-1980s, McLaren relocated to New York, where he makes films and teaches independent filmmaking at a variety of institutions.

Wrik Mead

Born Toronto, Ontario, Canada, 1960

Wrik Mead started making animated films as a young teen, and he continued in animation as a student at the Ontario College of Art in Toronto because, as he says, he liked the magic of it! He also wanted the absolute, frame-by-frame control animation offers and requires. He later took an MA at Goldsmith's in London, and now teaches digital printing and expanded animation at OCAD University. His work in film and digital media is made for screenings in cinemas and for gallery installations.

Wrik Mead's work exposes the gay male body. His earliest films, including *What Isabelle Wants* and *Gravity* (both 1987), *Jesus Saves* (1988), and *Warm* (1992), established both the subject matter and style—a single protagonist in simple performance, and the animation technique pixilation—that he would use in the main for his subsequent films. Like Norman McLaren, and unlike the usual use of pixilation, Mead animates live humans as well as inanimate objects. In Mead's hands this animation produces an eerie, uncanny movement as if the figures were being pushed around by unseen, perhaps malign, forces. *Warm* was shot in Super 8 and, as in other films, the grain and other surface blemishes—scratches, dust, dirt, and tape splices—give a rough look and add another type of movement inherent to the filmstrip itself. In *Manipulator* (2002), the 16mm film surface, which is scratched and burned, is further made part of the viewer's experience and participates in the narrative action.

Mead experienced a personal tragedy in 2010 out of which came the film *winter's end*. It is a film of grief and mourning. Although there is some use of pixilation, the overall

feel is calmer, aided by the choice of clean black-and-white film in a snowy winterscape. The calm is, however, suddenly broken as the protagonist is hurled down, falling into a different space, which recalls the life of the partner he has lost. Both this pixilated motion and the fall remind one of the feelings of pain and aloneness in *Warm*. In *winter's end,* an embrace is a kiss of farewell to the ghostly face of the partner whose loss he now accepts. The film ends with a shot of spring greenery pushing up through the snow. *Outcognito* (2017) brings together Mead's concerns with his full use of digital imaging techniques. Here, as in other of Mead's films, the anguish of gay identity is depicted, but not without its happy ending.

Sandra Meigs

Born Baltimore, Maryland, USA, 1953

Sandra Meigs studied at the Rhode Island School of Design, the Nova Scotia College of Art and Design (BFA 1975), and Dalhousie University (MA 1980). She has lived and worked in Canada since 1973. Her main practice is painting, which is whimsical, comic, and delves into the psyche. Her works often make use of text and a narrative thread. Her early installations involved 16mm films, which can be screened independently: *Aphasia: Caught in the Act* (1981) and *Purgatorio: A Drinkingbout* (1981). *The Western Gothic* (1984) uses looped footage shot in the badlands of Alberta; a male voice reads dinosaur names, and a female voice tells a "cowboy story," which is spoken twice, alternating the male and female roles.

François Miron

Born in Montréal, Quebec, Canada, 1962

François Miron is well known in the world of artists' film for his ambitious, stylistically innovative feature-length documentary on the late experimental filmmaker Paul Sharits. However, Miron is an adventurous film artist himself, working with and teaching optical printing at Concordia University, influenced by the work of Pat O'Neill, Norman McLaren, Stan Brakhage, and Paul Sharits. Miron works in Super 8, 16mm, 35mm, and digital, and frequently brings his sensibility to feature film title sequences, music videos, and feature narrative, as well as photographic work, including Arcade Fire's *Neon Bible* album. His earlier experimental films, like *What Ignites Me, Extinguishes Me* (1990) and *The Square Root of Negative 3* (1991), frequently use optical printing to achieve psychedelic effects.

Allyson Mitchell, *Don't Bug Me*, 1997

Allyson Mitchell

Born Scarborough, Ontario, Canada, 1967

Allyson Mitchell creates art installations with fun fur, found objects, and abandoned crafts. She was a co-founder of the fat activist/ performance group Pretty Porky and Pissed Off, and she runs FAG, Feminist Art Gallery, with Deirdre Logue. Mitchell has produced many films and videos and collaborates frequently with fellow filmmaker Christina Zeidler as the film craft collective Freeshow Seymour. Her short films use animation techniques to wittily, sardonically "discuss" gay, feminist, and political issues. She teaches in the School of Gender, Sexuality, and Women's Studies at York University in Toronto.

The animation *If Anyone Should Happen to Get In My Way* (2003), a collaboration with Zeidler, made from high-contrast coloured Lomo photographs, shows a girl in various animal states, licking her wounds—a meditation on female anger. Mitchell describes her 1997 *Don't Bug Me* thus: "Messy lives. Messy relationship. Messy sock drawers. This short and sweet animation will show you how to tidy it all up in less than one minute."

Caroline Monnet

Born Ottawa, Ontario, Canada, 1985

Caroline Monnet is a multidisciplinary artist from Outaouais, Quebec, moving freely from 16mm film to digital, experimental film to documentary and narrative, single-channel work to installation, painting, and sculpture. In 2009, she made her first experimental moving image work, *Ikwé*, for the Winnipeg Film Group. She describes it as "an experimental film that weaves the intimate thoughts of one woman (Ikwé) with the teachings of her grandmother, the Moon, creating a surreal narrative experience that communicates the power of thought and personal reflection." Monnet's *Tshiuetin* demonstrates the limits of generic categorization in today's creative universe. On the one hand, the film is a celebrated, award-winning documentary about the Tshiuetin rail line that came under control of a First Nations group in 2005. On the other hand, Monnet has chosen to shoot and edit the film in a manner that foregrounds the beauty of things themselves: the landscape, the snow, the train, the passengers, and the crew. The sense of time and the vastness of the country are communicated more poetically than didactically.

Cara Morton

Born Scarborough, Ontario, Canada, 1968; died Terrace, British Columbia, 2012

Cara Morton made a couple of beautiful and intense films before her untimely death in 2012. For *Across* (1997) Morton took her Bolex camera and immersed herself in the countryside near Toronto. Mónica Savirón remarks, "In a deep but playful search for self-expression, Morton hand-processes, solarizes, and over and under develops her footage. She makes her external and internal worlds communicate in frantic dialogue, pushing and pulling moods, places, past and present, with an exhilarating montage.... For her, personal experience and art-making are part of the same struggle, one of both fascination and survival" (program notes, "A Matter of Visibility: International Avant-Garde and Artists' Cinema").

Solomon Nagler, *perhaps/We*, 2003

Solomon Nagler

Born Winnipeg, Manitoba, Canada, 1975

Solomon Nagler is a University of Winnipeg philosophy graduate, and now a film professor at the Nova Scotia College of Art and Design University, Halifax. He co-founded, with Cecilia Araneda, the Winnipeg film festival, WNDX. Nagler's filmworks are almost exclusively black-and-white 16mm found, archival footage, augmented by staged re-enactments. His themes often reference his Jewish, Polish ancestry in poetic, semi-narrative recreations. "Solomon Nagler's film work twists and turns

through the uncanny topological spaces between abstraction and representation, negation and affirmation, place and placelessness. Allegorical by design, Nagler's vision is composed of fragments of recognizable reality commingled with the raw matter of hallucination and nascent form" (Scott Birdwise, CFI program notes, The Cinema of Ruins).

In *perhaps/We* (2003), over-damaged, scarred footage fragments and Hebrew text-on-screen, a voice-over speaks of floating dreams and the empty spaces, empty of the dead Jews of Warsaw. *Fugue Nefesh* (2007) begins with a young yeshiva boy enacting hide and seek among his elders' shawled, praying bodies in a strange mist-shrouded setting. An old man's voice speaks in a mix of Yiddish and English.

Kelly O'Brien

Born Vancouver, British Columbia, Canada 1966

Kelly O'Brien's filmmaking has focused on the everyday, or typical home movie subjects—kids and pets and the like—but also darker subject matter like compulsive behaviour, the construction of gender, heartbreak, and war. In 2016, O'Brien made a 16mm film (shot by John Price) about a special needs teacher at her son Teddy's school. Teddy has cerebral palsy, and while O'Brien mostly captures his boundless positive energy and an easygoing demeanour, she doesn't shy away from discussing the difficulties. In discussing another film about her family, *My Brother, Teddy* (2013), O'Brien says, "We'll all continue to struggle with Teddy's cerebral palsy, but this film isn't about that. It's about the things that make the struggle worthwhile."

In 2017, O'Brien found herself unable to continue making moving images, either as an artist or in her professional capacity as a television producer. She had gradually become a regular Facebook poster, despite a reluctance to embrace it for several years. This led

to *Postings from Home*, a half-hour slideshow and spoken word performance piece.

Étienne O'Leary

Born Montréal, Quebec, Canada, 1944; died Montréal, 2011

Étienne O'Leary's filmography consists of three 16mm experimental films completed in Paris between 1966 and 1968: *Day Tripper*, *Homeo* (a.k.a. *Homeo: Minor Death: Coming Back from Going Home*), and *Chromo sud*. They document the drug and hedonistic culture of that era. O'Leary worked with rapid cutting, superimposed images, and a spontaneous diaristic shooting style. "In common with O'Leary's other films, *Chromo sud* is a testament to the transformative powers of editing and the control it gives the filmmaker in shaping his own reality from the world around him" (program notes, Irish Film Institute, Dublin).

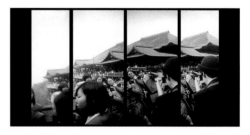

Midi Onodera, *I have no memory of my direction*, 2005

Midi Onodera

Born Toronto, Ontario, Canada, 1961

Midi Onodera began her filmmaking practice as a core member of the Funnel, an artist-run centre in Toronto that was crucial to avant-garde filmmaking and exhibition in the 1980s in Toronto. From the beginning, Onodera referred to her work as "experimental narrative": her films from this period combine narrative soundtracks with image tracks whose relationship to the narrative is often oblique or poetic. *The*

Bird that Chirped on Bathurst Street (1981) is perhaps exemplary. Shot in Super 8, as most of Onodera's work was in the first five years of her practice, the film is a montage of images that sometimes appear abstract, but that mostly seem to follow a woman in different urban settings (presumably Toronto). Meanwhile, the soundtrack goes from silence to what appears to be an overheard monologue by a woman dealing with change in her life, accompanied by a somewhat erratic percussion soundtrack. The effect is jarring and fragmentary, possibly closer to the daily experience of normal human consciousness than is suggested by commercial narrative feature films.

In 1985, Onodera completed four films, including her most ambitious to date at that time, *Ten Cents a Dance (Parallax)*, a 30-minute film, shot in 16mm and using a twin-screen device throughout, as a way to frame three sexual relationships: a lesbian and bisexual woman who are discussing the possibility of a sexual encounter; two gay men who have sex in a public toilet; and a man calling a phone sex partner who talks dirty but ignores him, while he gets off. The film is named after a Rodgers and Hart number sung by a dancer/prostitute, and suggests the transactional nature of sex in our culture. *Parallax* refers to the shift in vision when two cameras look at the same object from different angles; hence, the film suggests the inherent, or socially determined, dissonance in our sexual relationships.

In 1995, Onodera made a feature narrative film, *Skin Deep*, which explores sexual identity and sexual politics, and using a form that demonstrates Onodera's "without boundaries" approach to creativity. In 1998, her ambitious personal film, *The Displaced View*, did the same thing, only this time exploring her identity as a third-generation Japanese woman, and drawing on narrative, documentary, and experimental forms to construct the film.

Since 2006, Onodera has embraced the possibilities of online distribution and increasingly ubiquitous digital photography. She has produced a series of series, one video project

a year that might include one "vidoodle" (30-second to 2-minute video doodles) a day, "addressing themes of language, media, politics and everyday life" (midionodera.com).

Susan Oxtoby, *January 15, 1991: Gulf War Diary*, 1992

Susan Oxtoby

Born Montréal, Quebec, Canada, 1963

In the world of experimental film, Susan Oxtoby is best known as senior film curator at the Berkeley Art Museum and Pacific Film Archive (BAMPFA), former administrative director and programmer at the Cinematheque Ontario, and experimental film officer at the CFMDC. In 1988 and 1992, Susan made two films, *All Flesh is Grass* and *January 15, 1991: Gulf War Diary* respectively. Stan Brakhage said that *All Flesh Is Grass* "is one of the most aptly tragic visions of life-on-earth I've recently seen—one of the most perfect step-printed hand-held (hold your hand's eye) pain's taking orders-of-metaphor perhaps yet created through any conscious arrangement of symbols inasmuch as Susan evolves much of the aesthetic of Arthur Lipsett free of his symbolic cynicism; and she holds the camera personally to her 'heart' in a way Joseph Cornell would have, I'm sure, had he been able to work with the camera directly" (cfmdc.org). In *January 15, 1991: Gulf War Diary*, Oxtoby tries to grapple with the impending Gulf War, capturing the images swirling around her head, received from

the media, and from the commotion on the streets of Toronto that night, as the city geared up for a protest at the US Embassy.

Marnie Parrell
Born Preeceville, Saskatchewan, Canada, 1964

Marnie Parrell is a Métis filmmaker, writer, and artist who began making films in 1988. She completed an MFA in film production at York University in Toronto, where she wrote, directed, and edited *The Future. It's so last week* (2009), a half-hour "femsploitaction" sci-fi adventure. Her early work was small gauge and low-tech, including regular and Super 8 film and the Fisher Price Pixelvision camera. Parrell says, "My films have been described as lyrical, grotesquely funny, and pornographic. These varied descriptors reflect the diversity of style and subject matter my films embrace."

Ahoy! Métis! (2005) plays with the homophones "Métis" and "matey." "In language, spelling and meaning can change over time. This film explores the possibility that Ahoy, Matey! was not a greeting but a warning cry that would chill the bones of even the most fierce privateer. Métis pirates of the Hudson Bay, a part of our heritage" (VTape catalogue).

Andrew James Paterson
Born Toronto, Ontario, Canada, 1952

Andrew James Paterson is perhaps more obviously thought of as a video artist—as well as musician, writer, performance artist, actor, curator, and programmer. He once said that he doesn't like gatekeepers, and this is reflected in the ease with which he moves around artistic media and communities. For example, the work Paterson has made using Super 8 tends to be black-and-white documents of the world in his midst. Rather than capturing himself performing on camera, he tends to be behind the camera, though the whole piece

Andrew James Paterson, *The Walking Philosopher*, 2001

might be thought of as a performance. For example, in *The Walking Philosopher* (2001), Paterson uses his engagement with the world as a means of structuring his voice-over narration that addresses capitalism, the nature of money, citizenship, the body, and philosophy.

Paulette Phillips
Born Halifax, Nova Scotia, Canada, 1956

Paulette Phillips has worked in visual art, film, and theatre; was a Funnel member in the 1980s; and for the past fifteen years has primarily focused on sculpture and film installation. She teaches time-based and contemporary art practices at OCAD University. Her work deals with the relationship between viewer and subject, technological intermediaries, and the way psychological content is embedded in the physical world. In *Trace Elements* (2013), text cast in ice then captured on film, harnessing film's capacity to capture the magic of light, functions as a eulogy for celluloid film. Phillips says, "*When two things touch trace elements are exchanged*, is both a poetic description and the first law of forensic science. Nothing stays the same, everything is in a constant mingle" (paulette-phillips.ca).

Madi Piller

Born Lima, Peru, 1960

Madi Piller's filmmaking approach is broad, collaborative, and hands-on. She works in Super 8, 16mm, 35mm, and digital, and though her work is rooted in animation, she also works quite boldly with non-animated representational and abstract images boldly. *Untitled, 1925* is an ambitious embrace of the power of montage; its consistent element is the soundtrack, the flipping of pages that suggests images that might otherwise be random presumably hang together in some meaningful way. Piller brings this all together at the end of the film, with a text describing her grandfather's decision to live in Peru, and the profound upshot of that decision. Without the text to rationalize the film's contents, however, the film might stand on its own, owing to Piller's poetic adeptness with images, with juxtaposition, with the rhythm of the images, with grain, and with the play between positive and negative. Piller is also a film curator and a community builder, in both Toronto, her current city of residence, and internationally. Stephen Broomer writes in *Shock, Fear, and Belief* that Piller's "sense of community-building looks not only toward the future—by fostering in younger artists a wide-ranging appreciation of skill, and an accommodating definition of animation—but to the past, its fissures and blind-spots, a deep knowledge of the artists who came before her."

Gary Popovich

Born Niagara Falls, Ontario, Canada, 1956

Gary Popovich was one of the triumvirate of film buddies, with Mike Hoolboom and Steve Sanguedolce, who, after graduating from Sheridan College, talked film and worked on each other's films. Popovich made several films, worked as editor for Annette Mangaard's documentaries on visual artists, and most recently is making videos and has released a record album. Cameron Bailey writes that *Archaeology of Memory* (1992) is a "kind of double history that intertwines autobiography with the development of cinema, a stunning, enormously seductive array of images" (*NOW Magazine*).

John Price, *sea series #10*, 2011

John Price

Born Raritan Twp, Pennsylvania, USA, 1967

John Price is both a professional cinematographer and an independent filmmaker working in 35mm and 16mm. His understanding of the specifics of the film medium, its textures and reaction to light, leads to subtle aesthetic explorations as he shoots, documenting daily life around him. He is a prolific filmer, hand-processing his films and often optically printing the 16mm up to 35mm.

Price describes *Party #4* (2006) as "a special one for my first son...his last as a lone ranger (only child). Shot on double-perforation black-and-white 16mm, the film ran through the camera twice and doubled the consumption of ice cream and cake." Price's 2011 *sea series #10* was his response to the Fukushima nuclear disaster and US fundamentalists' prediction of end time. It was shot at Beachfront Park near the Pickering nuclear generating station in Ontario and processed in part with water from the lake. The resultant film is shrouded in an eerie blue cast.

Rick Raxlen, *The Brand New Triathlon*, 2003

Rick Raxlen

Born Toronto, Ontario, Canada, 1945

Rick Raxlen lived and worked for many years in Montréal, where he was active in Main Film and taught at Concordia University. He produced several shorts with the NFB between 1968 and 1976, winning a Genie for Experimental Film for *Legend* (1970). He now lives and continues to make films in Victoria, BC.

Raxlen's films and, later, his videos use a combination of found footage, often cartoons from popular culture, rotoscoping, hand-drawn animation, and other direct-on-film techniques, along with Dadaist texts, jazzy music, and absurdist humour. His attitude is irreverent and humorous—and feminist—as he comments, without actually saying so, on our social mores and ways of living. The movement of his films, almost a free associative one, is akin to Robert Breer's free-flow of imagery. He won Funniest Film for *Deadpan* (2001) at the Ann Arbor Festival. "*Deadpan* deals with dinner-table angst from the fifties. Laughter is forbidden. Anxiety reigns. Cow tongue is served. What to do?" is how Raxlen describes this film. Another description, for *RIX PIX NIX HIX* (2003), shows how his mind and films work: "This dub-track-driven-mashup of rotoscoped homages to earlier animation bops along at a not-seizure-inducing pace. Oodles of rabbits." So too *The Brand New Triathlon* (2003) is paced out for us verbally by Raxlen: "Busy. Got to keep busy. Busy is good, not busy is bad. So we

play at a new triathlon: bowling, cricket and tai chi—a veritable ironman or woman's dream."

Raxlen's work is playful and serious by turns. He has made several films in a serious and moving manner that work with poets and poetry—for example, *Sea Horses and Flying Fish*, and *Searching for Wallenberg*, both 2003, and *Song of the Suicide's Daughter* (2009).

Su Rynard

Born Toronto, Ontario, Canada, 1961

Throughout her career, Su Rynard has moved seamlessly between film and video, documentary and narrative, shorts and features, moving image installations and music videos. She occasionally brings an experimental film sensibility to bear on works like *As Soon as Weather Will Permit* (2014). In *Coronation Park* (shot in 16mm and transferred to HD video, 2009), the deep-blue shots of maple and oak trees teeter on abstraction. The leaves are punctuated by the word *breathe*, rendered in the different languages that are spoken in the parts of Toronto where the film was shot: Ukrainian, Polish, Chinese, French, Arabic, English. It is a suggestion or even a command to the leaves to breathe again, to turn from blue to green, or a suggestion or plea to the citizens of Toronto to keep breathing.

Steve Sanguedolce

Born Toronto, Ontario, Canada, 1959

Steve Sanguedolce studied at Sheridan College in Toronto, where he adopted the personal documentary approach that had many of his classmates under its spell. Sanguedolce took his initial inspiration from family home movies, and his experimental films incorporate elements of narrative and documentary forms. This has led him to an agonizing documentary on mental illness, *Full Moon Darkness* (co-directed with Carl Brown, 1983); *Sweetblood* (1993), memories constructed

from family albums; and *Mexico* (1992), a collaboration with Mike Hoolboom that Josh Ramisch has called, "Not so much a film as a series of live-action postcards, the images are sustained by an incisive voice-over. The tour ranges from an archeological museum to a car factory ('a factory which produces only smoke') to a hideously graphic bullfight, linking cultural colonialism to free trade" (*Variety*). Sanguedolce's most ambitious film to date is arguably *Smack* (2000), a documentary/fiction hybrid that synthesizes Super 8 diary footage, hand colouring, and addicts telling their stories on the soundtrack.

Gerald Saul, *Final (Toxic 6)*, 2002

Gerald Saul

Born Winnipeg, Manitoba, Canada, 1964

Gerald Saul has an MFA in Film Studies from York University in Toronto and is a professor in the Department of Film at the University of Regina. He is a prominent and active participant in the Regina film scene. After his first feature film, *Wheat Soup* (1987), Saul focused primarily on 16mm experimental film and animation. His work and quirky sense of play arise from involvement with his family and life around him. He also uses both film and digital cameras and devices to explore 3-D graphics and non-traditional narrative storytelling. Much of this work was conducted through the New Media Research Laboratory. He says, "My work has been increasingly about memory and identity as my body of work is slowly creating a self-portrait. My early work is concerned with a questioning of the process of art-making while my later works accept that art-making

and living are closely tied so to question the value of one is to question the value of the other." His later 16mm films series, especially *Toxic*, *Modern*, and *Grain*, are process-oriented as well as being his most personal films, with humour and sometimes a satiric edge. In *Final (Toxic 6)* (2002), the treatment and subject matter are matched: radiated (solarized) footage, film and buildings alike in tatters. "This moving film is a nihilistic glimpse of a future where our time has finally run out. Civilization is in ruins as storms explode over half-demolished buildings. The clock accelerates in anticipation of our encroaching successor" (cfmdc.org).

Dan Smeby

Born Newcastle, New Brunswick, Canada, 1985

Dan Smeby is based in Moncton, NB. He received a BFA from Concordia University in 2011. His work in Super 8 and 16mm moves between music videos and silent movies, Blake and Thoreau, and diaristic travelogues. While documenting and responding to the world around him, Smeby explores possibilities of the film medium. He has made collaborative works at residencies in Uganda, Kuwait, and recently Saint John, NB. His work here reflected the three language groups of the participants, French, English, and Mi'kmaq. His latest film, *À mains nues* (2021) celebrates the handmade.

John Straiton

Born Kapuskasing, Ontario, Canada, 1922; died Oakville, Ontario, 2019

John Straiton worked in advertising but created an autonomous amateur body of work, nine very different films responding to particular visual ideas or challenges. *Steam Ballet* (1968) freezes and then re-animates the movement of different parts of steam tractors, including the steam itself, in order to reveal

their intrinsic visual music, industrial ballet as it were. *Animals in Motion* (1968) took Eadweard Muybridge's collections of original photographs, which were originally animated by Muybridge's zoopraxiscope, and created animations for the movie projector. Straiton's ambitions with this film, and his others, seem quite modest—"little dances to music" he called them—but this film in particular became a key document for experiencing and studying Muybridge's work. Other Straiton films use techniques ranging from pastel drawings (*Portrait of Lydia,* 1964), to Plasticine (*Eurynome,* 1970) and collage (*MM Myth Myth-A Collage*, 1985).

Leslie Supnet
Born Winnipeg, Manitoba, Canada, 1980

Leslie Supnet has been producing films since 2007, working in animation, found footage, and live-action. Writing in *BlackFlash*, Amber Christensen characterized Supnet's films as having a "tenacious fragility—her early works, including *How to Care for Introverts*, 2010, are intimate glimpses into the internal minds of her hand-drawn characters: the cautious, the introspective, but nonetheless the reso-lute....Supnet's films take pause in those fleeting moments within moments that often go unnoticed yet are imprinted and waiting, some-where in the unconscious." For her 2016 film *In Still Time*, Supnet took images of the Syrian civil war from the internet and laser printed them onto film, abstracting them on the one hand, and animating them on the other. The sound is derived from news sources found on the internet and interviews with Syrian civilians, writers, and activists. According to Supnet, "through clues of shape, line, colour, and sound these abstracted images of catastrophe attempt to facilitate questions about the moral imperative to look, our ability or inability to bear witness to unthinkable human suffering and our complicity in the violence documented in the image."

Malena Szlam
Born Santiago, Chile, 1979

Malena Szlam takes her inspiration from analog cinema, and the way its various forms capture and transform light and create the sense of space and time. As with a number of artists of her generation, her work manifests itself as theatrical projections, installations, and performances. A member of Double Negative in Montréal, where she co-curates an ongoing experimental film series, Szlam has had her own work shown in Boston, Hong Kong, Montréal, New York, Rotterdam, Toronto, Zagreb, and other international centres. Her *Altiplano* (2018) is one of her most stunning achievements. In the preface to an interview with her at the Jeonju International Film Festival 2019, Dan Sullivan remarked that Szlam "films the reddish Andean Altiplano as if located on another planet...an expanse of deserts, salt flats, remnants of volcanic activity, and lakes stained the same hue of their environs, that is as ancient as it is visually spellbinding. Rhythmically edited (largely in-camera), marked by a faintly delirious density of superimposition, and photographed (on 16mm, blown up to 35mm for exhibition) with the eye of a keen observer who wishes to dig deeper despite the impossibility of reaching beneath the surface of the dunes, mountains, and craters, *ALTIPLANO*'s restlessly kinetic examination evokes the region's political history as well as the present-day mineral exploitation underway there."

Kika Thorne
Born Toronto, Ontario, Canada, 1964

Kika Thorne is a visual artist and curator. From 1991 to 2001, she made a number of videos, sometimes shooting in Super 8. *October 25th and 26th, 1996* (1996) documents the efforts of a few artists and architects during the Metro Days of Action. A 150-foot-long tunnel was inflated using the air vents in front of Toronto's

Nathan Phillips Square. The October Group action references both public institution and temporary home to protest the erosion of the city. The group included Adrian Blackwell, Cecelia Chen, Daniel Diaz Arrasco, Kenneth Hayes, Barry Isenor, Mike Lawrence, Christie Pearson, Kika Thorne, Wiebke von Carolsfeld, and Derrick Wang.

Kirk Tougas, *The Politics of Perception*, 1973

Kirk Tougas
Born Edmonton, Alberta, Canada, 1949

Kirk Tougas was the founder and director of Pacific Cinematheque in Vancouver, and although most of his career has been in documentary filmmaking, his experimental films, *The Politics of Perception* (1973) and *Return to Departure: The Biography of a Painting* (1986), are well known and regarded. In *The Politics of Perception*, a segment of a Hollywood film is reduced to white noise by its repeated re-filming, thereby laying bare the material actuality beneath the represented content.

Kyle Whitehead
Born New Westminster, British Columbia, Canada, 1983

Kyle Whitehead works with the materiality of film and process-based structures (like James Tenney's process music strategies) in his Super 8 films. He wants unpredictability and chance—with a plan. He also curates MONOGRAPH, an ongoing series of experimental film programs in Calgary, where he lives. *Heads or Tails* (2016) is made of the heads and tails of black-and-white Super 8 films, which Whitehead has hand-processed over the years. The clips were edited together by flipping a coin and then splicing in either a head or a tail selected at random, as determined by the toss. *Vapor* (2016) is a film of light: "Pinhole images coalesce into something recognizable and just as quickly fade into the mist of emulsion from which they came" (cfmdc.org).

Steven Woloshen
Born Montréal, Quebec, Canada, 1960

Steven Woloshen is best known for his scratch animation films, working mainly with 35mm CinemaScope stock. Like other filmmakers working in this arena, such as the NFB's Norman McLaren or Stan Brakhage, or other abstract animators like Oskar Fischinger, Woloshen is inspired by music. This is sometimes rendered obviously through synchronization in a film like *Cameras Take Five* (2002), where each of the graphic elements represents aspects of Dave Brubeck's composition, with dynamic lines synced to the saxophone lead, against a background of hot blue and green fields of colour. Occasionally Woloshen also works with found footage, creating jarring, uncanny films like *La Dolce Vita* (2009) and *Father Knows Best* (2018), the images of the latter manipulated, and cut to an improvised atonal music composition by Malcolm Goldstein. He is the author of two books on cameraless film techniques.

Acknowledgements

From the time we conceived of this book, we knew we would invite Stephen Broomer and Michael Zryd to write for it. The book had to be comprehensive, generous, and open-minded, qualities we knew Broomer and Zryd brought to all their writing, and to their interest in Canadian experimental cinema in particular. We're honoured that they both agreed to be involved in the project, contributing their research acumen and tremendous insights.

Goose Lane Editions is Canada's foremost visual culture publisher. We are thrilled that they have welcomed *Moments of Perception* as part of their thoughtful and distinguished roster.

We are immensely grateful for the generosity of the supporters of this publication. Type A Print understood and supported our ambition to create a first-rate publication, a beautiful and intelligent volume to honour Canadian experimental film.

Paul Roth at the Ryerson Image Centre (RIC) has always appreciated experimental film as part of the continuum of photographic expression, and saw the value in supporting this publication as consistent with RIC's mission.

The research and writing of *Moments of Perception* benefited greatly from the Social Sciences and Humanities Research Council of Canada (SSHRC), who supported the publication through grants to Archive/Counter-Archive; York University SSHRC Institutional Grant through the School of the Arts, Media, Performance and Design (AMPD); and the office of the Vice-President, Research and Innovation (VPRI).

The Canadian Filmmakers Distribution Centre (CFMDC) and the Images Festival, two organizations absolutely central to the story of Canadian experimental cinema, will be our partners on the launch and the tour in some post-pandemic future. We are grateful for their enthusiastic support, and especially appreciate Jesse Brossoit, CFMDC's Distribution and Collections Coordinator, for his resourcefulness and commitment to the project.

Jim Shedden benefited immeasurably from Robyn Lew's research in the early stages of the project, and Clint Enns and Phil Hoffman for their assistance in gathering images.

We have each seen thousands of Canadian experimental films at hundreds of screenings. Those filmmakers, programmers, curators, archivists, writers, distributors, funders, lab technicians, and other experimental film aficionados have inspired our love over the years. That love, in turn, inspired this book.

—JIM SHEDDEN and BARBARA STERNBERG

Madi Piller, *Graffiti*, 2003

Index to Filmmakers

Contributors

Stephen Broomer is a film historian and filmmaker. He has been a Fulbright visiting scholar at University of California Santa Cruz and an International Council for Canadian Studies postdoctoral fellow at Brock University. His writings on cinema have appeared in *Found Footage Magazine, Film International,* and *Desistfilm.* He is the author of *Hamilton Babylon: A History of the McMaster Film Board* and *Codes for North: Foundations of the Canadian Avant-Garde Film.* He is the presenter of Art & Trash, a video essay series on underground media.

Jim Shedden is responsible for the Art Gallery of Ontario's publishing program, where he also serves as a curator of special exhibitions, including the forthcoming *I AM HERE: Home Movies and Everyday Masterpieces,* as well as *Guillermo del Toro: At Home with Monsters* (2017), and *Outsiders: American Photography and Film, 1950s-1980s.* In the 1990s, Shedden worked at the AGO as a film and performing arts curator, before leaving for a stint as studio manager and creative producer at Bruce Mau Design. He coordinated the International Experimental Film Congress in 1989 and co-programmed the Innis Film Society. Shedden has directed a number of documentaries, including films on the artists Michael Snow and Stan Brakhage, and has written on music, film, video, art, books, and design. Shedden has been involved in the independent arts scene in Toronto since 1980.

Barbara Sternberg has a long and broad involvement in the field. She has been making and showing her experimental films since the mid-seventies, for which work she received the Governor General's Award in 2011. She worked at Canadian Filmmakers Distribution Centre (CFMDC) as Experimental Film officer, taught in the film and visual arts faculties at York University, was founding member of Pleasure Dome film exhibition group in Toronto, and co-founder of Struts Gallery in Sackville, NB. Sternberg was one of the organizers of the 1989 International Experimental Film Congress, and she initiated the Association for Film Art (AFFA) to actively support and promote awareness and appreciation of film art. Sternberg has programmed films and written articles on various film and visual artists. She wrote a column, "On (Experimental) Film" for *Cinema Canada,* and she has made biographical videos posted to YouTube and Vimeo on Canadian visual and film artists at CDNartists.

Michael Zryd teaches cinema and media arts at York University, where he is a member of Sensorium (Centre for Digital Arts and Technology) and the Robarts Centre for Canadian Studies. He is a researcher in experimental film and media, focusing on its institutional histories and ecologies. He has published essays on Hollis Frampton, Su Friedrich, Philip Hoffman, Ken Jacobs, Midi Onodera, Ruth Ozeki, and Joyce Wieland, and programmed films for Anthology Film Archives, Art Gallery of Ontario, and ZKM Karlsruhe. Zryd co-founded the Experimental Film and Media Scholarly Interest Group in the Society for Cinema and Media Studies and the Toronto Film & Media Seminar, and served on the board of directors of the Images Festival and the Canadian Filmmakers Distribution Centre (CFMDC).

Credits

Copyright in the images reproduced in this book is held by the individual filmmakers or photographers unless otherwise indicated. Other images appear courtesy of the following copyright holders or lenders. Complete film information can normally be found at cmfdc.org.

1 Lesley Loksi Chan, projector performance at Harbourfront Centre, Toronto, 2011 © LIsa Narduzzi **8-9** York University Libraries, Clara Thomas Archives & Special Collections, Joyce Wieland fonds, ASC07123, copyright © 1969 by National Gallery of Canada **10-11** © by Cinémathèque Québécoise **21** © 1988 by IsumaTV **26** © 1989 by Images Festival **30** Cover photo by Kika Thorne, © 2001 by Mike Hoolboom **31** Cover photo by Michael Snow, cover design by Vijen Vijendren. *Image and Identity: Reflections on Canadian Film and Culture* © 1989 by Wilfrid Laurier University Press **37** *Opsis: The Canadian Journal of Avant-Garde and Political Cinema* 1, no. 1 © 1984 by *Opsis*; Journal cover, *Incite Journal of Experimental Media*, no. 4, 2013, cover image © 2013 by Walter Forsberg, *Video Preservation (SMPTE)*, Kodak 7285 16mm reversal film **82** © 1986, Kitchener-Waterloo Art Gallery, cover design by Hofstetter Graphics Limited **83** *Spirit in the Landscape* © 1989 by Art Gallery of Ontario, cover design by Marilyn Bouma-Pyper; *David Rimmer: Films & Tapes* © 1993 by Art Gallery of Ontario, cover design by Bryan Gee; *Presence and Absence: The Films of Michael Snow, 1956-1991* © 1995 by Art Gallery of Ontario, cover design by Bruce Mau Design; *Richard Hancox* © 1990 by Art Gallery of Ontario, cover design by Lisa Naftolin **94** Poster design by Marilyn Bouma-Pyper © 1988 by Art Gallery of Ontario **98** Poster © 1989 by Nora Patrich **108** Halifax Independent Filmmakers Festival poster design by Erin McDonald © 2019 by AFCOOP; Media City Film Festival poster © 2017 by Media City Film Festival; Pleasure Dome image by G.B. Jones (production still for *Sex Bombs!*, 1987) © 1990 by Pleasure Dome; Vancouver Underground Film Festival poster © 2000 by Alex MacKenzie **110** © 2013 by Saskatchewan Filmpool Cooperative; © 1996 by Queer City Cinema Festival **123** © 2019 by WNDX Festival of Moving Image **133** Winter 1992 program poster design by Gregory Van Alstyne; Fall 2013 program poster design by Jake Pauls **137** © 1991 by Innis Film Society **139** Program poster, *Lighthouse* © 2008 by Loop Collective **145** © 2010 by Double Negative Collective **149** © 2020 by Handmade Film Collective **166-167** Pierre Abbeloos and Michael Snow with the "camera-activating machine" designed by Abbeloos for *La région centrale*, 1971 (Photograph by Joyce Wieland, courtesy Michael Snow).

Publication of this book has been
supported by:
Archive/Counter-Archive (A/CA):
 Activating Canada's Moving Image
 Heritage, which is funded by a
 Social Sciences and Humanities
 Research Council of Canada
 (SSHRC) Partnership Grant.
Social Sciences and Humanities
 Research Council of Canada
 (SSHRC) through the York University
 SSHRC Institutional Grant,
 through the School of Arts, Media,
 Performance and Design (AMPD),
 and Office of the Vice-President
 Research & Innovation (VPRI).
Ryerson Image Centre.
Type A Print Inc.

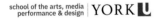

RYERSON
IMAGE
CENTRE

Edited by James Harbeck and Paula Sarson.
Cover and page design by Julie Scriver with Jim Shedden and Barbara Sternberg.
Cover image: Photograph of Eva Kolcze during an independent residency at
Artscape Gibraltar Point, Toronto Islands, 2011. Copyright © 2011 by Spencer
Barclay.
Pre-press and print coordination by Type A Print.
Printed in Belgium.
10 9 8 7 6 5 4 3 2 1

Library and Archives Canada Cataloguing in Publication

Title: Moments of perception : experimental film in Canada / Stephen Broomer
and Michael Zryd ; edited by Jim Shedden and Barbara Sternberg.
Names: Broomer, Stephen, author. | Zryd, Michael, author. | Shedden, Jim,
1963- editor. | Sternberg, Barbara, editor.
Description: Includes bibliographical references and index.
Identifiers: Canadiana (print) 20210182210 | Canadiana (ebook) 20210182229 |
ISBN 9781773102030 (softcover) | ISBN 9781773102443 (EPUB)
Subjects: LCSH: Experimental films—Canada—History and criticism.
Classification: LCC PN1995.9.E96 B76 2021 | DDC 791.43/6110971—dc23

Goose Lane Editions acknowledges the generous support of the Government of
Canada, the Canada Council for the Arts, and the Government of New Brunswick.

Goose Lane Editions
500 Beaverbrook Court, Suite 330
Fredericton, New Brunswick
CANADA E3B 5X4
gooselane.com

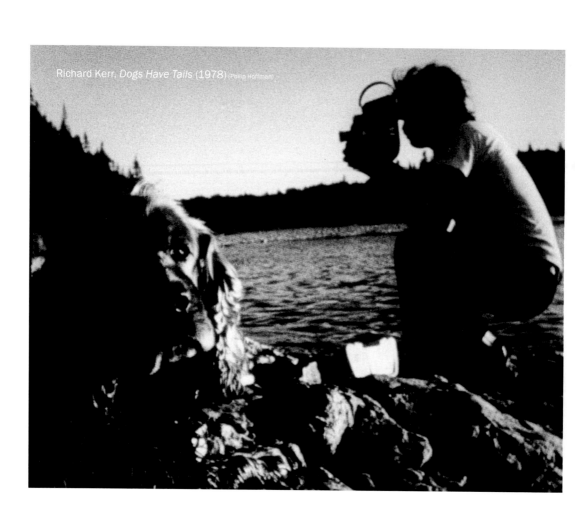

Richard Kerr, *Dogs Have Tails* (1978) (Philip Hoffman)

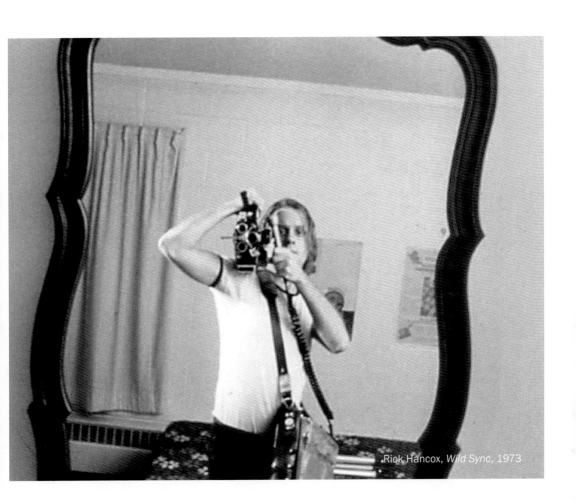

Rick Hancox, *Wild Sync*, 1973

Christina Battle, self-portrait, 2021

Daïchi Saïto, 2010 (Braden King)

Malena Szlam, 2019 (Adam Bobbette)